# 生命之渺
## 方力鈞創作25年展

**Endlessness of Life：**
**25 Years Retrospect of Fang Lijun**

生命之渺

# 方力鈞創作25年展

# Endlessness of Life：
# 25 Years Retrospect of Fang Lijun

# 序

1990年代以降，國際當代藝壇開始聚焦六四之後的中國，代表中國當代藝術分水嶺「後八九」的藝術家逐漸受到西方藝壇重視，兩岸三地也開始進行民間的文化藝術交流活動。為整合更多的海內外資源，拓展華人當代藝術在藝壇的影響力，本館首度推出「後八九」最具學術價值的中國當代藝術家方力鈞回顧展，展出其自1984年至今各創作階段的代表作品七十餘組件，包括素描、油畫、版畫、雕塑、裝置以及最新力作。這也是方力鈞二十五年創作生涯的第一次回顧型個展，由台灣策展人胡永芬策劃，作品來自歐洲、美洲與亞洲的美術館、基金會與私人收藏。

方力鈞被中國藝評家栗憲庭認為是「玩世現實主義」的代表人物。1990年代初期，他所創造的「光頭」經典形象，影響了張曉剛、岳敏君、曾梵志等中國當代藝術家眾多作品中符號化的人形創作。方力鈞1963年生於河北，1989年畢業於中央美術學院版畫系，現居北京。學生時期的版畫訓練，影響了他日後的創作，而1980年代開始發展光頭形象的另類、挪揄的藝術符號，在1990年代成為中國當代藝術的經典圖象之一。這些人物、嬰孩、或蟲獸形象，消弭了個別特色，改用集體主義取代，成為芸芸眾生的象徵，方力鈞藉此標誌當代人叛逆、戲謔、躁動、迷惘的內心。在社會主義的國度裡，這些面目扭曲而無聲地張大了嘴的無名面孔，勾繪了個人內在對映於社會現實的容顏，也凝結成為全世界人們心目中，「六四」之後整個時代下中國人的心理縮影。

本展展出的另一特色是中國籍策展人盧迎華與方力鈞合作的「1963-2008方力鈞文獻展」，盧迎華以研究論述的角度，深入挖掘並梳理出方力鈞從河北邯鄲老家直到移居北京，三十多年來各時期的鉅量習作、手稿、筆記與出版品等素材，以「展中展」的形式首次在本展呈現。

本館一向以引介國際當代藝術潮流為辦展重要方向，「生命之渺──方力鈞創作25年展」的展出，藉此提供觀眾一個觀照中國當代藝術的機會，進而開啟華人藝術圈的學術交流與研究。本展得以順利成功，要感謝藝術家方力鈞先生、策展人胡永芬女士與盧迎華女士的共同合作與策展、藝術家雜誌社社長何政廣先生的慨然協辦，以及義之堂負責人陳筱君女士的大力協助。此外，更感謝首度與本館合作的德國比利菲爾德美術館對多件重要作品借件、展出，以及北京今日美術館在文獻展的出版協助。透過以上國際美術館友館間的借展合作與學術資源共享，以及各方的贊助與支持，才能讓本展順利呈現，謹代表臺北市立美術館致上誠摯的謝意。

臺北市立美術館館長

During the 1990s, the international contemporary art community began to focus on China after the June 4 incident. The Post-'89 artists, who represent a watershed in contemporary Chinese art, have attracted increasing attention from the West, while non-governmental cultural and artistic exchange also started between mainland China, Taiwan and Hong Kong. With a view to pooling resources at home and abroad to widen the influence of contemporary art by ethnic Chinese artists, the Taipei Fine Arts Museum presents for the first time a retrospective of Fang Lijun, a contemporary Chinese post-'89 artist of great academic interest. The retrospective will feature some seventy works from his different creative periods since 1984, including drawings, oil paintings, prints, sculptures, installations and his latest works. Curated by Taiwanese curator Hu Yung-fen, it is Fang's first solo exhibition in the twenty-five years of his career, and includes works from the collections of European, American and Asian museums, as well as foundations and private collections.

Chinese critic Li Xianting cites Fang Lijun as a representative of "cynical realism." In the early 1990s, his classic "bald" figures influenced the sign-like human forms in the works of Zhang Xiaogang, Yue Minjun and Zeng Fanzhi. Born in Hebei in 1963, Fang graduated from the Print Department of the Central Academy of Fine Arts, Beijing and now lives in Beijing. The print training at college has had an impact on his later work. During the 1980s, he began developing the alternative, satirical artistic symbols consisting of bald figures, which became classic images of contemporary Chinese art in the 1990s. His human figures, babies or insects and animals are devoid of individual traits. Instead, they are depicted as one collective, as symbols of all living things, through which Fang expresses the rebellious, playful, restless and bewildered hearts of contemporary people. In a socialist country, these distorted anonymous faces with wide open mouths from which no sound comes out suggest people's helplessness in the face of reality, and came to be seen as psychological portraits of the Chinese people after the June 4 incident in the minds of the world.

Another feature of this retrospective is the presentation of *Fang Lijun's Documentation 1963-2008*, a collaboration between Fang and the Chinese curator Yinghua Lu. Using an academic approach, Lu researched and compiled the vast amount of studies, manuscripts, notes and publications during three decades of Fang's life from his native place Handan, Hebei Province to Beijing. The results are presented in this exhibition for the first time.

Introducing the contemporary international art trends has always been one of the main objectives of the Taipei Fine Arts Museum. With *Endlessness of Life: 25 Years Retrospect of Fang Lijun*, it hopes to offer the public a chance to get acquainted with contemporary Chinese art, and further to promote academic exchange and research in the Chinese art circles. This exhibition would not have been possible without the help of the artist Mr. Fang Lijun, the work and collaboration between curator Ms. Hu Yung-fen and Ms. Yinghua Lu, the joint organization by Mr. Ho Cheng-kuang of Artist Magazine, as well as the generous assistance of Ms Chen Hsiao Chun of Xi Zhi Tang Gallery. We also thank Germany's Kunsthalle Bielefeld Museum for its loan of several major works for exhibition in our first partnership, as well as Beijing's Art Today Museum for its assistance in publication for the documentation and archive exhibition. On behalf of the Taipei Fine Arts Museum, I wish to express our gratitude for the friendly loans and sharing of academic resources by international museums, as well as the sponsorship and support of various quarters which have facilitated the successful mounting of this exhibition.

Hsiao-yun Hsieh, Director of Taipei Fine Arts Museum

# 序

中國當代藝術這三十年來的發展，概括而言，是以中國大陸自70年代末以來的改革開放政策所引起的社會與文化遽變，及其和傳統價值與管理體系之間形成的隔閡，作為背景。從較廣的層面來看，此遽變坐落於全球經濟與文化結構的緊密化之內；從較遠的時軸來看，此隔閡又銜連了文化大革命的歷史漣漪，這些因素再經90年代以來科技文化的高速擠壓、吞吐，從而構成了近年中國當代藝術具激變性的獨特孕生脈絡。傷痕美術、鄉土現實主義、八五新潮、政治波普，乃至方力鈞被歸諸的玩世現實主義等潮流，都可以被囊括在這段演變形成的詮釋架構內；而也是從這裡開始，我們可以邁步對藝術的自主角色進行析釐。

這次由台北市立美術館主辦、藝術家雜誌協辦、胡永芬與盧迎華共同策展的「生命之渺——方力鈞創作25年展」，作為中國當代藝術家在台灣官方美術館的第一場個展，無疑具有指標性的意義。方力鈞為近年頗受國際矚目的中國新生代藝術家，收藏其作品的單位廣布中外各地；為促成這場展覽，北美館透過和德國比利菲爾德美術館的跨國合作，向亞、歐、美洲各國的個人和團體借展七十組不同媒材的作品，其間牽涉的行政程序之龐雜，不難想見。這場展覽得以順利展出，表示台灣與中國大陸，以及國外美術館之間的交流皆已漸成熟，而這場展覽的先例，也顯示著往後國內外的官方文化機構合作，將出現更多可能。

同樣重要的，在學術上，這場展覽也為國內疏通了兩岸藝術論述的往來通路。方力鈞雖為具國際知名度的中國當代藝術家，但國內評論對之著墨者仍不多見。伴隨著這次的生涯創作展，策展人胡永芬小姐特別於展覽的專輯中，針對方力鈞作品中的重要主題，耕築了將近兩萬餘言的文字，可說是國內首篇專注於單一位中國當代藝術家生涯作品的大型論述。在方力鈞生涯作品圖版的蒐羅下，這本專輯也許是目前在台灣出版、勾勒方力鈞身為中國後八九以來最重要藝術家之一的代表性，最完整的一本畫冊暨論述。此展覽的另一個部分、由盧迎華小姐策劃的「像野狗一樣生活：1963-2008方力鈞文獻展」之圖文，則另以專輯印製出版。

方力鈞二十五年來的創作生涯，同時也是他從光頭、游水、人群、鳥獸到孩童，逐步建立起其被標示為玩世現實主義代表的象徵體系的過程。藉由這本展覽專輯，我們希望充分鋪陳這個體系的來龍去脈、其和人們的時代處境的聯繫，同時傳遞方力鈞身為群體一員和藝術家之雙重身分的感受與回應；而身為藝術文化出版業的一分子，我們亦希望它在梳理作品的政治－社會面向外，更為方力鈞於近代中國藝術史上的地位與美學角色，尋出定點。

藝術家雜誌社社長

Generally speaking, the development of contemporary Chinese art in the past thirties years is marked with the social and cultural changes resulted from the open market policies inaugurated by the end of the seventies, and the rare extent to which the administrative and value systems have accommodated themselves to them. From a broader perspective, the changes are made on the pulse of the tightening process of economic and cultural structure on a global scale; from a more distant viewpoint, their effects hark back to the historical ripples of the Cultural Revolution. All of these factors, compressed and ruminated with the speed of technology which has been accelerating since the nineties, constituted the uniquely versatile environment for the recent development of contemporary Chinese art. The trends of Trauma Literature, Native Realism, '85 New Wave, Political Pop, and Cynical Realism to which Fang Lijun is ascribed can be generally included in the interpretive framework it shaped, which also gives us impetus to examine the autonomous status of art.

The exhibition *Endlessness of Life: 25 Years Retrospect of Fang Lijun*, organized by Taipei Fine Arts Museum, co-organized by Artist Magazine, and curated by Hu Yung-fen and Yinghua Lu, as the first solo exhibition of contemporary artist from mainland China in the official museum in Taiwan, has undoubtedly a pivotal role in the history of museum exhibition in Taiwan. Fang Lijun is a young Chinese artist of international fame, whose works are collected worldwide. For the exhibition, Taipei Fine Arts Museum loaned, in the collaborative assistance of Kunsthalle Bielefeld Museum of Germany, 70 (groups of) works of diverse media from individual and institutional collectors in Asia, Europe, and America. The complexities involved in the required procedures themselves are worth of note. They also imply that the communications among museums of Taiwan, mainland China, and other countries have achieved an institutional maturity that may give rise to other possibilities in the future.

Equally important, the exhibition has opened a venue for cross-strait exchange of artistic discourses in Taiwan. Internationally renowned as Fang Lijun is, his work has received limited critical attention on the island. In the catalogue published alongside the exhibition, the curator Hu Yung-fen offers a survey of more than twenty thousands words on the major themes of Fang's work, the scale of which makes it readily the first detailed exposition of the work of a single contemporary Chinese artist in Taiwan. Joined by a comprehensive selection of Fang Lijun's works, the catalogue can be said to be a complete record of the art of Fang Lijun as one of the most important representative artists of post-'89 period published in Taiwan The record of the exhibition *Fang Lijun's Documentation 1963-2008* edited by Yinghua Lu will be published in another catalogue.

The twenty-five years career of Fang Lijun has seen the gradual establishment of symbolism of bald head, water, crowds of people, birds and beasts, and children, etc., which situated him in Cynical Realism. By the catalogue, we wish to unfold in full the process and its relation to the human condition of our time, and chronicle the feelings and responses of Fang Lijun, in his dual role as an artist and an individual in society. As a member of publishing industry of art-related books, we also wish that besides summarizing of the politico-social aspects of his work, it will succeed in locating the aesthetic role of the artist in the history of modern Chinese art.

Ho Cheng-kuang, Director of Artist Magazine

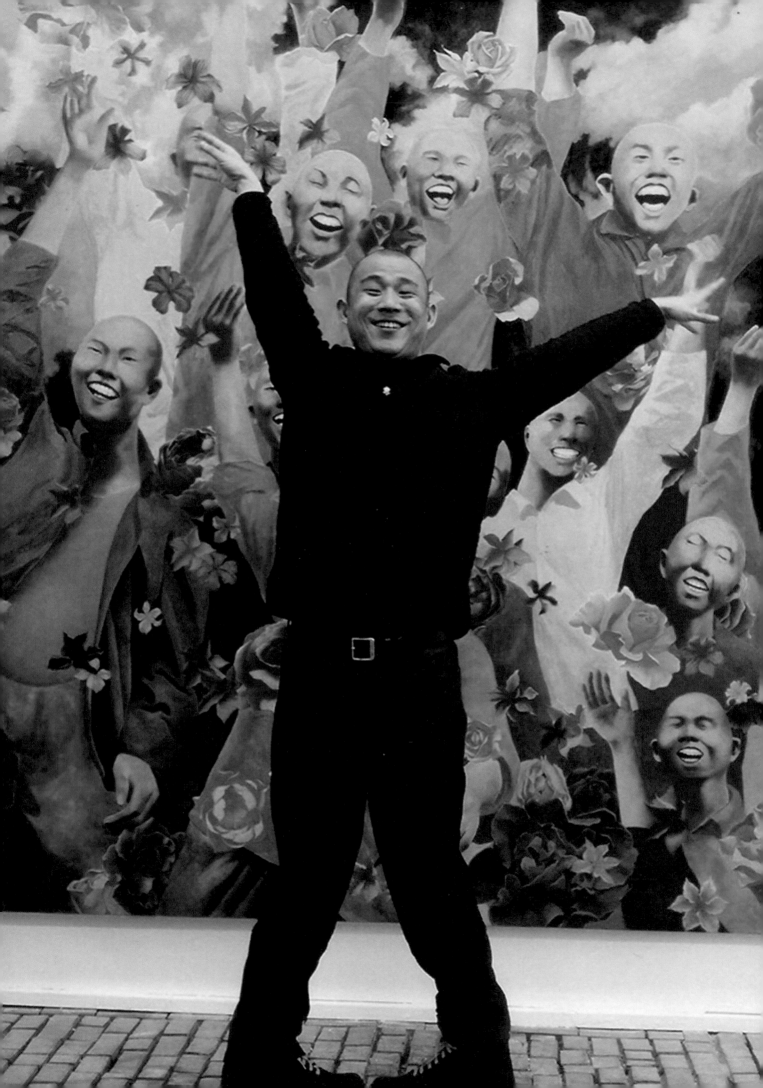

# 方力鈞——碧海與藍天

## Fang Lijun. Sea and Sky

文／湯瑪斯·克萊因（德國比利菲爾德美術館館長）

Thomas Kellein（Director of Kunsthalle Bielefeld Museum）

當中國不斷富裕起來，再過不久，每個人就都將有能力擁有一輛轎車、一間房子及到海邊去度假了。在這個時候，中國人會做什麼呢？文化大革命結束了，中國實踐了最成功的自由開放經濟。中國的藝術家在1989年之後，透過他們的藝術作品，得到了令人印象深刻的財富。1963年出生的方力鈞就是透過創作，反思出他自己在歷史中的定位。

　　在方力鈞剛開始從事繪畫創作的時代，當時的藝術題材，若沒有標榜共產黨，是不太能想像的。方力鈞曾在一場會談中提及：每完成一張新畫的時候，一開始，他會先行等候一段時間，觀察有沒有哪位黨的幹部會從中找到可疑之點，對畫作提出不滿或是認出負面的徵兆。中國在1991年左右的時候，造型藝術的處境又再次變得令人沮喪。藝術家和以前一樣受到嚴苛的控制，他們真的如字面所形容，流露出下垂的嘴角及深深的嘴角紋。那個時候，方力鈞的作品就是可被讀作這種赤裸裸的現實主義。畫中，那些多半光著頭、穿著制服，面露冷笑的人，事實上，該是一種暗示：因為在中國，沒有什麼可以令人發笑的事。較特別的一點是：方力鈞作品中的人物，通常是跟他年紀相仿的男人，不過，漸漸地也出現了年輕的女人，她們可是完完全全的警醒。她們的姿勢，誇張的強調出期待的模樣。但這樣的姿勢，只有透露同時也隱藏起來她們的冷諷。

　　1992年起，當方力鈞首次著手創作，畫面上溢滿水的游泳者及在藍天白雲下的人群之時，局勢則有些緩和了。1994年他得以參加在鹿特丹及巴塞爾的展覽，這亦是他第一次參加國際的展覽。然而，接下來的幾年發展就又不那麼順利了。當時，在北京的北方有個藝術家村，他便居住在那兒，並且在當地造就影響，但是就在2000年之際，中國政府在幾天之內便關閉了第二大的藝術家村，以致於一夕之間，二百多名的藝術家流落街頭，只好去向同僚求救。方力鈞果敢出色的表現，再次地克服了此次的危機。他設法讓很多離鄉背井的藝術家與他為鄰定居下來。所以，今天中國最大的藝術家共同體便是與他比鄰而居。方力鈞說：如果能夠的話，他最想要做的事，就是就地建起一間藝術學院，讓中國國內所有的藝術家及後起之秀，能夠同受一樣的影響，切磋琢磨，齊聚一堂。

　　方力鈞1993年起把自己置身於水中之畫作，可以視為其創作之精髓。它們展現了方力鈞平和之氣息、躬身於己的目光及無與倫比的專注。那個絕望又獰笑的藝術家在這裡找到了自信。烏利‧希克（Ueli Sigg）所收藏的一幅方力鈞1995年的第二號畫像，畫中的他背對觀者，低著通紅的頭（臉），好像是在前輩的面前應考。藝術家挺起的身後，一面寬大的背脊，像是一座無法克服的障礙。

　　方力鈞的工作，記錄了率直的努力追尋及持續不斷的蓄勢而發。在其中，藝術也得要容忍延宕、反撲、等待，以及永遠的不確定性。在創作與展覽上得到的自由，依舊是他所得到的最大收穫，表明在他作品中的無休止願望，是在西方幾乎無法想像的期待。這種態度，以喻言圖像式地表現在水及天空的題材上。水中的游泳之人，變成了不會溺斃的嬰孩。繁花與蒼穹不是用來裝飾藝術家的「另我」，而是表現出藝術家開朗起來的心情。人

在這裡不是被描述成英雄、汪洋中的小舟，或是風中飄葉，而是人們生活在一種多重的意義當中：在害怕與勇敢、困境與希望、痛與樂之間，這正是中國文化本身正在進行整合之時的兩種面貌。我們同時也發現，畫面是一分為二，擁擠無數的人群或是近幾年才出現的大量昆蟲。好與壞的雙重性，只有稀少和片段的出現。

　　與方力鈞同負盛名的同儕黃永砅與蔡國強，早在方力鈞之前就已享譽國外，他們的作品明顯地與西方藝術家有更多的對話，他們既沒受過壓迫也沒有受到冷淡的待遇。儘管2008年來的經濟危機也波及了中國，方力鈞有理由正面看待未來：「未來是好的！」他不帶修飾地順便一提。他在北京經營數家餐廳，因為除了靠藝術掙錢之外，他更希望能確保日常的收入來源。他已婚，他的妻子有意識地不同於新興中國的明星和名模的形象。他驕傲地望著引人目光的小女兒，她以赤子之童心與父母同樂或是鬧情緒。2008年的夏天，方力鈞在印尼教他的三歲女兒學會了游泳。一開始她被寒冷的水嚇到，但是不久便慢慢勇敢起來，抱著爸爸就像抱著一條大魚。他在一波一波的浪潮下帶領著她，游過水，告訴女兒要如何開展出自己的軌道。這個小女孩不只與父親同樂，她還了解了水的運行。當她的父親終於獨自行游於水中，幾乎如同一條海象，以穩定的節奏不時地潛入水中，她為此感到驚奇，一個這麼大的人，如何會在眼前出沒，甚至完全消失。

　　方力鈞有相當自信的肢體語言。就像一位舞者，他的任何姿勢都有一定的架勢。他的頭顱很少是靜止不動的，他的眼光亦如他的思緒朝向四面八方。其中傳達出的不只是一種顯著的開明作風，還有一種玩過界的調皮。在他的藝術中的十足信心，即源自於他知道要節省題材與他的精力。有海洋有藍天。在它們之上或在它們之中出現生物，我們可以讀出它們的遠與近、它們的實與虛，以及它們的真實性與象徵性。方力鈞觀察自己的同胞，覺得是很瘋狂，因為他們就像野生動物，在中國各地幾乎是二十四小時地活躍。就算是夜晚，電話也不曾少過。沒有人要給自己休息一天或放個長假。中國人在有休閒的時候，甚至不知道該做什麼。方力鈞覺得，正是在這一方面仍有巨大的學習空間。他又言道：人們低估了中國人不願放棄的特質。他們只有等到征服全世界後，才會歸於平靜。方力鈞以一種宣揚驚嘆、閒情逸致和自由墜落的藝術來對他的國家提出反駁。這些圖畫如同食物也如同按摩。兩者對中國人而言都特別的重要。

　　他早期的作品看起來嚴肅、小聲、偶爾還帶著憂傷。最近幾年的作品則顯得諷刺、跳舞般、甚至幾乎是快樂的。2005年開始方力鈞成了巨星；2006年和2007年間他在中國最重要的三間博物館展出，每一次都發行一本內容豐富的展覽目錄。在北京今日美術館所辦的是方力鈞至目前為止最大的個展。開幕之時，成千好奇的觀眾蜂湧而至，人群擠到水洩不通。亞洲的私人美術館邀請方力鈞展覽，至少藉此能買到他的一幅重要作品。就算是目前市場有點冷卻下來，想要對這位成功的中國藝術家作有目標的收藏，看起來是幾乎不可能的，因為買他的畫之需求實在太大，而且排隊的名單實在太長。

方力鈞對這樣的盛名並不感到舒服。因為對他而言，不是大清倉而是文化的建設才是最重要。在中國特別仔細衡量外界人士的需求與請求，是很普遍的事。中國藝術家不願從手中交出一件作品，是為了要再失去一位可能的收藏家。他們的系統是成效與義務的一致，這種義務的想法，亦同樣適用於對方。1989年後，每位藝術家都試著建立自己的人際網絡，不同於西方的是，藝術家之間的關係不會因為某人的成功而中斷。這種因為老關係而有的集體觀念所帶來的影響，會和個人的商業利益小心地協調合作。持續的生產是要可以信賴的，市場的穩定是要維持的，自己國家的當代博物館也只能稍作收藏，加入運作的一環。不只僅是針對藝術而已，在中國必須一直留意政治的局勢。

　　方力鈞最新的畫作和雕刻表現的是赤裸裸的原初的生物，他們瞧著、他們呼吸、他們打哈欠、還有吼叫著，或者只是沉默。他們看起來既汲汲營營又悠閒自在。他們不是在游泳就是在飛翔。他們的秘密是幾乎都不著地。他們的外型倒是圓潤了一些，大概是因為藝術家自己也老了一些。不管是嬰孩還是成年男子，方力鈞畫的不再只是中國人，他們成了世界人口的一部分。從構圖的格式來看，他們的出場，從來沒有這麼像過你和我的代表。要是我們今天要論定藝術家的歷史定位，就會感受到方力鈞的空間感。方力鈞拒絕所謂的「美國式生活」，雖然對於富有的中國人而言，一直值得他們追求的，正是美國文化。方力鈞一樣不相信早期令他成名的「玩世現實主義」有鞏固地位的一天。由於他的人物呈現瞧著、呼吸著、打哈欠或是吼叫的狀態，方力鈞不跟別人一樣，他用佛教的沉靜回應國人所受到的政治壓迫。我們將會看到方力鈞的藝術對未來中國藝壇影響的深廣度。（崔延蕙譯）

Was die Chinesen tun würden, wenn der Wohlstand immer weiter zunähme und sich bald jeder ein Auto, ein Apartment und einen Urlaub am Strand leisten könnte? Nach dem Ende der Kulturrevolution in China, nach der höchst erfolgreichen Liberalisierung der Wirtschaft, nach dem eindrucksvollen Wohlstand, den zahlreiche chinesische Künstler durch ihre künstlerische Arbeit seit 1989 erlangt haben, reflektiert der 1963 geborene Fang Lijun seinen Platz in der Geschichte.

Fang hat in einer Zeit zu malen begonnen, in der künstlerische Motive ohne parteiliche Vorbilder nur ganz langsam denkbar wurden. Bei jedem neuen Bild, so sagte er in einem Gespräch, habe er anfangs abgewartet, ob ein Parteikader Verdacht schöpfen, Unmut äußern oder andere negative Zeichen erkennen lasse. Neuerlich sei die Situation der bildenden Künste in China um 1991 deprimierend gewesen. Die Künstler, die nach wie vor unter rigider Kontrolle standen, hätten buchstäblich herabhängende Mundwinkel mit tiefen Falten gezeigt. So seien seine eigenen Werke aus jener Zeit als blanker Realismus zu lesen. Das Grinsen der glatzköpfigen, weitgehend uniformen Männer hatte damit zu tun, dass es in seinem Land nichts zu lachen gab. Auffällig ist, dass Fangs Figuren, in der Regel junge Männer seines Alters, die sich von Zeit zu Zeit mit jungen Frauen zeigen, überaus wachsam sind. Dabei zeigen und verstecken sie außer ihrer grinsenden Präsenz nichts. Ihre Haltung besteht aus ostentativem Warten.

Ab 1992, als Fang die ersten Bilder mit Schwimmern in bildfüllendem Wasser und Männern vor aufgespanntem blauem Himmel malt, entschärft sich die Situation. Es folgen Ausstellungen in Rotterdam und Basel 1994, an denen er teilnehmen kann, womit für ihn die ersten internationalen Gastspiele stattfinden. Jedoch verlaufen die Dinge auch in den folgenden Jahren nicht wohl geordnet. Es gibt ein Künstlerdorf im Norden von Beijing, in dem er wohnen und in dem er Einfluss nehmen kann, aber noch im Jahr 2000 beschließt die chinesische Regierung, ein zweites großes Künstlerdorf der Stadt binnen weniger Tage zu schließen, so dass über Nacht rund 200 Künstler auf der Straße stehen, um bei ihren Kollegen an die Tür zu klopfen. Auch diese Krisensituation meistert Fang mit Bravour. Er setzt durch, dass sich sehr viele der heimatlosen Künstler neu in seiner unmittelbaren Nachbarschaft ansiedeln können, so dass heute die größte Künstlergemeinschaft Chinas in seiner unmittelbaren Umgebung lebt. Am liebsten, so Fang, würde er hier eine chinesische Kunstakademie gründen, um alle Künstler seines Landes, auch die Heranwachsenden, unter dem gleichen Einfluss und unter einem Dach zu wissen.

Es sind die Bilder ab 1993, die ihn im Wasser zeigen, die als Essenz seiner Arbeit gelesen werden können. Sie demonstrieren die Ruhe seines Atems, den in sich gekehrten Blick und eine gewaltige Konzentration. Der zweifelnde, feixende Künstler findet hier zum Selbstbewusstsein. Fangs Bildnis aus der Sammlung von Ueli Sigg, Nr. 2 von 1995, zeigt ihn von hinten, mit gesenktem und gerötetem Kopf, wie zur Prüfung vor älteren Männern stehend. Der Künstler richtet seinen Rücken, das breite Kreuz, als eine fast unüberwindliche Barriere auf.

Fangs Arbeit dokumentiert ein aufrichtiges Streben und eine anhaltende Bereitschaft, in der Kunst auch Verzögerungen, Rückschläge, Wartezeiten und eine anhaltende Unsicherheit in Kauf zu nehmen. Die errungene Freiheit beim Malen und Ausstellen ist sein gleichbleibend höchstes Gut. Diese im Westen fast unvorstellbare Erwartung kennzeichnet das andauernde Hoffen im Werk. Mit den Motiven des Wassers wie des Himmels wird diese Haltung sinnbildlich umgesetzt. Der Schwimmer im Wasser wandelt sich zum

Säugling, der nicht ertrinkt. Die Blumen und der offene Himmel dekorieren nicht das Alter ego, sie zeigen die sich aufhellende Stimmungslage des Künstlers. Der Mensch ist weder als Held noch als Schiffchen im Meer oder als Blatt im Wind dargestellt. Er lebt stattdessen in einer Mehrdeutigkeit, in der Angst und Mut, Bedrängnis und Hoffen, Schmerz und Lust als die zwei Seiten der chinesischen Kultur selbst inmitten eines konsolidierten Lebens zu sehen sind. Man findet die Zweiteilung auch auf Bildern, die voller unzähliger Menschenwesen oder wie in den letzten Jahren voller Insekten sind. Die Doppelungen des Guten und Bösen erscheinen lediglich verknappt und rudimentär.

Fangs nicht minder berühmte Kollegen wie Huang Yong Ping oder Cai Guo-Qiang, die lange vor ihm Erfolg im Ausland hatten und deren Werke deutlich stärker mit denen von westlichen Künstlern korrespondieren, haben weder Unterdrückung noch Zurücksetzung erlitten. Trotz der Weltwirtschaftskrise seit 2008, die auch China erreicht, sieht Fang guten Grund, die Zukunft positiv zu sehen. „The future is good", sagt er beiläufig und trocken. Er betreibt in Beijing mehrere Restaurants, denn neben dem künstlerischen Broterwerb möchte er sich auch alltägliche Einkommensquellen sichern. Er hat geheiratet, eine Frau, die bewusst nicht dem Bild der Stars und Models des jungen China entspricht. Er sieht mit Stolz auf seine kleine Tochter, ein bezauberndes Mädchen, das den Vater wie die Mutter mit den Höhen und Tiefen seiner Kinderseele genießt. Ihm, dem dreijährigen Mädchen, bringt er 2008 in Indonesien das Schwimmen bei. Es reagiert auf die Kälte des Wassers zunächst erschreckt, um sich langsam, zunehmend aber mutig an den Vater wie an einen großen Fisch zu klammern. Er zieht sie wieder und wieder, durchaus mit Wellengang, durch das Wasser, um dem Kind zu zeigen, wie man seine eigenen Bahnen zieht. Das Mädchen genießt nicht allein den Vater, es lernt körperlich, wie das Teilen von Wasser funktioniert. Als der Vater schließlich alleine, fast wie ein Walross, durch das Wasser zieht, immer wieder tauchend und in einer stetigen Weise gleitend, staunt das Kind, wie ein so großer Mensch vor seinen Augen sogar ganz verschwinden kann.

Fang Lijun hat ein souveränes Körpergefühl. Wie ein Tänzer nimmt er in fast jeder Stellung eine Pose ein. Sein Kopf, der selten still steht, blickt und denkt in alle Richtungen. Nicht nur die markante Offenheit, auch eine Verspieltheit drückt sich darin aus. Die Souveränität seiner Kunst rührt daher, dass er mit seinen Motiven wie mit seinen Kräften zu haushalten weiß. Es gibt das Meer und den Himmel. Auf ihm und in ihm erscheinen Lebewesen, deren Nähe und Ferne, deren Fülle und Leere sowohl real als auch symbolisch zu lesen sind. Die eigenen Landsleute, beobachtet Fang, seien verrückt, denn sie sind wilden Tieren ähnlich an den verschiedenen Orten Chinas fast rund um die Uhr aktiv. Das Telefon ginge unablässig, auch in der Nacht. Niemand würde sich einen freien Tag oder gar einen längeren Urlaub gönnen. Die Chinesen wüssten nicht einmal, was sie tun sollten, wenn es für sie Freizeit gäbe. Gerade auf diesem Gebiet sieht der Künstler enormen Lernbedarf. Was man unterschätze, fügt er hinzu, sei die Neigung der Chinesen, keinesfalls nachzugeben. Erst wenn sie die ganze Welt erobert hätten, würden sie Ruhe finden. Seinem Land hält er eine Kunst entgegen, die Staunen, Muße und den freien Fall propagiert. Die Bilder sind wie Nahrung und wie eine Massage. Beides ist den Chinesen besonders wichtig.

Ernsthaft, leise, bisweilen schwermütig wirkt seine frühe Arbeit. Ironisch, tänzerisch, fast glücklich erscheint sie in den letzten Jahren. Seit 2005 ist Fang ein Star. 2006 und 2007 wurde er in den drei wichtigsten chinesischen Museen ausgestellt. Zu jedem der Projekte erschien ein opulenter Katalog. Bei der Eröffnung seiner bislang größten Ausstellung im Today's Art Museum in Beijing war die Menschenmenge aus Tausenden von Neugierigen so groß, dass sie die gesamte Straße blockierte. Die privaten Museen in Asien laden Fang zu Ausstellungen ein, um wenigstens ein bedeutendes Bild von ihm zu erwerben. Auch wenn sich der Markt inzwischen etwas abgekühlt hat, ein gezieltes Sammeln bei den erfolgreichen Chinesen erscheint generell kaum möglich, zu stark ist die Nachfrage, zu lang sind die Wartelisten.

Für den Künstler ist es schwer, diese Nachfrage zu verkraften. Für ihn steht kein Ausverkauf, sondern der Aufbau von Kultur im Vordergrund. In China ist es üblich, Anfragen und Bitten von Außenstehenden besonders sorgsam abzuwägen. Die chinesischen Künstler geben ihre Werke nicht aus der Hand, um die in Frage kommenden Sammler wieder zu verlieren. Ihr System aus Leistungen korrespondiert mit der Idee von Verpflichtungen, die auch für das Gegenüber gelten. Ein jeder Künstler versucht seit 1989, sein Netzwerk zu etablieren, wobei die Beziehungen unter den Künstlern, anders als im Westen, durch den Erfolg nicht abreißen. Sorgsam werden die im Kollektiv, aufgrund alter Bindungen, erhofften Einflüsse mit den individuellen Geschäftsinteressen koordiniert. Die Produktion soll verlässlich bleiben, der Markt soll seine Stabilität behalten, die zeitgenössischen Museen gerade des eigenen Landes dürfen mitwirken. Die politische Lage, das gilt keineswegs für die Kunst allein, gilt es stets im Auge zu behalten.

Die neuesten Bilder Fangs, auch die Skulpturen, zeigen nackte, elementare Lebewesen, die gucken und atmen, gähnen und schreien, oder man sieht sie schweigen. Sie wirken rastlos und zugleich entspannt. Sie schwimmen oder sie fliegen. Ihr Geheimnis ist, dass sie fast nie auf Erden stehen. Ihre Gestalt ist etwas rundlicher geworden, wohl weil der Künstler älter wird. Ob als Baby oder als erwachsener Mann, Fangs Figuren sind nicht mehr nur Chinesen, sie sind zu Teilen der Weltbevölkerung geworden. Sie treten aufgrund der kompositorischen Schemata mehr denn je als Stellvertreter von uns allen auf. Wenn man heute sagen müsste, wo der Platz des Künstlers in der Geschichte sei, stieße man auf Fangs Raumgefühl. Fang Lijun verweigert sich dem "American Way of Life", obwohl die Kultur der Vereinigten Staaten gerade für wohlhabende Chinesen immer noch erstrebenswert ist. Ebenso wenig glaubt er an die Konsolidierung seines früheren "zynischen Realismus", mit dem er berühmt geworden ist. Indem die Figuren gucken, atmen, gähnen oder schreien, hat er wie kein Anderer die politische Unterdrückung seiner Landsleute mit buddhistischem Gleichmut quittiert. Wir werden sehen, in welchem Ausmaß damit auch die Zukunft der chinesischen Kunstszene zu prägen ist.

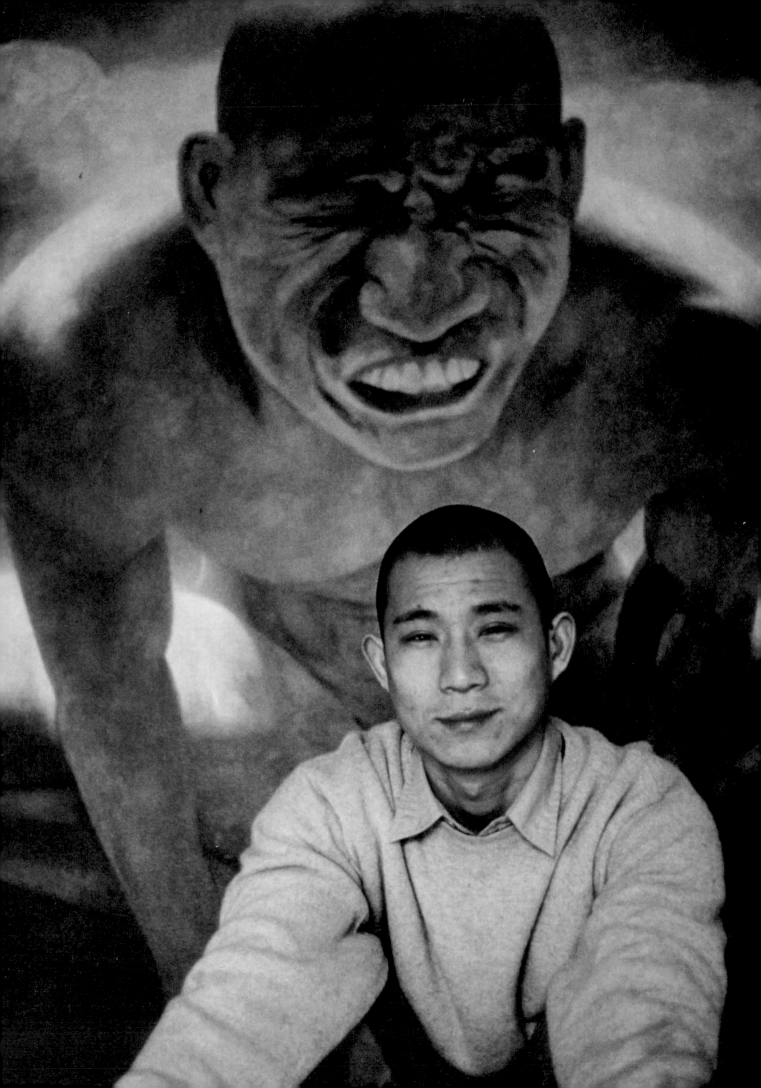

# 生命之渺——
# 方力鈞創作25年展
## Endlessness of Life:
## 25 Years Retrospect of Fang Lijun

文／胡永芬
Hu Yung-fen

我作品的出發點是用那種最樸素、最容易懂的語言去說話，所以我不怕跟觀眾見面，不怕跟觀眾建立這樣的關係，我甚至也不怕跟觀眾發生那種矛盾。　　──方力鈞

　　一個藝術家，以他所專長的「藝術」的方式，來書寫他（們）當下所在的生存方式、文化狀態、生活樣貌；這個行為背後的意義，就已經隱含著對於時代的反映，甚至是對於當時具有同一性的主流價值、權力系統的提問與質疑；這或許正是「當代藝術」的界域裡，「藝術」所存在最重要的價值與功能之一。

　　但是，一個時代裡，通常只有極少數的藝術家能夠先見、敏銳而準確地掌握到這個落點，並且有勇氣這麼做，進而蔚成同一時代人必須跟隨，並且影響下一代人的生活與創作。方力鈞與他的作品，就是這樣。

## 成長期的時代背景

　　方力鈞出生於1963年，文化大革命就發生在他三歲到十三歲之間。他的祖父作為一個富農階級的身份，當然對於整個家族而言是個災難，但是其實對於當時還在幼年期至前少年期的方力鈞而言，並沒有立即在心靈上發生什麼過於深刻嚴重的傷痕，真正無可泯滅的傷疤，其實是在他成長之後，返顧那段過程之所以然，才恍然震慟。

　　他敘述過幾個記憶的片段：為什麼會開始畫畫呢？因為在批判「地富反右壞」的文革年代裡，群眾日常的階級武鬥也無可避免地影響到孩童的行為，於是這個壞成份家族裡無知的黃口小兒，在社區、學校懵懂的孩童群體中，也自然成為遊戲裡面模仿政治活動被欺負的主要目標；為了盡量避免他跟同儕群體接觸跟衝突，他的父親遂以圖紙跟畫筆誘導他，留在家裡，畫畫。「這初始的理由造成了我對畫畫這件事一種奇怪的感情，即便是在自己覺得熱愛畫畫的時候，心裡仍有一種酸溜溜的感覺。」方力鈞如此描述這詭譎而複雜的情感。

　　第一次親眼看到自己的爺爺在批鬥大會上被吊起來，成為所有人的「階級敵人」，這件事也是他第一次真正無可迴避地正面撞擊人性之惡，尤其，這「惡」在當時的政治意識形態中卻被詮釋為「善」與「真理」，這種傷害，要比跟其他小孩在遊戲中被欺侮，更為真實而殘酷得多。

　　另一個童年記憶的片段是：十三歲那年毛澤東、周恩來相繼過世，跟著大家去靈堂悼念時，父親向他使眼色，要他作出悲痛的樣子，方力鈞回憶：「我知道我必須哭，一開始哭不出來，後來卻哭得不可收拾，所有的人都來勸我，老師還表揚我……」他說：「從小所受到的教育，經常是跟你認為正確的行為相反，我想，我那時就很可能已經是一個『兩面派』了。」

　　這些敘述既有種一針見血的痛感，又有種像旁觀者一般怪異的理性、疏離、甚至是冷酷，而這些語言的方式與內容，則是不只讓我們有機會窺及對於方力鈞深具影響的時代事件，同時也可以明確地感受到方力鈞那種比一般人更為明白、透晰、冷靜而絕決的

聰慧。

## 登場

　　方力鈞於中央美院在學時期，當時中國美術界最活躍的，主要是文革期間下鄉的知青一代，這一代藝術家服膺於藝術作為社會批判，作為指向人性之真、善、美的終極價值；與此同時的，西方現代主義思潮與現代藝術資訊大量進入中國，80年代中期出現的八五新潮藝術呈現出兩條路線，一條路線是透過演練一遍西方現代主義中的形式追求，諸如抽象藝術、冷調的超現實風格等，來嘗試從形而上的角度關注人的生存狀態，以及討論回歸藝術本體、藝術語言純化的可能性，這也是對於之前全面將藝術作為意識形態鬥爭武器的極左年代，表達反對意見的一種姿態；另一條路線則是循著寫實主義的傳統來反社會主義寫實主義（Socialist Realism）的意識教條，透過「傷痕美術」和「鄉土現實主義」，把過去為服務意識形態而創造的假象的現實主義，轉換成真實反映中國現實和個人情感的寫實主義風格。

　　之後登場的，與方力鈞同一時代的這批藝術家，基本上都出生在60年代，固然，上一代知識分子悲情之所在的文化大革命結束於他們的孩童時期，基本上像是模糊記憶中的皮影戲，或者是更遙遠的，書本上說的故事，但是相對地，他們也錯過了前輩知識分子那種理所當然地文以載道、熱血澎湃的理想主義年代；從方力鈞他們有意識的童年開始，整個世界的價值與觀念，就一直不斷在改變、不斷的推翻、又重建……。

　　80年代末，方力鈞與他同一代的藝術家們終於離開了學校開始要參與社會了，但是馬上迎面而來遇到的，卻是整個山雨欲來蠢蠢然騷動的大環境，栗憲庭這麼描述：「代表80年代現代主義思潮的『中國現代藝術展』以西方各種語言模式為榜樣，大喊大叫地登上官方的舞台，卻隨著官方的壓力，迅速又轉入地下」，再加上接踵而來的時代事件，於是「無論社會和藝術，拯救中國文化的理想都成了子虛烏有，留給這一代藝術家的只有來去匆匆的偶然的碎片」。

　　大眾文化、消費文化、市場經濟帶來的開放腳步下的社會型態與價值觀，迅速地改變著整個社會國家，前一代藝術家知識分子式的理想主義英雄色彩，此際可能達到了歷史新低，一個新的時代開啟在眼前，青年的生活卻如此百無聊賴，無所寄託，這是一個沒有英雄、沒有戰場的新時代，方力鈞以及跟著他同時登場的新一代藝術家，「把前兩代藝術家對人的居高臨下的關注，轉換成平視的角度，放回到自身周圍的平庸現實中，用潑皮的方式去描繪自己及自己周圍熟識、無聊、偶然乃至荒唐的生活片斷」。（栗憲庭語）

　　1990年開始，方力鈞連續畫出一系列表情帶著嗤笑、嬉謔、躁動、百無聊賴之中打著呵欠的大光頭青年群像，呼應對照著當時那一整代人所處的社會情境、集體生命處境，這個畫面與形象立即有效地凝結成為全世界人們心目中，整個中國這一代人的心理縮影。自此，方力鈞，與他的時代，開始了。

　　以方力鈞作為代表，來看中國當代藝術的發展過程，雖然它的形式語彙，基本上已經跟西方同時發展中的當代藝術語彙脈絡有很明顯的差異，但是它確實完成了一個屬於它所在社會、所屬人群的主體詮釋，也就是說，像方力鈞這樣的藝術家，因為夠誠實，夠真實地以藝術反映自己的生存狀態，因此能夠成功地創造了一個藝術時代，完成了一段文化歷史，同時也因此實踐了當代藝術的終極價值：對於未來的藝術產生了影響性。對於這個終

極價值，方力鈞可以說是有意識地，長期以來每一步都以反覆焠鍊的思慮與強大的意志，盡力去達成。

## 敢破敢立的藝術發展過程

方力鈞創造了「光頭」，也為從此以後的中國當代藝術家創造了一種成功的模式，但是方力鈞自己在藝術風格的發展與探索上卻是毫不耽溺而無畏的，光頭之後，他很快地開啟了關於「水」與「水中人」的系列作品，從另一種方式、藝術語言、與思考角度，討論他所關心，所一直挖掘的關於生命中各種深刻而曖昧莫名的內部／外在情境。

這個跟「光頭」系列比較起來，在形式上更為單純，主題卻更為深沉的作品，也展現了方力鈞那種獨特的，未雨綢繆、機鋒交迭、辯證騰挪的聰明與能力，以及敢破敢立的霸氣、智慧與勇氣。

1997 年，出現幾張炎炎烈日將水色映照得如焚如沸的詭異畫面，其中一張出現在前景、背對著觀者的光頭，因為面對太陽，而在頭部四周滲出光暈。距離青春期越遠，方力鈞骨子裡傳統文人須載道的一面愈為顯現。

1998、1999 年以後，方力鈞作品中的人物逐漸成群浮出水面，甚至向上懸浮、飛昇到天上、雲端、山岳峰巒之上，人們露出衣衫以外的肉身部分，多以一種奇特的鮮橘肉色表現，人們仰望天際的臉龐上，表情或者是歡欣喜悅，或者似聖神充滿，或者遲鈍呆滯、失落沮喪……，無論人群是什麼表情，身後的背景一逕是鮮麗盛放的花團錦簇（因為太過鮮亮豔麗而更像是假花），或是堆滿腳邊，或是在光耀飽和藍色的天空、如絮的雲朵、煙雲縹緲中飄然散落。各種非自然的情境，一方面跟真實世界完全隔離相悖，另一方面又像似人生的寓言，像似對於眾生苦樂的指喻。

這個階段又重回 1992、1993 年，跟 1996 年出現過的，一種瑰麗魅異，充滿矯飾風格，具有怪異感的高度裝飾性色彩，基本上就像是一個虛假的、臨時性搭建出來的舞台佈景，消費文化中過度的物慾與過繁的花飾，具現於畫中俗豔的場景，以及畫中人失了靈魂似的獰笑的臉龐。方力鈞在每個主題的後期階段，都回到這種最鮮豔又最虛矯的風格上作總結。

## 單色開始，豔色總結

傳統版畫對於方力鈞另一個關鍵性的影響，或者說是因為與方力鈞性格切合，而特別產生的作用，尤其出現在他對於創作研究的每一個階段中的黑白繪畫，以及他對於單色系繪畫所顯現的偏好。從黑白或單色著手，再進到彩色繽紛的畫面，幾乎是他每一個體裁系列發展過程中必經的階段。

從還在大學就讀時候，1988 年的「素描」系列黑白作品開始，甚至可以更早推到 1984 年的「鄉戀」系列基本上也近於單色畫的概念；1991 年開始的「系列一」系列是黑白油畫，接著 1992 年開始的「系列二」系列則是彩色油畫；1993 年所做的「水／水中人」系列油畫都是黑白油彩，1994 年開始單純的彩色畫面，到了 1995 年出現更為鮮豔的水中人；木刻版畫也是從黑白灰的單色，發展到加入鮮橘等彩色的階段；甚至每一個新開始的小子題，都可以看到頭幾張創作是黑白畫；或者可以說，方力鈞習慣對於所有新創作的研究階段，都從黑白、單色開始，以豔色繽紛作結。

跟方力鈞堅韌、理性、冷靜／潑皮、舒散、漫不在乎，這種不只兩面兼具，而且兩面皆甚為鮮明強烈的性格對照，可以想像：每一個創作階段初期，他都是以極大量的腦部工作，盡其可能地完成、處理他所賦予此一階段命題的多元象徵，這個階段的作品嚴謹而飽和，屬於他意志力與控制力的淋漓展演；接下來的階段則是他放拓開來揮灑，恢復但求盡興愜意而後已的潑皮本色，就像他畫中人滿臉平庸無賴的痴笑一般，屬於一種市井小民才有的莫名勇氣——既然已無所有，就更沒有什麼值得畏懼，沒有什麼可以阻礙。

*The starting point of my works is to use the plainest and the simplest words to articulate my thoughts, therefore I am not afraid to meet the viewers, not afraid to build up a certain relationship with the viewers, I am even not afraid of bringing up certain conflicts with my viewers.* – Fang Lijun

An artist gives expression to his existence as well as the culture and life of his time at this very moment in his special domain of "art;" the very act of doing so already indicates a reflection of the time and questioning of the mainstream values and power mechanisms. Perhaps this is one of the most important values and functions of the role of the artist in "contemporary art".

But generally, there are often only few artists who can anticipate and seize this point sharply and precisely, while at the same time being courageous enough to carry it through, which makes them idols followed by contemporaries and exert an influence on the life and artistic creation of the next generation. Fang Lijun and his works do just that.

## Childhood and early adulthood

Fang Lijun was born in 1963. The Cultural Revolution occurred from when he was three to when he turned 13. His grandfather's class as a rich farmer was a catastrophe for the whole clan, but as Fang Lijun was very young at that time, this catastrophe did not immediately harm him seriously and leave wounds on his mind. It was only after he grew up and looked back at what had happened during that period that he had a sudden and profoundly disturbing realization of the truth.

He described some fragments of his memory in order to answer the question why he began to paint. During the Cultural Revolution, when "landlords, rich farmers, counter-revolutionaries, bad elements and right wings" were persecuted, the every-day class struggle inevitably influenced children's behavior. Thus this child with an unfavorable family background naturally became the target of bullying by ignorant children who imitated the political campaigns in the community and at school. To avoid his conflicts with his peer-group as much as possible, Fang Lijun's father gave him painting-paper and brushes to make him stay at home and paint. "This initiation made me have a strange attitude towards painting; even though I loved painting enthusiastically, I felt somehow painful about it," Fang Lijun described his strange and complicated feelings at that time.

When he saw his grandfather publicly exposed for the first time at a class struggle rally as the "class enemy" of all the people, he could not but face the truth and had his first real confrontation with human evil, one that was interpreted as "good" and "righteous" according to the existing political ideology. This harm was much more real and cruel than being bullied by the other children while playing.

Another fragment of childhood memory is about the deaths of Mao Zedong and Zhou Enlai in quick succession when he was thirteen years old. When he followed the other mourners to the mourning hall, his father gestured him to pretend to be very sorrowful. Fang Lijun recalled, "I knew I had to cry, I couldn't cry at the beginning, but later on I could hardly stop crying. Everyone came to console me; my teacher even praised me.... The education I had had since I was young taught you the opposite of what you considered was right. I think I was already a trimmer at that time."

These descriptions both betray a pertinent pain and a strange rationality, an alienation as brutal as if by an observer, and the content and way of what he said allows us to not only get a glimpse of the historic events which influenced Fang Lijun profoundly, but also feel why Fang Lijun has a clearer,

more analytical , cooler and absolutely firmer wisdom than the other people.

## Entering the stage

When Fang Lijun was studyng at the Central Institute of Fine Arts, the most active people on the Chinese art scene were the intellectuals who went to the countryside during the Cultural Revolution. These intellectual-artists believed that art functions as social criticism, and addresses the ultimate values of the truth, goodness, and beauty off human nature. At the same time, the Western modernist trends and massive information on modern art made their way into China. The '85 New Wave emerged in two paths. One was to try to tackle the question of human existence from the metaphysical point of view, and to discuss the possibility of returning to the essence of art and purifying the language of art, by pursuing forms once typical of the Western modernist schools such as abstract art and the cool surrealism. This is also an argument against using art as a weapon of the ideological struggle during the ultra-left era. The other path was to use the tradition of realism in "trauma art" and "regional realism" to counter the ideological doctrines of socialist realism, and to convert the fake realism in the service of ideology into one which truly mirrors the reality and personal emotions in China.

The artists who emerged with Fang Lijun belong to the same generation. Most of them were born in the 60s. The Cultural Revolution, from which the intellectuals of the previous generation derived their sadness and pathos, ended during the childhood of these artists and basically appeared like a shadow play in vague memory, or distant stories in books. Meanwhile, they missed the years of enthusiastic idealism, in which the intellectuals of the older generation took the ideal to instruct for granted. When Fang Lijun and his generation began to be conscious of reality in their childhood, the values and views of the whole world were constantly changing, overthrown and rebuilt....

At the end of the 80s, Fang Lijun and his contemporaries finally left school and took up their position in society. But they were confronted with a situation of the quietness before the storm, of imminent commotion. Li Xianting said, "The *China Avant-Garde Art Exhibition* representing the modernist trend of the 80s followed the various language patterns of the West, entered the stage with loud cries, but yielded to the pressure of the government and went underground soon again." Besides, as a direct consequence of the events which succeeded one another, "the ideals of rescuing China of both the society and art did not succeed, leaving only an ephemeral fragments of coincidences to the artists of this generation."

Popular culture, consumer culture and the market economy brought different social values along with open policies, and changed the whole society and nation quickly. The heroic idealism of the intellectual-artists of the older generation reached its historically low point. It was the dawn of a new era, but the lives of the young generation were so boring and rootless that it was a new epoch without hero and battlefield. Fang Lijun and his contemporaries "changed their viewpoint from a commanding position of the artists of the former two generations to a horizontal one. They merged themselves with the mediocre reality around them, resorting to the methods of rascals to describe themselves and the everyday fragments of which the boredom, fortuity, and absurdity are familiar to them." (Li Xianting)

Began from 1990, Fang Lijun painted a series of group portraits of baldheaded youths jeering, making jokes, moving chirpily and yawning out of extreme boredom. They mirror the social and collective condition of the whole generation, and the images became immediately the psychological epitome of the generation of China in the eyes of the world. Since that moment, Fang Lijun's era has come.

Taking Fang Lijun as a representative, the development of Chinese contemporary art has actually achieved an interpretation of the subject of the society in which it is situated, of the group it belongs to, though its vocabulary is strikingly different from what is unraveling in the West at the same time. In other words, because the artists like Fang Lijun are honest enough to reflect their own state of existence, they can create art successfully, documenting a historic and cultural period, and thus put the ultimate value of contemporary art into practice: to impact on the art of the future. One can say that Fang Lijun has been striven consciously to attain the ultimate value by refining and condensing his thoughts repeatedly and by showing a strong determination.

## An artistic development of courageously breaking down and building up again

Fang Lijun created the image of "bald head," and set up an ideal for upcoming Chinese contemporary artists in his wake. But Fang Lijun was never in a standstill. He fearlessly observed the development and explored his own artistic styles. After the bald head image, he soon initiated a series of works on "water" and "man in water," in which he resorted to the other way, the other language of art, the other way to discuss what he is concerned about and what he never stops exploring, the various deep and ambivalent inside and outside situations about life.

Unlike the bald head series, this series of works was formally simpler and thematically profounder, which showed Fang Lijun's unique integrity and capability that enables him to take precautions before it is too late, argue wisely and concurrently, and discuss enthusiastically and dialectically. The new series also shows his aggressiveness, wisdom and courage to break down and build up.

In 1997, some strange scenes depicting water seemed to be boiled by the hot sun appeared. One of them shows a baldheaded man in the front of the picture with his back to the viewers. The head emits an aura caused by the sun he is facing. The farther from adolescence Fang Lijun is, the more clearly he shows his instructive characteristic as a man-of-letters in the line of tradition.

After 1998 and 1999, the figures in Fang Lijun's works gradually break away from water in groups and even float up to the sky, upon clouds and ranges of mountains. The parts of their bodies not covered by clothes mostly appeared in strange orange colors. They face the sky; their facial expressions are sometimes delighted, sometimes appear to be filled with the ethereal inspiration, and sometimes appear dull, dumb and distressed.... No matter what their expressions are, there are always brightly colored, gorgeous and luxuriant flowers behind them or are strewn around their feet (because they are

too bright and too beautiful they look more like artificial flowers). Sometimes the flowers are scattered in the bright, saturated blue sky, among the cotton-wool-like clouds and smoky mist. These various unnatural situations are totally at odds with the real world on the one hand, and on the other hand they seem to be fables of life, like metaphors of the happiness and bitterness of all living creatures.

This period harks back to the time of 1992, 1993 and 1996, when strange, gorgeous, totally mannered and highly decorative colors appeared. Basically they are like an artificial stage temporarily built up. In the consumer culture, excessive materialism and lavish flower decorations are represented in vulgar colorful scenes and in the soulless people with fleers in the paintings. Fang Lijun returns to the most colorful and mannered style as a summary at the final period of each topic.

## Monochrome beginning and colorful completion

Traditional woodcut prints have another key influence on Fang Lijun. One can say that this special function derives from the fact that woodcut prints match Fang Lijun's nature, and is especially shown in his preference of black-and white paintings appear at the beginning of every of his creative stage and of monochromes. Beginning in black and white and then switching to color is almost an inevitable developing process of each of his topic.

The paintings in monochrome already appeared in 1988 when he was a university student. It could even be traced back to a much earlier period, his 1984 series called *Country Love*, which are basically works depicted in the concept of monochrome. *Series 1* began from 1991 is also a series of black-and white oil paintings. *Series 2* initiated in 1992 then are color oil paintings. The 1993 series works on water / man in water were painted in black and white; one year later they are painted in simple colors. In 1995 bright and colorful men in water appeared. Fang Lijun's wood prints also begin in grisaille before switching to color, featuring bright orange among other colors. Furthermore, one can find some initial monochromes at each new creative stage. One is thus led to believe that Fang Lijun's habit is to begin in black and white and monochrome before switching to colorful and gaudy paintings.

Fang Lijun is both tough, rational, cool-headed and rascal-like, lax and unconcerned. He does not only have both characters; with him, they appear in an extremely strong opposition. From this point of view, one can imagine that he takes large amount of efforts at the beginning of each creative phase to complete and tacle the multiple symbols of a certain topic. The works of this stage, carefully and amply structured, are a perfect display of his will and mastery. In the following stage, he just turns loose and wields his brushes freely, reverting back to the original rascal nature, in order to get his fill of enjoyment. Fang Lijun has this kind of the nondescript courage of the common people, one that the shamelessly simpering figures in his paintings have — since they do not possess anything, they are not afraid of anything, and nothing can stop them.(text by Hu Yun-feng, trans. by Tseui Yen-huei)

# I

# 原型的創造
The Origin of Archetype

屬於我個人的審美趣味，包括對於簡潔的偏好，以及對於炫耀細節的厭惡。
——方力鈞

法國後現代主義哲學家吉爾‧德勒茲（Gilles Deleuze, 1925-95）曾經從論文學的角度，如此論述藝術的使命：「應該要與母語告別了，應該要創造新的語法，惟需要解決的問題在於，要用什麼方式來呈現出一種奇怪陌生的新語言，要用什麼方法，才能突顯不同於所有語法的另一種語言。」

很多線索透露出方力鈞在藝術上的早慧，比如，他很早就顯現了對於創造一種新語言的意識，對於表現獨殊美感風格的企圖心，以及要求具有自我特色的個人品味。

方力鈞最早一批透露出與未來風格已經有所聯繫的作品，是源自於他在 1982 年十九歲的時候，偕同少時至今的老友柴海燕，一起到邯鄲市西部、太行山東麓的河北省涉縣所做的一批寫生稿，以這批寫生稿為本，之後陸續完成的作品，包括眾所熟悉的，他在 1984 年創作的紙上粉彩「鄉戀」系列。

油畫（之三）
46.5×60.2cm 油彩、畫布
1988-89

Oil painting No. 3
46.5×60.2cm
Oil on canvas 1988-89

這些作品的畫面基本上都是由眾多圓墩墩、簡單而渾實的線條與造型堆疊組織，構築而成。〈鄉戀之一〉、〈鄉戀之三〉，以及 1984 年粉彩的〈無題〉這幾件作品，一種如波如浪，如沙丘之無聲推移，充滿了能量，厚實卻安靜的綿長曲線成為畫面最主要的結構。而〈鄉戀之二〉佔據畫面 80% 以上的石塊、〈鄉戀之三〉整個畫面中遠景所鋪陳延展的樹叢，以及〈無題〉以中央點為核心向四周無盡擴散的陽光，全都是完全無法迴避與忽視地統馭在一種簡單、渾圓、而厚實的造型與量感上。

然後在 1986 年，方力鈞另一批到河北冀縣燕山山區所做的寫生稿，給予了他更多的題材，來發展他已經成型的個人語言。特別是在 1988、89 年所創作的「素描」與「油畫」兩個系列的大部分作品。

這一批作品中固然延續著之前他已經突顯出來的渾實造型與量感，比如〈素描〉之一、二、三、四，這四件作品都描繪了山城中宕跌起伏的狹隘路徑兩旁，以石磚疊疊成的壁牆，原本是四方形的石磚在畫面上卻全都消磨得不見一個銳角，人、物與景，都是圓呼呼的。不過更值得注意的是：在這時期的作品之中，作為方力鈞最為典型的光頭人物形象已經悄悄登場。「素描」與「油畫」兩個系列的所有作品都看得到光頭人，不只每個光頭都圓得渾渾實實，而且這些人物無論是鼻頭、嘴唇、眼皮蓋、手指頭……，個個都圓得敦厚而樸實，所有人物狀態都處在一種安祥、寧靜、而至為平常的氛圍之中。

30

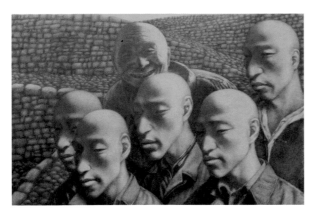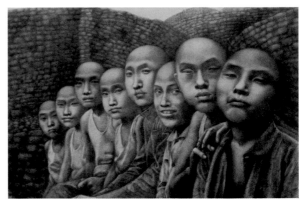

Left：
素描（之三）
54.8×79.1cm 鉛筆、紙
1988

Drawing No. 3
54.8×79.1cm Pencil on paper（左圖）

Right：
素描（之一）
54×79cm 鉛筆、紙
1988

Drawing No. 1
54×79cm Pencil on paper
1988（右圖）

　　這段時期方力鈞的作品主要是以他當時生活所在的故鄉邯鄲市周遭，所謂燕趙之地的人物與地貌為主題，而這些最原初而單純的造型元素，一直延續到今天，幾乎所有方力鈞的作品中都仍然可見。科班出身的方力鈞曾經簡單而直截的這麼說過：「屬於我個人的審美趣味，包括對於簡潔的偏好，以及對於炫耀細節的厭惡。」這也很明白地解釋了其實原本大有能力炫技的方力鈞，之所以所有的作品卻皆取向於一種鉅力萬鈞的——單純——而這單純，顯然是出自於一種近乎於意識形態般堅持的美感品味，一種蓄意叛逆的選擇。

　　整個中國美術學院的教學系統自50年代以後，素描與造型技巧就受到蘇聯寫實主義最大的影響，素描與造型講究解剖、透視、明暗、尤其講究以一個個分明的「面」，以及面與面之間界限分明的線，來建構成立體的描繪對象。在如此強大的集體標準所制約的情境中，方力鈞以弱冠之齡，仍然能夠毫無滯礙地提出他背行之已有三、四十年的學院主流標準完全不同，甚至是相反的美感與方法，確實是一個非常特殊的現象，其中揭露藝術家更為深層而本質的人格特質、自信與意志強度。

　　從方力鈞十六、七歲以來大量的早期素描，一直到1984年的粉彩作品、1988年的素描作品及1989年的油畫，都可以看到他以細筆一筆一筆，逐漸構築出安靜而綿密的畫面的過程，從這些一點一滴的過程與細節之中，方力鈞超乎於平常的，強大的自制力、意志力，以及控制力，已經在少年時期即展現無遺。

　　將這些作品跟當時學院主流教學方法中所體現的標準相比較，方力鈞的作品特別顯露出他是刻意消泯掉所有明顯的「面」與明顯的「界線」，而蓄意地選擇了一種有一點傾向於碳精畫之趣味，但也還沒有碳精畫那麼滑溜的趨向，屬於一種體量感實在，質感素樸沉厚，頗為獨特的美感風格，蘊有強大的動能卻寧靜，明顯地流露出叛逆的意志卻沉著。可以說從早期的作品來看，方力鈞以其大量的自我鍛鍊，其實很早便能夠很成熟地掌握並且運用素描及繪畫的各種技巧，但出於審美的主觀，由於他厭惡炫技，因而刻意地摒除炫技。透過這種安靜的叛逆手段，方力鈞早在此時就已經成功地創造出了他所有創作的原型語彙，並且一直連繫到他今天的創作。

　　於此同時，方力鈞也看穿了：自80年代以來從西方借來的現代主義，以及知識分子所擁抱的理想主義，這些對於當代中國其實是既無能又無力，面對著變動中的中國，以及破門而入、迎面而來的資本主義消費主義，方力鈞與他同時代的這一波人，在心理上與現實生存狀態上都處在一種邊緣的情境，他所唯一能做的，就是回到他最擅長、最簡單的方式——透過藝術，來書寫他們當時的生存方式、生活樣貌，也讓他們找到一個能比較踏實地介入、參與的路徑。方力鈞後來回想時這麼說：「繪畫使我擺脫孤獨和尷尬的心境。」

　　惟這種生存狀態是如此真實，使得他們不但對於80年代以來模仿西方各種現代藝術形式，卻終究搔不到癢處的方式完全揚棄了，而且選擇重新回到具有敍事性的寫實主義傳統裡，試圖尋找一種要跟自己的血肉生命狀態貼得更近的，新的可能。（胡永芬／文）

*It attests to my personal aesthetic preference, including a preference to simplicity, and the detest for boosted details.*
– Fang Lijun

The French Post-modernist philosopher Gilles Deleuze (1925-1995) once theorized on the destiny of art from a literary perspective, "We should bid farewell to our mother tongue, and invent new grammar, the only question that needs to be resolved was, which approach should we adopt to present a new language that is bizarre and strange? What is the method to highlight in another language the differentiates of the existing grammars?"

Many evidences have shown Fang Lijun's early maturation in art. For instance, he has shown very early on a consciousness to create a new language and his own personal taste of aesthetics.

Fang Lijun's earliest series revealing styles of the future originated from the sketches he made on the journey with Chai Haiyuan, an old friend from childhood, in She County of Hebei Province west of Handan and east of Taihang Mountain in 1982, when he was nineteen years old. These sketches triggered a sequence of other works, including the famous pastel series *Country Love*, made in 1984.

These works were basically constructed with numerous round, simple and solid lines and compositions. *Country Love No.1*, *Country Love No. 3*, and the 1984 pastel work *Untitled* were chiefly structured by waves of lines which move silently yet potently, substantially yet quietly on the canvas. The stones occupying more than eighty percent of the canvas in *Country Love No. 2*, the expanse of trees in the background of *Country Love No. 3*, and the omnipresent sunlight emitted from the center in *Untitled*, are all measurably dominated by a simple, round, and solid composition and sense of quantity.

Another group of sketches Fang Lijun made on his journey to Yan Mountain of Ji County, Hebei Province, in 1986, contributed even more materials to his established personal language. Its impact can especially be felt in most of the works of *Drawing* and *Oil Painting*, the two series made during 1988 and 1989.

The solid composition and sense of quantity already present in his previous works were maintained in the two series. *Drawing No. 1*, *Drawing No. 2*, *Drawing No. 3*, and *Drawing No. 4*, for instance, in their depiction of the walls of stone bricks flanking the narrow and cragged pathways in a mountain village, had rounded out the four edges of stone bricks, and virtually every figure, object, and scenery. More noteworthy, these works had seen the quiet appearance of the bald figures most typical of Fang Lijun's work. Round and solid in not only construction but also noses, lips, eyelids, fingers, and so on, the bald figures present throughout the series of *Drawing* and *Oil Painting* were placed in a serene, tranquil, and by all means common surrounding.

Fang Lijun's work of the period mainly adopted his hometown Handan where he was living, the people and landscapes in the so-called Yan-Zhao region, as his subjects. These most original and untainted composition elements have been used until today, and one can find them in almost all of Fang Lijun's works. Trained professionally, Fang Lijun once said simply and directly, "It attests to my personal aesthetic preference, including a preference to simplicity, and the detest for boosted details." This clearly elucidated Fang Lijun, who has the ability to put his skills to work, yet all his artworks strive for a kind of concentrated naivety — this naivety apparently originates from a taste in aesthetics maintained as almost an ideology, a choice of intentional rebellion.

Since the 1950s, the drawing and compositional techniques in the whole educational system of art institutes in China have mostly been under the spell of Russian realism, which places emphasis on anatomy, perspective, and light and shadow, and particularly on constructing its subject as a three-dimensional one by using "planes" and the lines distinguishing one plane from another. In so overwhelming and totalizing a system, it is indeed remarkable that Fang Lijun was able to propose, at the age of twenty, an aesthetics and a method drastically different, if not in direct opposition to, the standards adopted by the mainstream institutions of art for scores of years, as if it was a spontaneous outcome. They disclose, in a profounder and more fundamental way, the personality and intensity of confidence and will of the artist.

From the earlier sketches Fang Lijun made at the age of sixteen and seventeen, to his 1984 pastel work, *Drawing* series in 1988, and *Oil Painting* series in 1989, we may perceive the process his thin brushes work to form a quiet and dense canvas. The process and details displayed an extraordinary power of self-restraint, will, and self-control that had been strongly present in the teenage years of the artist.

Measuring against the standards adopted by the mainstream institutions of art, these works were characterized by an intention to obliterate every trace of obvious "plane" and "line," and to pine for the gusto of charcoal painting, while substituting the latter's slipperiness with a fairly unique style inherent with a sense of quantity and solidity, a powerful yet tranquil dynamics, a distinct yet imperturbable will of rebelliousness. His earlier works lent us a glimpse of an artist who was already capable of grasping and utilizing, with a sure hand disciplined by numerous trainings, the various sketching and painting techniques at an early age, but nevertheless rejected technical opulence out of his aesthetic sentiment and detestation of show-off. Through this quiet rebellion, Fang Lijun had successfully created his archetypes and language for his later works, and they have persisted throughout his art career until today.

Meanwhile, Fang Lijun was also aware that, both the modernism borrowed from the West in the 80s and the idealism embraced by the intellectuals have neither capability nor power to deal with the contemporary China. Faced with a China in constant changes and the frontal intrusion of capitalist consumerism, Fang Lijun and those of his generation lived in a state of marginality in terms of psychology and everyday reality. The only thing he could do was to go back to the most familiar and simplest way — art — to describe their existence and faces of life. This way allowed them to intervene and participate in practical terms. As Fang Lijun looked back on it later, he said, "Painting helped me to get rid of the feeling of loneliness and awkwardness."

This state of existence was so real that eventually, they not only forsake the kind of art that had been doing nothing except imitating the various forms of the modern Western art since the 80s, but also chose to return to the narrative tradition of realism, in order to find a new possibility closer to their existence and sentiments.(text by Hu Yung-fen,trans. by Yu-sheng Chien)

鄉戀（之一）　60×60cm　不透明水彩、紙　1984　藝術家自藏
Country Love No.1　60×60cm　Gouache on paper　1984　Collection of the artist（右頁為局部圖）

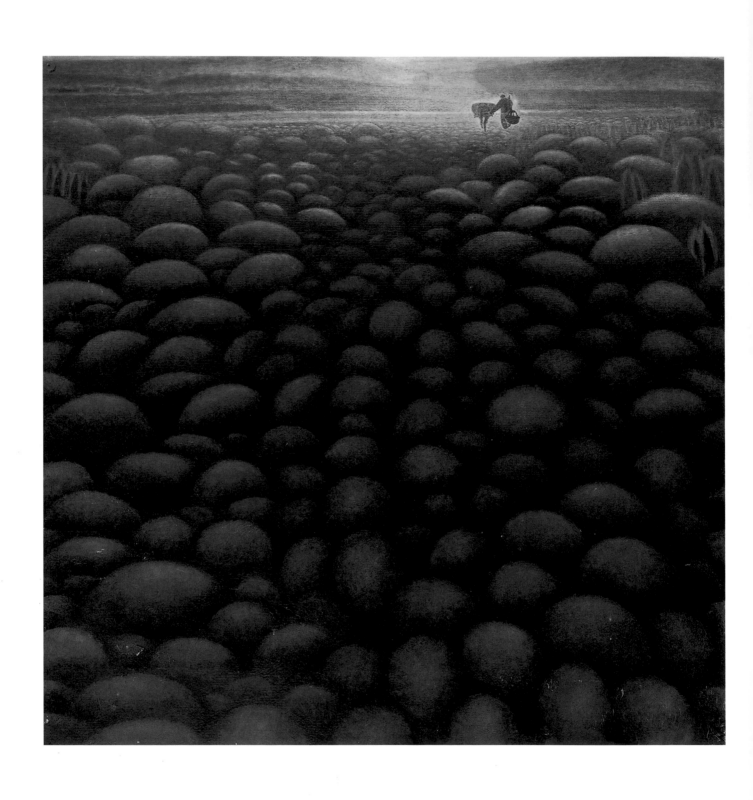

鄉戀（之二） 60.2×60.2cm 不透明水彩、紙 1984 趙旭先生收藏
Country Love No.2 60.2×60.2cm Gouache on paper 1984 Collection of Mr. Zhao Xu（右頁為局部圖）

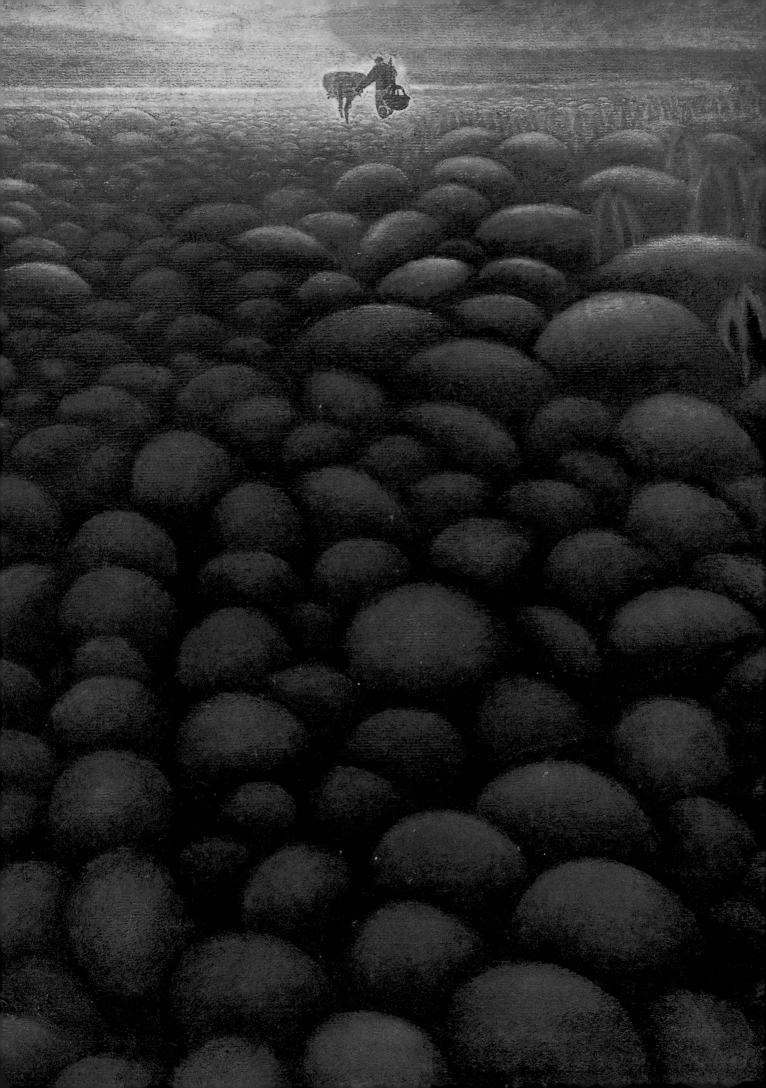

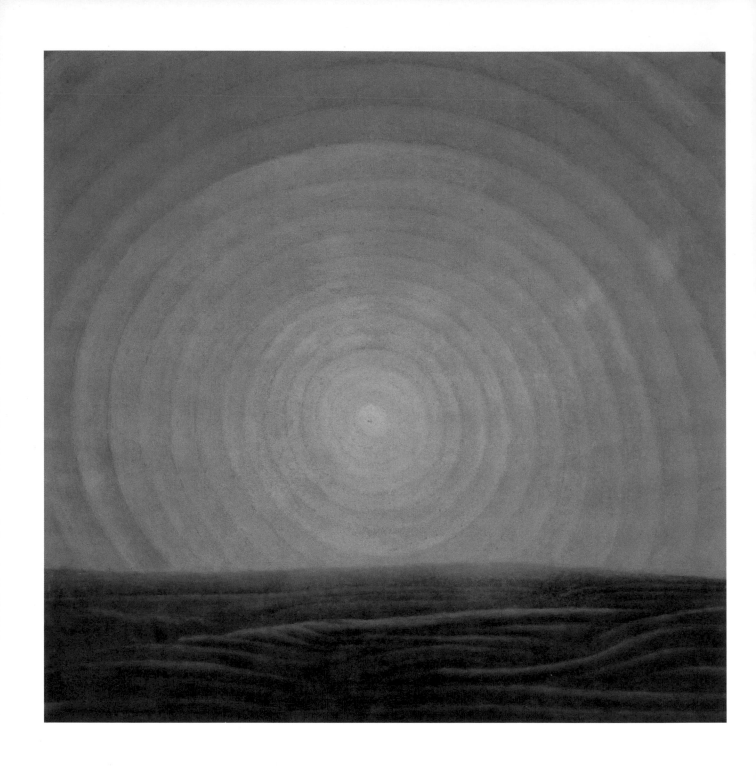

無題　60×60cm　不透明水彩、紙　1984　藝術家自藏
Untitled　60×60cm　Gouache on paper　1984　Collection of the artist（右頁為局部圖）

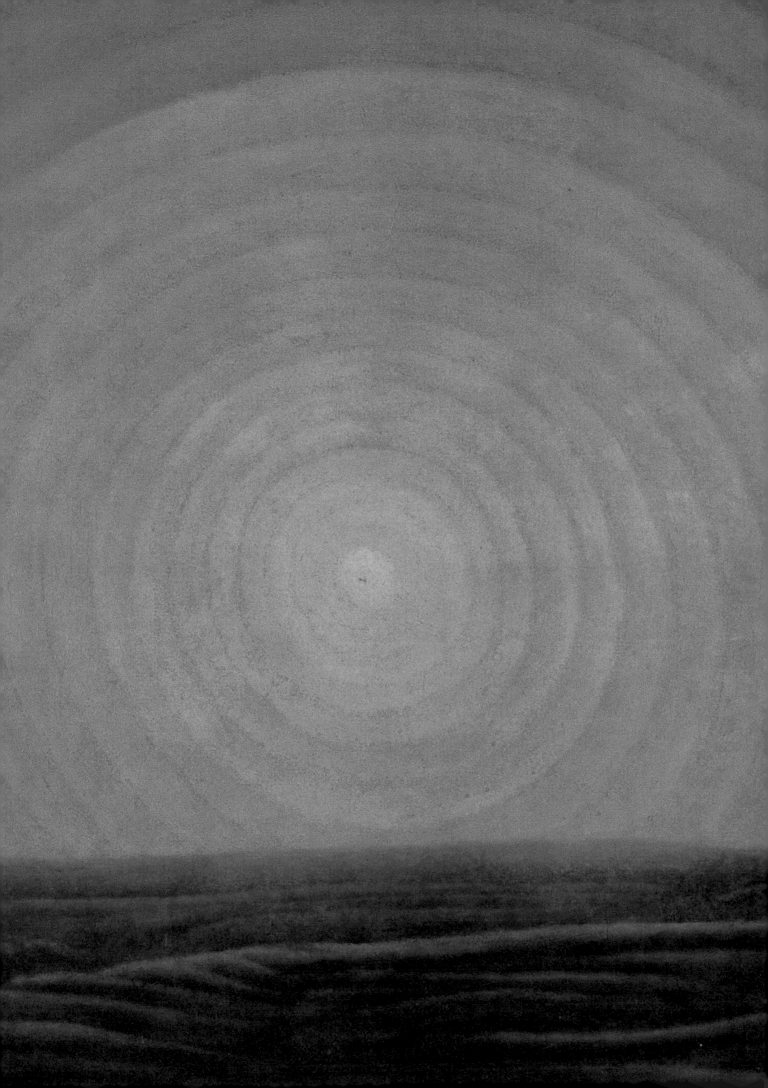

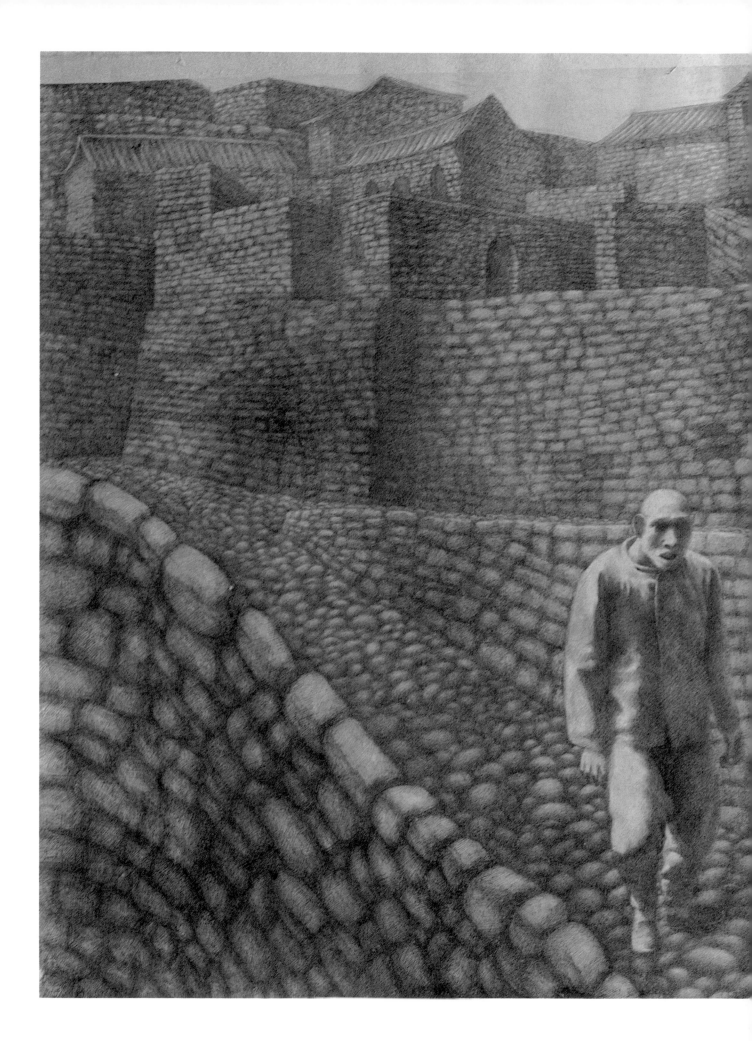

素描（之四）
54.8×79.1cm
鉛筆、紙　1988
藝術家自藏
Drawing No.4
54.8×79.1cm　Pencil
on paper　1988
Collection of the artist

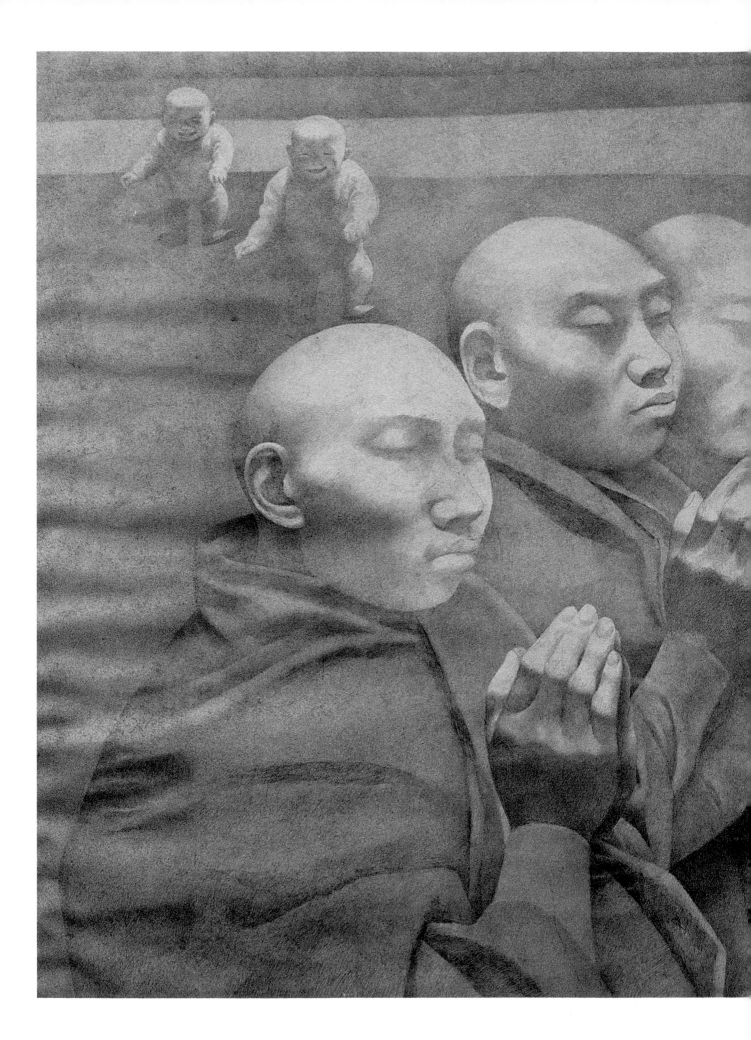

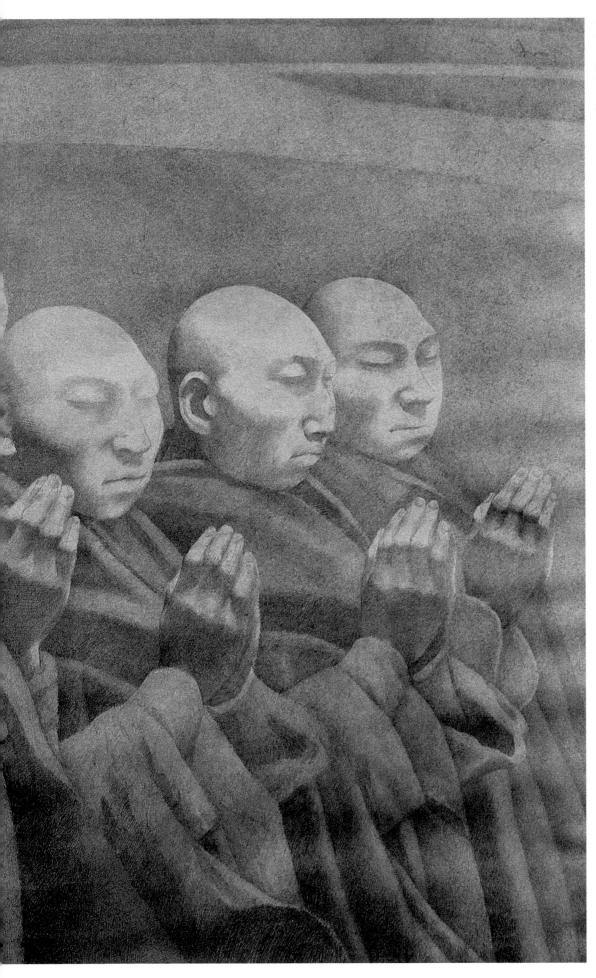

素描（之六）
79.5x110cm 鉛筆、紙
1989-90 樊紅女士收藏

Drawing No.6
79.5x110cm Pencil on paper
1989-90 Collection of
Ms. Hong Fan

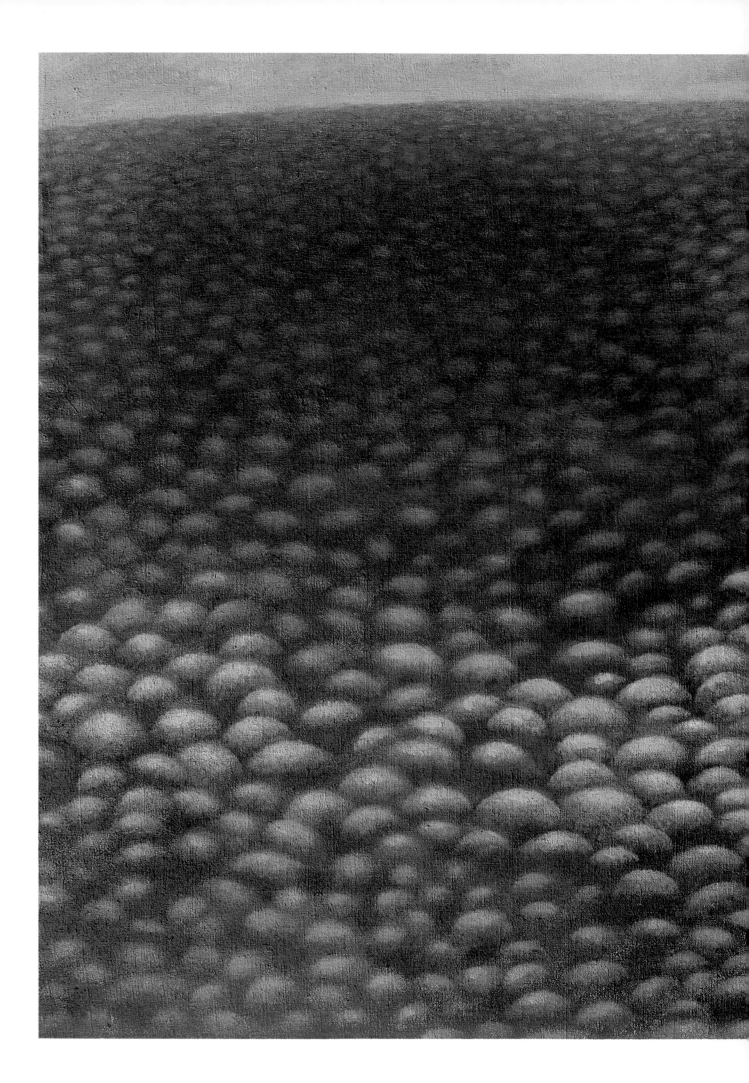

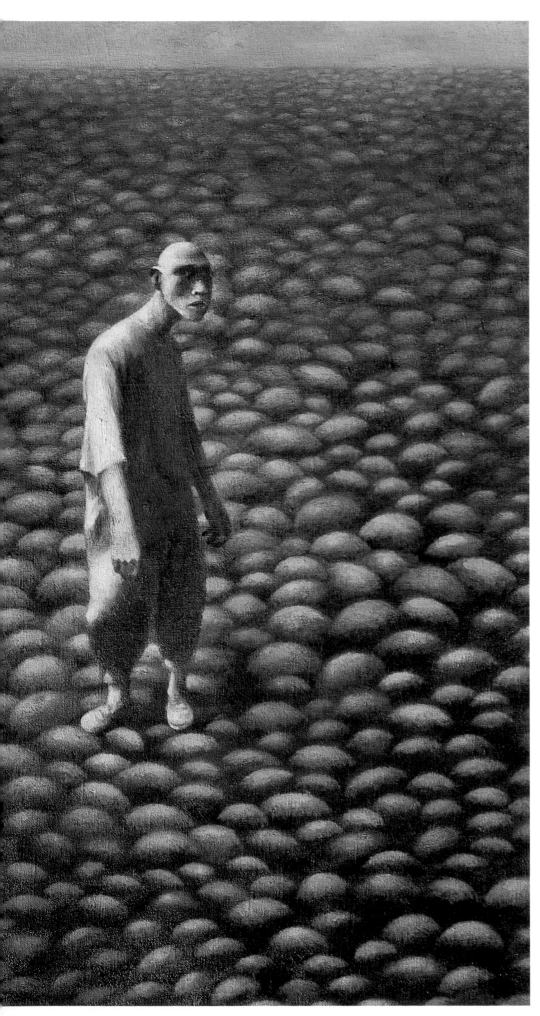

油畫（之二） 47×60cm
油彩、畫布 1988-89
私人收藏，香港蘇富比提供
Oil Painting No.2 47×60cm
Oil on canvas 1988-89 Private
Collection, courtesy of HK Sotheby's

# Ⅱ
# 光頭的表徵
## The Emblem of Bald Head

我嘲笑崇高，但崇尚尊嚴。——方力鈞

80年代初期的中國現代藝術，面對著跟西方現代藝術在語言與形式上近半個世紀的時差，猶處於正在努力尋求跨越、快速消化與反芻的階段。當時的藝術家們一方面是因為對於這種外來語言的生疏感，另一方面則是對於個體經驗和公共現實的反觀與省思，透過理想主義的暈染，對照官方對現代藝術視為狼虎，這種現實上的保守環境，而產生了一種高壓箝制下反作用力的抗拮性。在與西方藝術史接軌的進程上，初萌的中國現代藝術，因為激進地快速催熟，以及自身對於這些外來語言運用能力的侷限性，反而形成了一種與西方美學看似不得其門而入、但實已另闢蹊徑的張力關係。

德勒茲在他的著作《尼采與哲學》（*Nietzsche and Philosophy*, 1965）裡說過：「未來的哲學家是藝術家和醫生，簡言之，是立法者。」1989年的事件發生之前，沒有史評者能肯定德勒茲未來的「立法者」現象會應驗在中國當代藝術上。相對於80年代前、中期的開放訊息而言，從1987年啟動「反對資產階級自由化」的政經氛圍，於89年的事件之後達到高峰，有如緊箍咒般籠罩著整個中國，直到1992年隨著鄧小平第二次南巡啟動的中國第二場改革開放，確立了所謂具有中國社會主義特色的市場經濟政策，才使得原本框限於社會主義架構中局部開放的資本主義終於如猛虎出閘，風起雲捲地迅速改變了整個中國的經濟體質。

也就是在這段變動的年代裡，中國出現了在精神與意識形態上具有反叛體制、反資本主義消費文明的藝術現象，圖寫了「後八九」的當代藝術新潮。

1989年甫自中央美院踏出學院藩籬的方力鈞，不但選擇開始面對當時尚未被社會機制認可的獨立創作者身份，還恰好一腳踏進這個撼動整個中國的歷史轉折年份。一段現代藝術演進的「小歷史」（micro-history）片段，卻因為政經社會的時局變遷，緊緊地扣合了「大歷史」（macro-

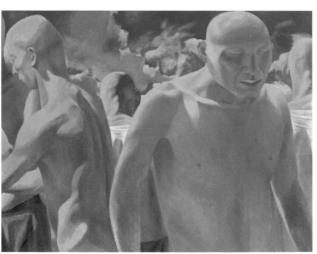

Above：
系列一（之一）99.2×99.2cm 油彩、畫布 1990-91
Series 1 No. 1 99.2×99.2cm Oil on canvas 1990-91（上圖）

Below：
油畫（之四）90×120cm 油彩、畫布 1991-92
Oil painting, No. 4 90×120cm Oil on canvas 1991-92（下圖）

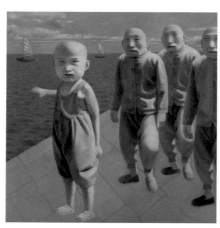
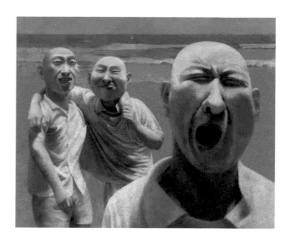

history）的脈動，正是「後八九」當代藝術潮可遇不可求的契機。

「政治波普」與「玩世現實」藝術的興起，一改 80 年代的狂熱和焦慮，顯得異常冷靜和理性，這正是取決於當時社會變革、經濟轉軌的現實。不同於八五新潮、星星畫會等等這些先進們熱烈地陳述自我理想的狀態與方式，「後八九」的環境氛圍醞釀了另一種文化態度與藝術基調，為這一代藝術家提供了一種習慣於保持一點距離、一種冷眼熱心的視角。個體的理想主義、英雄主義之獨特性基本上已被徹底地消泯掉，集體的生命情境、生存狀態等等平庸凡俗的現實景況、社會輪廓，才是這一代藝術家們有興趣予以正視、勾繪的體裁。儘管他們這批缺乏正當身分的藝術家，在當時的社會體制下是最卑微、最可欺、隨時隨地可被驅逐的弱勢社群；但他們卻擁有獨立的自覺與勇氣，有膽量脫離社會主體，過自己決定要過的生活方式。

因緣之偶然與歷史之必然，方力鈞在這樣的時代中登場，也擔任起扮演一個關鍵角色的重任，今日回頭來看：若是這個年代沒有方力鈞、沒有劉煒這樣的人物在此時登場，中國當代藝術今天或許會走成一個跟今日所見完全不同的樣貌。

方力鈞的哲學就是簡單直白，這二十多年來，方力鈞一以貫之地反覆思考辯證的，也就是如何更準確更有力地簡單直白。

延續著 1984 年「鄉戀」系列以來那種圓墩墩、簡單而渾實的造型語彙，方力鈞 1988 年開始的「素描」系列與「油畫」系列，陸續以基本上是單色概念的畫面中，出現了在空闊寬敞的背景前方，剃著光頭、形象重複而表情空茫的人物；這些光頭而無所事事的人兒，為後八九世代在社會轉折的動態演變中，標誌了一種看似平庸但卻深入人心的獨特符碼。也將中國一整世代面對外在環境濃烈衝擊的時代交響，化為一種更深刻於疾言吶喊的無調性複音。

Above Left：
系列一（之二）
100×100cm 油彩、畫布
1990-91

Series 1 No. 2
100×100cm Oil on canvas
1990-91（左上圖）

Above middle：
系列一（之七）
99.4×99.4cm 油彩、畫布
1990-91

Series 1 No. 7
99.4×99.4cm Oil on canvas
1990-91（中上圖）

Above right：
系列一（之三）
80.2×100cm 油彩、畫布
1990-91

Series 1 No. 3
80.2×100cm Oil on canvas
1990-91（右上圖）

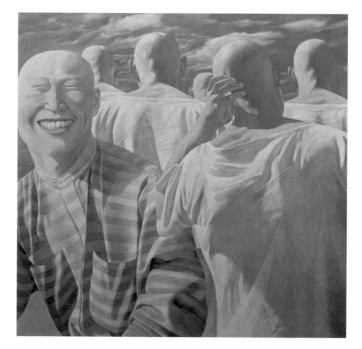

Below：
系列二（之五） 200×200cm 油彩、畫布 1991-92
Series 2, No. 5 200×200cm Oil on canvas 1991-92（右圖）

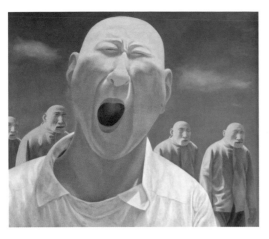
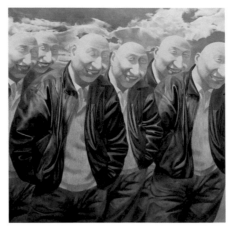
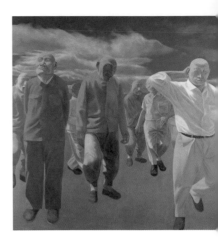

80年代末的時代鉅變，對於方力鈞而言顯然是個關鍵。1989年初「中國現代藝術大展」上的兩聲槍響，成為中國現代藝術的「謝幕禮」。接踵而來的情勢變動，對知識分子來說更為嚴酷。前一代藝術家們承載的知識分子的理想主義，至此受到無情重挫，面對集體失落、無奈的殘酷現實，使得方力鈞一下子清楚了自己關注以及可以著力的焦點是什麼——生命未必如此微渺，當你面對整個權力與主流價值系統的時候，有勇氣選擇蔑視的姿態，就是一種勝利——同時，他也從自己以前原本依著感覺摸索的形式與技術中，找到了未來應該以什麼手段去完成它；而舊中國裡小市民生存哲學的潑皮風格，此時跟他畫面中光頭人物的結合，就成了對於當時整個群體生命狀態最為直白而準確的本質形象。

「潑皮主義」、「玩世現實主義」，眾所周知是藝評家栗憲庭在當時提出的：「而所謂潑皮，是我把中國的一個處世俗語引作的文化概念。含義兼有玩笑、痞氣、放浪、無所謂，看透一切意味。」因此，玩世、潑皮幽默作為一種在精神上自我解脫的方式，不但是後八九時期的一種標誌，甚至成為當時中國知識分子一種相對安全的批判模式。

方力鈞既反對合流於當下以一種文化的集體失憶來逃避；亦不類魏晉狂士以脫離現實、放浪形骸的生活，作為消極對應主流政治的姿態來達到自我解脫的目的；也不像米蘭・昆德拉（Milan Kundera, 1929-）這類選擇以藝術「抵抗遺忘」，藉由藝術手段隱身於他

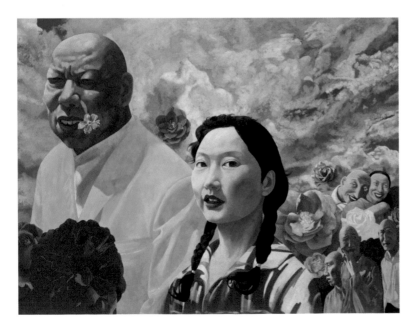

方。方力鈞選擇以忠實地彰顯他作為一個個體的生存體驗，來對應整個時代集體的生命經驗。

如何以這種態度去彰顯出每個個體的生存體驗？方力鈞有不同俗論的見地：「一個個體能夠抽離當時的社會，成為一種獨立存在，無論你是反向的還是順向的。從個體來講，正是因為你特別強調個體，你可能更代表這個時代的人的一種感覺。也可以反過來說，正因為你特別符合這個時代，所以你也是特別個體的一個人。」所以他筆下的光頭潑皮、玩世現實形象既是共相、也是殊相，是立足在現實人間的、而非避世的。

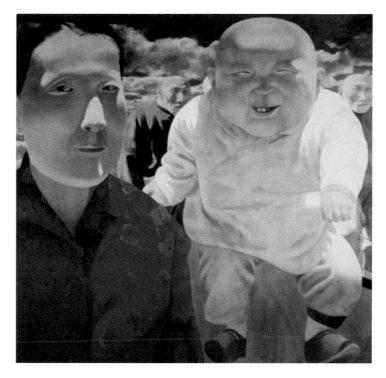

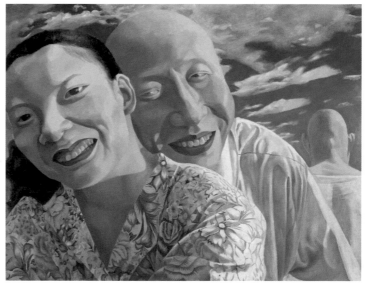

Below left：
1993.4 180×230cm 壓克力顏料、畫布 1993
1993.4 180×230cm Acrylic on canvas 1993（左頁下圖）

Above：
系列二（之七） 200×200cm 油彩、畫布 1991-92
Series 2 No. 7 200×200cm Oil on canvas 1991-92（上圖）

Below：
系列二（之八） 89.7×116cm 油彩、畫布 1991-92
Series 2 No. 8 89.7×116cm Oil on canvas 1991-92（下圖）

　　1990 年開始，方力鈞連續兩個「系列」系列油畫，畫出表情帶著嘻笑的青年，戲謔、躁動、百無聊賴之中打著呵欠的大光頭，一方面鮮明地表達了對待主流權力與價值系統一種滿不在乎的、輕蔑的態度；另一方面，就像是呼應德勒茲作為一個「立法者」的預言一般，這個畫面與形象便凝結成為全世界人們心目中，整個中國這一代人的心理縮影。

　　這同時讓我聯想到傅柯（Michel Foucault, 1926-84）的一個論點，他認為：權力通常是依靠一個真理系統而建立的，因此若是透過討論、知識、歷史等等方式來重建或修正這個真理系統，權力當然可以被質疑；傅柯直指：甚至是透過藝術創造的手段，也可以達到對這樣的權力挑戰。方力鈞無疑是非常輕巧地，以他畫中這個閒極無聊的姿態，不只是挑戰，並且成功的修正了一個龐大的真理系統。這當然不是偶然，而是他精確選擇之下的策略。

　　方力鈞曾經多次提到他當時決定選擇「光頭」這個形象的策略意義。「光頭」這個形象充滿了一種不明確的邊緣與反叛的暗示與曖昧性，和尚是光頭、犯人也是光頭，剃了頭以後的形象似乎抹滅了某些個體之間明確的差異性，而藉以用來作為「人（類）」這個整體性的象徵概念便被突顯出來。作品〈系列一（之六）〉以灰白色調所繪厚掌支頤的光頭，像一尊泥胚捏塑而漸風化的眾生凡胎，因無喜悲愛憎、罣礙憂懼，而徹底實現了方力鈞筆下平等的共相。當「人」的意義被徹底地概念化之後，作為對於既有的真理系統不斷提問的戰略位置，才更為精煉有力。

　　在西方寫實主義焦點透視可及於的客觀構圖視角侷限之外，方力鈞從一開始就很習慣地挪借了中國傳統繪畫中多點透視、散點透視的心理視點構圖，不受限於一個小的現實景象，將可視的畫面擴張轉換成可視的內容。〈系列一（之一）〉、〈系列一（之二）〉、〈系列一（之三）〉以單色調描繪藍天白雲、海岸線或園林場景這些市井平民遊玩逗留的空闊場景，處理了多重空間的暗示，同時也達到他自身堅持不著相簡單直白的美學。這些

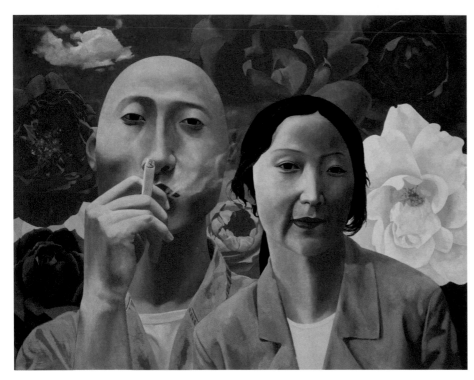

1993.5　180×230cm
壓克力顏料、畫布　1993

1993.5　180×230cm
Acrylic on canvas　1993

保留地平線與海平線的空間場域，為方力鈞畫中的人們與畫外的觀者同時提供了「讓心理的空間能夠更自由、境界就更開闊的可能性。」（方力鈞語）。畫中前景的主人翁們不論笑臉盈盈或者盯著鏡頭般的與觀者互看，在他們背後一字排開不明關係的人群、或面對或背對著主角，這種空泛、滑稽、無聊，但看似歡喜樂觀的陣仗，成就了一種百無聊賴，但亦不可束縛的心理指喻。

作為一個獨立的藝術家身分，方力鈞思考著人的問題，但不將人置身於特定的歷史背景中。在給他的友人或者任何一個市井小民做生活記錄片刻的再現同時，這些人也是作為一個經歷了重要時代轉折點的群體而存在著。他並不是刻意地忽視看來幸福情事背後的真實，及溫暖不可救藥的樂觀裡可能潛藏著現實的凶險，但他亦不想因此被絆住而失去自己自由的身分，及作為一個自由的夢想家的權利。

1991 年以後的「系列二」系列作品，方力鈞的油畫從「系列一」以來仿如是從記憶中挖掘出來的黑白、褐色般的畫面，走向鮮豔熱鬧的色彩，咧嘴笑的痴人逐漸替代了打呵欠的渾人，藍天白雲，繁花如錦，所有人世間最簡單而美好的幸福嚮往就實現在他的畫面上。但是絢麗的「系列二」畫面中雖然仍有碧波藍天，卻已一致地失去了「系列一」構圖所依恃的地平線或海平線，擁塞在「系列二」畫面的人兒，排班成列地擁襯著畫中主角的笑顏。雖然畫中人人都有些樂吱吱地，但更為徹底地顯得全是一幫不帶魂的潑皮牛二。此時的方力鈞並沒有停步眷戀於這個他所創造出來的典型裡，他已經悄然地轉身開步，轉而探索另一個以「水」為主題所延伸的心理象限去了。

這時的中國已經大步邁著開放的腳步，消費文化撲面而來，走上所謂「具有社會主義特色的資本主義道路」。而方力鈞，無疑是中國當代「豔俗藝術」的預見者與先行者，從1991 年的「系列二」作品以後，他有一部分的作品畫得越來越鮮豔刺激，人、水、天、雲彩、花朵這些自然物，在他筆下越來越傾向處理成矯飾虛假的、非自然的、工業性的、令人感到說不出地尷尬不適的豔俗色彩，這並非扭捏作態，而是一種他最擅長的，一針見血

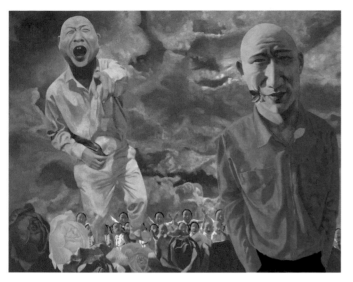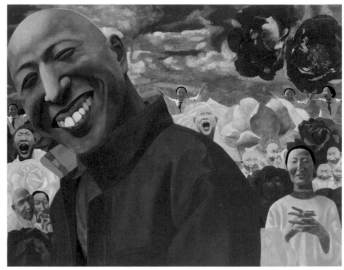

的直率的曖昧，因為他太瞭解：美往往令人乏味，醜則有無限可能。

　　方力鈞的理性與眼界，使他顯然很早就意識到消費文化的氾濫，即將造成他這一整代人所有生活巨大的、無可復返的改變——物質條件的改變造成了文化與價值系統的徹底改變——就跟面對著無力相抗的權力系統一樣，他的自由藝術家身分，至少使他能從容地選擇以蔑視、嘲諷的姿態，與權力的軸心對看，冷眼熱心地保持著作為一個人的尊嚴，並且透過他的藝術，他筆下所創造光頭潑皮人物所表徵的集體精神力量，某種程度地，成為德勒茲筆下的「立法者」。（胡永芬／文）

Above left：
1993.2　180×230cm
壓克力顏料、畫布　1993

1993.2　180×230cm
Acrylic on canvas
（左上圖）

Above right：
1993.3　180×230cm
壓克力顏料、畫布　1993

1993.3　180×230cm
Acrylic on canvas　1993
（右上圖）

Below：
1993.6　180×230cm
壓克力顏料、畫布　1993

1993.6　180×230cm
Acrylic on canvas　1993
（下圖）

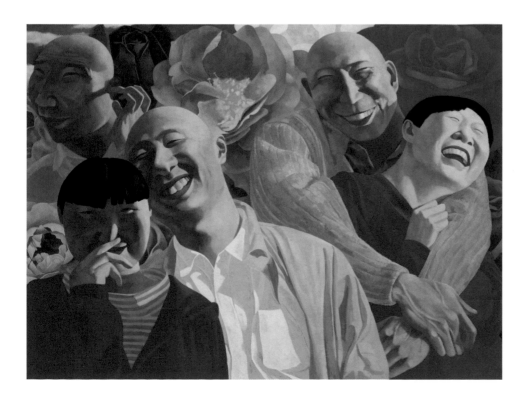

*I laugh at the sublime, but revere dignity.* – Fang Lijun

The modern Chinese art in the early 1980s is at the stage of struggling for breakthroughs and hungrily absorbing and ruminating information, in hope of overcoming the distance of nearly half a century between East and West, in terms of language and form. Due to on the one hand the foreignness of the Western language, and on the other hand the reflection and thoughts on personal experiences and the larger reality, magnified by an idealism against the backdrop of the conservative and coercive policy environment, the artists generally adopted an antagonistic stance towards the oppressive system. Speedily ripened and limited in its ability to use the foreign language, Chinese modern art thus burgeoned, in the process of contacting with the history of western art, into one that, seemingly alien to the Western aesthetics, is potent with alternative tensions.

Deleuze once stated in *Nietzsche and Philosophy* (1965), "The philosopher of the future is both a physician and an artist, in a word, a legislator." Before the 1989 incident, no historian was able to envisage that Deleuze's legislator as a phenomenon would emerge in Chinese modern art. Although in reaction to the open policy in the early and mid 80s, the politico-economic atmosphere gave rise to the 1987 movement against "bourgeois liberalization," and culminated after the 1989 incident as an all-encompassing spell, the second wave of reform and open policies, inaugurated by Deng Xiaoping's second south trip in 1992, announced the eventual establishment of the so-conceived market policy informed by Chinese socialism in China. Capitalism, which was previously bound in the socialist framework, has since then been given a free rein, and in turn imposing a sweeping and instant change on the economic constitution of China.

It was at this time of change that the art phenomenon which was spiritually and ideologically anti-institution, anti-capitalism, and anti-consumerism, was conceived in the post '89 art world.

Fang Lijun, who chose to be an independent artist, an identity still unrecognized by the social institution, found himself in the year 1989 at the turning point of history that jolted the entire China, when he was just liberated from the confines of the Central Academy of Fine Arts. The micro-history of modern art was thus brought to close contact with the current of macro-history by the politico-economic shift of the time, and paved the way for the blossoming of the post '89 art in contemporary China.

The "political pop" and "cynical realism" that veered away from the frenzy and anxiety of the 80s, and emerged to be extraordinarily level-headed and rational, were an outcome of the social and economic changes of the time. Differing from the vehement accounts of personal ideals of the senior artists in '85 New Wave and Stars Group, they cultivated another cultural attitude and artistic approach in the singular environment of the post '89 era, generating a distanced, calm, yet involved perspective for the young generation. In place of the attributes of individual idealism and heroism, which were essentially obliterated, the mundane reality, the social contours, of the collective life and its state of existence rose to seize the artists' eyes and hands. Although these artists, not legally recognized, were the most menial, vulnerable, and dispensable group at that time, they nevertheless retained an independent thinking and courage, which empowered them to detach themselves from the society as a whole, and live their lives as they wanted them to be.

The coincidence of chance and consequence of history together erected the stage for Fang Lijun, who has played a key role in the Chinese art world since then. To look back at that time: if there were not artists like Fang Lijun and Liu Wei, the art scene in the contemporary China may be utterly different.

Fang Lijun's philosophy manifests straight-forwardness and simplicity, and what he has been reflecting and elaborating in the past twenty some years is the way to be more pointedly and powerfully simple and straightforward.

Continuing the round, simple, and solid linguistic composition of the 1984 *Country Love* series, Fang Lijun's *Drawing* and *Oil Painting* series, initiated in 1988, were essentially composed of the repetitive image of a shaved head with blank facial expressions, placed on a spacious, dominatingly monotonic background. These bald and idle figures, seemingly banal but psychologically arresting, became a unique sign for the social vicissitudes of the post '89 era, which transformed the historical symphony of the swirling era into an atonal polyphony profounder than rallying cries.

The drastic transformation at the end of the 80s was obviously a key for Fang Lijun. The two gunshots at the China Contemporary Art Exhibition in the early 1989 was the curtain call to Chinese modern art, which foreshadowed the harsher incidents for the intellectuals to come. They crushed the intellectuals' idealism, carried along by the older generation of artists. Fang Lijun suddenly realized, in face of the harsh reality of a collective sense of disappointment and helplessness, where his concern should lie and how it could take effect — life can strive beyond being trivial; to show contempt to the power apparatus and mainstream value system is also a kind of success. At the same time, the form and techniques he had been groping for in accordance with his own perception provided him with the approach to present his view. The plebeian philosophy of life in the rascal style found in old China was therefore combined with the bald figures on his canvas, and became the most appropriate and direct emblem of the essence of state of existence of the entire collective life.

"Rascal style" and "cynical realism," it is known, are terms introduced by the art critic Li Xiangting, "...and by 'rascal,' I use the common byword in China as a cultural concept. It refers widely to joke, rogue, extravagance, indifference, and seeing through." This way, the cynical and rascally humor as a way of spiritual self-deliverance is not only an emblem in the post '89 era, but even also a relatively safe way of criticism for the contemporary Chinese intellectuals.

Fang Lijun neither escape by aligning himself with the cultural attitude of collective amnesia; nor seclude himself and live outside social norms to resist passively the political mainstream, and thereby achieve self-deliverance, as the wild intellectuals in the Wei-Jin dynasty did; nor, like Milan Kundera (born 1929), choose to "resist forgetting," to hide himself elsewhere by means of art. Rather, Fang Lijun displays faithfully his life experiences as an individual to suggest the collective experiences of his time.

How is the display also one of the life experiences of other individuals? Fang Lijun noted with a point, "Every individual is able to detach oneself from the society and become an independent entity, either in a rebellious or in a compliant way. In terms of the individual, it is precisely because you emphasize the individual that you become the representative of your time; or, conversely, it is precisely

because you are representative of your time that you, among others, live as an individual." This is why the image of bald rascal / cynical realist in his paintings can perform both as the representative and the singular depiction of one not secluded from, but firmly situated in the everyday reality.

The two consecutive *Series* of oil paintings initiated in 1990 depicted youth in jeering laughter. Bantering, agitated, and yawning in utter boredom, these bald figures on the one hand clearly expressed a careless and disdainful attitude towards the mainstream power apparatus and value system, and on the other hand, as an echo of Deleuze's prophecy of being a "legislator," epitomized the psychological state of the entire generation of Chinese.

Meanwhile, it reminds me of Michel Foucault's (1926-1984) concept that power is used to be built on a system of truth, and therefore, if this system of truth were to be rebuilt or modified through discussions, knowledge and history, it is also certainly validated to question power. Foucault points out that even the approach of art creation can be a means to challenged power. And to be sure, by the nonchalant stance in his paintings, Fang Lijun has not only swiftly challenged but also successfully revised an enormous system of truth. This, of course, was no coincidence, but a strategy he has chosen carefully.

Fang Lijun has mentioned in numerous occasions the strategic significance of choosing the motif of "bald head." The image of "bald head" is full of suggestiveness and ambiguity of an unidentified marginality and rebelliousness. Monks are bald, and so are criminals. To use the image of a shaved head, which seems to erase the clear distinction between some individuals, therefore, highlights its status as a symbol of the entire humanity. In the grey-and-white *Series 1 No. 6*, the bald head resting on the thick palms was like a weathered clay statue of everyman which, devoid of joy, sadness, love, hatred, concern, anxiety, and fear, fully realized its role as a representative of plesbian in Fang Lijun's paintings. The more thoroughly conceptualized the term "human" is, the more refined and powerful the strategic position of constantly challenging the existing system of truth becomes.

Going beyond the limits of the objective perspective in a Western realist composition, Fang Lijun has, since the beginning of his career, been habitually appropriating the psychological approaches of multiple perspective and cavalier perspective of the traditional Chinese painting. It allows him to transcend the circumscription of physical reality, and broaden the scope of the visible to include those lie within. The single color depicting the blue sky and white clouds, the coastline, or gardens and forests on the horizon of the entertaining places for the common people in *Series 1 No. 1*, *No. 2* and *No. 3* was used in a way to both suggest the presence of multiple spaces, and fulfill the artist's aesthetic demands of simplicity and straight-forwardness. These places with horizons and sea lines provided both the figures on the canvas and spectators outside of canvas with "a freer place for the mind, a wider sphere for the spirit." (Fang Lijun) The main characters at the foreground that smiled or stared at the spectators, and the group of people of unclear relationship that lined at their back and face or turn their backs to them, together constituted a seemingly joyful and optimistic, but loosely formed, funny, and bored lineup, yielding a psychological metaphor of boredom and intransigence.

As an independent artist, Fang Lijun thinks about human, but does not place human in a specific historical background. In his recording of the life experiences of his friends or any of the plebian, the people are represented as a group existence at the turning point of history. He does not mean to question the people's happiness as they appear to the eyes, or the danger of reality latent in the incurably warm optimism, but he does not want to be confined by them, and be deprived of his freedom as an artist and right as a carefree dreamer either.

In *Series 2*, a series of oil painting begun in 1991, Fang Lijun transformed the discolored, black-and-white canvas, as if it was depicting fragments of memory, of *Series 1*, into one of bright and clamoring colors, in which grinning boobs replaced the yawning drones, and all of the simple and beautiful yearnings for happiness were embodied in the blue sky, white clouds, blossoms of flowers in his

paintings. However, against the beautifully depicted sea waves and blue sky in *Series 2*, the horizons and sea lines on which the composition in *Series 1* relied had given way to the crowds of people swarming to highlight the grinning face of the protagonist of the paintings. Although every one of them appeared to be in high spirits, they were unexceptionally depicted as a soulless bunch of rascals. Fang Lijun did not linger in the symbolism at this point, however; instead, he took leave to explore another motif with psychological dimension, that of "water."

China now was sprinting forward. Consumer culture was floating over, and the country was on the road of the so-called "capitalism with socialist characteristics." At the contemporary scene of China, Fang Lijun was undoubtedly the foreseer and pioneer of kitsch art. Since *Series 2* of 1991, part of his work has tended to be more and more colorful and stimulating. People, water, sky, clouds, flowers and other natural objects were depicted, in an unutterable and embarrassing way, in vulgar colors that emphasize increasingly their artificial, unnatural, and industrialized aspects. This is not pretension, however, but an ambiguity of which he is expert in laying bare, because he realizes all too clearly that: beauty is often banal, while ugliness is potent with possibilities.

Fang Lijun's reason and ken had early raised his consciousness of the tremendous and irretrievable changes — the change in material condition completely alters the culture and the value system — of the whole generation that will be caused by the inundation of consumer culture. As with the power apparatus that one is powerless to counter, his identity as an independent artist enables him at least to choose to confront the power axis with a cool stance of contempt and scorn, and retain, calmly and yet with emotion, his dignity as an individual, while performing to a certain extent as a "legislator" in Deleuze's sense through the collective spiritual power embodied by the bald rascals in his paintings. (text by Hu Yung-fen, trans. by Yu-sheng Chien)

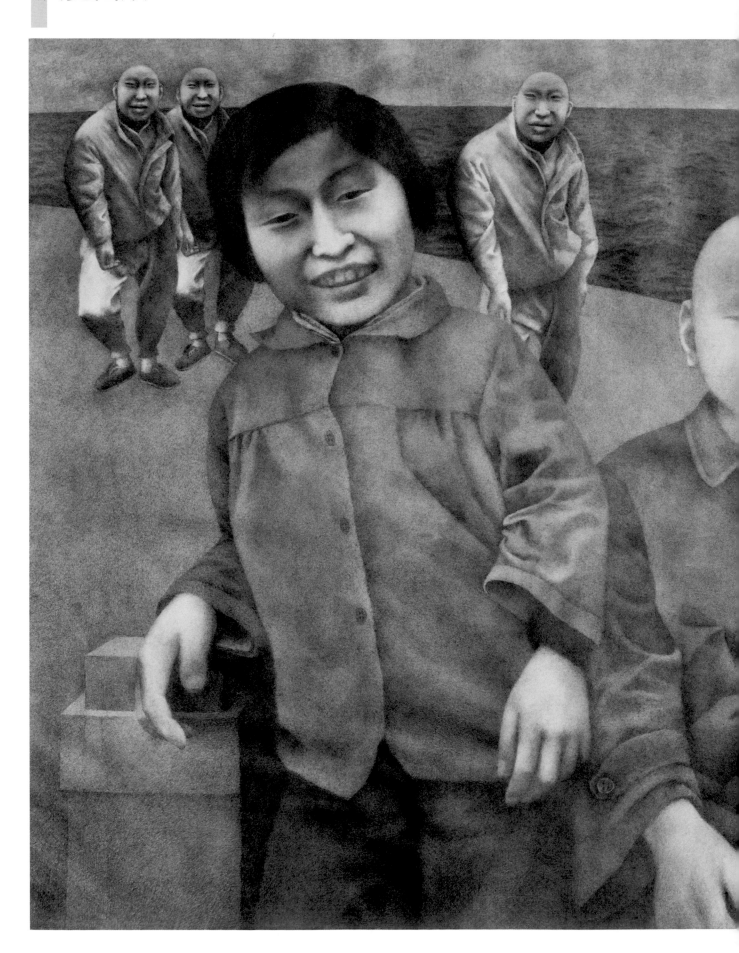

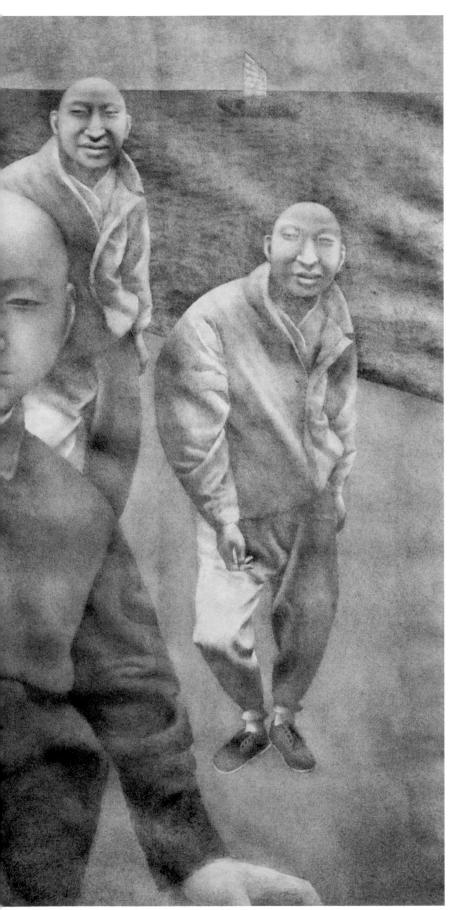

素描（之五）　75.6×110cm　鉛筆、紙　1989-90
荷蘭福瑞得先生收藏

Drawing No.5　75.6×110cm　Pencil on paper　1989-90
Collection of Mr. Fu Ruide, the Netherlands

無題 47×60cm 油彩、畫布 1989-90
藝術家自藏

Untitled 47×60cm Oil on canvas 1989-90
Collection of the artist

無題 47×60cm 油彩、畫布 1989-90
藝術家自藏

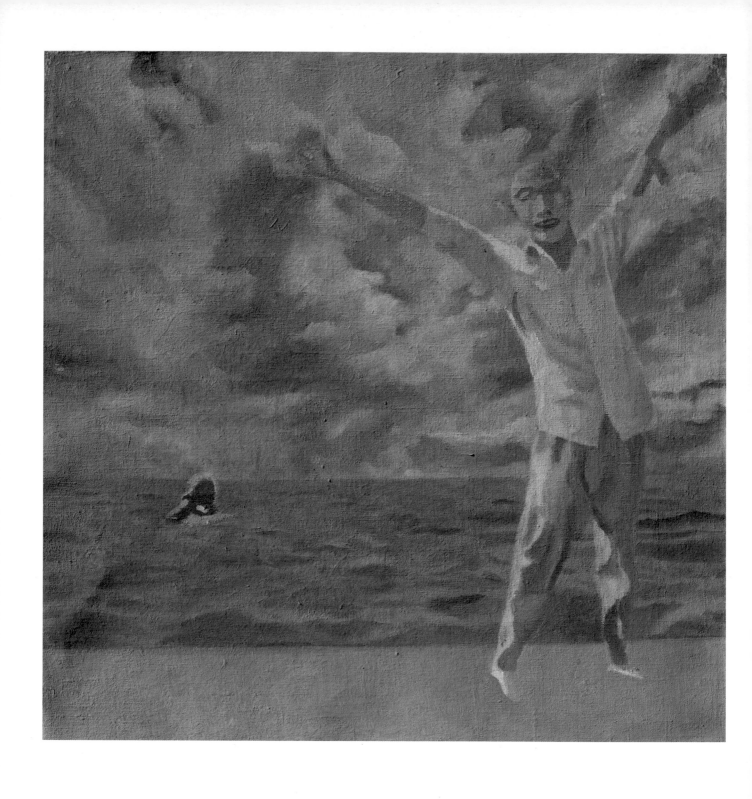

無題　40×40cm　油彩、畫布　1989-90　藝術家自藏
Untitled　40×40cm　Oil on canvas　1989-90　Collection of the artist（右頁為局部圖）

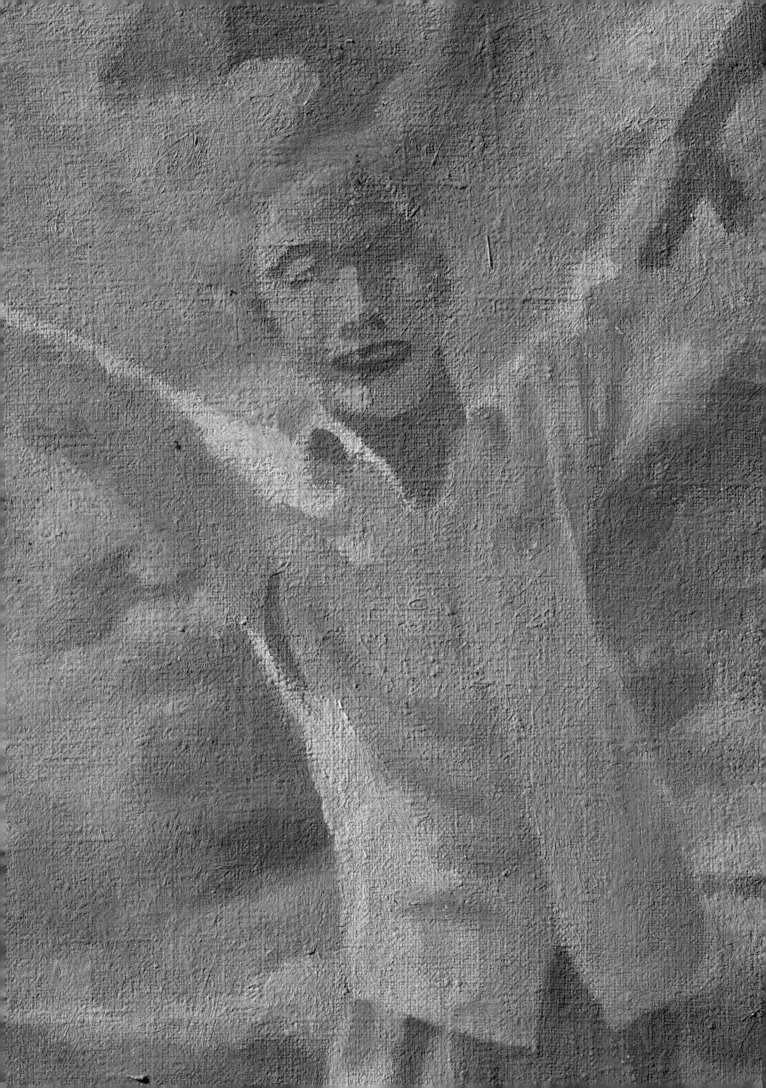

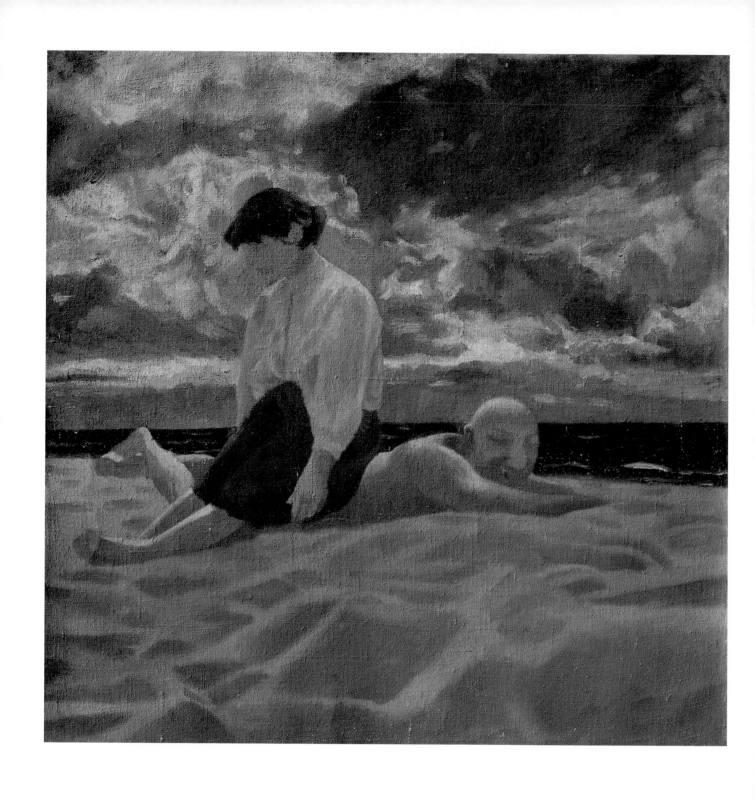

無題　40×40cm　油彩、畫布　1989-90　藝術家自藏
Untitled　40×40cm　Oil on canvas　1989-90　Collection of the artist（右頁為局部圖）

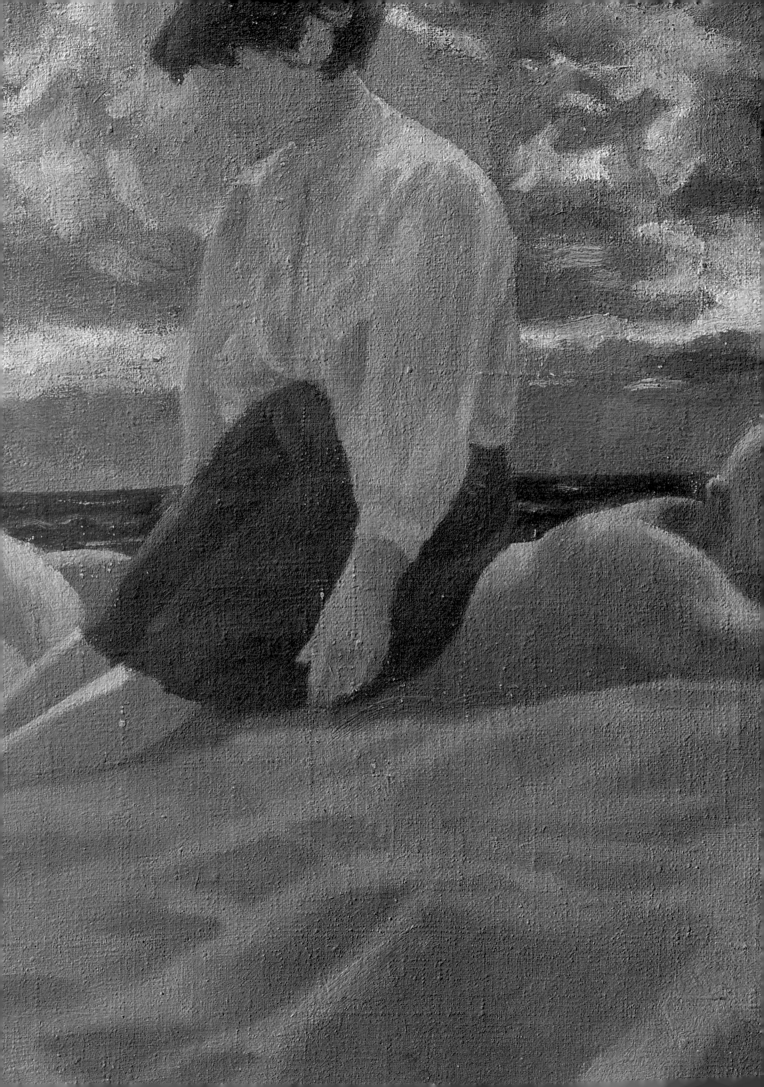

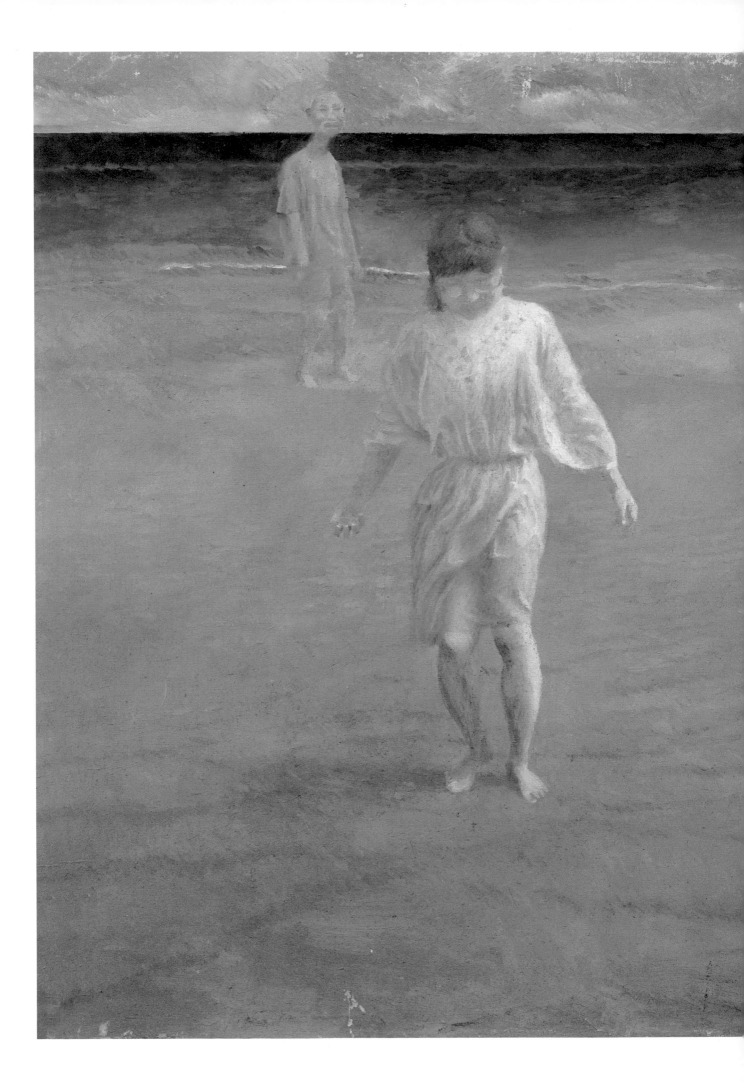

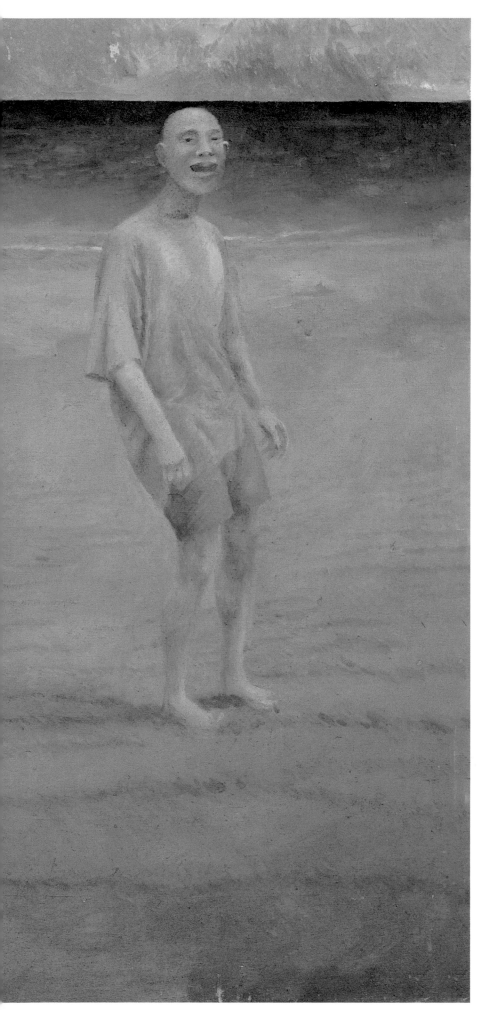

油畫（之四） 81×105cm 油彩、畫布 1989-90
荷蘭福瑞得先生收藏

Oil painting No.4  81×105cm  Oil on canvas
1989-90  Collection of Mr. Fu Ruide, the Netherlands

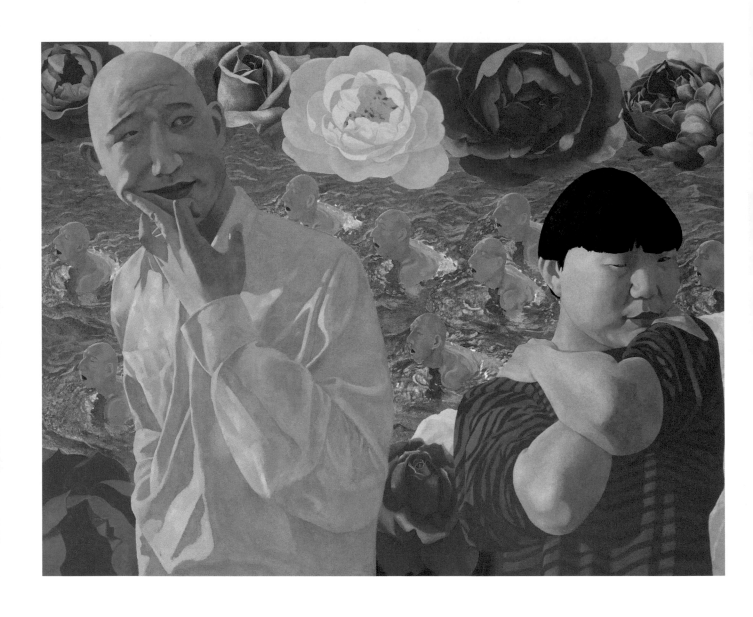

1993.1  180×230cm  壓克力顏料、畫布  1993  私人收藏，香港漢雅軒提供
1993.1  180×230cm  Acrylic on canvas  1993  Private collection, courtesy of Hanart TZ Gallery（右頁為局部圖）

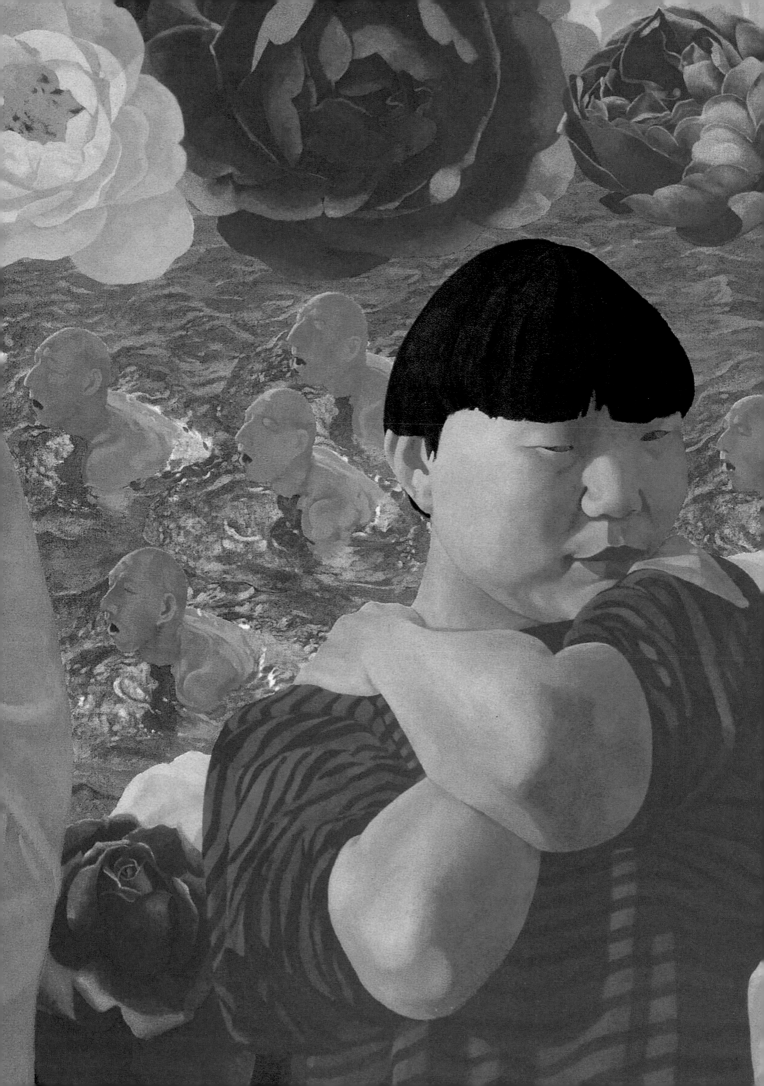

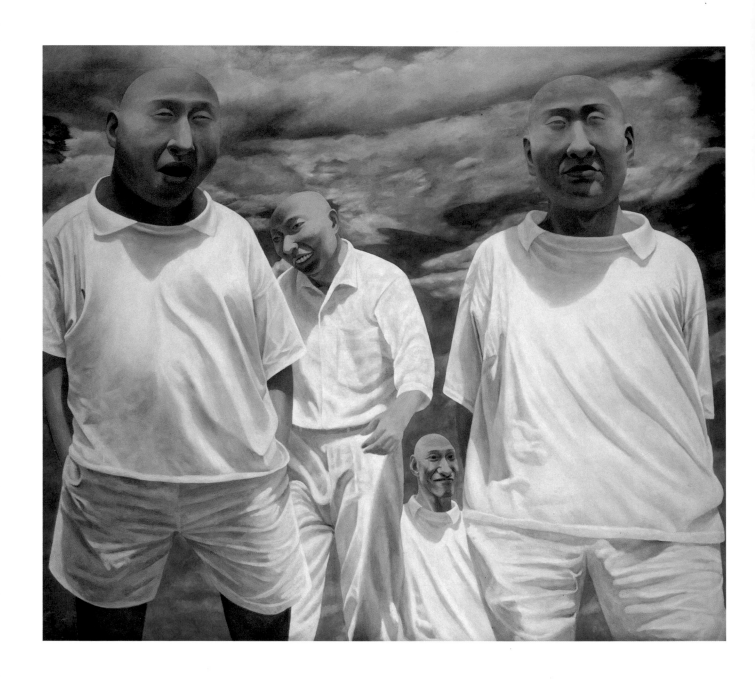

Above：
系列二（之六） 200×230cm 油彩、畫布 1991-92 私人收藏，紐約蘇富比提供
Series2 No.6 200×230cm Oil on canvas 1991-92 Private collection, courtesy of NY Sotheby's（上圖）

Right：
1997.1 162.6×129.5cm 油彩、畫布 1997 張蘭女士收藏
1997.1 162.6×129.5cm Oil on canvas 1997 Collection of Ms. Zhang Lan（右頁圖）

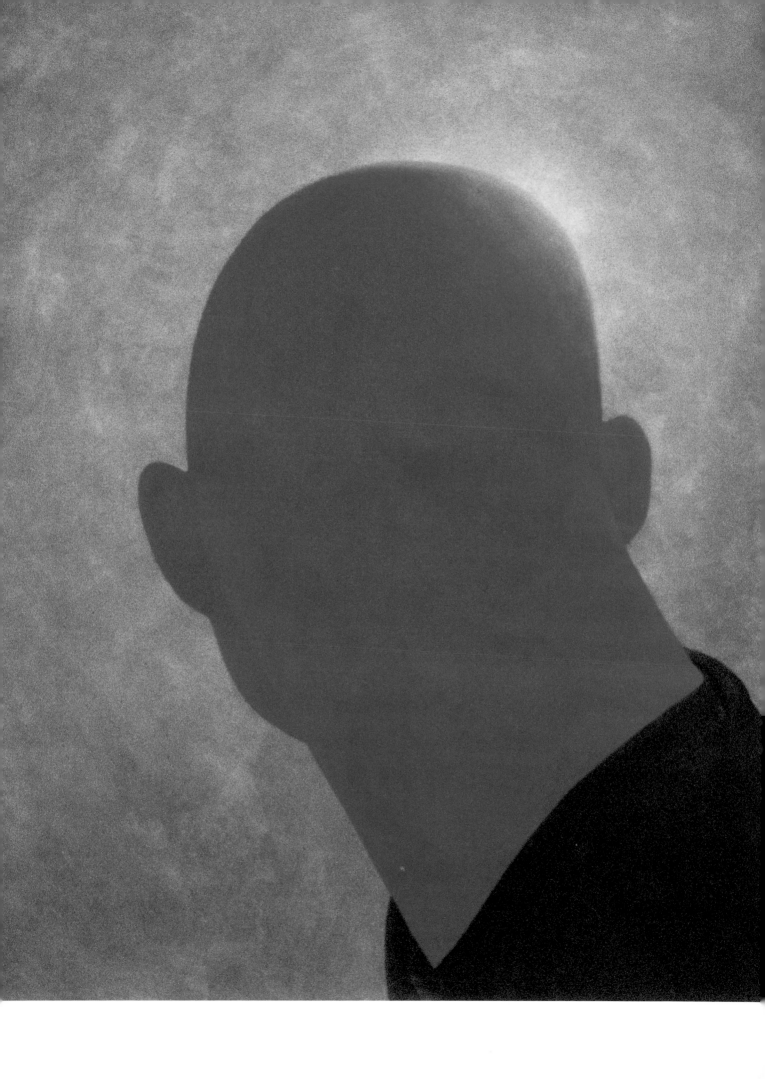

# III

## 水的指喻
### The Allusions of Water

但是，作為這麼大的一個國家，她的文化不能集體地選擇一種逃避，必須得有人去面對。
——方力鈞

　　大約是從 1991 到 1992 年「系列二」系列後半段作品開始，方力鈞的畫作中開始出現以「游泳」這個在庶民生活中比較普遍的休閒活動作為主題，「游泳」顯然也是他當時日常生活裡甚為熱愛的活動。大約在 1993 年，方力鈞已經將游泳這個主題發展成為完全捨卻、省略了對於環境景物敍事性的描寫，而最終簡練地聚焦以對於「水」，以及「水中的人」為僅有之描繪對象的畫面。這個命題一直延展了一段很長的時間，甚至在他 90 年代後期重返版畫的研究中，也成為最重要的主題之一。

　　拿英國畫家大衛·霍克尼（David Hockney, 1937- ）畫的游泳池系列，來跟方力鈞游泳與水的作品相比較，格外可以顯現出藝術家所處的生存狀態與其藝術之間絕對的關聯性。霍克尼的畫作，在精細的類照相寫實風格中，又有些變形的簡略與誇張，所有畫面上都具有一個特徵，就是暴露於充分的陽光之下而特有的那種豐富亮麗的色彩，顯現了霍克尼這個生長於陰冷地域的英國人，對於加州所代表的，充滿個人主義與享樂主義的熱帶生活之耽溺與迷戀，畫面中看似寧靜簡單的物件佈置，隱藏著人與存在、人與時間、人與社會，這些豔麗的表面底下，幽微奧妙陰暗變化的寓意。

　　至於方力鈞的畫面裡，漂浮在無邊水域中的無名人物，則與他的光頭人物有一個相同的指涉——作為一個概念性的「人（類）」此一整體性的象徵。在他筆下這一片漾著淺淺波紋、沒有邊際的水域，看來似乎既寧靜安詳、又似乎隱隱然潛伏著未可知的恐怖與危險，而仿如失重一般被包覆、漂蕩於其中的「人」，則顯得如此地耽溺、愉悅，又如此地無知、無助。

　　方力鈞所有畫水域以及游泳的作品，幾乎全部都是採取俯視的畫面，整張畫除了單純而帶著莊嚴與神祕感的深藍、湖綠，除了深黝難測的水域，以及清淡而微妙地撩撥著漾散開來的水波紋路之外，畫面的焦點就是潛在水下隱約可見的肉身人影；或者是因為游泳的動作而露出水面的部分肢體：局部的臉、半截手臂或腿；或者是因為悠閒的漂浮而大半

Below left：
1998.8.15　250×360cm
壓克力顏料、畫布　1998
1998.8.15　250×360cm
Acrylic on canvas　1998
（左下圖）

Below right：
1996～2003.11.3
230×180cm 油彩、畫布
1996～2003
1996-2003.11.3
230×180cm
Oil on canvas
1996～2003（右下圖）

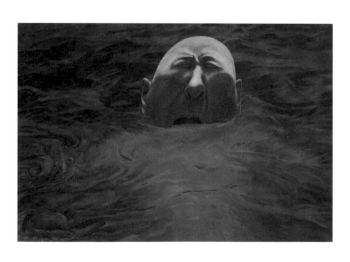
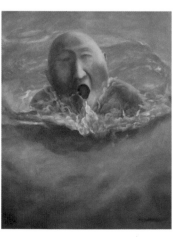

74

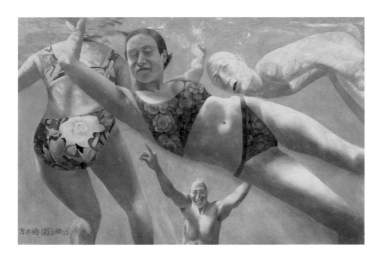

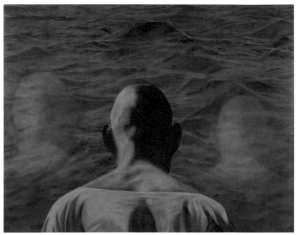

Left：
1993.15　180×260cm
油彩、畫布　1993
1993.15　180×260cm
Oil on canvas　1993
（左圖）

Right：
1996.4　180×230cm
油彩、畫布　1995-1996
1996.4　180×230cm
Oil on canvas　1995-1996
（右圖）

浮鼓出水平面上的身體。觀者對於水中人的心理狀態，因為畫家曖昧的呈現，而被賦予了與人類種種生命經驗相關的無限想像：他是感到獲得無限解放的自由？還是正耽溺於放縱的飄然逸樂？是暫時放空一切的心靈休憩？還是溺水之前面對死亡幽谷的無助、懼怖與掙扎？……主人翁之外的觀者，被作者設定了面對作品永遠只能想像，而不能得知真相。

　　常民日常休閒中習慣去消遣游泳的水域，通常會因為人群眾多而充斥著嬉鬧嘈雜，這種氣氛只短暫地出現在最早期極少數的幾件作品中，其中甚至只有〈系列二（之十）〉是彩色絢爛的，另外兩件作品〈1993.10〉與〈1993.15〉，即使畫的是穿著彩色泳衣歡樂的人們，方力鈞也採取了黑白單色畫的方式，使得這原本應該是比較單純於接近紀實描寫的作品，卻似乎帶著更為隱藏而複雜的隱喻似的，是關於某些遙遠的記憶與甜美的憂傷？

　　除此之外，在方力鈞大部分人／水／游泳的畫中，泅泳中的無名水域基本上都是全然地闃寂、靜謐、甚至彷彿是帶著祭獻氛圍般莊嚴、神祕而美麗，卻又，可以嗅出潛藏著莫名的危機，彷彿是展開殺戮之前一刻的寧靜。這片水域之魅異，在於它既恐怖又崇高；既平常安詳，又危機四伏，一種莫可名狀的氛圍在其中不斷擴大。

　　整個90年代方力鈞畫人／水／游泳的作品，其中有少數幾張出現一種特殊的構圖——佔據畫面最前景出現一個光頭人物肩頸以上的背影。這種構圖在1991到1992年的作品〈系列二（之十一）〉中首度出現，往後數年之中大約還有五、六件類似圖像的畫作，〈系列二（之十一）〉可視為這些作品的原型。畫面近景這雄闊的肩背，巨大碩實的，正對著觀者光溜溜的後腦杓，正（在岸邊）沉靜地俯首觀視著水中之人。方力鈞幾乎全部是俯視的畫面，以及偶爾出現在畫內旁觀的光頭，都一再強烈暗示了存在著一股未知的力量，以及作者抽身置外的心理位置。

　　方力鈞的聰明，一方面來自於他擅於抽離，以旁觀的角度冷靜思考之後，以具有非常強度的理智與意志的控制力，來達成他所要的結果與目的；另一方面，則是來自於他對於知識（尤其是歷史）的熱愛，以及擅於借鑑、擷取及運用知識的才智，這部分不止增強他的判準能力，更增強了他的意志力與自信。這種等閒難以相抗的控制力的強度，方力鈞同樣貫徹到他的創作上。一片原本再單純平常不過的日常場景、無名水域，他卻能畫出飽含關於生命的各種隱喻、徵兆、預言、意旨與矛盾，不僅具足層次多面的指涉，甚至完成一段機鋒交迭而完整的辯證。

　　「水／水中人」這個主題與之前「光頭潑皮」系列的作品相較，明顯地，畫面更為低限、單純，也更為接近、體現方力鈞個人主觀的審美趣味：「對於簡潔的偏好，以及對於

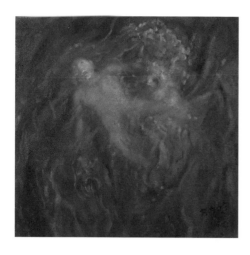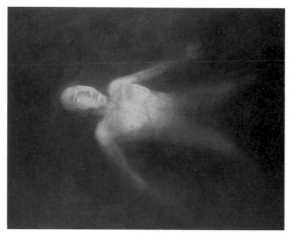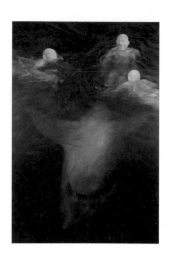

**炫耀細節的厭惡。** 」但也正是因為他選擇了一種過於簡潔的圖像，卻仍要表達其背後多層的言外指喻，因此迫使方力鈞必須更為著力於如何在不過於惹眼炫技的方式下，精確地呈現其隱微之意。簡潔／多層指喻，這原本似是相悖的兩面，方力鈞能夠以其強大的節制、意志與技藝，在「水／水中人」這個系列的作品中表現其駕馭的才能。

　　同樣是一個精煉之後簡潔單純的語彙，將「水／水中人」這個階段放在「光頭」時期之後實踐，依然是方力鈞經過思慮之後，才從策略上考量所做的決定。這種縝密的能力與意志，也使得他終究能夠準確地達成他更為深化、多層次的藝術目的——在這個理性的實踐已經成為非理性的時代裡，透過藝術這種非話語性的知識，與非實用性的實踐形式，為充滿了各種壓迫的整個社會結構，藉著藝術的價值，提供一種形式的解放與靜思的空間。而正因為藝術的非實用性，也使他可以既政治性而又和平地，達成一種間接，卻具有改造性的意義。

　　「光頭」這個符號化的語彙固然強烈而有效地捕捉了所有人對於他背後所主張的注意力，卻也很容易因此帶引出來另一面的問題：經過一段時間之後，由於對於鮮明符號慣性的理解方式，簡而將這種容易讓人印象深刻的藝術風格與意識型態予以概念化、定型化，歸類於某一種類型的檔案夾中，而成為既成的歷史文件。

　　方力鈞自己當然比誰都更意識到這兩面刃隱藏的弔詭，因此，與齜牙咧嘴、鮮豔強烈的「光頭」、「潑皮」在形象以及視覺語彙上形成兩極的「水／水中人／游泳」系列，就是在而立之齡的方力鈞，以自我顛破的方式向世界昭告：他的藝術思維與藝術生命，還有更長遠、更為多元、更為宏闊的可能性。

　　做為後八九「玩世潑皮」一脈無可取代的經典與代表性人物，方力鈞並不耽溺於既往，而對於個人、環境、社會、國族不斷變異與進行中的生命狀態生存樣貌提出對話的方式與態度，若從這一點來看，那麼將「水／水中人」系列與整個90年代因為資本主義消費主義而狂亂騷動，集體走向一種逃避的中國社會相對照，就很容易看到：一向以來方力鈞在面對主流價值走向時，所一貫保持的一種冷眼熱心、冷靜思辯的角度。面對這麼大的一個國家、文化、社會，他選擇了一種雖然不是對抗，但也絕對不逃避的醒覺態度。
（胡永芬／文）

*But, as so large a country, it and its people cannot collectively choose to escape culturally. Someone has to face it.*
– Fang Lijun

Swimming — an activity of leisure common to the people and also apparently enjoyed by the artist at that time — began to appear as a theme in the later works of Fang Lijun's Series 2 in 1991 and 1992. Around 1993, Fang Lijun developed the theme into one shedding off all the narrative details of the environment, and was addressed succinctly and exclusively by the images of "water" and "people in water." This theme continued for a very long time, and even became one of the most important subjects in his return to printmaking in the late nineties.

A comparison of the British artist David Hockney's (born 1937) series on swimming to that of Fang Lijun illuminates the direct relationship between the state of existence of the artist and his art. In his meticulous style bordering on photorealism, Hockney's paintings are differentiated with a certain distorted simplification and exaggeration. His canvas is unanimously occupied with the kind of rich and bright colors exposed to abundant sunlight, which reveals the infatuation and fascination of Hockney, as a British man growing up in a cold region, with the individualism and hedonism that living in the tropical California represents. The seeming serene and simple arrangement of objects suggests the mysterious, minute and dark changes under the brilliant surface of the relationship between man and existence, man and time, and man and society.

Meanwhile, the nameless people floating on the boundless waters of Fang Lijun's paintings are like his shaved head figures — both act as a symbol of "humanity." Under his paintbrush, the boundless water tossing shallow ripples, a seemingly serene and peaceful scene, gives an impression of a lurking and unknown horror and danger, and the people surrounded by and floating in the weightless water appear to be rather indulgent and joyful, meanwhile ignorant and helpless.

Almost all of Fang Lijun's works on water and swimming are depicted from an overlooking perspective. Besides the monochromatic, grave and mysterious dark blue and lake green, and the slightly disturbed water and the intricately rippled off waves, the focus of the canvas is the faintly visible body under the water; or the body parts exposed above the water in swim strokes: parts of the face, arms or legs; or the half exposed body leisurely floating above the surface of the water. The viewers are allowed endless imaginings of the various life experiences of mankind due to the artist's ambiguous presentation of the state of mind of the man in water: Does he feel completely liberated? Or is he indulging in unrestrained relaxation and happiness? Is it the spiritual peace as he momentarily lets go of everything? Or is it the helplessness, fear and struggle as he faces the darkness of death before drowning? In the artist's scheme, one can only imagine before the painting, and no one except the man in water in the painting can possibly know the answer.

The water where common people enjoy going for a leisurely swim is usually filled with hustling and bustling sound of the crowds, but the atmosphere can be felt only in a few of Fang Lijun's earlier works, among which only *Series 2 No. 10* is colorful, and *1993.10* and *1993.15*, though depicted merry people in colorful swimsuits, were painted in black and white. This made the two supposedly simple and realist works seem to conceal complex allusions — Are they about some distant memories and sweet sorrows?

Besides, in most of Fang Lijun's paintings on people in water and swimming, the nameless water

for swimmers was utterly quiet, serene, even solemn, mysterious, and beautiful, as if in a ritual, and yet reeked of unidentifiable danger, as was at the moment of silence before a fight breaks out. The water fascinates because it was both horrible and sublime, peaceful and yet with potential danger; the force of its inexplicability increases as one looks at the canvas for a long time.

Of Fang Lijun's works on people in water and swimming in the nineties, several are distinguished with a special composition — the image of the back from shoulder up of a bald figure appeared in the foreground. This arrangement made its first appearance in *Series 2 No. 11*, made in 1991 and 1992, and was ensued by five or six paintings in the following years. In *Series 2 No. 11*, which can be seen as the archetype of the group of paintings, the staunch shoulder and back, and the massive, cleanly shaved back of a head, placed right in front of the viewers' eyes, were quietly bending to look at the people in water. The overlooking perspective that predominated in the group of Fang Lijun's paintings, and the bald figure occasionally appeared on one side of the canvas, suggested strongly the presence of an unknown power, as well as the artist's psychological position as an observer.

On the one hand, Fang Lijun's intelligence is reflected by his ability to detach himself, to calmly deliberate from an observer's point of view, with high level of control in rationality and will, to achieve the outcome and goal he aimed at; on the other hand, it comes from his love of knowledge (especially of history), and his ability to appropriate, distill and apply this knowledge. It not only enhances his ability to make judgment, but also boosts his determination and confidence. Such a degree of control, which others would find difficult to challenge, was fully attended to by Fang Lijun's creative works. A simple and common scene in daily life, a nameless water, was painted to embody various metaphors, signs, prophecies, connotations, and contradictions about life, complete with multi-layered and multi-faceted references, and even with a dialectics of tumultuous and constructive twists.

Comparing to the "bald rascal" paintings made earlier, the paintings on water / people in water are apparently simpler and more economical in details, and more fully demonstrative of Fang Lijun's own aesthetic sentiment: "a preference to simplicity, and the detest for boosted details." However, precisely because the strictly simple images were to be loaded with layers of allusions, Fang Lijun was forced to work more laboriously than the other artists on arranging the details, to strike every chord in an exact way without technical showoff. Simplicity and multi-layered allusions — the two features appearing to be oppositional to each other — were shown to be in fine balance under Fang Lijun's strong sense of restraint, will, and command of skills in the paintings on water / people in water.

That the works on water / people in water, as also displaying a refined language of simplicity, were executed after those on bald heads, was Fang Lijun's strategic decision after consideration. The ability of deliberation and determination also allowed him to accurately fulfill a profounder and more multi-layered artistic goals – through the non-verbal knowledge of art and its non-practical way of practice, art functions in our time, when rational practices turned out to be irrational ones, by providing a formal liberation and space for meditation for the entire social structure filled with various kinds of oppressions. And it is precisely the non-practicality of art that allowed him to both subversively yet

peacefully accomplish an indirect yet reformative significance.

While the sign-like vocabulary of "bald head" powerfully and effectively seizes the attention of people by its claim, it also induces another problem: after a period of time, the interpretation of the distinct sign is likely to grow into a habit, and thereby reduces the impressive style and ideology into a certain concept and model, classifying them into a certain category, and resulting in an archived understanding of it as an established historical document.

To be sure, Fang Lijun is more aware than anyone is of the paradox inherent in the double-edged sword. The stark contrast in image and visual language between the grinning, bright-colored, and memorable "bald heads" and "rascals," and the group of paintings on water / people in water / swimming, are used by Fang Lijun, approaching thirty, to exclaim emphatically to the world that: his aesthetic thoughts and art career are yet to develop profounder, more diversified, and more extensive possibilities.

As one of the personages and representatives of the post-'89 art of "cynical rascals," Fang Lijun is not carried away by the past accomplishments; instead, he has been proposing ways and attitudes to initiate dialogues on the ever-changing process of life and state of existence of the environment, society, and nation. From this perspective, to parallel his paintings on water / people in water with the Chinese society inclined for a collective escape in face of the embroilment of capitalism and consumerism in the nineties may provide us with a glimpse of the distanced yet attentive, level-headed yet involved stance Fang Lijun has been adopting against the mainstream value systems. Although he does not rebel against the country, culture, and society of so vast a scale, he nevertheless chooses, with an alert eye, not to escape from them. (text by Hu Yung-fen, trans. by Yu-sheng Chien)

# 展覽圖版 Plates

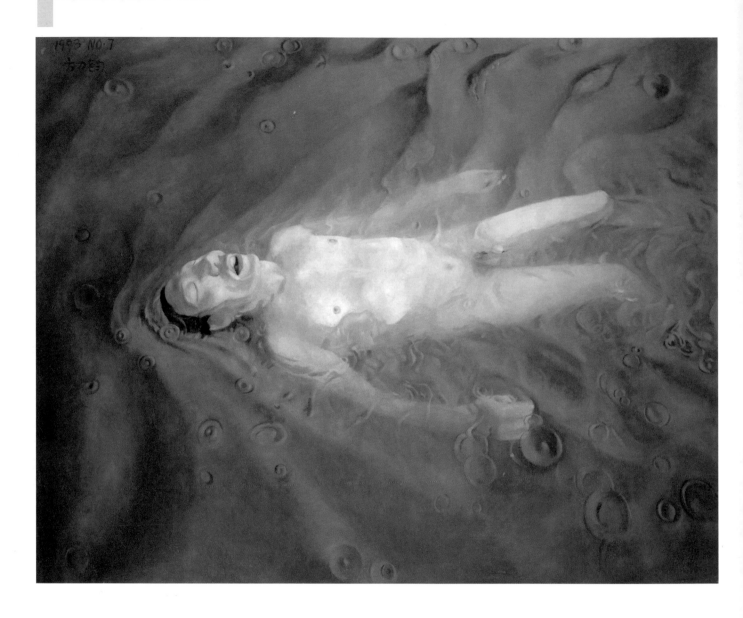

1993.7　130×160cm　壓克力顏料、畫布　1993　私人收藏，香港漢雅軒提供
1993.7　130×160 cm　Acrylic on canvas　1993　Private collection, courtesy of Hanart TZ Gallery, Hong Kong（右頁為局部圖）

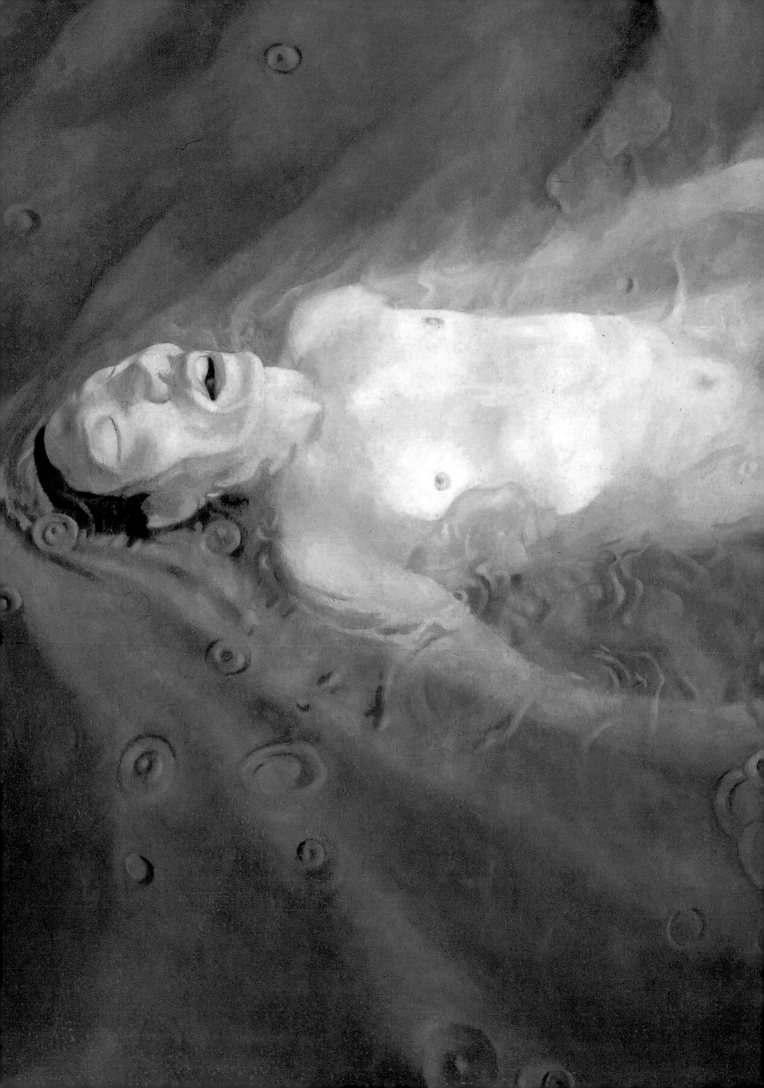

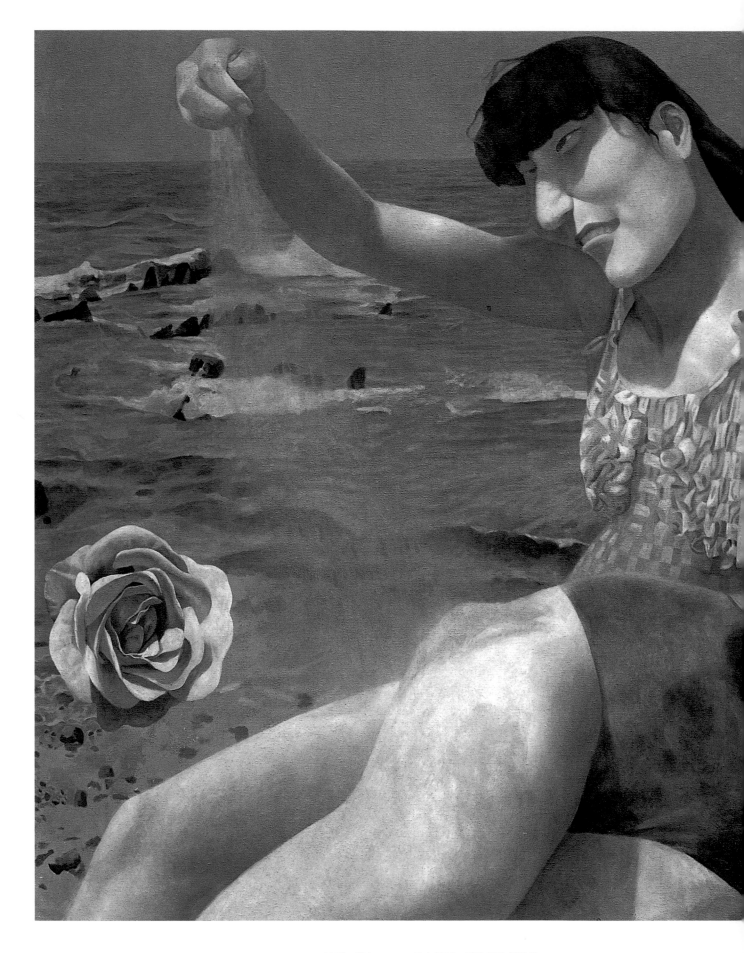

1993.10　180×260cm　油彩、畫布　1993　私人收藏，香港漢雅軒提供
1993.10　180×260cm　Oil on canvas　1993　Private collection, courtesy of Hanart TZ Gallery, Hong Kong

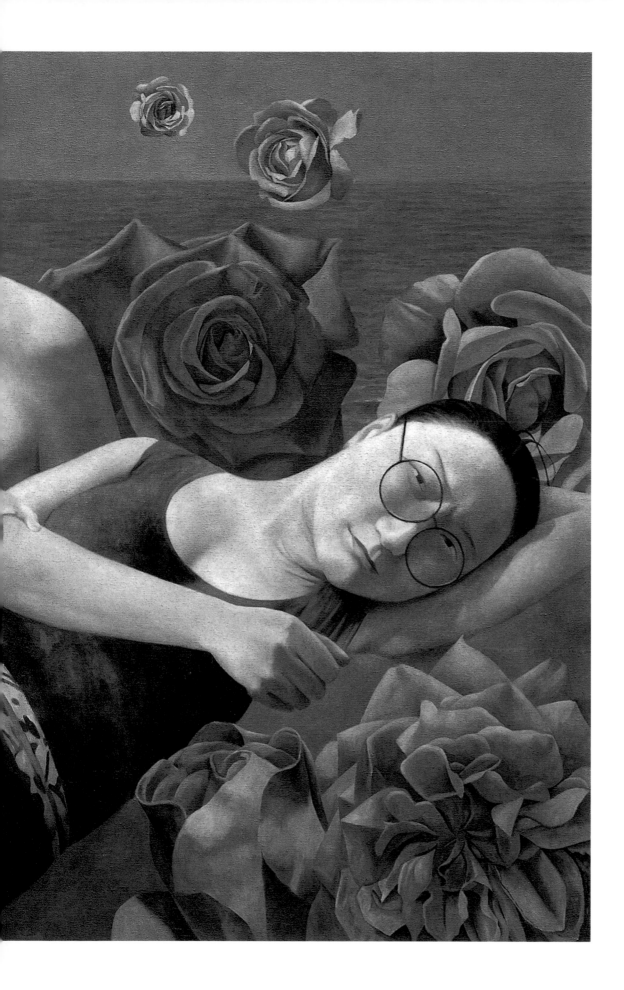

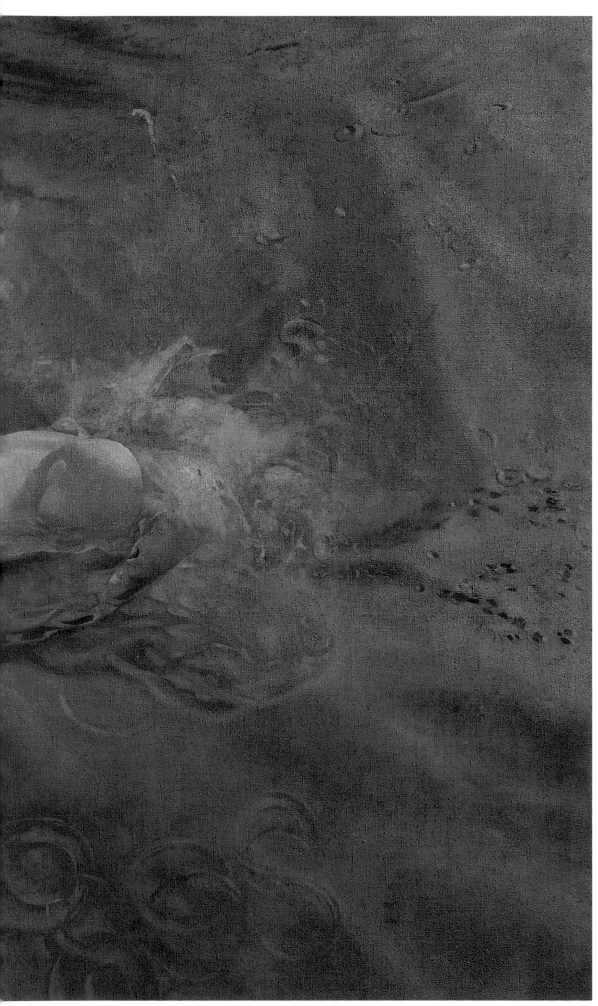

1994.9 180×250cm
油彩、畫布 1994
荷蘭 麥克斯・伏爾斯特
先生收藏
1994.9 180×250cm
Oil on canvas 1994
Collection of Mr. Max Vorst

85

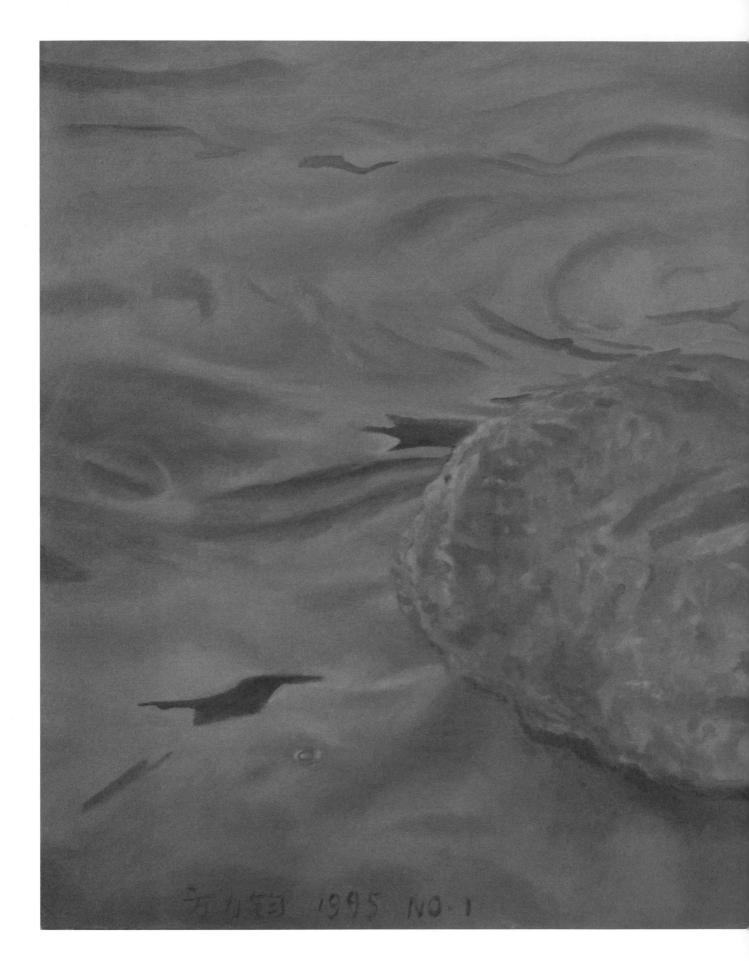

1995.1　70×116 cm　油彩、畫布　1995　藝術家自藏
1995.1　70×116 cm　Oil on canvas　1995　Collection of the artist

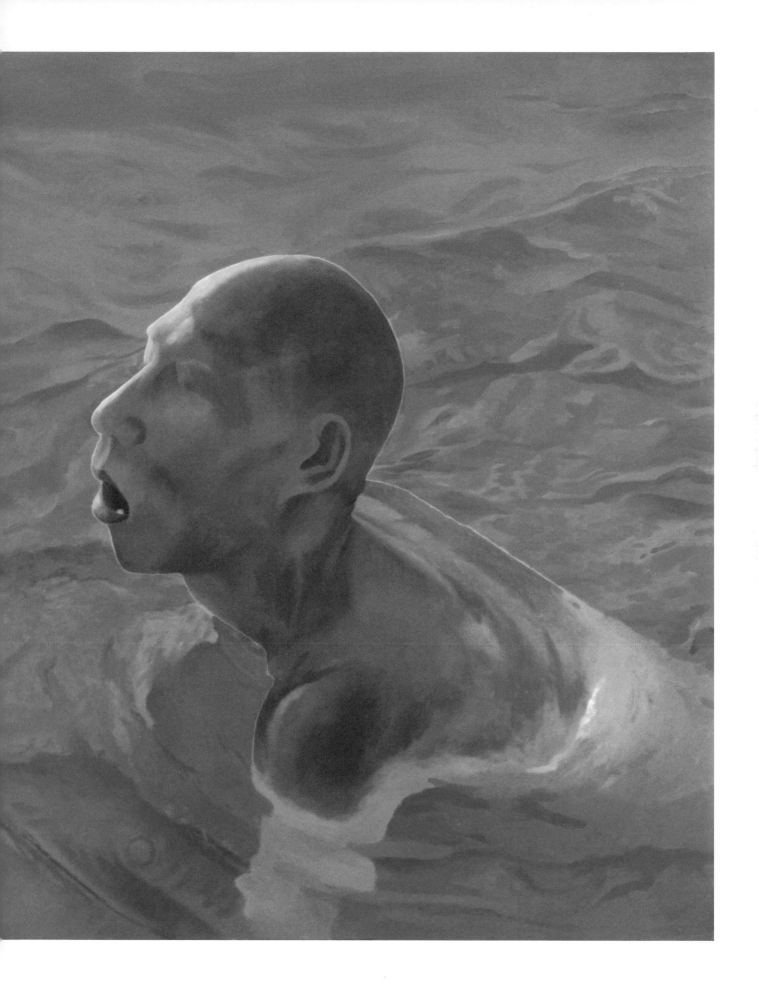

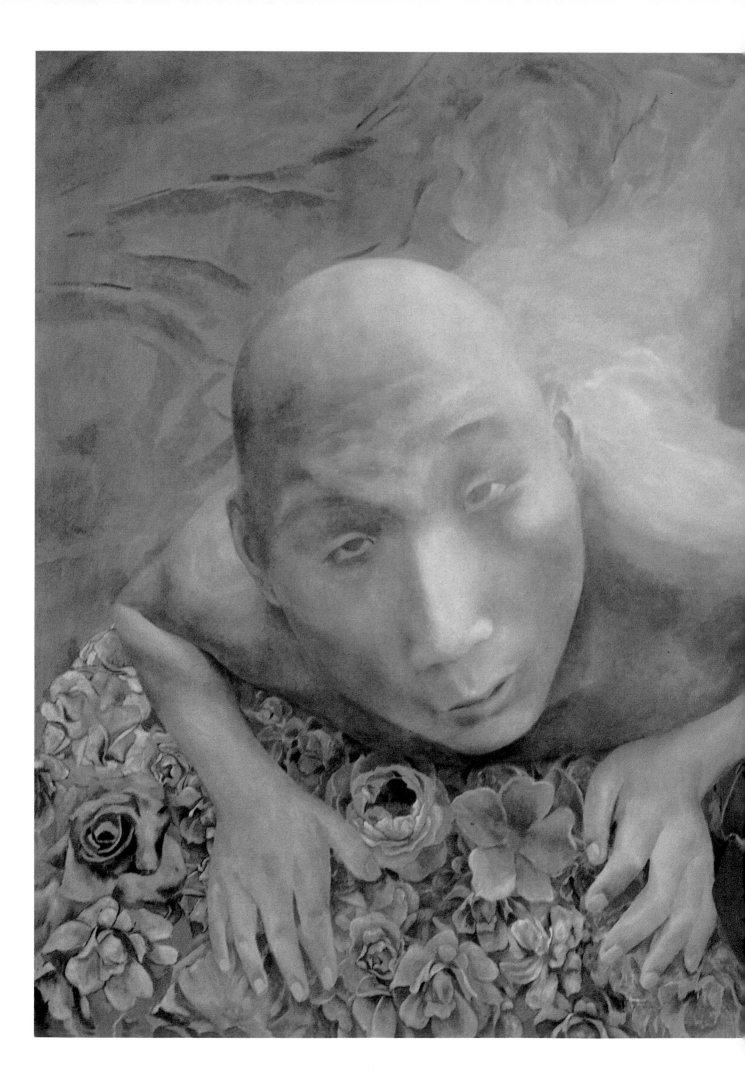

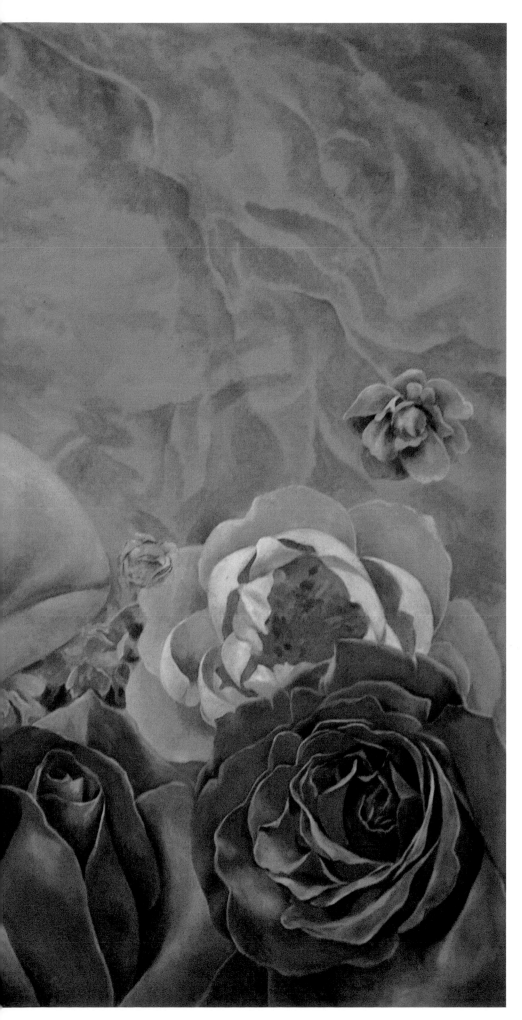

1996.12　130×160cm　油彩、畫布
1994-96　私人收藏，香港漢雅軒提供

1996.12　130×160cm　Oil on canvas
1994-96　Private collection, Courtesy of
Hanart TZ Gallery, Hong Kong

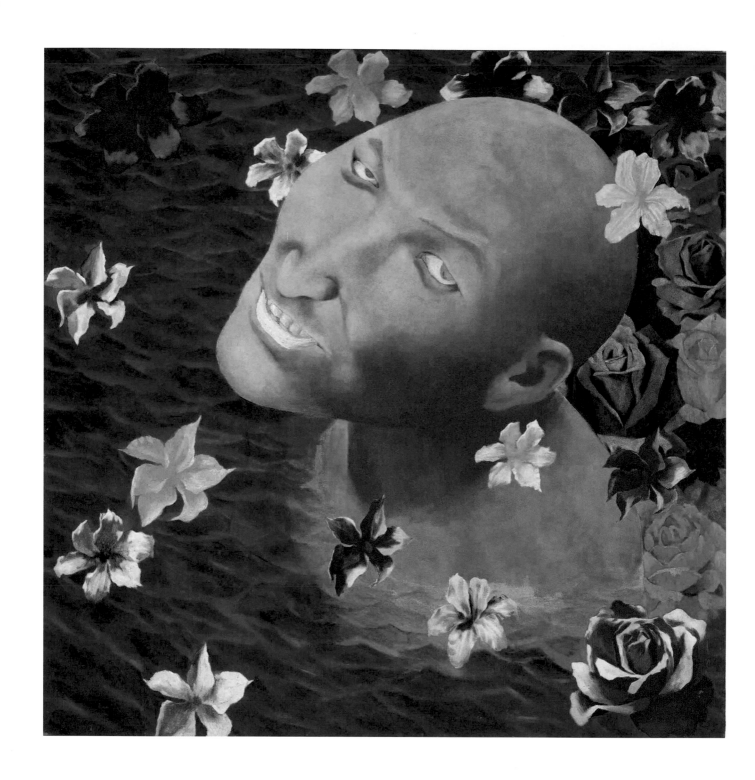

Above：
1994-1995.3　100×100cm　油彩、畫布　1994-95　私人收藏，香港蘇富比提供
1994-1995.3　100×100cm　Oil on canvas　1994-95　Private collection, courtesy of HK Sotheby's（上圖）

Right：
1997.11　150×110cm　油彩、畫布　1997　趙旭先生收藏
1997.11　150×110cm　Oil on canvas　1997　Collection of Mr. Zhao Xu（右頁圖）

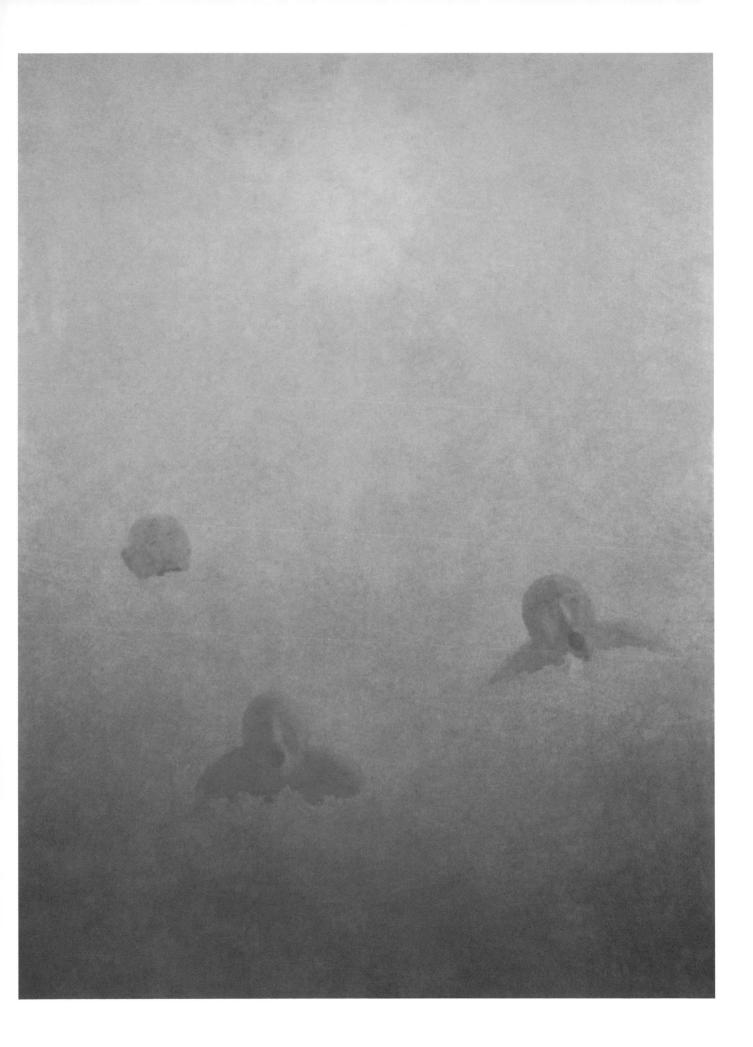

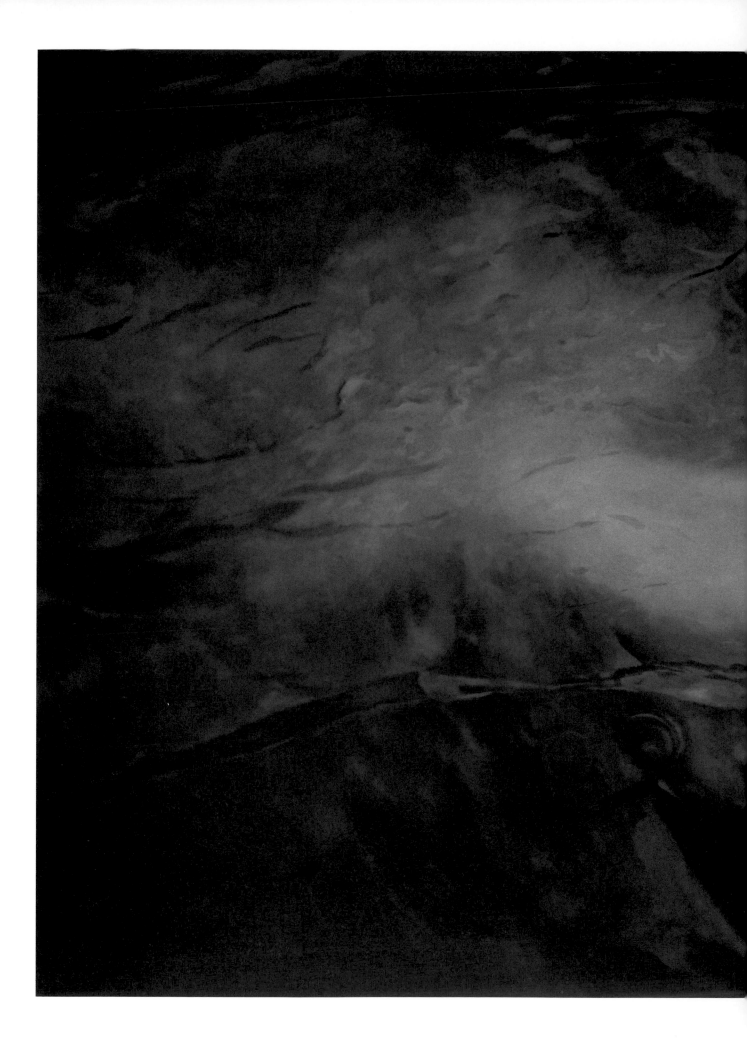

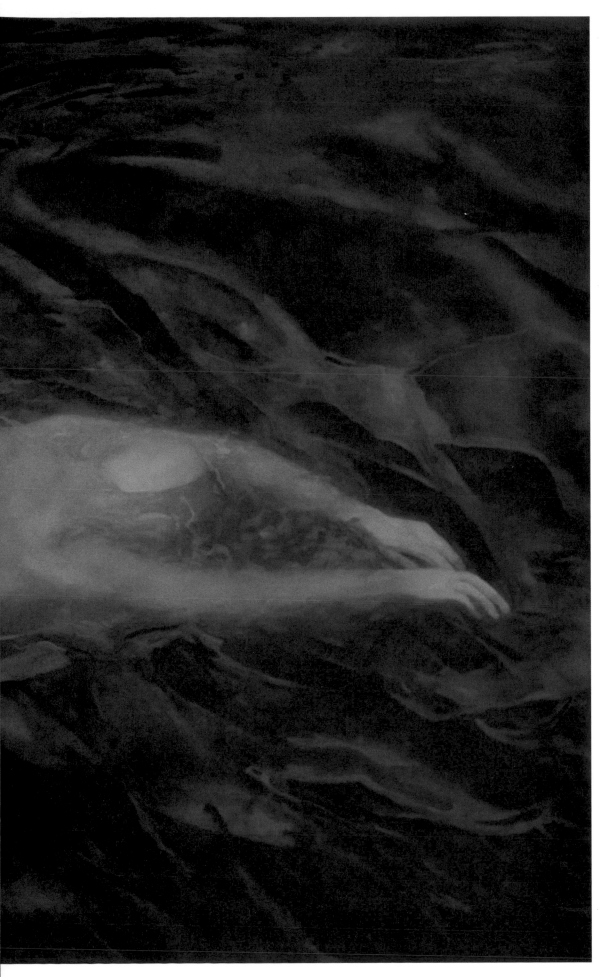

1998.8.25
250×360cm
壓克力顏料、畫布
1998 瑞士 烏利・希
克先生收藏

1998.8.25
250×360cm
Acrylic on canvas
1998 Courtesy of Sigg
Collection, Switzerland

93

1998.8.30 250×360cm
壓克力顏料、畫布 1998
私人收藏，新加坡斯民國
際藝苑提供

1998.8.30 250×360cm
Acrylic on canvas 1998
Private collection, courtesy
of Soobin Art Int'l Gallery,
Singapore

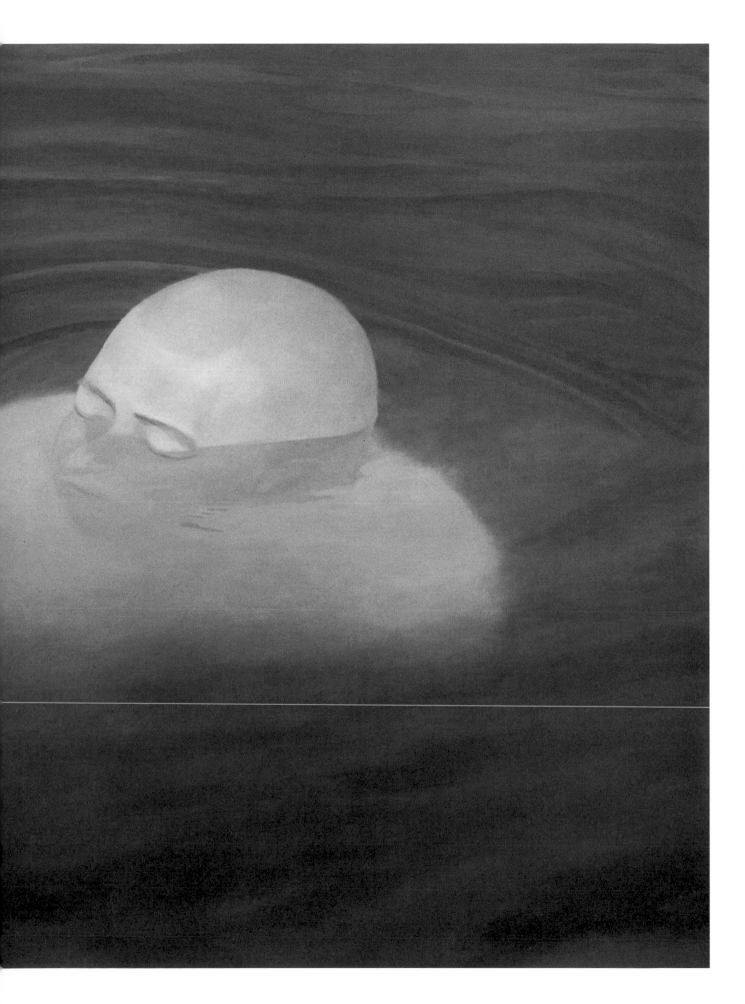

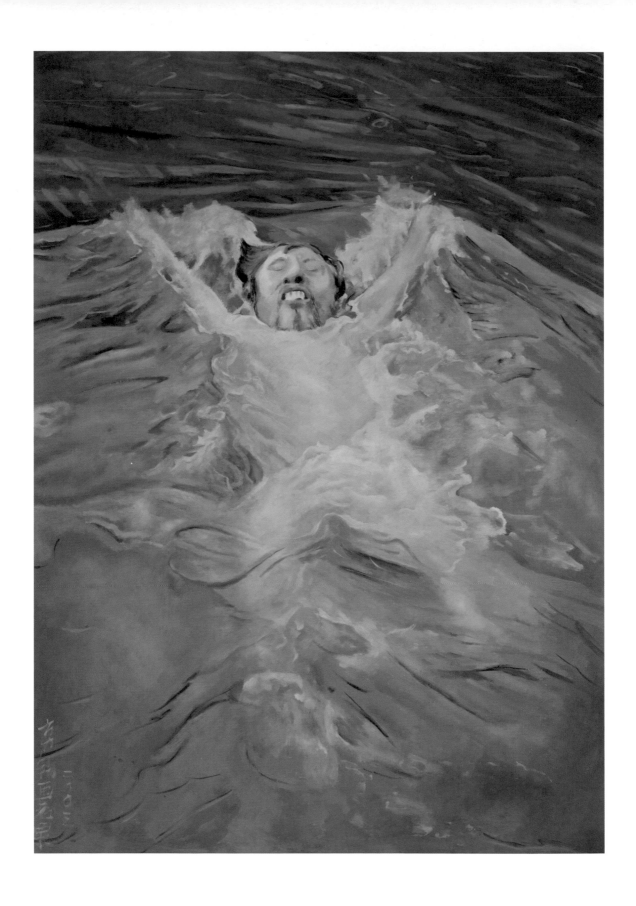

方力鈞畫老栗　70×50cm　油彩、畫布　2003　今日美術館收藏
Fang Lijun Draws Lao Li　70×50cm　Oil on canvas　2003　Collection of Today Art Museum（右頁為局部圖）

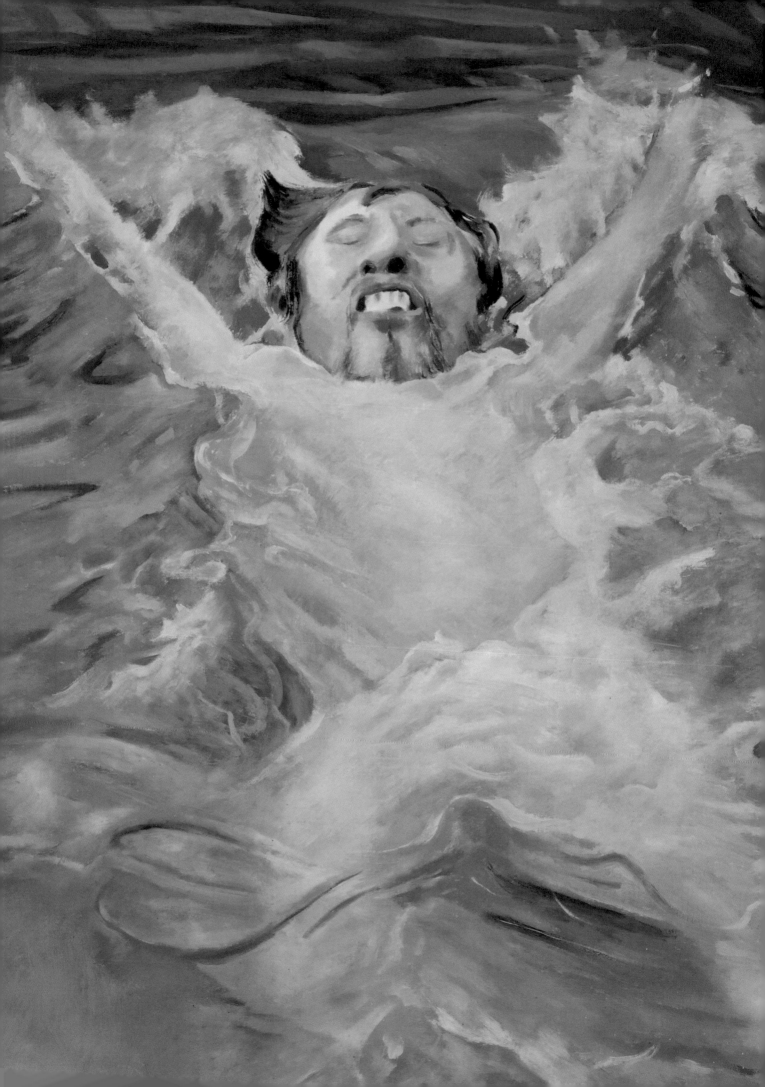

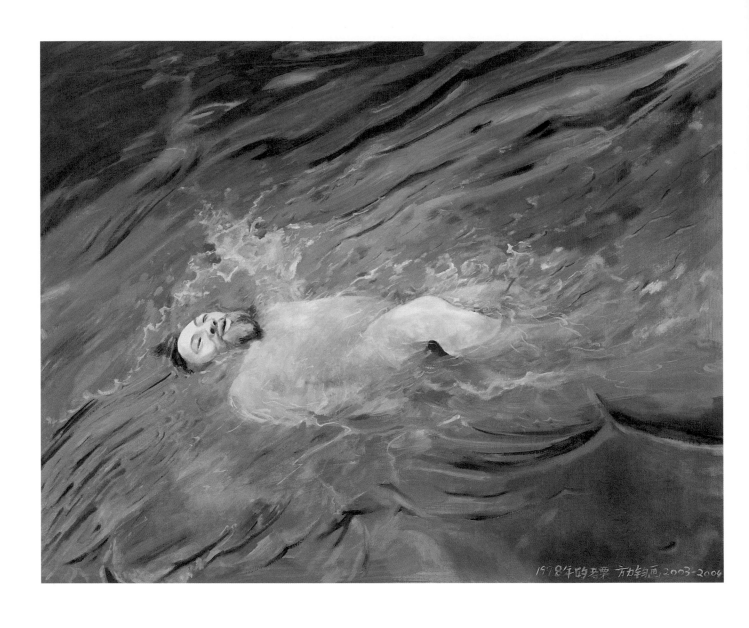

1998年的老栗　90×100cm　油彩、畫布　2003-04　鄂爾多斯美術館收藏
Lao Li at 1998　90×100cm　Oil on canvas　2003-04　Collection of Ordos Art Museum

# IV

# 版畫的再開創
The Renewal of Woodcut Prints

藝術家應該是夢想家或批評家，對社會的習慣方式抱一種個人觀點。──方力鈞

　　1996 年，當時 33 歲的方力鈞開始著手一系列單色木刻版畫作品，而且尺幅極其巨大，這個開啟，可視為他創作發展歷程上又一個高峰。

方力鈞畢業於中央美院版畫系。在過去中國的工藝傳統中，木刻版畫的製作先天上受限於手工印版所適合的較小尺幅，主要的使用與定位在於作為書籍插圖等功能性、說明性與裝飾性，以及作為年畫等等節慶與傳統民俗的實用意義，簡單地說，也就是歷史以來，「木刻版畫」皆傾向於工藝性與實用意義的價值，跟所謂的傳統文人書畫從階級上就有根本性的差異。

　　之後，誠如俄國文豪托爾斯泰（Lev Nikolayevich Tolstoy, 1828-1910年）所言：「**一切藝術莫不根植於本土，與自己的同胞共哀榮。**」「版畫」在中國的功能與意義，在 1930 年代，受到 19 世紀以來從俄國而來的左派思潮與人道主義深刻影響，出現了全然不同於既往的戲劇性質變──從 1931 年魯迅倡議推廣木刻版畫，作為知識分子藉以與人民大眾溝通，展現其人道情懷與社會批判之手段開始，木刻版畫一直到延安時期、新中國開啟、再跨越至 70 年代文化大革命期間，這將近半個世紀之中，「版畫」，尤其特別是「木刻版畫」，擔負著更多的則是遠遠超過「民俗」、「工藝」、乃至「藝術」之外的政治、社會，等等俗世性功能。這個趨勢一直到冷戰與文革結束，所肩負承擔著的激情都成了過去了之後，木刻版畫的演繹又陷入了失重的沉寂。

1998.11.15　488×610cm
木刻版畫　1998

1998.11.15　488×610cm
Woodcut prints　1998

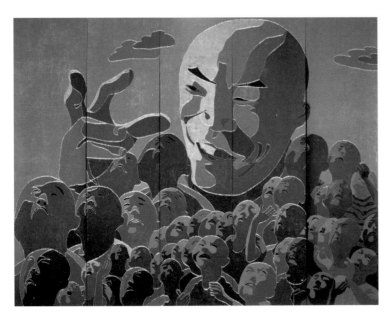

　　作為一個藝術家，以方力鈞的聰明與野心，他找到方法打破木刻版畫所曾負載的所有框限：捨棄了鑿刀，他掄起大馬力的工業電鋸，在以大塊現成的夾合板取代傳統木版的版面上，刀切豆腐似地迅速劃切出流暢澎湃的線條；木刻版一刀下去不可逆反、不能更改的特性，加上前人所未有的巨大尺幅，動輒八公尺、十公尺的畫面，都更為考驗創作者的意志強度、自信、以及掌握畫面的能力。方力鈞顯然三者兼具。

　　方力鈞作木刻版畫最重要也最成功的系列，還是以游泳的人為題材，但是在版畫上的表現跟他在油畫上的游泳系列又可以說是完全不同，甚至是相對的詮釋角度。

　　方力鈞油畫的游泳系列如上所說，從單純的日常場景表現出神祕、寧靜、充滿隱喻的畫面，基本上採取中長景構圖，為觀者保留了靜思的空間與距離；而版畫的作品卻恰恰相反，〈1998.11.15〉、〈1999.2.1〉、〈1999.3.1〉、〈1999.5.1〉、〈1999.6.1〉，以及這次展出

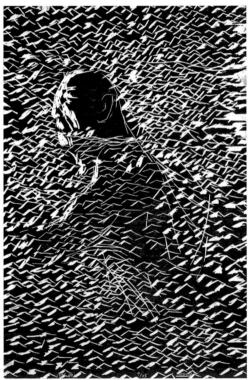

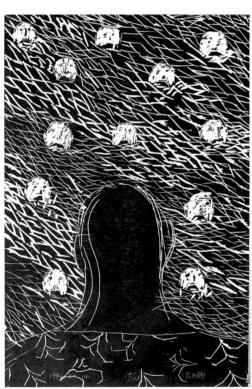

Above left：
1995.12  112×82cm
木刻版畫  1995

1995.12  112×82cm
Woodcut print  1995
（左上圖）

Above right：
1995.13  92×63cm
木刻版畫  1995

1995.13  92×63cm
Woodcut print  1995
（右上圖）

Below left：
1996.11  112×82cm
木刻版畫  1996

1996.11  112×82cm
Woodcut print  1996
（左下圖）

Below right：
1996.14  112×82cm
木刻版畫  1996

1996.14  112×82cm
Woodcut print  1996
（右下圖）

的〈2003.3.1〉，這幾件全都超過八公尺以上的鉅作，無論畫中的角色是一個人，還是一群人，基本上方力鈞在構圖取鏡上都採取一種非常非常迫近的近景特寫，觀者彷彿在耳邊就可以聽得到畫中人的掙扎吶喊，感受到潑濺迸散的水花；而且由於是一個聚焦的特寫，觀者也更為無法判斷：這究竟是沉溺前的最後掙扎？還是抵達彼岸前的奮力一搏？他流利的電鋸，不僅劈出水花波浪的動能，也劈出主人翁以生命嘶吼的能量；方力鈞藉著布上油畫與木刻版畫兩種不同特性的媒材，完成他藉著「水／水中人」這個體裁，表達對於「人生」的體會與詮釋。

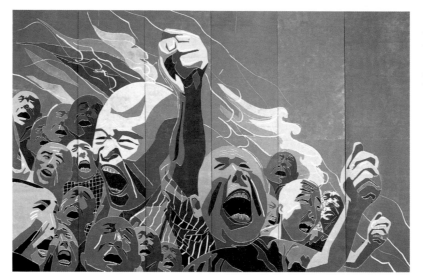

1999.6.1
488×732cm
木刻版畫 1999

1999.6.1
488×732cm
Woodcut prints 1999

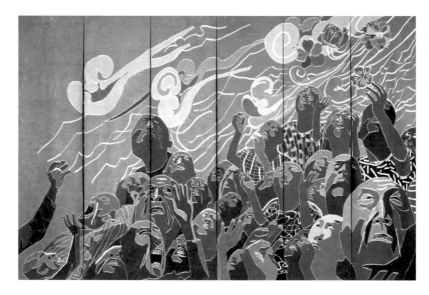

1999.5.1
488×732cm
木刻版畫 1999

1999.5.1
488×732cm
Woodcut prints 1999

　　許多人看到方力鈞的游泳系列作品，尤其是版畫系列，經常會聯想起毛澤東於1966年游泳橫渡長江，展現他的健康與活力的宣傳鏡頭。跟偉大領袖的宣傳樣板比較起來，方力鈞畫面裡的無名人物，無疑迸發更為真實而震動心魄的生命能量，其中是否具有對於過去神話領袖擬造之歷史偉績的嘲諷？對於這個提問，過往的美術史工作者與藝評者似乎很有默契地寧願以沉默，保留更多想像的餘地。即使是有，方力鈞所提出的，也是在當代世界，以一個個體之生命尊嚴與生存狀態所嚴肅地提出的，與歷史神話之間的對話。
這些版畫作品，一方面顯露了方力鈞對於藝術形式開創的野心，另一方面同時也揭露了他與傳統的連結。

　　所有這些單色的巨幅作品，都是採取切割畫面之後裱為卷軸，再於展場以多拼組成的方式展現。更確切地說，他是以分開來製作的不同的版，印出畫面之後再重新拼組成一整個完整的大畫面，因為尺幅過於巨大，以致有時候一整件作品甚至必須以十幾二十個以上的版才能組構完成，作品完成之後流利而飽具力度的線條，讓人很難想像：藝術家是如何在分開的二十餘個版之中仍然能夠掌握、貫徹的能力與過程。

　　方力鈞在版畫作品中絕多數採取黑白灰、單色中不同的色階表現，粗礪的夾合板在工業電鋸擘切的過程中，產生了具有崩裂感的邊緣線；於印製的過程中，藝術家又蓄意地

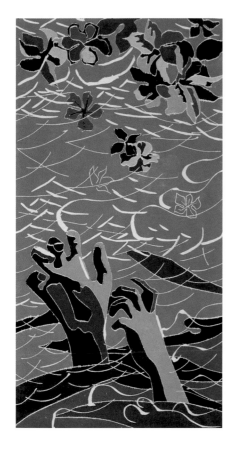
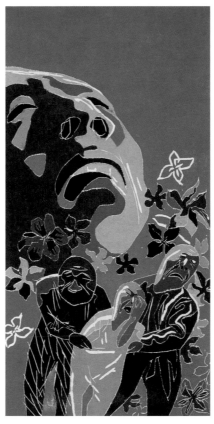
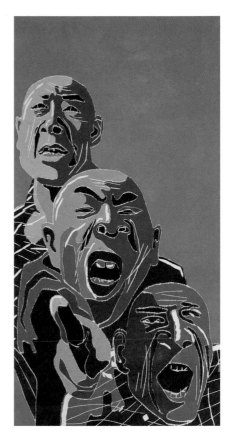

捨棄了傳統版畫工藝中套版時要求的準確對位，反而在套版過程中刻意製造些許錯位的效果；此外，卷軸的裝裱形式，讓這一長條一長條的畫幅在不同的展場中舒展開來的時候，總是會因為重力的因素與溼度變化的關係，每一條的兩側都出現微微向內捲起的現象，使得原本攤平的畫面，不只又還原到切割的樣態，而且還因為粗礪崩裂的邊緣線、套色錯位、以及「掛軸」這種形式所產生的材質特性的影響，而出現了一種新的立體感與律動，這種律動對於畫面中澎湃搏擊的氣氛產生呼應與增強的作用。

　　這種條幅或是卷軸的形式隱含著另一種實用性的考慮：如此巨幅的作品若是以其他任何框裱形式，在展覽運輸的過程中勢必會佔據龐大的體量，造成負擔，因此在各種展覽條件的考量上，經常有可能犧牲掉展出的機會。以傳統卷軸方式裝裱，巨幅的作品瞬時可捲成輕便可攜的體積，作品如果是藝術家征戰的武器，那麼方力鈞裝裱成卷軸形式的巨幅版畫，無疑因為這種體、面積可伸可縮的靈活性，更增加了它的征戰威力。

　　顯然，方力鈞選擇「卷軸」這種展出的型式並非偶然，而是他在情感上鏈結傳統，以及在理性思慮上對於材質的熟悉與掌握，對於策略的研判之後，所綜合出的決定。

## 單色筆記

　　從方力鈞這二十餘年來的創作過程可以觀察到一個很有意思的規則，就是他在開啟每一個新的嘗試、新的系列之初，都是從單色畫著手，無論是一開始他畫早期家鄉附近涉縣的石磊牆、燕山的鵝卵石，以及最早的潑皮光頭油畫「系列一」系列作品，或是自 1993 年起他最早的十多張以「游泳」為題材的油畫……，任何一個新的「開始」，可謂毫不例外，全都是黑白灰調的單色畫。這個規則透露了：「單色畫」似乎是方力鈞所有思考之原初階段的習慣。

Left：
2001.1.3　244×122cm
木刻版畫　2001

2001.1.3　244×122cm
Woodcut print　2001
（左圖）

Middle：
2001.1.9　244×122cm
木刻版畫　2001

2001.1.9　244×122cm
Woodcut print　2001
（中圖）

Right：
2001.1.12　244×122cm
木刻版畫　2001

2001.1.12　244×122cm
Woodcut print　2001
（右圖）

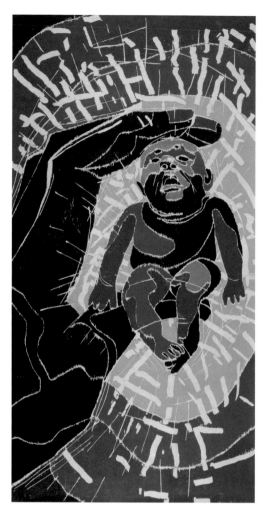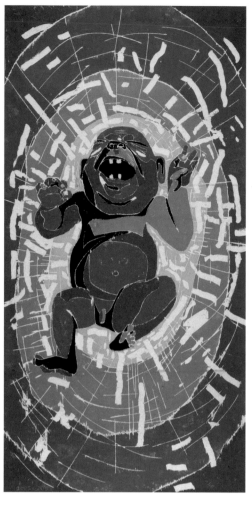

Left：
2002.12.13　244×122cm
木刻版畫　2002

2002.12.13　244×122cm
Woodcut prints　2002
（左圖）

Right：
2002.12.15　244×122cm
木刻版畫　2002

2002.12.15　244×122cm
Woodcut prints　2002
（右圖）

　　「單色畫」其實充斥著方力鈞創作軌跡上的每個腳步，而且各種媒材不拘，有鉛筆素描、黑白油畫、木刻版畫、甚至還有水墨速寫。在他的畫室，隨處都可以看到他隨手的速寫稿，大量的速寫稿為我們拼湊出一些訊息：這些單色畫其實是方力鈞對於正在進行中的生活、思想、思考的問題等等的紀錄、筆記、以及備忘，甚至，是某些未來要完成的作品之草圖原型。

　　面對著生活裡大量的資訊、生活中瞬間的所知所感、平常日子裡的小情小緒、人情悲喜、腦中隨時閃過的靈光幻影……，作為一個藝術家，方力鈞很清楚這都是他需要捕捉、儲存之後反芻、過濾，然後灌注成為創作中真實而有重量、而非虛誇矯情的言説內容。藝術家只有真實的生活、真實的生命體驗，才能保持創作的能量飽滿，才能與大多數人的生命體驗產生對話，才能對於他所身處的時代，以及未來，產生意義。（胡永芬／文）

*An artist should be a visionary and critic, holding a personal viewpoint to social habits.* – Fang Lijun

In 1996, Fang Lijun, aged 33, began to create a series of monochrome wood-block prints. They were of monumental dimensions, so that this renewal can be viewed as another creative peak of his artistic development.

Fang Lijun graduated from the Print Department of the Central Institute of Fine Arts. In the tradition of Chinese crafts and arts, wood-block print — limited by its nature — must be adjusted to the size of the hand printing process, at smaller measurements. The wood prints are mostly used as illustrations in books and classified as functional and illustrating decorative art. And they are also used functionally to make pictures for traditional festivals and folklore, such as new year's pictures. To put it simply, throughout history wood-block printing has tended towards workmanship and functionality, and is basically different from the so-called traditional calligraphy and painting by men-of-letters solely from the point of view of class.

Just like the great Russian writer Lev Nikolayevich Tolstoy (1828-1910) once said, "No art is not rooted in its land, declining and flourishing with his own fellow countrymen." The function and meaning of wood prints in China in the thirties, which had been influenced since the 19th century by leftist thoughts and humanism from Russia, underwent a dramatic change of nature, which made it totally different from what it used to be. Since Lu Xun advocated in 1931 to popularize wood prints, as an initial medium for intellectuals to communicate with the masses and to show their humanitarian concerns and social criticism, wood prints had developed through the Yanan Period, the dawn of New China, and lasted up to the Great Cultural Revolution of the 70s. In this period of roughly half a century, graphic arts, especially wood print, fulfilled secular functions which were far more political and social than the functions of folklore, craft or even art. The trend went on until the end of the Cold War and the Cultural Revolution, after which all the enthusiasm once shown for wood-prints passed away. From then on, the development of wood-block print passed into oblivion.

As an artist, Fang Lijun, smart and ambitious, found the way to break the inherent limitations of wood-block print: he gave up chisels and brandished powerful industrial chainsaws. He used them to engrave the surfaces of enormous pieces of ready-made plywood plates which substitute traditional wood blocks, and, like using a knife cutting into tofu, created flowing and surging lines. Once cut, no more changes are possible; this characteristic, plus dimensions never seen before of pictures ranging from eight to ten meters, challenge the artist's will, self-confidence and capabilities. Fang Lijun obviously has these three qualities.

Fang Lijun's depictions of swimmers remain the most important and the best series of his wood-block prints. But it can also be said that the expression created by printing works is totally different from that created by oil paintings, since they stem from opposing viewpoints of interpretation.

As mentioned above, Fang Lijun's swimming series in oil show a mythical, tranquil and fully metaphoric expression of scenes in daily lives on the surfaces. The compositions, basically middle and deep scenes, allow the viewers time and space for contemplation. But the complete opposite can be found in the woodcut works *1998.11.15*, *1999.2.1*, *1999.3.1*, *1999.5.1*, *1999.6.1*, and *2003.3.1*, which will be shown in this exhibition, are all monumental works of a size of more than eight meters. Regardless

of subjects with one single person or a group of persons on the prints, Fang Lijun basically uses an extreme close-up view, suggesting that the viewers can hear the struggle and shouts of the figures in the pictures not far from their ears and feel the crashing of the waves; because of the focused close-up perspective, the viewers are also left to guess whether this is the last struggle before being drowned or the final stroke before reaching the shore. The artist's flowing chainsaw does not only represent the dynamic energy of crashing waves, but also the expressive cries of the protagonist. Fang Lijun gives expression to his understanding and interpretation of life through the different characteristics of the two media — oil painting on canvas and woodprints — concerning the subject "water/ man in water."

Many people associate his works on swimmers, especially the wood print series, with the propaganda scene of Mao Tsetung swimming through the Yangtzi River in 1966 to show his health and vitality. In comparison with the propaganda sample of the great leader, the nameless men in Fang Lijun's pictures are doubtlessly more real and more shockingly vital. Is this a satirical allusion to the construction of the myth of the leader in the past? Regarding this question, art historians and critics in the past seemed to have an unspoken consensus to remain silent and left more space for imagination. Even if there is an allusion to this, what Fang Lijun proposes, from the perspective of one's dignity in life and state of existence, is also a serious dialogue between an individual and historical myths in a contemporary world.

On the one hand, these wood prints represent Fang Lijun's ambition to renew art forms; on the other hand, they reveal his connection to the tradition.

All of these monochrome monumental works are created by dividing up the picture, then mounting it with paste like a scroll, and finally piecing it together in the exhibition room. To put it more exactly, the artist makes the wood plates separately, and, after the prints have been made, puts them back together in a complete monumental picture. Because of the immense dimensions, one work can sometimes be composed of more than ten or twenty blocks of plates. The flowing and powerful lines shown on their completion makes one wonder: how does the artist conduct and master the whole process among more than twenty separate plates?

Fang Lijun uses almost exclusively black, white and gray in various monochrome shades in his wood prints. The process of cutting rough plywood plates by using chainsaws results in open contours. While printing, the artist intentionally abandons the demand for precisely-laid colors in the traditional printing, but instead creates the intended effect of displacement. Besides, when the scrolls of long stripe stretch out in different exhibition rooms, they always roll a bit towards the middle on the sides due to the factors of gravity and humidity. This causes the spread-out picture surfaces to return to their original divided appearance. Due to the rugged and broken edges, displaced layers of colors, and the material effect of the form of "hanging scroll," a new three-dimensionality and rhythm are born. This rhythm responds to and reinforces the surging atmosphere of the picture surface.

This kind of hanging scroll or rolling scroll also has a practical concern: if works of so monumental sizes were framed in any other way, they would result in huge places and weights during the transportation to an exhibition site, and become a burden. Taking account of the various conditions

of a show, the works would therefore risk being rejected. The traditional form of scrolls, on the contrary, enables the colossal works to be readily reduced into fairly portable sizes. If works of art are the weapons of an artist, Fang Lijun's monumental wood prints in the form of scroll doubtlessly have more fighting power because of their flexible dimensions and sizes.

Obviously, it is not by accident that Fang Lijun chooses the form of scroll to display his works. He made this decision following strategic considerations about his emotional connection to tradition and his rational understanding and mastery of the materials.

## Monochrome notes

We find a very interesting rule in Fang Lijun's more than twenties years of artistic development: at the outset of every new attempt, he resorts to monochrome. From his early sketches of the flint walls in his hometown She County, the pebbles in Yan Mountain, and his earliest oil paintings on the bald rascals *Series 1*, to the more than ten oil paintings on the subject of swimming made since 1993, at every new start, Fang Lijun uses without exception the grisaille monochrome. This rule reveals that working in monochrome seems to be the artist's habit to develop an idea.

Monochromes, whose medium ranges from pencil drawing, black-and-white oil painting, wood print, to even ink sketch, have accompanied Fang Liqun in every stage of his creative career. One can find his quick sketches everywhere in his studio. The numerous sketches reveal bits of information: these monochromes are in fact Fang Lijun's records, notes, and memorandums which show the artist's reflections on life, thoughts, questions etc. Furthermore, they are the sketches and prototypes for future works.

Confronting massive information, momentary thoughts and perceptions in our daily lives, changing moods and sentiments, occurrences of grief and joy, the inspirations running through our minds, Fang Lijun as an artist clearly knows that he needs to capture them all, then preserve them, ruminate them, filter them and put them into his creations as real and weighty, not coxcombical and affected, discourses. Only when an artist really lives, really experiences life, he can keep his creations fully energetic, start dialogues about life with most of the people, and finally mean something in his time and in the future. (text by Hu Yung-fen, trans. by Tsuei Yen-huei)

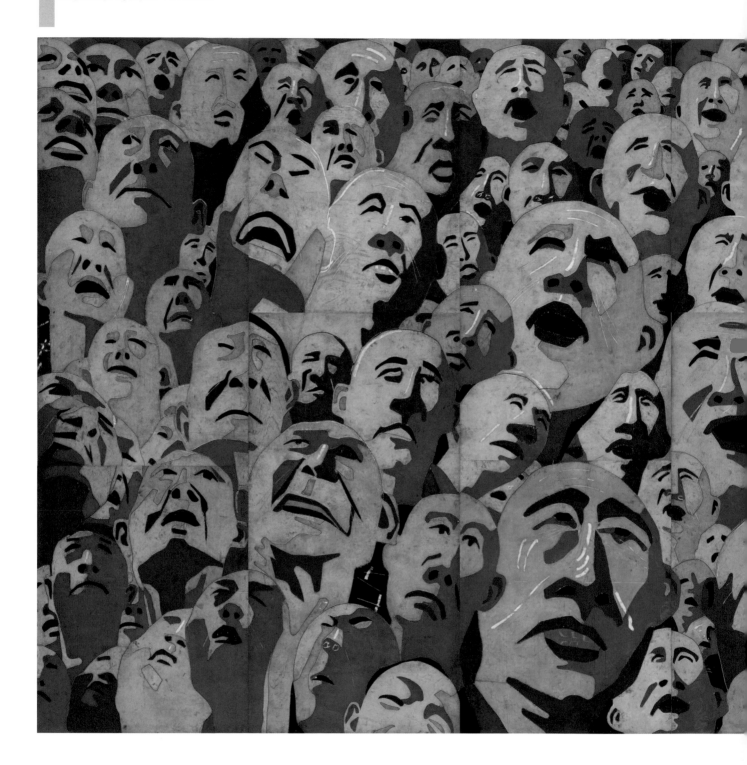

2003.2.1　400×851cm　木刻原版　2003　藝術家自藏
2003.3.1　400×851cm　Woodcut original plates　2003　Collection of the artist

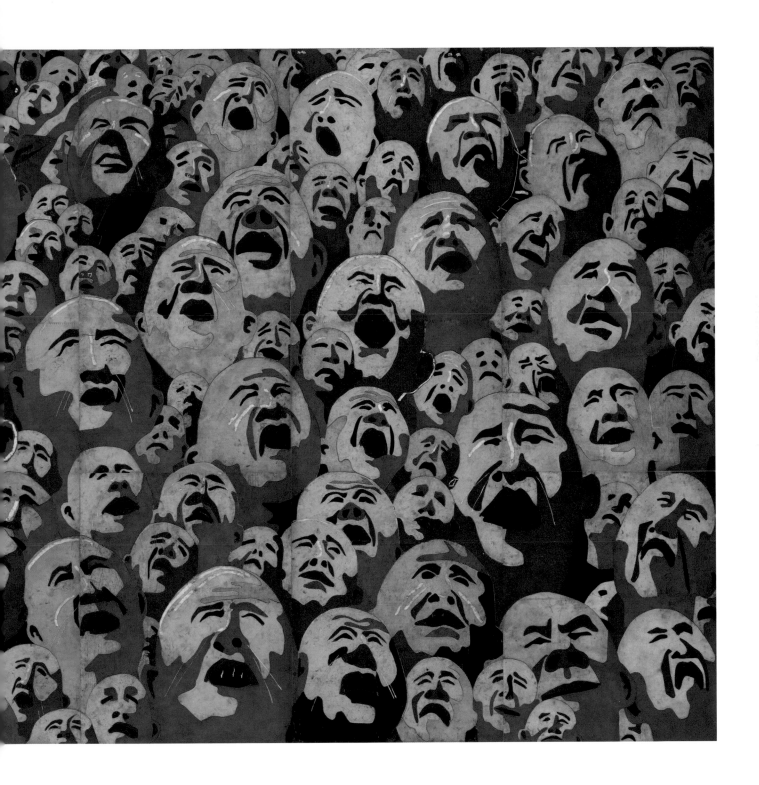

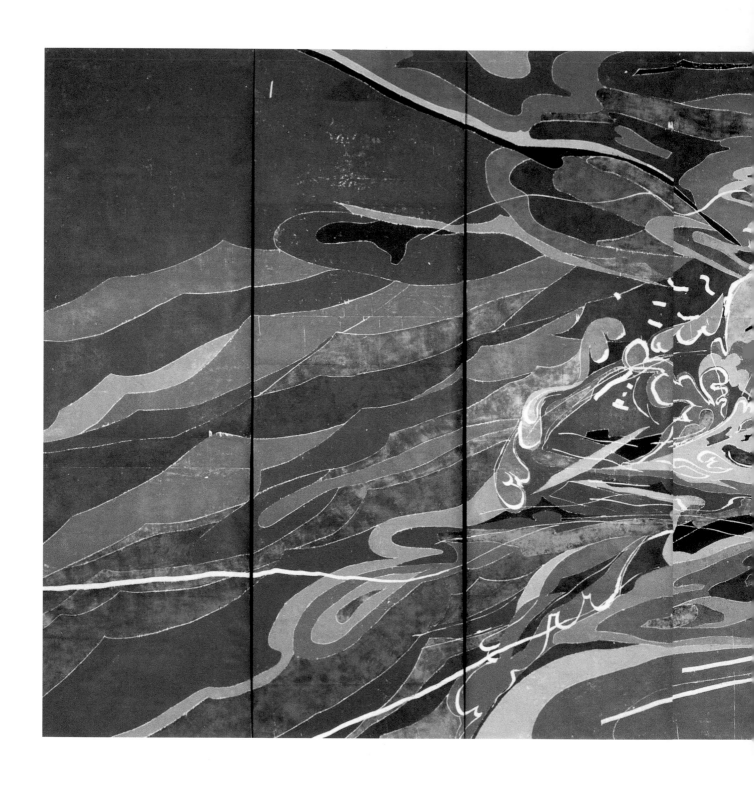

2003.3.1　400×852cm　木刻版畫　2003　藝術家自藏
2003.3.1　400×852cm　Woodcut prints　2003　Collection of the artist

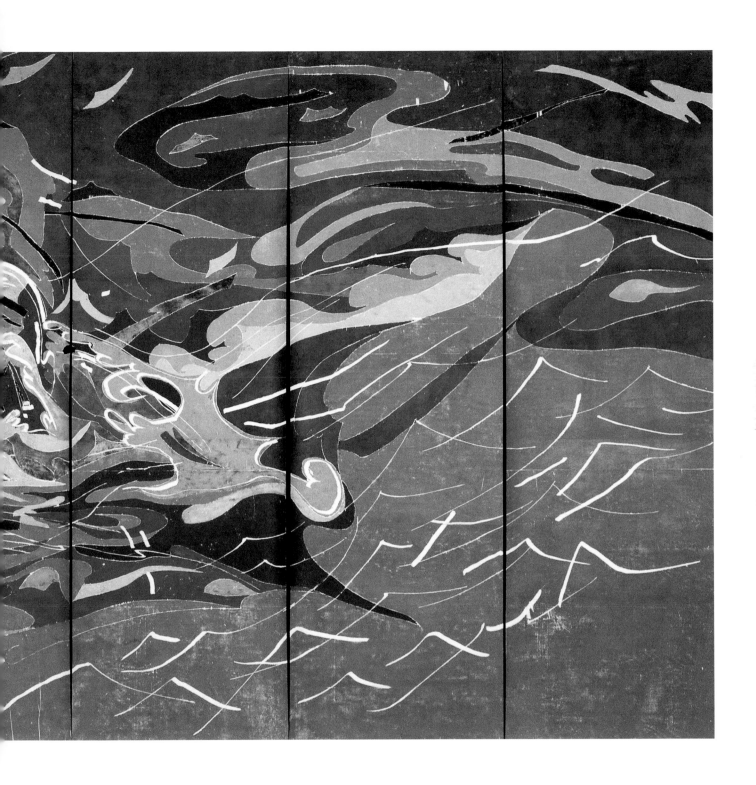

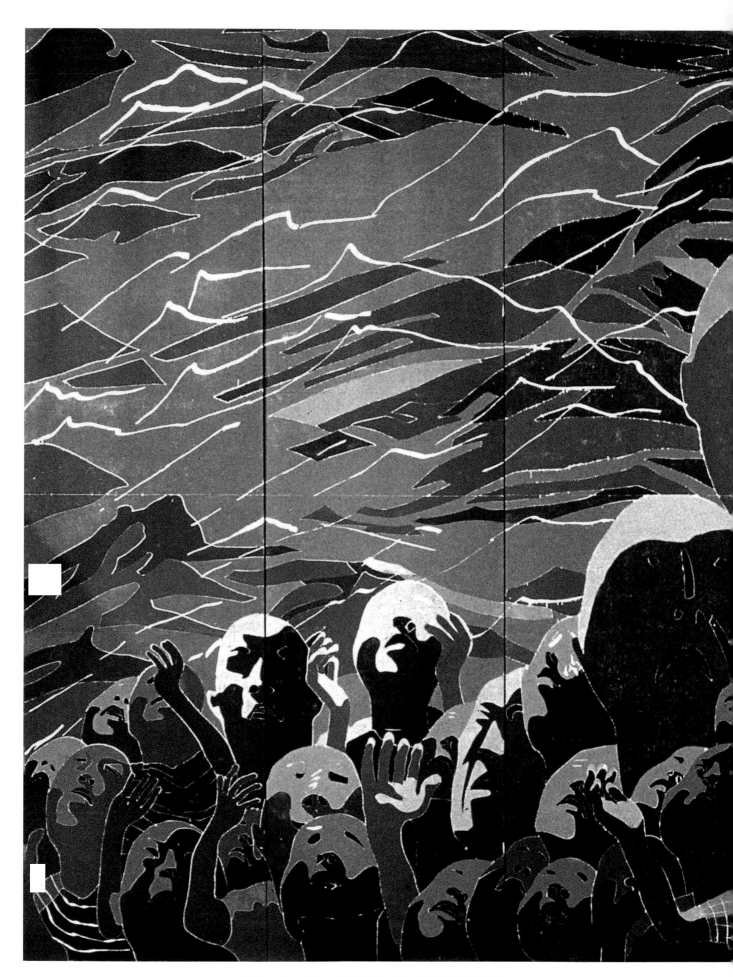

1999.3.1　488×732cm　木刻版畫　1999　典藏藝術家庭收藏
1999.3.1　488×732cm　Woodcut prints　1999　Collection of Art & Collection Group

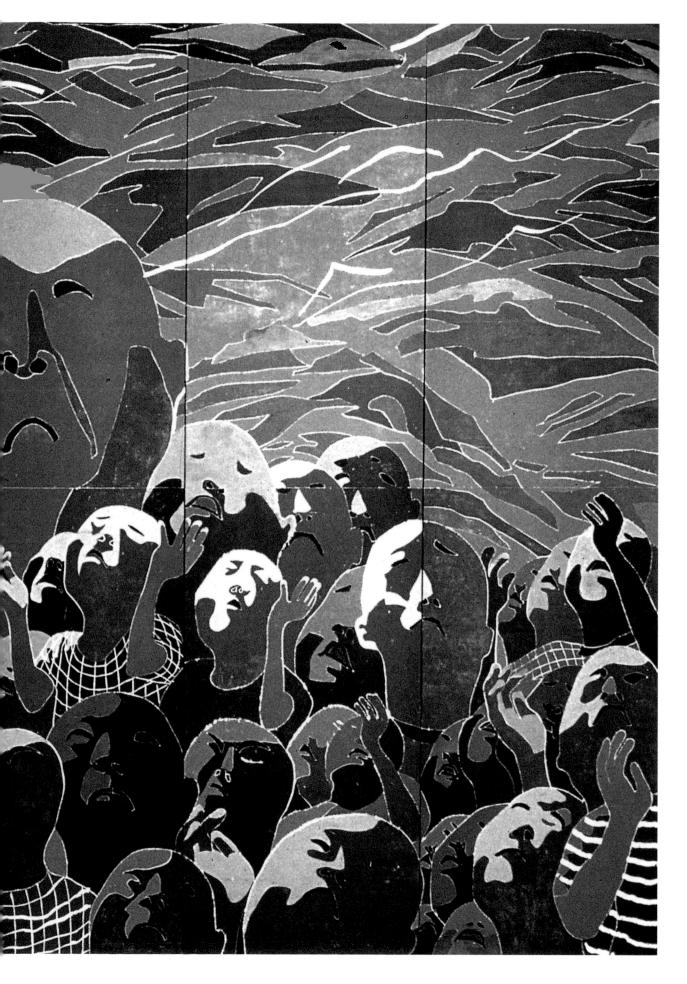

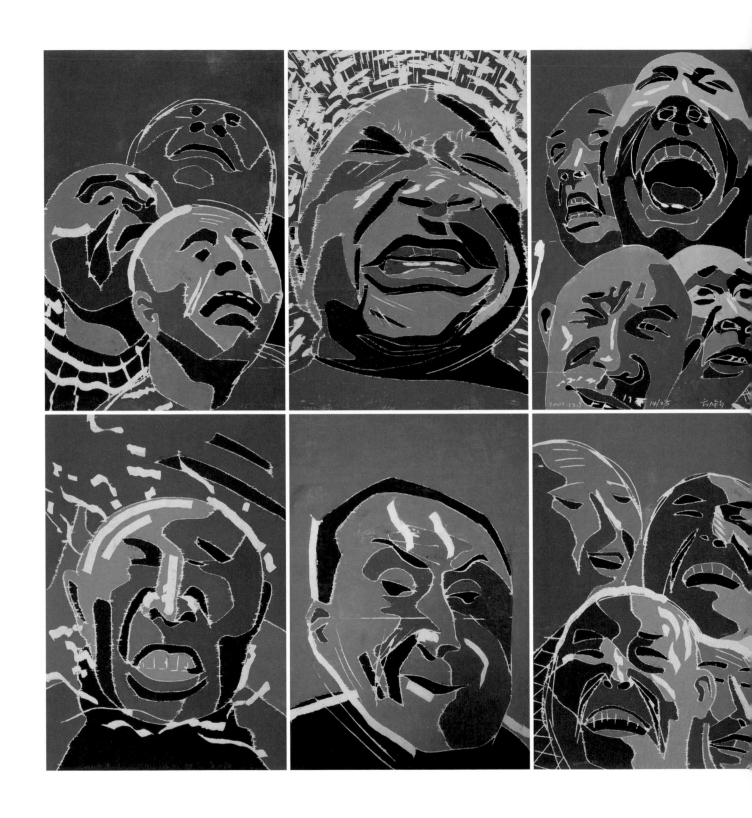

2000.6.25, 2002.12.11, 2002.12.9, 2002.11.11, 2002.11.9, 2000.6.30, 2000.6.15, 2000.4.20, 2000.5.20, 2000.5.10, 2000.5.25, 2000.4.5
81×122cm ×12張　木刻版畫　2000-02 藝術家自藏

2000.6.25, 2002.12.11, 2002.12.9, 2002.11.11, 2002.11.9, 2000.6.30, 2000.6.15, 2000.4.20, 2000.5.20, 2000.5.10, 2000.5.25, 2000.4.5
81×122cm each, 12 pieces　Woodcut prints　2000-02　Collection of the artist

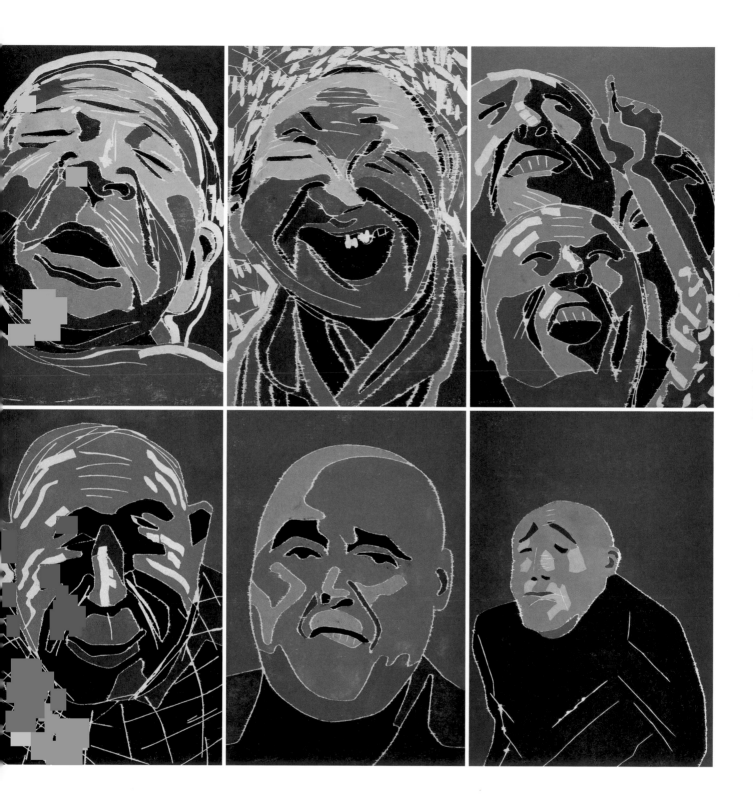

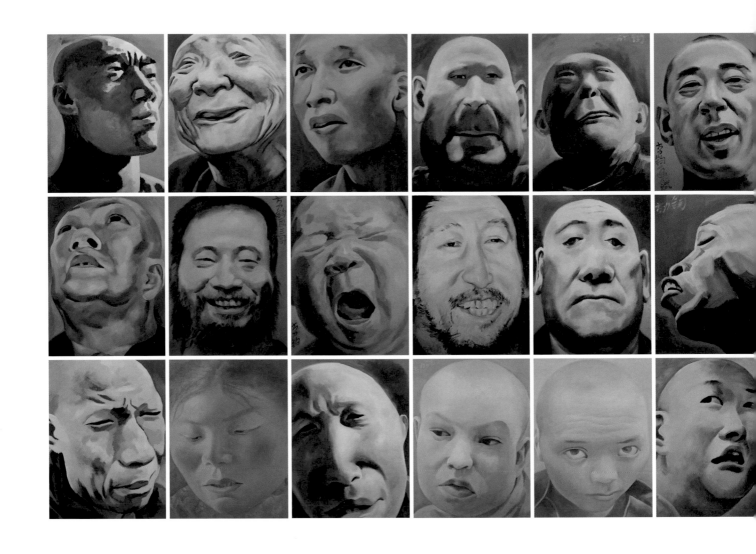

肖像 33×24cm×36張 油彩、畫布 2000-03 藝術家自藏
Portraits 33×24cm each, 36 pieces Oil on canvas 2000-03 Collection of the artist

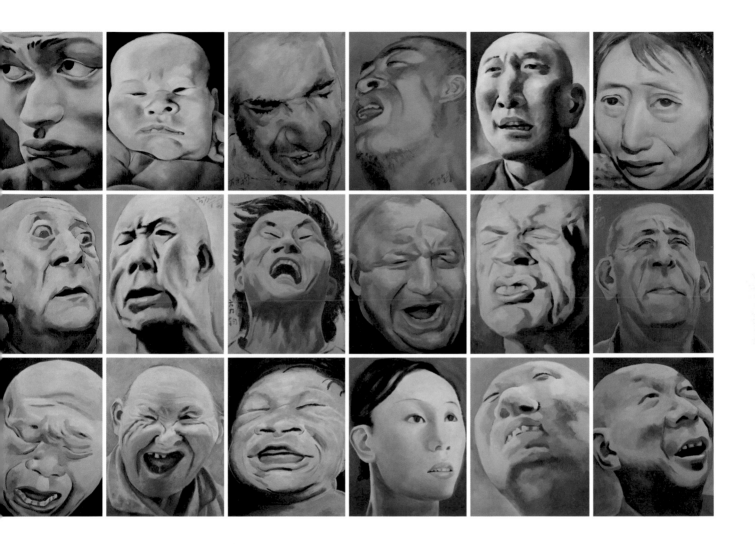

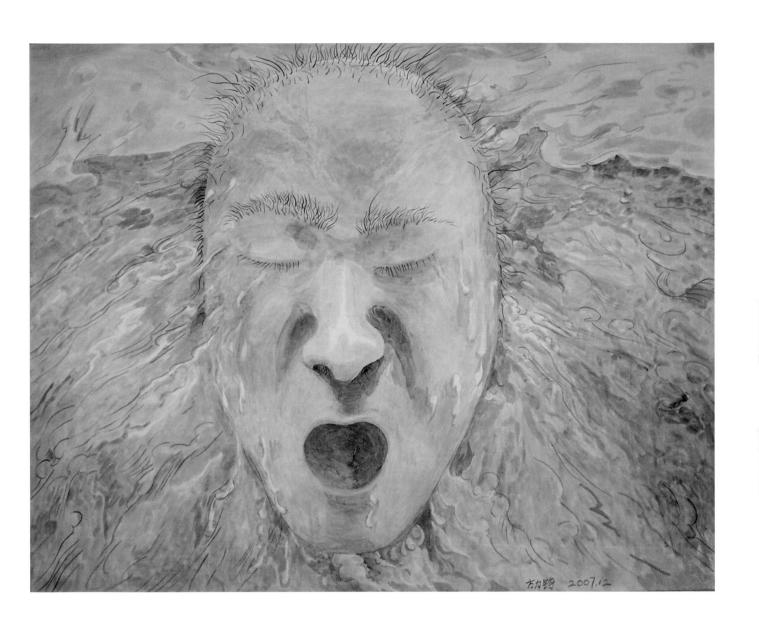

Left：
2007.2.4　70×50cm　油彩、畫布　2007
2007.2.4　70×50cm　Oil on canvas　2007（左頁圖）

Above：
2007.12　80×100cm　油彩、畫布　2007
2007.12　80×100cm　Oil on canvas　2007（上圖）

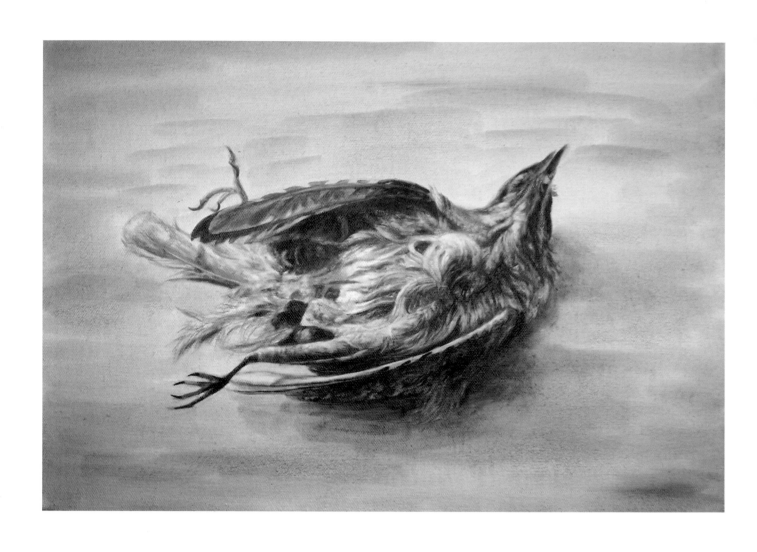

2007　35×50cm　油彩、畫布　2007
2007　35×50cm　Oil on canvas　2007

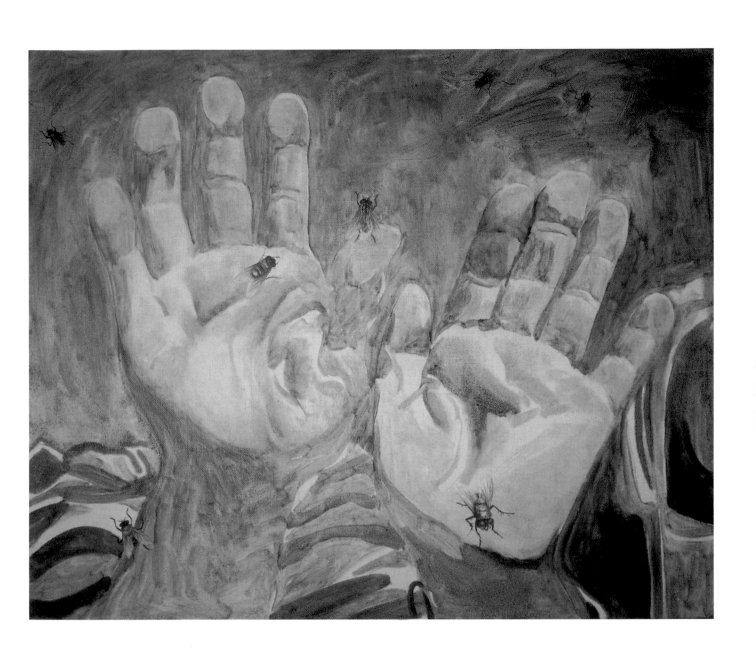

2007 7.1　50×60cm　油彩、畫布　2007
2007 7.1　50×60cm　Oil on canvas　2007

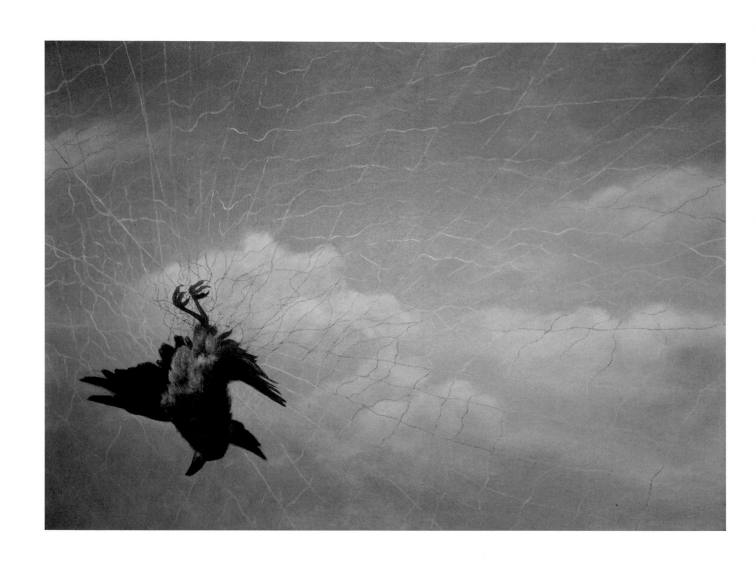

Above：
2008春　50×70cm　油彩、畫布　2008
2008 Spring　50×70cm　Oil on canvas　2008（上圖）

Right：
2008　50×35cm　油彩、畫布　2008
2008　50×35cm　Oil on canvas　2008（右頁圖）

122

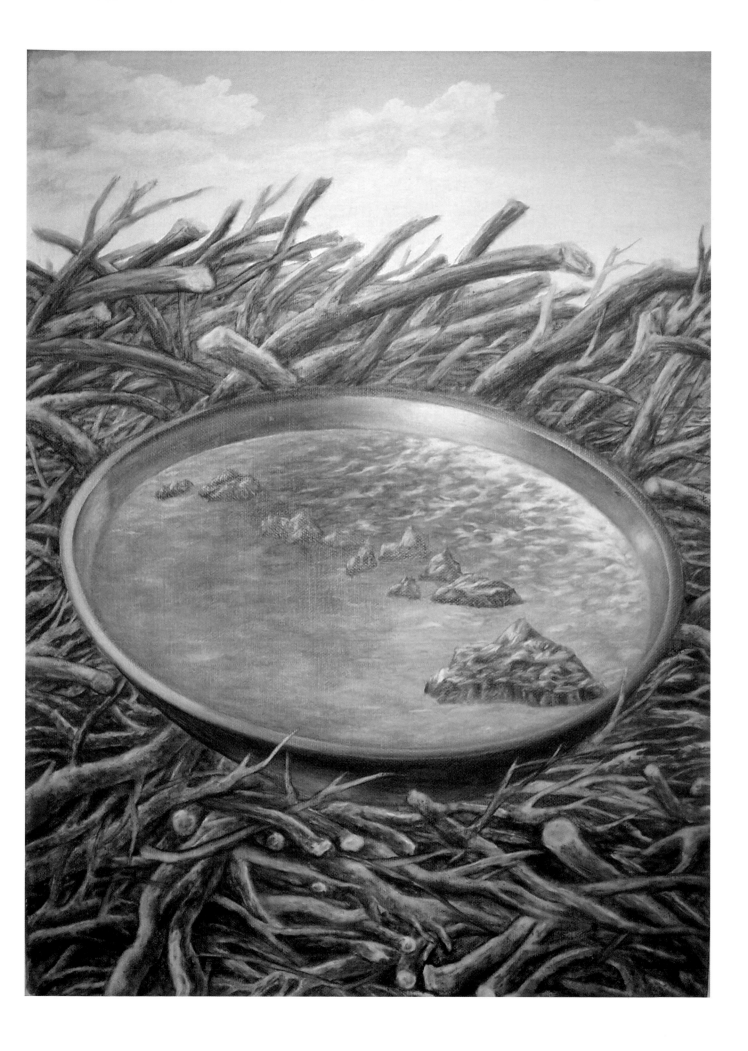

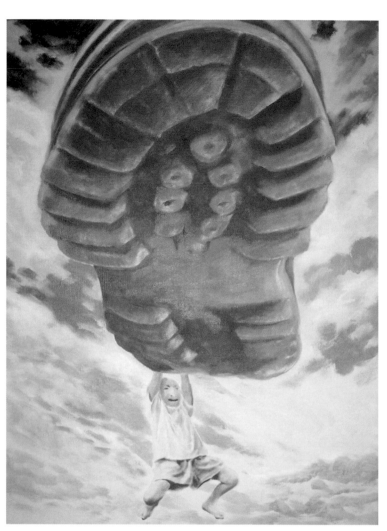

Above：
2006  64×47cm  油彩、畫布  2006
2006  64×47cm  Oil on canvas  2006（上圖）

Below：
2007.6.1  65×91cm  油彩、畫布  2007
2007.6.1  65×91cm  Oil on canvas  2007（下圖）

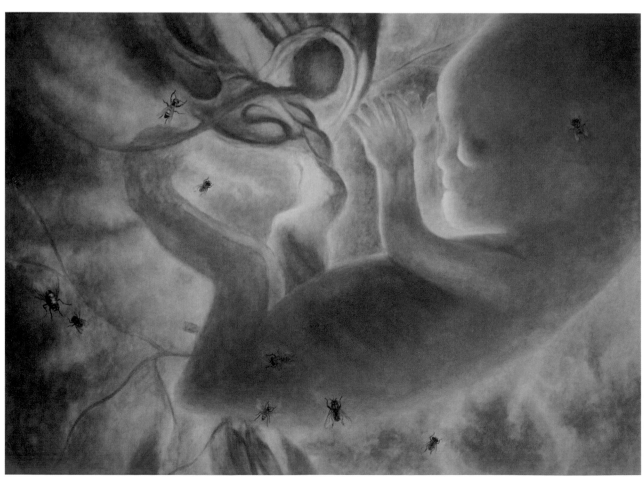

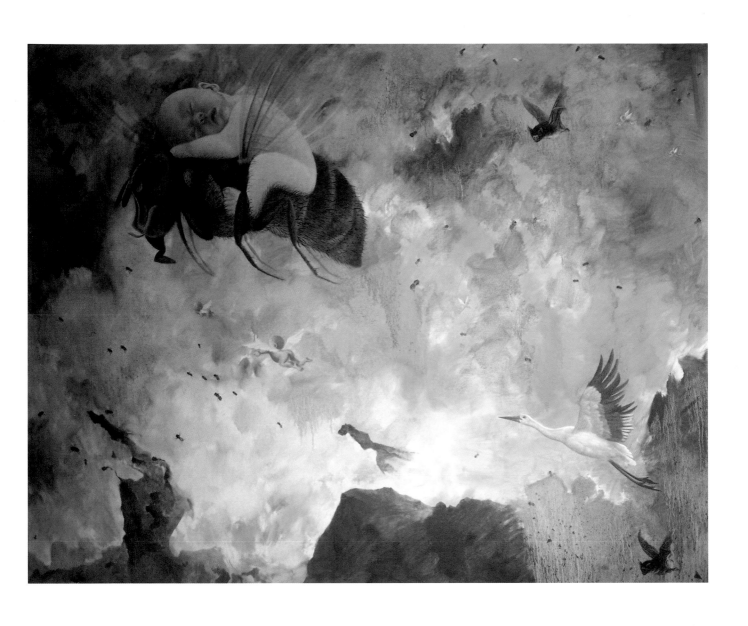

2006-2008　140×180cm　油彩、畫布　2006-2008
2006-2008　140×180cm　Oil on canvas　2006-2008

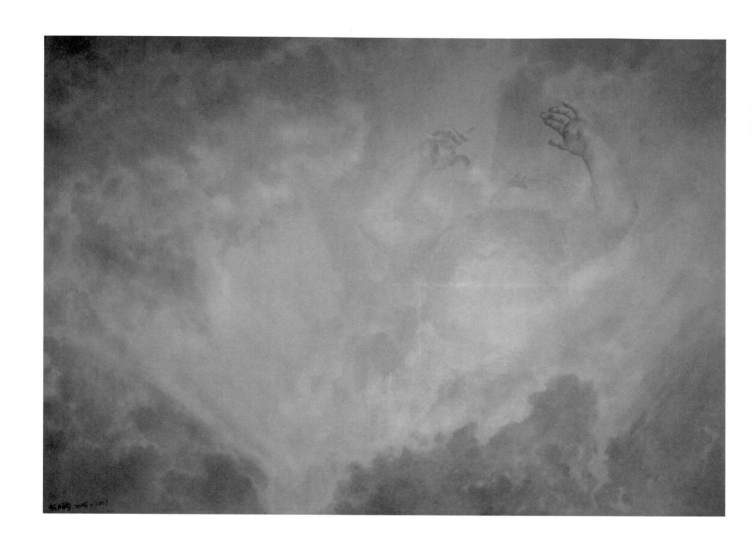

2005-2007　90.3×130.5cm　油彩、畫布　2005-2007
2005-2007　90.3×130.5cm　Oil on canvas　2005-2007

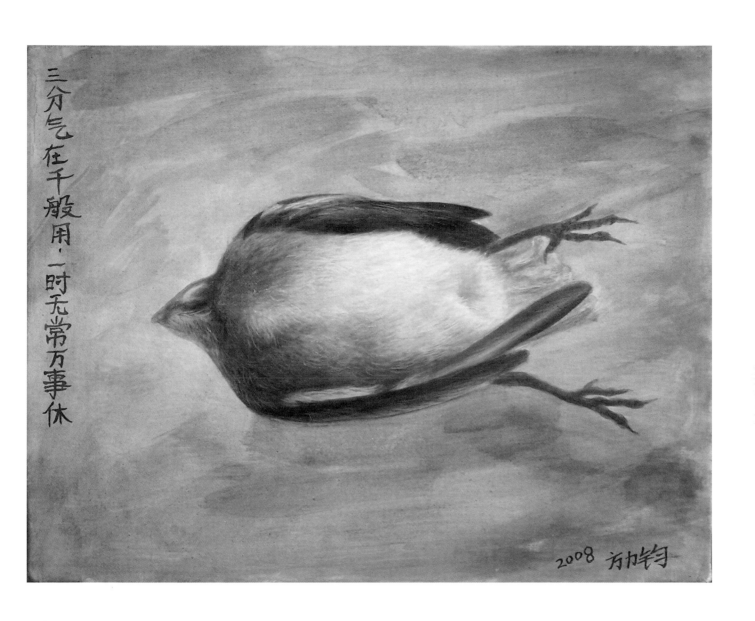

三分气在千般用，一时无常万事休

2008 方力钧

2008　22×27.5cm　油彩、畫布　2008
2008　22×27.5cm　Oil on canvas　2008

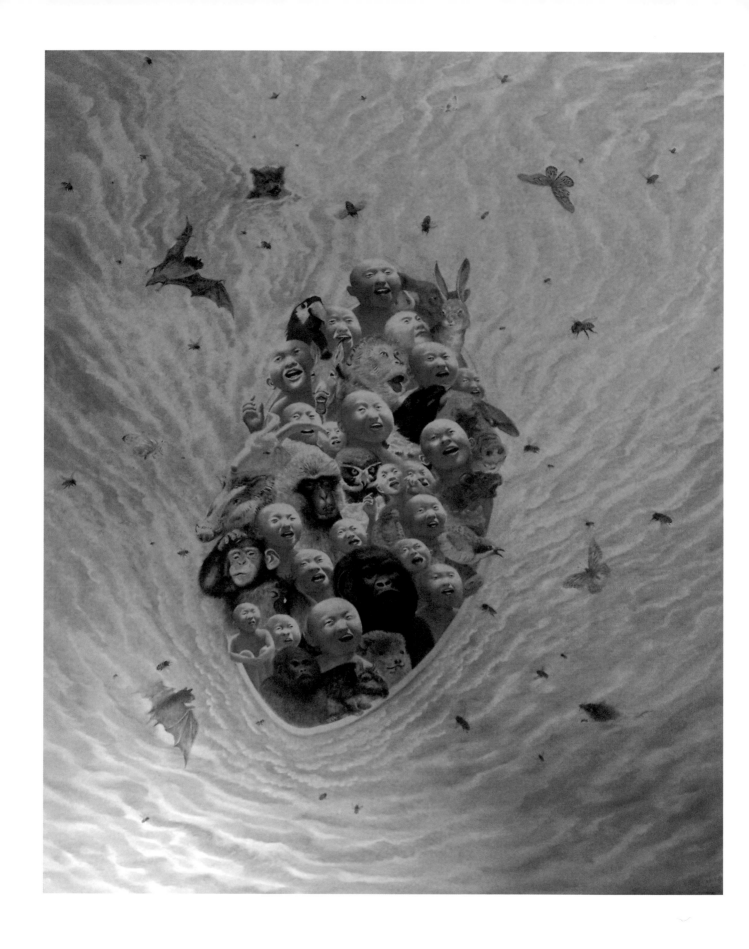

2009春　180×140cm　油彩、畫布　2009
2009 Spring　180×140cm　Oil on canvas　2009

2008　35×50cm　油彩、畫布　2008
2008　35×50cm　Oil on canvas　2008

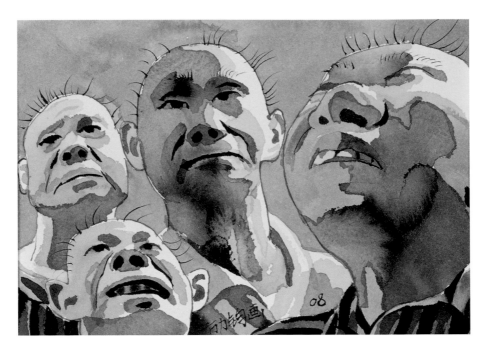

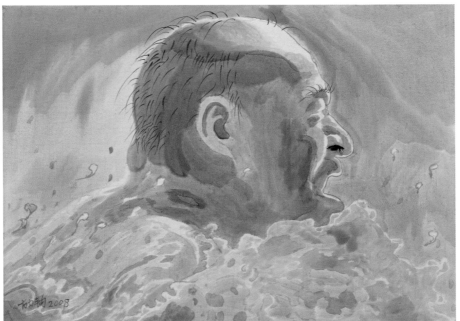

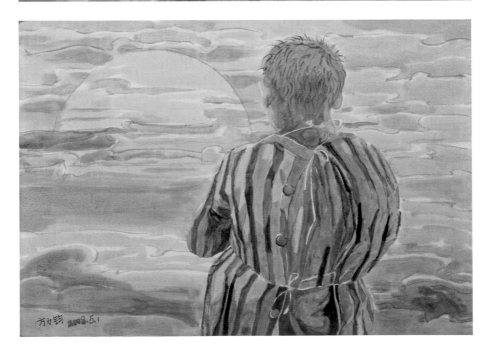

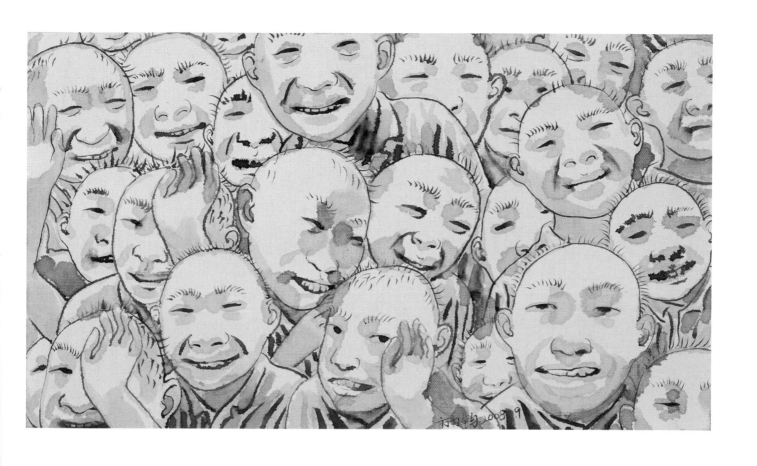

Above left：
2008　12×17cm　水墨、紙　2008
2008　12×17cm　Ink on paper　2008（左頁上圖）

Middle left：
2008　35×50cm　油彩、畫布　2008
2008　35×50cm　Oil on canvas　2008（左頁中圖）

Below left：
2008.5.1　35×50cm　油彩、畫布　2008
2008.5.1　35×50cm　Oil on canvas　2008（左頁下圖）

Above：
2008.9　24×41cm　水彩、畫布　2008
2008.9　24×41cm　Watercolor on canvas　2008（上圖）

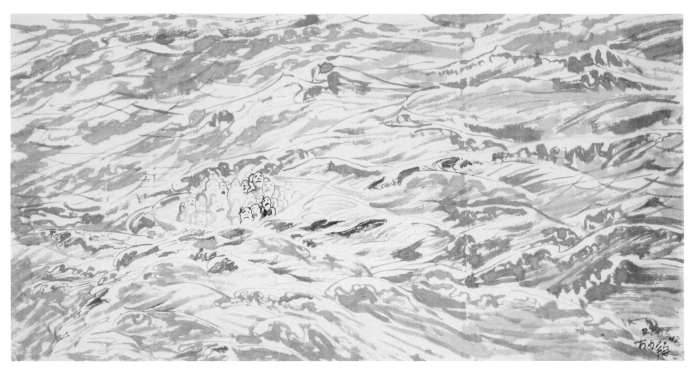

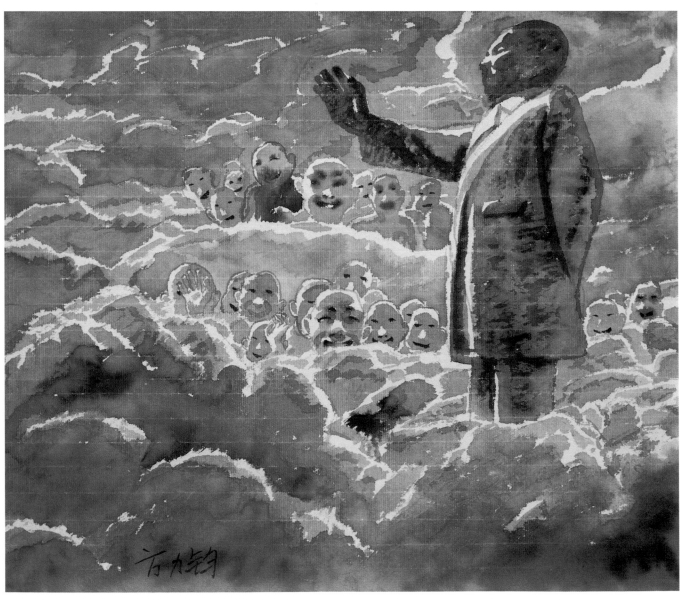

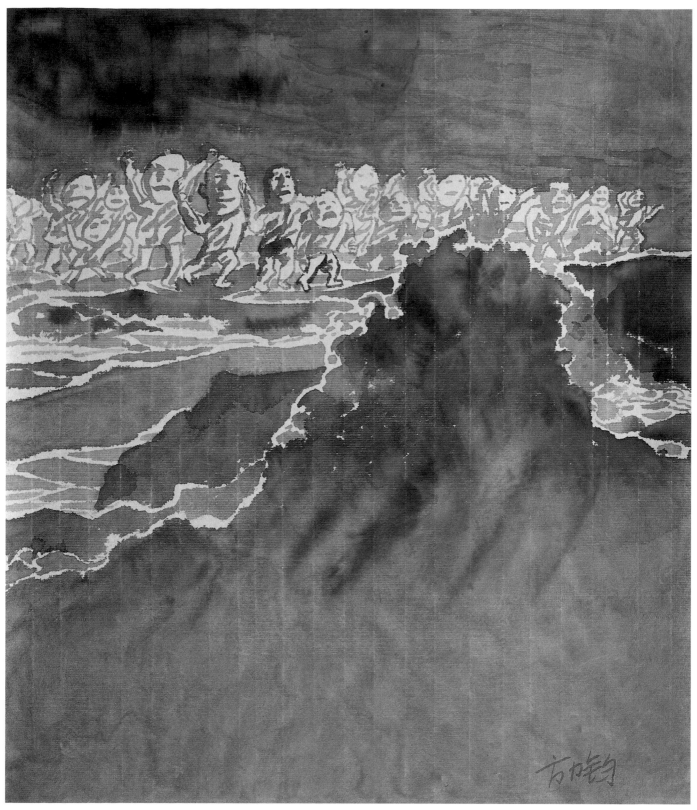

Above left：
水墨之一　71×132cm　木刻版畫　2004
Ink-and-Wash Painting No. 1　71×132cm　Woodcut Prints　2004（左頁上圖）

Below left：
水墨之四　37×43cm　水墨、紙　2004
Ink-and-Wash Painting No. 4　37×43cm　Ink on paper　2004（左頁下圖）

Above：
水墨之五　43×37cm　水墨、紙　2004
Ink and Wash Painting No. 5　43×37cm　Ink on paper　2004（上圖）

133

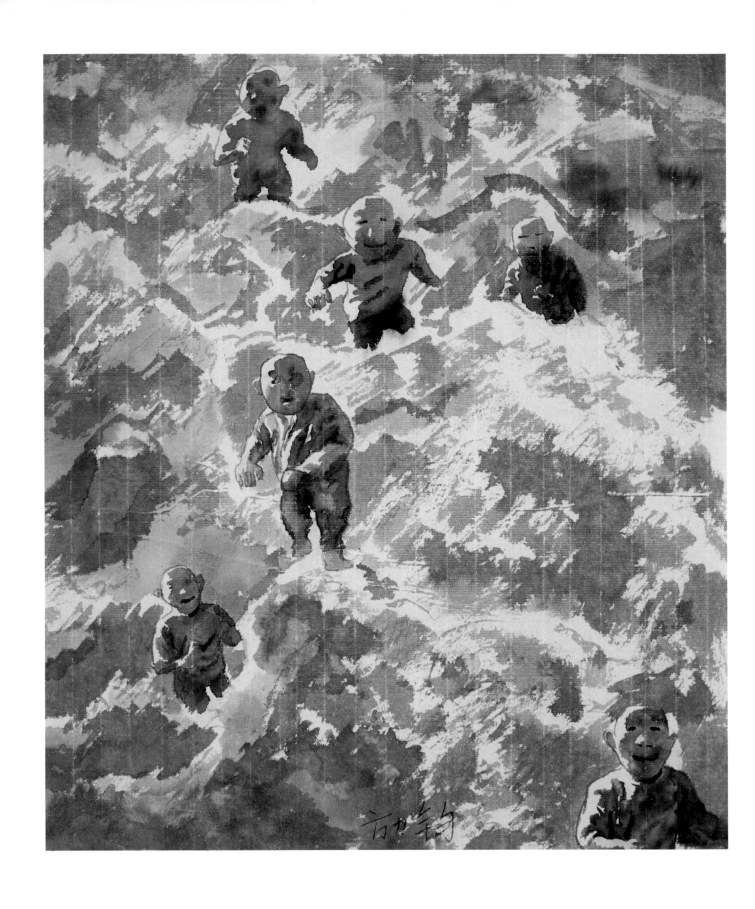

水墨之六　43×37cm　水墨、紙　2004
Ink-and-Wash Painting No. 6　43×37cm　Ink on paper　2004

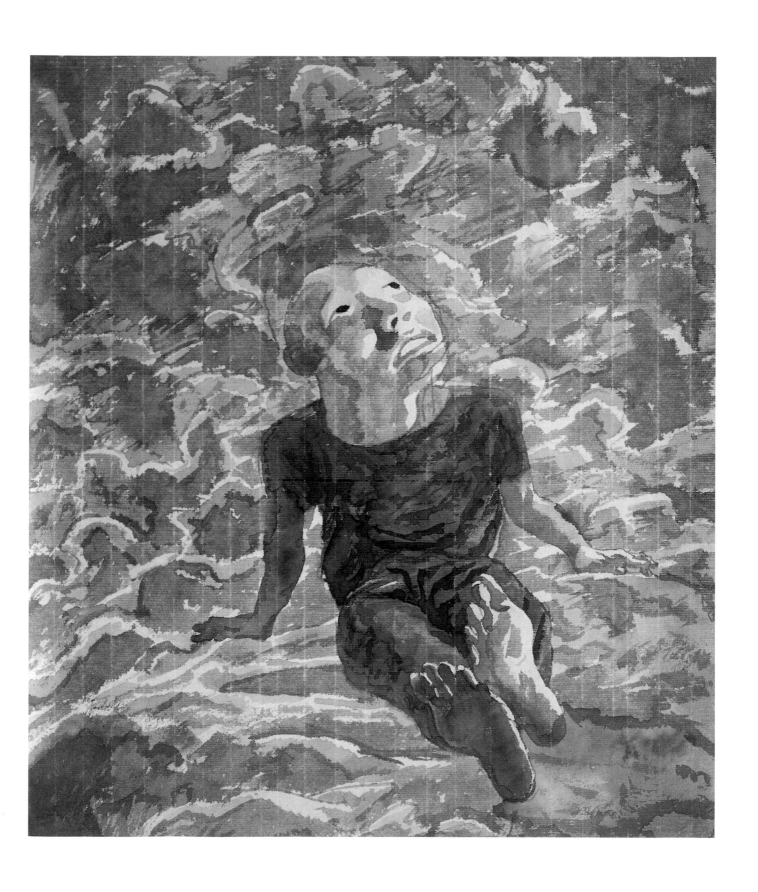

水墨之七　43×37cm　水墨、紙　2004
Ink-and-Wash Painting No. 7　43×37cm　Ink on paper　2004

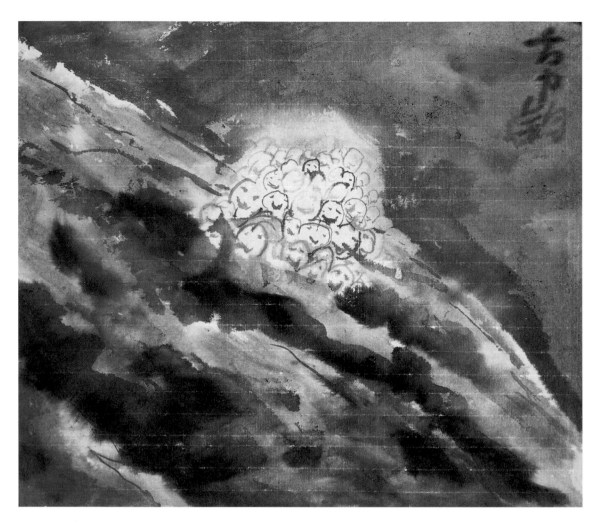

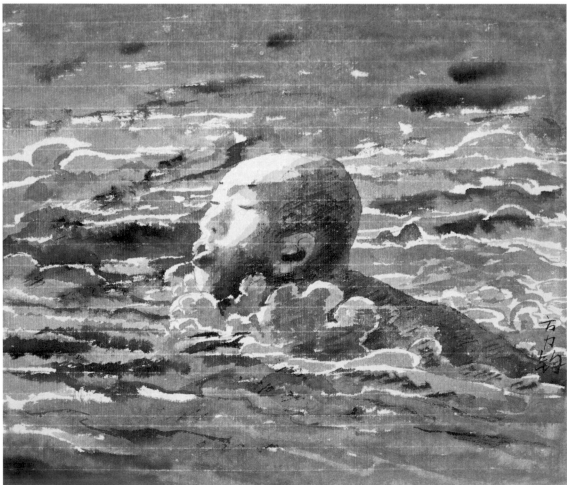

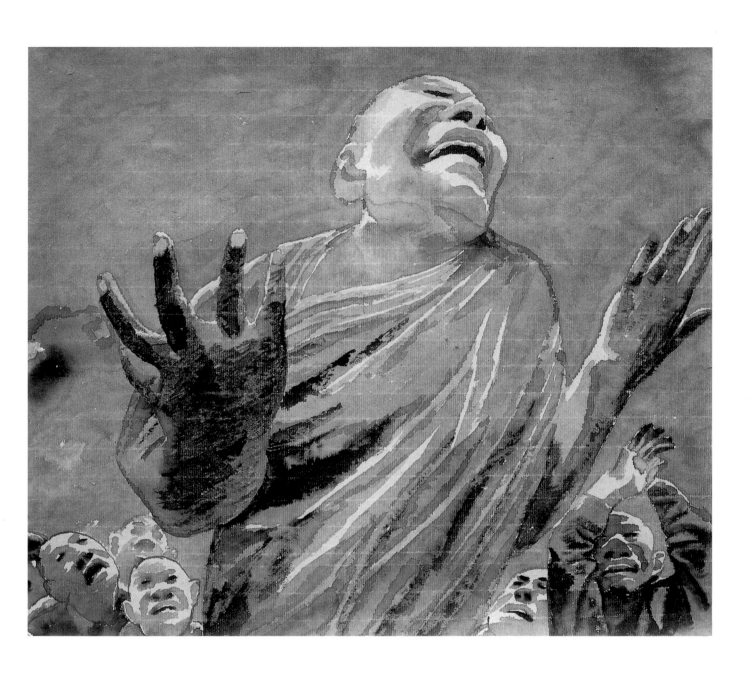

Above left：
水墨之九　37×43cm　水墨、紙　2004
Ink-and-Wash Painting No. 9　37×43cm　Ink on paper　2004（左頁上圖）

Below left：
水墨之十　37×43cm　水墨、紙　2004
Ink-and-Wash Painting No. 10　37×43cm　Ink on paper　2004（左頁下圖）

Above：
水墨之十六　37×43cm　水墨、紙　2004
Ink-and-Wash Painting No. 16　37×43cm　Ink on paper　2004（上圖）

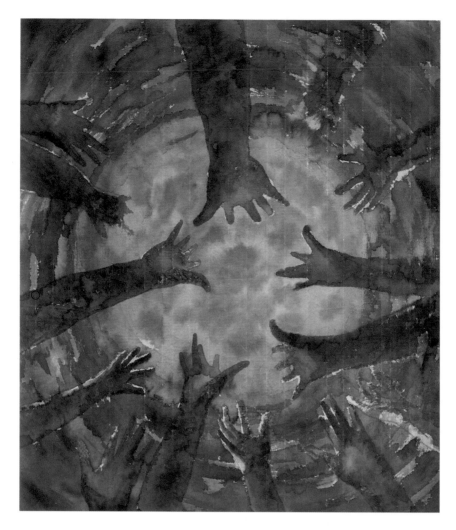

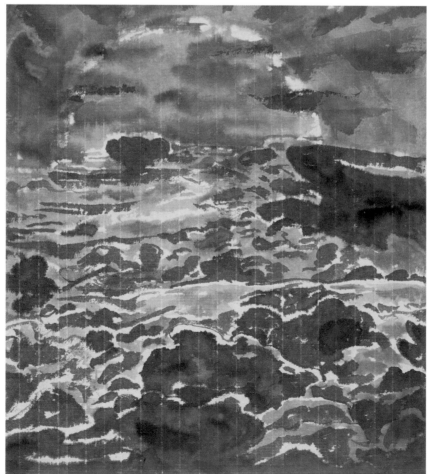

Above left：
水墨之十七　43×37cm　水墨、紙　2004
Ink-and-Wash Painting No. 17　43×37cm　Ink on paper　2004（左頁上圖）

Below left：
水墨之十八　43×37cm　水墨、紙　2004
Ink-and-Wash Painting No. 18　43×37cm　Ink on paper　2004（左頁下圖）

Above：
水墨之十九　37×43cm　水墨、紙　2004
Ink-and-Wash Painting No. 19　37×43cm　Ink on paper　2004（上圖）

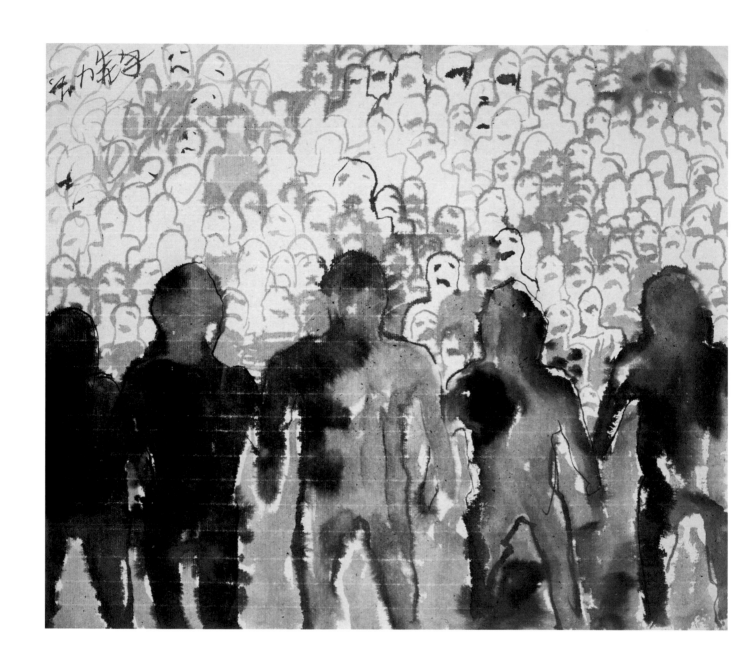

Above：
水墨之二十一　37×43cm　水墨、紙　2004
Ink-and-Wash Painting No. 21　37×43cm　Ink on paper　2004（上圖）

Above right：
水墨之二十二　43×37cm　水墨、紙　2004
Ink-and-Wash Painting No. 22　43×37cm　Ink on paper　2004（右頁上圖）

Below right：
水墨之二十三　43×37cm　水墨、紙　2004
Ink-and-Wash Painting No. 23　43×37cm　Ink on paper　2004（右頁下圖）

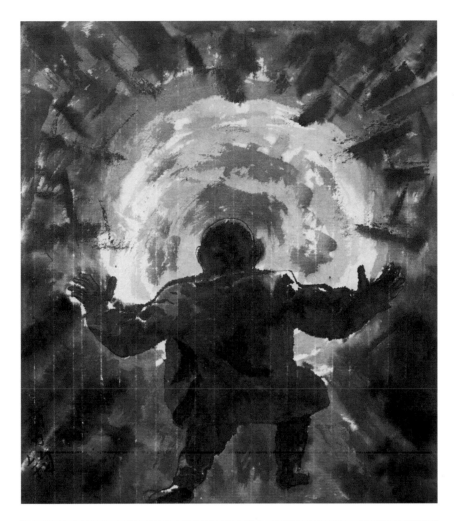

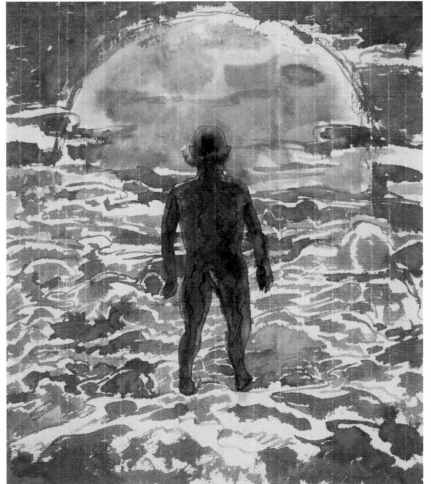

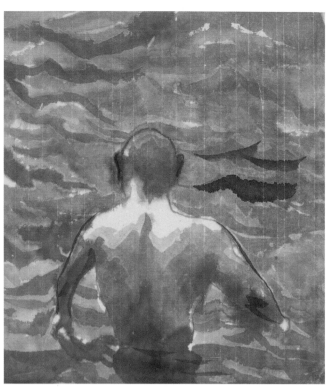

Above：
水墨之二十四　43×37cm　水墨、紙　2004
Ink-and-Wash Painting No. 24　43×37cm　Ink on paper　2004（上圖）

Below：
水墨之二十五　37×43cm　水墨、紙　2004
Ink-and-Wash Painting No. 25　37×43cm　Ink on paper　2004（下圖）

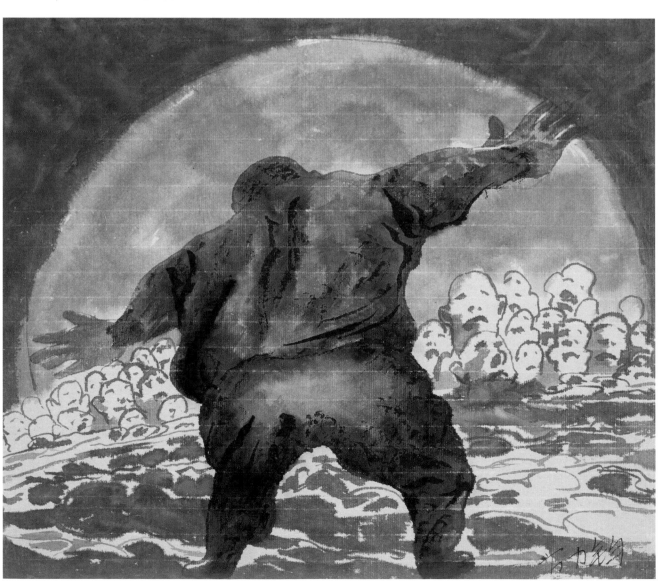

# V

# 生命之鉅，生命之渺
Endlessness of Life

我就希望自己別掉進陷阱裡，別被什麼東西捕獲了，不要失去自己自由的身分，
這是最重要的。——方力鈞

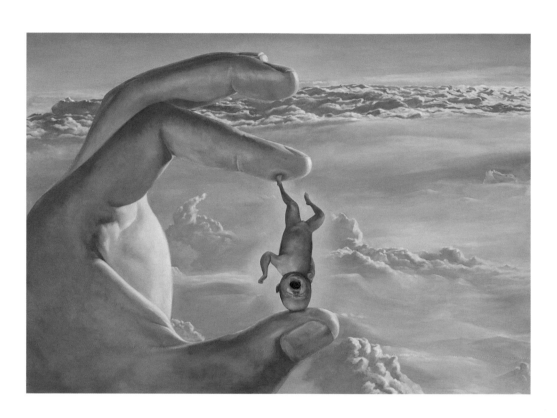

2000.1.5　180×250cm
壓克力顏料、畫布　2000
2000.1.5　180×250cm
Acrylic on canvas 2000

　　1998、1999 年以後，懸浮於半空之中雲靄之端，周圍或有層疊峰巒，或有似錦繁花環
繞的嬰兒、兒童、人群、與巨掌，也開始成為方力鈞畫面中的主題。尤其是 2000 年以後，
這些主題幾乎佔據了他所有繪畫性的作品。

### 兒童、嬰兒與人群

　　兒童或者是嬰兒，就跟之前光頭的人一樣，因為模糊、泯沒了個體與個體之間的差異
性、區別性，而成為方力鈞藉以用來作為「人（類）」這個整體性的象徵概念。嬰兒與兒
童都是人類最為純淨的時期，弔詭的是，所有方力鈞筆下的嬰兒與兒童，都帶著某種曖昧
不明、模糊混濁的，更像是成年人才會有的神情：癡笑的、強顏的、欲泣的、渴慕的、愁
苦的、憂傷的、扭曲的、貪欲的、絕望的、猙獰的、深沉的、陰暗的、怔忡的、空茫的、
莫可名狀的、像失去了靈魂的……什麼樣微妙複雜的神情都有，就是幾乎沒有孩童原本應
該有的，純潔爛漫天真可愛的臉龐，沒有能讓觀者感到安心愉悅的任何一張臉、任何一個
暗示；方力鈞藉著人們原本認為應該最是天真純潔的嬰兒與孩童，來指諭人世多嗔苦的意
旨，已經不言可喻。

　　這些孩童基本上也都是光頭的，或者其中極少數，腦殼上留有幾根，根根分明，卻極

Above：
1998.8.10　250×360cm　壓克力顏料、畫布　1998
1998.8.10　250×360cm　Acrylic on canvas　1998（上圖）

Middle：
1998無題　40×40cm　油彩、畫布　1998
1998 Untitled　40×40cm　Oil on canvas　1998（中圖）

Below：
2001.1.15　180×250cm　油彩、畫布　2001
2001.1.15　180×250cm　Oil on canvas　2001（下圖）

其稀疏得讓人尷尬的毛髮，方力鈞潑皮的一面
在這裡還是露出來了——這幾根毛他總是調戲
著觀者本能的感官，特別把它畫得讓人怎麼看
都覺得噁心、不舒服，於此小節上，再次顯露
出他對於耽美的嗤之以鼻。

　　嬰兒與孩童做為「人」這個整體性的象
徵，較諸成年的「人」，藝術家顯然一方面是
更增強了所有生命之無助之脆弱不堪的指喻。
其中有許多作品的構圖，都是密密麻麻一大群
孩童，或是難以辨別年齡與性別的人們，集體
一致地結隊奔赴迎向一個莫可名之的遠方，彷
彿彼岸就是天堂，卻也因為他們臉龐上那種不
明是悲是喜，詭異曖昧而又失了魂魄似的表
情，終究像是指喻著：天堂之道，其實永遠不
可企及。

## 層巒、雲海與繁花

　　「空間」與「環境」，以及安置於其中的
訊息性符號，也是方力鈞在每一個創作階段中
思之再三，藉以為他的主題豐富、強化、延伸
更多意旨的精確手段之一。

　　80 年代中，方力鈞的作品仍以描繪家鄉附
近的地文地貌為主題：踽踽行於高牆窄巷之間
佝僂的人們，這些情境的暗示無疑提供了觀者
一種滯塞晦澀的心理感受。80 年代末之後，他
將畫中的的主人翁抽出高牆阻斷的迫近空間，
而重新安排放置在視野開闊的場景裡，畫中舒
懶散漫無所事事般的人們，背後是天際、是海
平線。於其時，正值人心動盪的年代，這樣的
作品很容易就勾帶出一整代人對於鬆動的自由
的夢想，挖掘出原本沉潛於每個人內心底層靈
魂解放的想望。然後到了 90 年代初，當他畫中

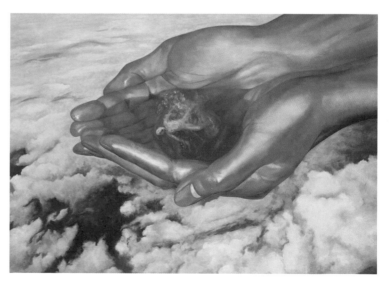

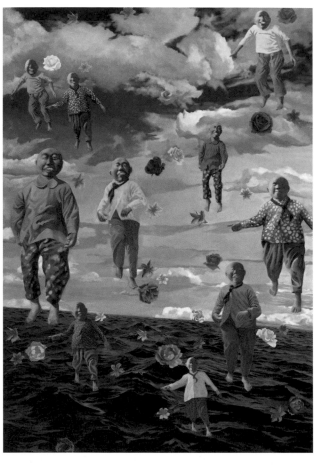

Above：
2000.1.10　360×250cm　壓克力顏料、畫布　2000
2000.1.10　360×250cm　Acrylic on canvas　2000　（上圖）

Below：
2000.1.30　360×250cm　壓克力顏料、畫布　2000
2000.1.30　360×250cm　Acrylic on canvas　2000　（下圖）

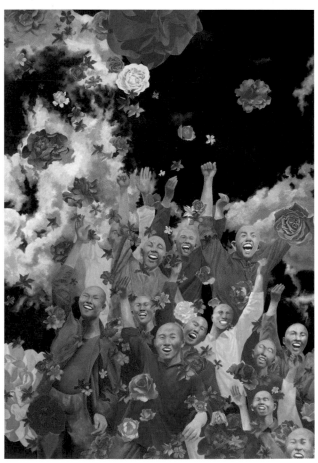

的主人翁被四面八方地包覆於無邊之水當中時，這個情境的營造，又有效地佔據了觀者從心魂的安詳寧謐、到生死掙扎的驚恐懼怖，這心理的兩個極端。

　　至於從 90 年代後期開始到 21 世紀之後，方力鈞作品中大量出現的空間場景，則是在如濤的雲海之中、層巒疊嶂的群山之端、似錦繁茂的鮮豔花海之上，一大群神情難以明確言述的人們，處於一種因為足不沾地，所以分不清究竟是向上飛升？還是向下墜落？的狀態中，眼神似乎正集體畏懼著？渴慕著？未可知的他方。

　　方力鈞非常擅長，也一直喜歡探討挖掘人類這種莫可名狀的、曖昧的、彷彿混雜著痛苦與快樂、昇華與墮落的集體生存狀態，其中層層剝繭反覆悖論的細密性，體現了方力鈞在創作上的偏好：一是聚焦於作品內在的論述；二是樂於挑釁、戳刺人們對於「藝術」是作為愉悅人心的習慣性期待。比如這些彩色斑斕、鮮豔明亮，彷若天堂花園的場景，方力鈞卻總要刻意在暗中搞破壞，把它營造成因為過分明豔反而像是暗藏著某種不安與厄運的氛圍，整體帶著一種非真實的、樣板似的呆滯感，這種讓人不舒服的挑釁，正洩露出了方力鈞其實是從來也不曾馴服過的。

　　如果黑白的「單色畫」是方力鈞每一個新的創造階段的實驗、練習、與思考的方式的話，那麼彩色的作品就可說是他在思考成熟完全掌握之後的揮灑。方力鈞的彩色畫作有一種獨特而具有高彩度、高裝飾性的色感，瑰麗得很是奇怪，像是直接從顏料罐中擠出來不曾調色就直接上了畫布，甚至明豔銳利得像是廣告顏料的色彩般有些扎眼，他畫中所有那些傳統中表意富貴與幸福的肥大牡丹、芍藥，看起來都像是塑料做的假花、畫的人奇怪偏橘的膚色也像塑料皮的假人、畫中人臉上的笑容更像是皮笑肉不笑、樣板的假笑……，這些虛假、戲劇化而缺少了真實感的美豔與燦爛全加在一起，使得他所有的畫面都有種像是蓄意在調侃「樣板」的味道。正是這種看起來漫不經心、有些潑皮的調侃與嘲笑，卻產生

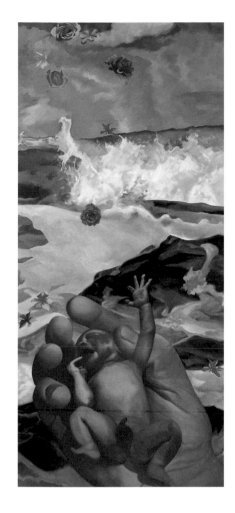

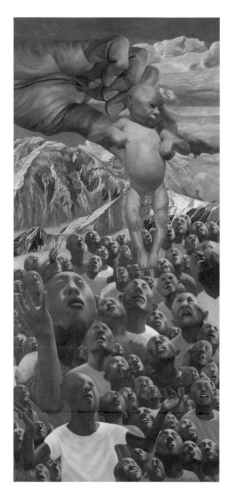

了比直接聲嘶力竭地批判更有效的挑釁。這些作品對於 90 年代中以後中國當代藝術中出現的豔俗藝術潮流，有著必然的影響。

## 天空中的巨掌

　　另一個與層疊山巒、波濤雲海跟錦繡繁花同一時期出現的重要符號，是一個自穹宇天際陡然伸出的巨掌，這個巨大而敦實的手掌，或者捧著滿手的花朵自天空向人世間灑落，或者是托著、握著、呵護著一個初生的幼嬰，或者是張手伸向更高更遠的天際，彷若呼喚渴求……，這個巨掌出現在畫面上通常是只有一小節腕部跟整個手掌，作者未曾交代這個厚實的手掌所屬何人（神？）。似乎，一方面象徵著宗教、宇宙、未可知而又更為巨大神祕、令人敬畏的超能力量；另一方面又象徵著做為每一個微小的「人」，也都具有能夠掌握自己、掌握他人、掌握整個世界生命與未來的能力與力量；象徵著人類最後一抹可貴的悲憫、真情、與希望。

## 鳥、蟲、魚

　　方力鈞是一個習慣於隨時隨刻都在思考的人，熟悉方力鈞或是訪談過方力鈞的人都很容易發現：他從思維方式、語言方式到創作內容，都是一個超乎尋常絲毫不放過地一環扣著一環，反覆辯證，方力鈞從來不會忘記：任何事物都有兩面，甚至有好幾面，因此在他所有的論述中，無論是日常言語還是藝術創作上，都沒有甚麼是「絕對」的，都是綿密而

Left：
2001.9.28　270×120cm
壓克力顏料、畫布　2001

2001.9.28　270×120cm
Acrylic on canvas　2001
（左圖）

Middle：
2002.2.1　270×120cm
壓克力顏料、畫布　2002

2002.2.1　270×120cm
Acrylic on canvas　2002
（中圖）

Right：
2003.7.1　400×176.5cm
油彩、畫布　2003

2003.7.1　400×176.5cm
Oil on canvas　2003
（右圖）

147

Above：
2005.11.30　180×250cm
油彩、畫布　2005

2005.11.30　180×250cm
Oil on canvas　2005
（上圖）

Below：
2004.1.5　80.5×179.5cm
油彩、畫布　2004

2004.1.5　80.5×179.5cm
Oil on canvas　2004
（下圖）

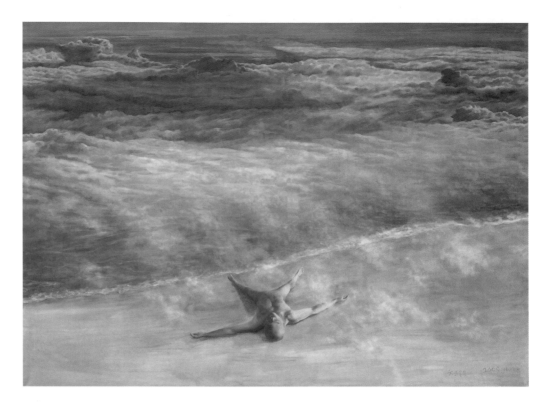

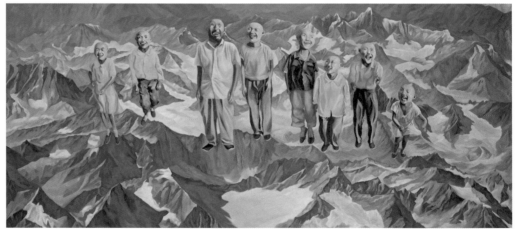

複雜的。

　　在明亮高彩而豔麗的天空系列之後，最近這幾年，方力鈞的作品中又逐漸發展出一些新的符號，各種飛鳥、蟲子、游魚出現在他的新作當中。原本是中國傳統文人生活、文人繪畫中甚是風雅的素材，「花、鳥、蟲、魚」自有其舒散閒逸的雅致情趣，但這個題材用在方力鈞作品中就全然不是那麼回事了——他作品裡的鳥蟲魚都是一大群一大群以成千、成萬的巨量密密麻麻地出現，有時是集體朝向一個方向，氣氛蕭殺箭也似地飛奔而去，有時則是像集體被吸捲入一個巨大引力的漩渦之中氣力用盡無法自己⋯⋯，仔細分辨其中的鳥呀蟲呀魚呀都像似在宿命中掙扎，或是已經筋疲力盡瀕臨死亡墜落的瞬間，當然其中還是有一部分大限未至精神抖擻的，有些則是剛處於新生蠕蟲階段的⋯⋯，這些畫作多是三米以上到甚至十餘米的巨幅之作，但因為密密麻麻的數量太多了，所以其中的蟲子很多必須像傳統翎毛工筆畫一般，以極其纖細的畫筆一絲一絲地描繪。這些作品給予觀者最直接的感受，就像是一則關於死亡、關於生與滅的佛偈，像是每個人生命中最真實、最無力可

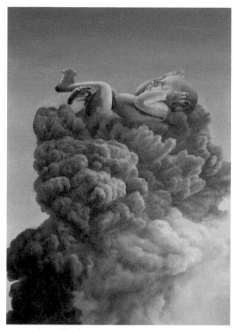

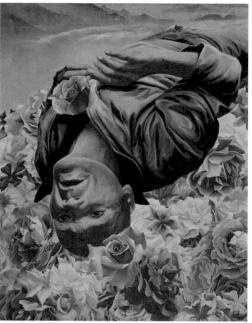

Above left：
2005.11.1　303×176cm
油彩、畫布　2005
2005.11.1　303×176cm
（左上圖）

Above right：
2004.1.7　91.5×71.5cm
油彩、畫布　2004
2004.1.7　91.5×71.5cm
Oil on canvas　2004
（右上圖）

Below：
2006.1.1　100×80cm
油彩、畫布　2006
2006.1.1　100×80cm
Oil on canvas　2006
（下圖）

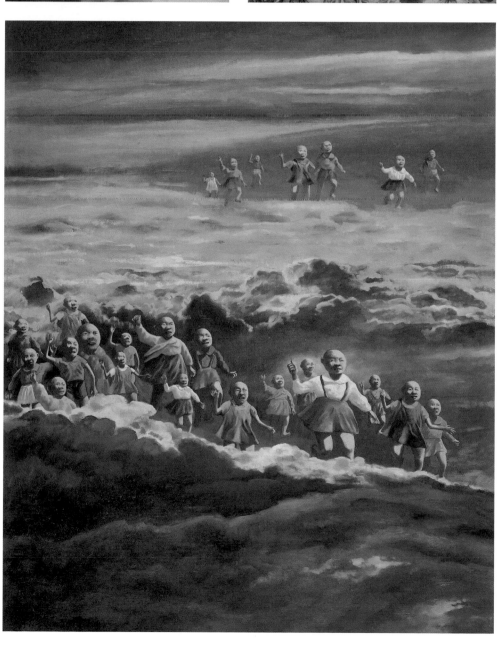

Left：
2006.1.1　250×360cm
油彩、畫布　2006

2006.1.1　250×360cm
Oil on canvas　2006
（左圖）

Right：
2008.6.15　250×360cm
油彩、畫布　2008

2008.6.15　250×360cm
Oil on canvas　2008
（右圖）

回天的苦。

當個體面對生命的困境，群體面對人類集體的苦難時，當代藝術最可珍貴之處在於，有一部分藝術家即使在自己的生命也必須選擇逃避時，仍然具有勇氣以他的藝術面對人類集體命運的現實，「並且以藝術來處理、討論這些問題」，方力鈞説。

這句話無疑也揭露了方力鈞對於自己作為一個當代藝術家這個身分，所自我期許的意義與價值。而既然，當代藝術最終體現的是時代和文化的意義，那麼對於藝術創作這件事而言，一個藝術家，就不僅是以他所專長的「藝術」的方式，來反映他（們）當下所在的時代，而且還要有更大的勇氣、更高的眼界，來概括他所在的時代，並且對於當時的主流價值、權力系統的提問與質疑；然後，對於未來，賦予悲憫寬懷，寄予希望。於是，藝術也可以是一則偈語。

## 裝置雕塑

最近這五年，方力鈞跟平面繪畫同時進行的，又創作了一系列裝置雕塑的立體作品，這些作品量體多數都非常巨大，在主題與內容上則可視為方力鈞近期所關注的題材從平面繪畫的再延伸。立體作品中的光頭人物形象更為清晰強烈，體態則多數已經是癡魯的中年人，或是在自身處境未明的龐雜人間機器中漫無目的地攀爬掙扎，有些甚至已經化為人間機器的一部分，身上牽繫著輸送的管線；或者如獸般困於牢籠之中無聲的吶喊祈求，有些則已揉擠在透明管中成為福馬林中的屍體標本，卻呈現一種奇特的清涼寂靜，煩惱不現，眾苦永寂，不生不滅、不垢不淨，如涅槃般寧靜莊嚴的氣氛……。

最近一件新作〈40800mm〉，一條總長 40.8 公尺的透明壓克力道路上面，從胚胎、襁褓與爬行中的嬰兒、幼年、少年、成年、壯年、佝僂的老年、到最終肉身的死亡，具現了「人」這一生於世的所有肉身實像，具現了身心高速生滅的刹那無常，方力鈞藉此內觀，也讓觀者一起體驗生滅隨觀智的領悟。（胡永芬／文）

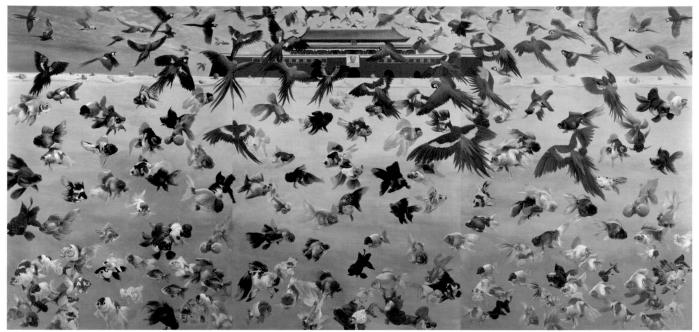

2007.8.15 360×750cm 油彩、畫布 2007
2007.8.15 360×750cm Oil on canvas 2007

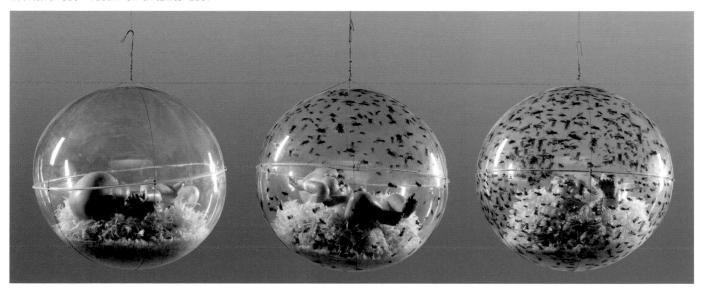

 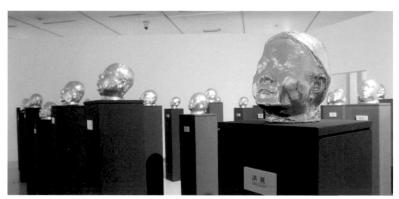

Middle： 2007.8.30 120×120×120cm×3 油彩、有機玻璃、羽毛、玻璃鋼等 2007
2007.8.30 120×120×120cm×3 Oil, organic glass, plume, painted FRP, etc. 2007（中圖）

Below left： 2008.2.20 55×55×55cm 綜合媒材 2008
2008.2.20 55×55×55cm Mixed media 2008（左下圖）

Below right：無題 32件，2/8真人原大 銅、金箔、鐵板 2006
Untitled 32 pieces, 2/8 life size Copper, goldfoil, iron plate 2006（右下圖）

*I, for my part, do not want to get caught in a trap, do not want to be captured by something, and do not want to lose my freedom. This is the most important thing.* – Fang Lijun

After 1998 and 1999, scenes like infants, children, crowds of people and giant hands floating upon clouds in midair, surrounded by successive layers of mountain ranges or embedded in luxuriant flowers, also became the topics of Fang Lijun's pictures. Especially from 2000 onwards, these themes have almost exclusively dominated all his paintings.

## Children, infants and crowds of people

As in his previous series of paintings depicting baldheaded figures, the differences between individuals are blurred or vanish without a trace through the images of children and infants, which are used to present the abstract concept of "mankind" as a whole. The phases of infancy and childhood are the purest periods of human beings. Paradoxically, all of Fang Lijun's infants and children have ambivalent, vague and fuzzy expressions, ones that make them appear more like adults: simpering, constrained, weeping, longing, miserable, grieved, distorted, greedy, despairing, mean and ferocious, deep, dismal, startled and distressed, vacant, indescribable, soulless.... all kinds of subtle, complicated expressions are there, all except the pure, innocent, and cute ones that one associates with children. None of the faces makes the viewer feel at ease with delight. Far from it. It is obvious that Fang Lijun uses the images of infants and children, who are generally assumed to be innocent and pure, to capture the annoyance and bitterness of life.

Basically, these children are almost bald, maybe only a few of them have some hairs on their skulls. The hairs are clearly separated from each other and embarrassingly sparse. The allusion to Fung Lijun's rascals still emerges here — these few hairs molest the senses of the viewer, especially because they are presented in a disgusting and uncomfortable way. Through these details, Fang again reveals his low opinion of indulgence in beauty.

Infants and children, rather than grownups, as a symbol of human beings, are apparently used, on the one hand, by the artist to highlight the helpless and fragile status of human beings. Many of his paintings are swarmed with multitudes of children or people of indistinguishable age and sex, who line up and run towards an unknown and faraway place, as if paradise lies out there. On the other hand, the sad yet happy, the ambivalent, weird, and soulless expressions on their faces seem to denote that: despite all efforts, paradise is no where to be found.

## Mountain ranges, seas of clouds and luxuriant flowers

Fang Lijun reflects again and again on "space" and "environment" and the message signs hidden in them during every stage of creation, as one of the elaborating methods to make his subjects rich, intense and offer multiple meanings.

In the mid eighties, the people and places around his hometown were still the subjects of Fang Lijun's works: the scenes featuring stooping hunchbacked people walking along narrow, high-walled alleys doubtlessly give viewers a hint of a stagnating and obscure state of mind. Starting from the end of the eighties, the artist drew his protagonists from the compelling space blocked by high walls and re-installed them in scenes with wide stretches of vision; behind the lazy and idle people in the pictures

lies the skyline and sea horizon. This was a time of commotion. These works outlined the dream of liberating freedom of a whole generation in a very simple way, digging out the desire to empancipate the soul concealed deep inside everyone's heart. Then, at the beginning of the nineties, the protagonists in his pictures were entirely surrounded by unlimited expanses of water. This staged atmosphere occupies the two extreme poles of psychological states of the viewer with great effect — from the peacefulness and silence of one's soul to the horror and fear in the struggles for life.

From the end of the nineties up to now, spacious scenes appear massively in Fang Lijun's work. They are set in the middle of a surging sea of clouds, on top of layered mountain ranges, and upon seas of luxuriant and brightly-colored flowers. Crowds of people with indescribable expressions are portrayed to be in the situation where their feet do not touch the ground, so it is hard to tell if they are soaring or descending. Their eyes look as if they are collectively frightened by or longing for something unknown.

Fang Lijun is very good at and is always fond of exploring the kind of collective existence which is indescribable, vague, and mixed with pain and happiness, and the sublime and the decadent, while systematically and repeatedly deliberating upon paradoxes. This manifests Fang Lijun's two preferences in creation: one is to focus on the inner discourses of the work, the other is to provoke and disappoint us because we are used to assume that "art" serves to please us. For example, in the colorful, bright , gorgeous scenes resembling the Garden of Eden, Fang Lijun feels forced to do damage by implication, creating an extravagantly gorgeous atmosphere that seems to conceal something disturbing and evil. As a whole, it carries something unreal, as if it is following a dull pattern, which reveals precisely that Fang Lijun has never been tamed.

If the black and white "monochrome" is the means of experimenting, exercising and thinking for every new stage of creation, his works in color show a bold brushwork after his thoughts have matured and he can master them totally. Fang Lijun's color paintings have a unique color sense with high degrees of saturation and decoration. It is strangely beautiful, like the paints were painted on the canvas directly and without being mixed after having been pressed out of the tube. Furthermore, the bright colors seem so showy that they are almost as dazzling as those of acrylic paints. All of the big and fleshy peonies, which traditionally symbolize wealth, class and happiness, look like artificial flowers made of plastic, and people in strangely orange tones in the paintings also look like artificial beings with plastic skins. Their smiles appear very dishonest; they are examples of fake smiles. The pretentious, dramatic and unreal beauty and glamour gather to make an intentional mocking of the "propaganda sample" in all his paintings. It is precisely this kind of seemingly inattentive and rascal-like mockery and scorn that is more effectively provocative than loud cries. These works have inevitably influenced the trend of kitsch emerging since the middle of the nineties in contemporary Chinese art.

## Huge hand in the sky

Another important sign appearing in the same period of layered mountain ranges, seas of clouds and luxuriant flowers is a huge hand abruptly stretching out from the big sky. This huge and sturdy hand

holds a handful of flowers to scatter them on earth, or holds, grips and takes care of a new-born baby, or reaches out farther towards the sky, as if it is calling out or longing for something.... Usually, only a small section of the wrist and the hand itself are shown on the canvas, and the artist never explains to what person (or deity?) the sturdy hand belongs. It on the one hand seems to symbolize religion, the cosmos, or the unknown and immensely mysterious, frightening extraterrestrial power, and on the other hand also symbolizes that each "man," tiny as he is, has the ability and power to understand himself, the other people, and the life of the entire world and its future. It symbolizes the last ray of human kindness, sincerity, and hope.

## Birds, bugs and fishes

Fang Lijun is a person who never stops thinking. Those who are acquainted with or have interviewed him easily find that his way of thinking, the way he expresses himself verbally, and the content of his creation are all unusually intent on logical structure and repeatedly dialectical. Fang Lijun never forgets that there are two or even more sides to one thing. Therefore, all of his discourses, no matter they stem from everyday life or from artistic creation, address nothing which is absolute; all of them are meticulous and complicated.

After his series of brightly colored and beautiful skies, Fang Lijun has recently been developing new signs in his works. Various kinds of birds, bugs and fishes appear in his new pictures. They are originally the motifs and taste in the traditional lives and paintings of men-of-letters in China, in which "flowers, birds, bugs, fishes" are thought of as elements of easy and leisurely pleasures. However, they mean something totally different in Fang Lijun's works — the flowers, birds, bugs and fishes in his work appear in huge amounts of thousands or ten-thousands, which sometimes move towards the same direction collectively, remorselessly and quickly like flying arrows, and sometimes seem to be caught in and worn out by a powerful, huge whirl.... When we look at the flowers, birds, bugs and fishes carefully, they seem to be struggling with their fate, or exhausted as if they are about to die and fall at any moment. Of course, there is still part of them whose time has not come yet and who are full of vigor, and part of them who are at the stage of caterpillar.... Most of these paintings are huge, ranging from three to ten meters, and because the bugs and birds are so numerous, most of them have to be painted carefully in extremely fine lines, as are those depicted in the realist tradition of quill painting. These paintings directly impact on the impressions of the viewer, as if they are a Buddhist verse about death, and about life and extermination, addressing the most real and insuperable sufferings of every individual.

At the moment when an individual is confronted with the dilemma of life and a group of people with the collective predicament, the most precious merit of contemporary art is that some artists resort courageously to art to confront the collective fate of human beings, despite that they have to choose to escape in everyday life, "and use art to deal with, to discuss these questions," in the words of Fang Lijun.

These words doubtlessly betray what significance and values Fang Lijun has expected for himself

as an artist. And since contemporary art eventually embodies the meanings of its time and culture, an artist should not only give expression to his time of the moment in his specialized domain of "art," but also contemplate on his time, and question and investigate the mainstream values and power mechanisms with a greater courage and a broader point of view, before he expresses hopes of kindness and generosity for the future. Thus, art can also be seen as a Buddhist verse.

## Installations

In recent five years, concurrently with his paintings, Fang Lijun created a series of three-dimensional works. Most of them have monumental dimensions and their themes and contents are the continuation of recent themes Fang Lijun has taken interest in in recent years. The bald-headed images are clearer and stronger in the three-dimensional works, most of whom have the dull and rough bodies of middle-aged people. Sometimes they struggle and climb aimlessly among vast and varied machinery on earth, unsure about themselves, among them some are even turned into part of the machinery, with bodies connected with cables and cords. Sometimes, they are like caged beasts crying and begging soundlessly, with some of them even squeezed into transparent tubes and become preserved bodies in formalin liquid, while leaving a strange impression of coolness and peaceful silence, of the eternal elimination of earthly sufferings, with no birth and no death, no cleanness and no dirt, a sublime, nirvana-like silence.

In one of his recent work (*40800mm*), a transparent road of 40.8 meters in length, made of acrylic, showing the human development from the embryonic stage to infants, climbing babies, children, teenagers, grownups, middle-aged adults, hunchbacked old people, and finally the death of flesh. This work embodies all of the physical images of human being as flesh and blood, as well as the ever-changing impermanence. With this reflection, Fang Lijun makes the viewers share the Buddhist wisdom of birth and death. (text by Hu Yung-fen, trans. by Tsuei Yen-huei)

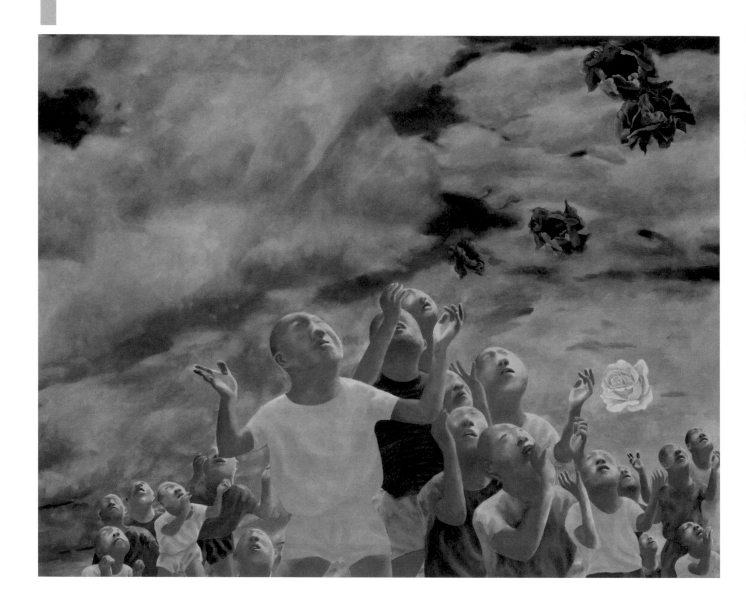

1999.12.31　110×140cm　油彩、畫布　1998-99　楊濱先生收藏
1999.12.31　110×140cm　Oil on Canvas　1998-99　Mr. Yang Bin

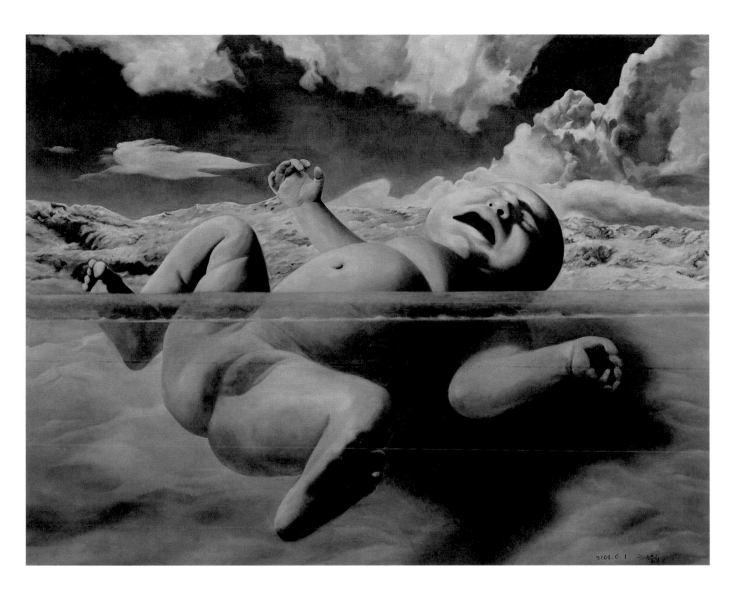

2004.6.1　116×180 cm　油彩、畫布　2004　印尼 CP基金會收藏
2004.6.1　116×180 cm　Oil on canvas　2004　CP Foundation, Indonesia

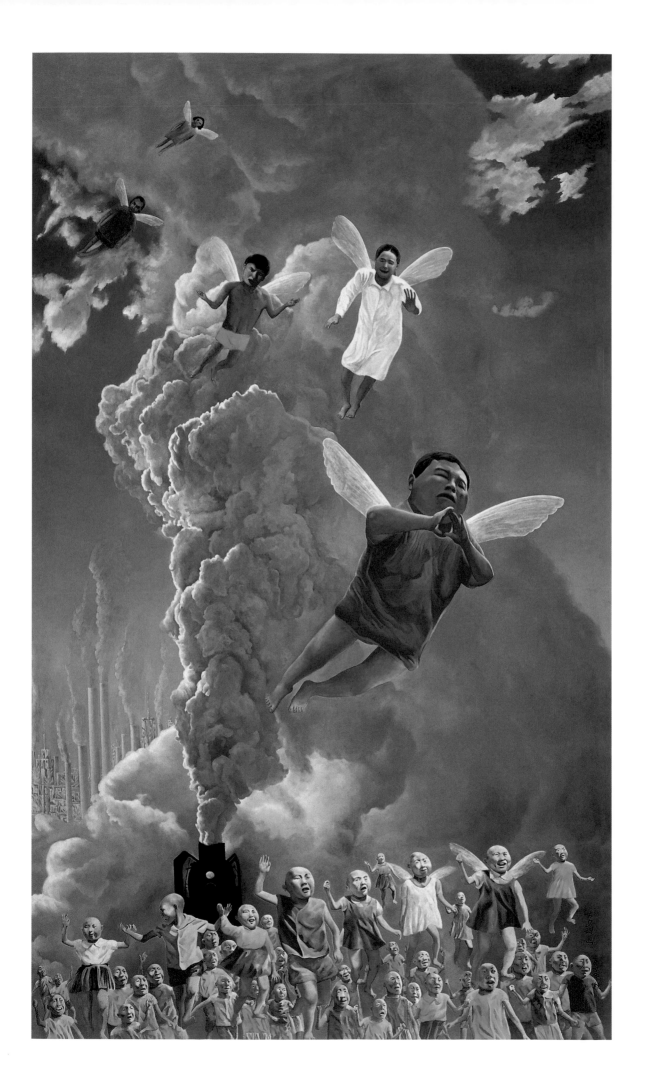

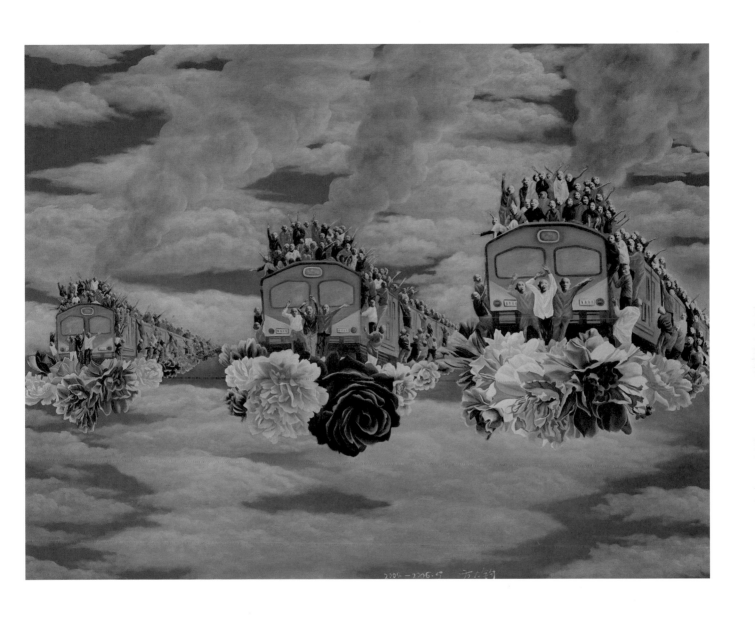

Left：
2004 秋　303×176cm　油彩、畫布　2004　藝術家自藏
2004, the autumn　303×176cm　Oil on canvas　2004　Collection of the artist（左頁圖）

Above：
2004-2006.5　140×180cm　油彩、畫布　2004-06　今日美術館收藏
2004-2006.5　140×180cm　Oil on canvas　2004-06　Today art Museum（上圖）

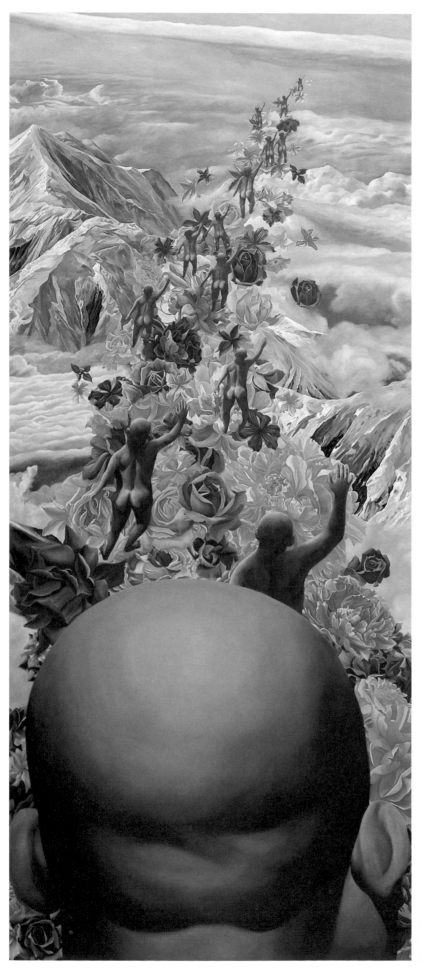

2004.12.4 油彩、畫布 400×175cm
2004 吳青峯先生收藏

2004.12.4 Oil on canvas 400×175cm
2004 Mr. Wu Ching Fong

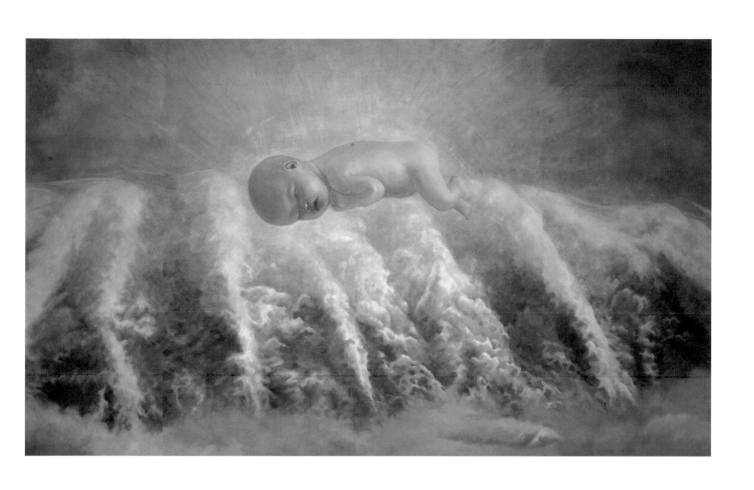

2005.6.1　400×705cm　油彩、畫布　2005　張晧銘先生收藏
2005.6.1　400×705cm　Oil on canvas　2005　Mr. Zhang Haomung

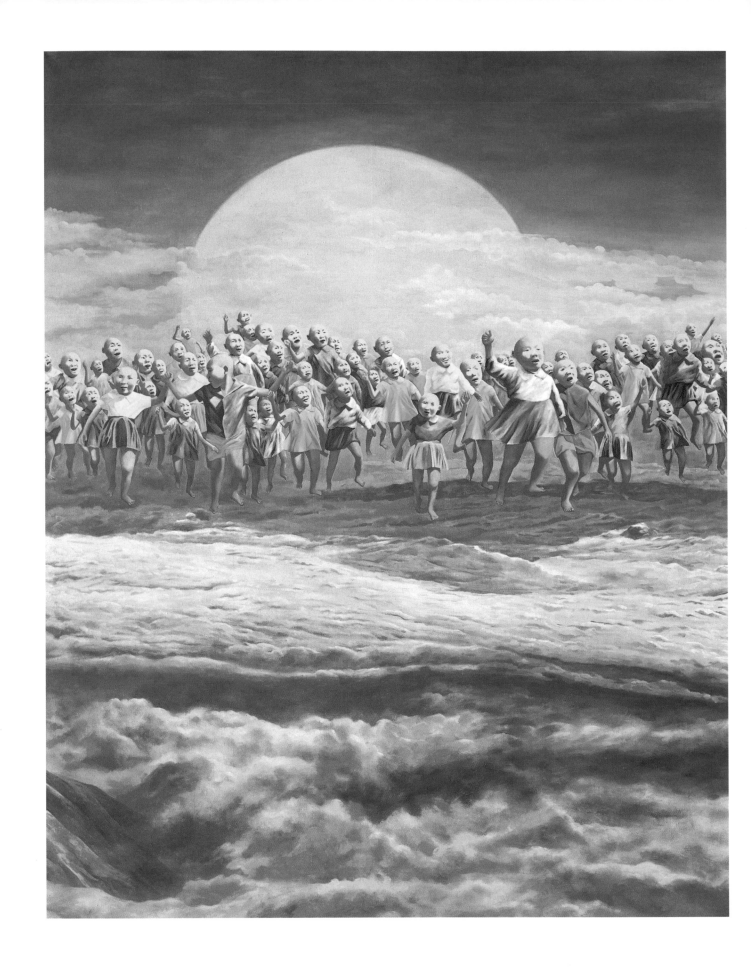

2005.6.23 230×180cm 油彩、畫布 2005 印尼 CP 基金會收藏
2005.6.23 230×180cm Oil on canvas 2005 CP Foundation, Indonesia

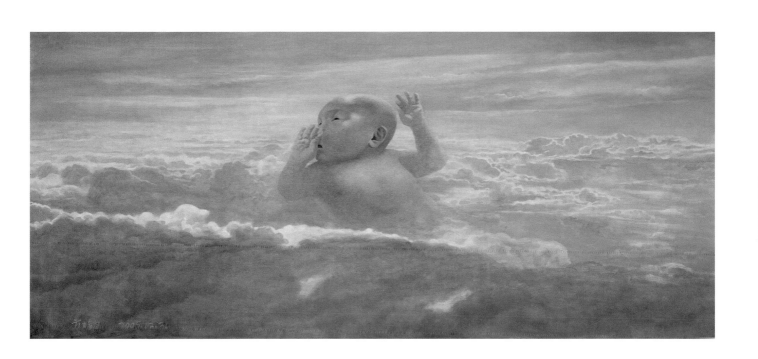

2005.12.31　85×180cm　油彩、畫布　2005　譚國斌當代藝術博物館收藏
2005.12.31　85×180cm　Oil on canvas　2005　Tan Guobin Contemporary Art Museum

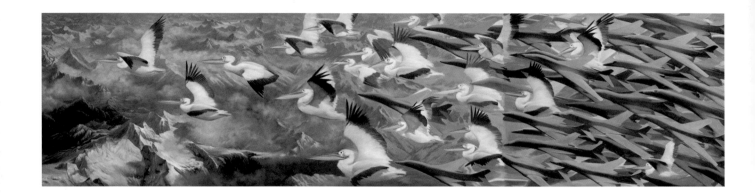

2006.5.5  170×750cm  油彩、畫布  2006  88 MOCCA 中國當代藝術博物館收藏
2006.5.5  170×750cm  Oil on canvas  2006  88 MOCCA Museum of Chinese Contemporary Art（p 165 - 167為局部圖 detail）

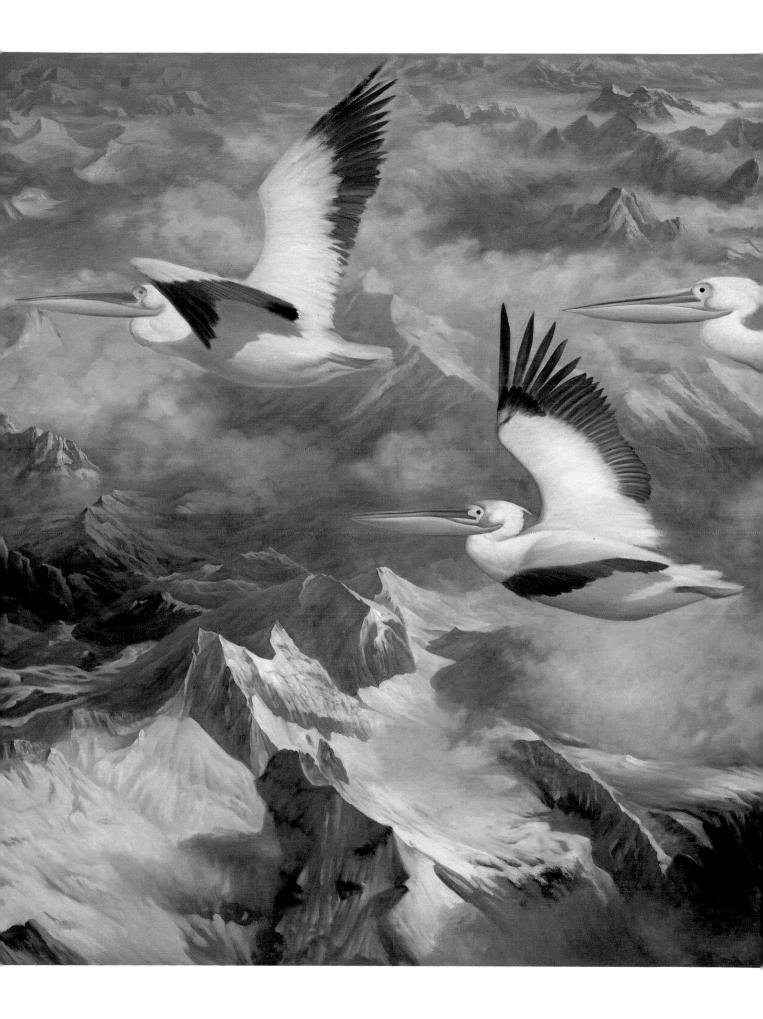

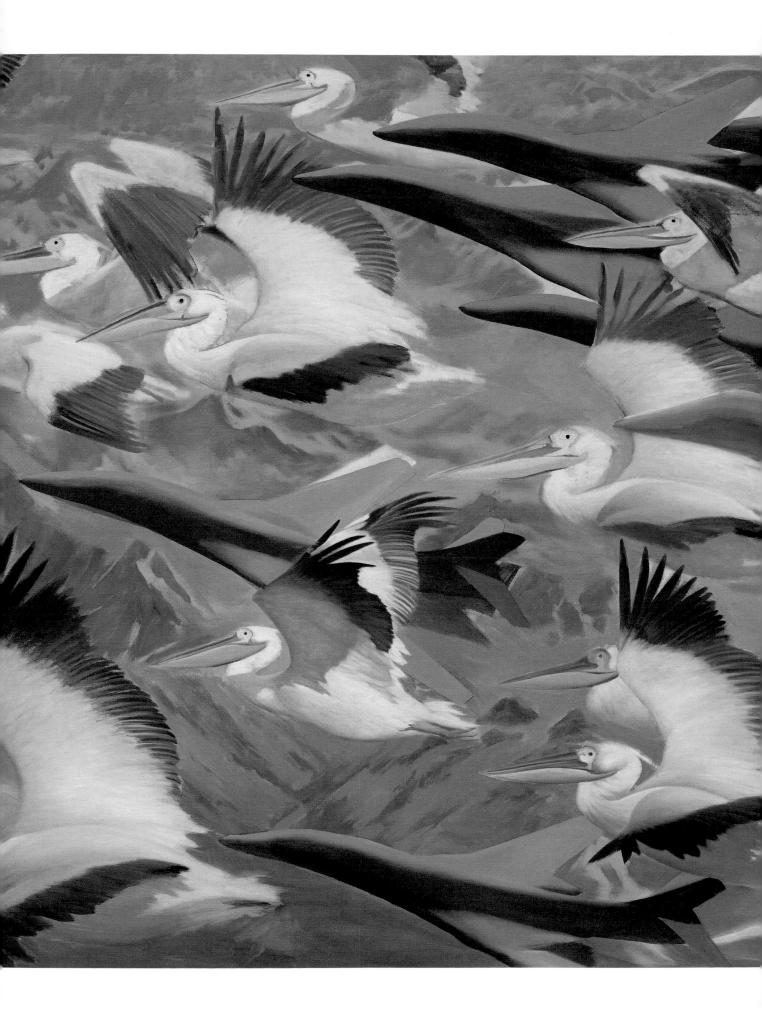

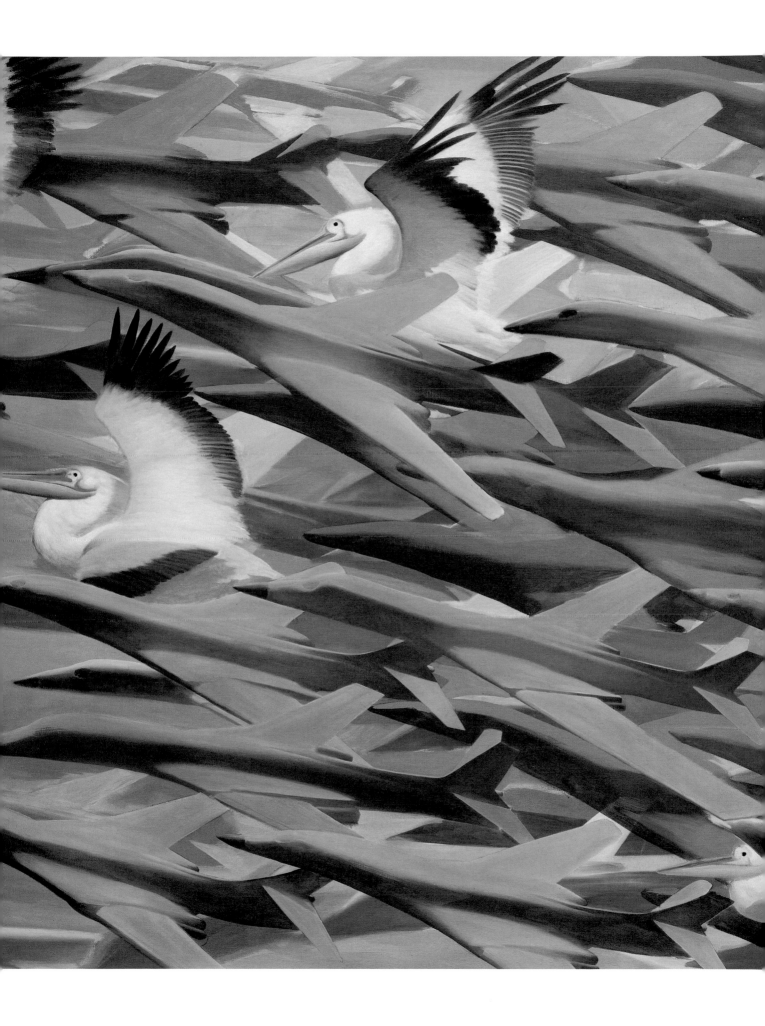

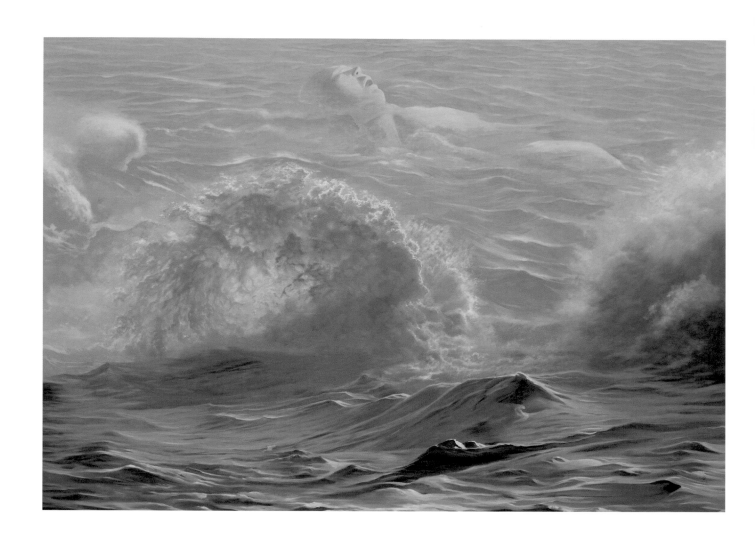

2006.5.30　250×360cm　油彩、畫布　2006　印尼 CP基金會收藏
2006.5.30　250×360cm　Oil on canvas　2006　CP Foundation, Indonesia

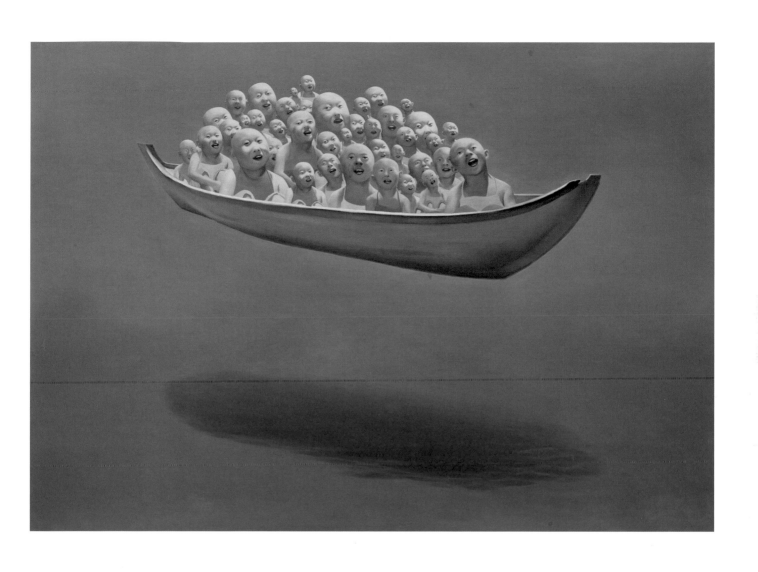

2006.6.1　180×250cm　油彩、畫布　2006　莎隆‧郝魯茲夫人與佩茲‧里特曼先生收藏
2006.6.1　180×250cm　Oil on canvas　2006　Mrs. Sharon Haluts & Mr. Paz Littman

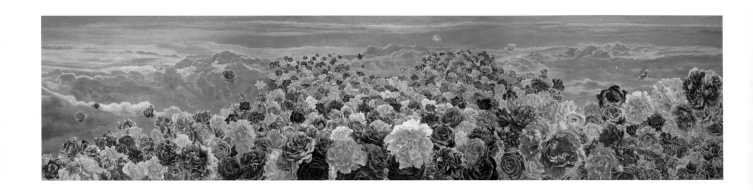

2006.6.4 180×750cm 油彩、畫布 2006 印尼 CP基金會收藏
2006.6.4 180×750cm Oil on canvas 2006 CP Foundation, Indonesia（p 171-173頁為局部圖 detail）

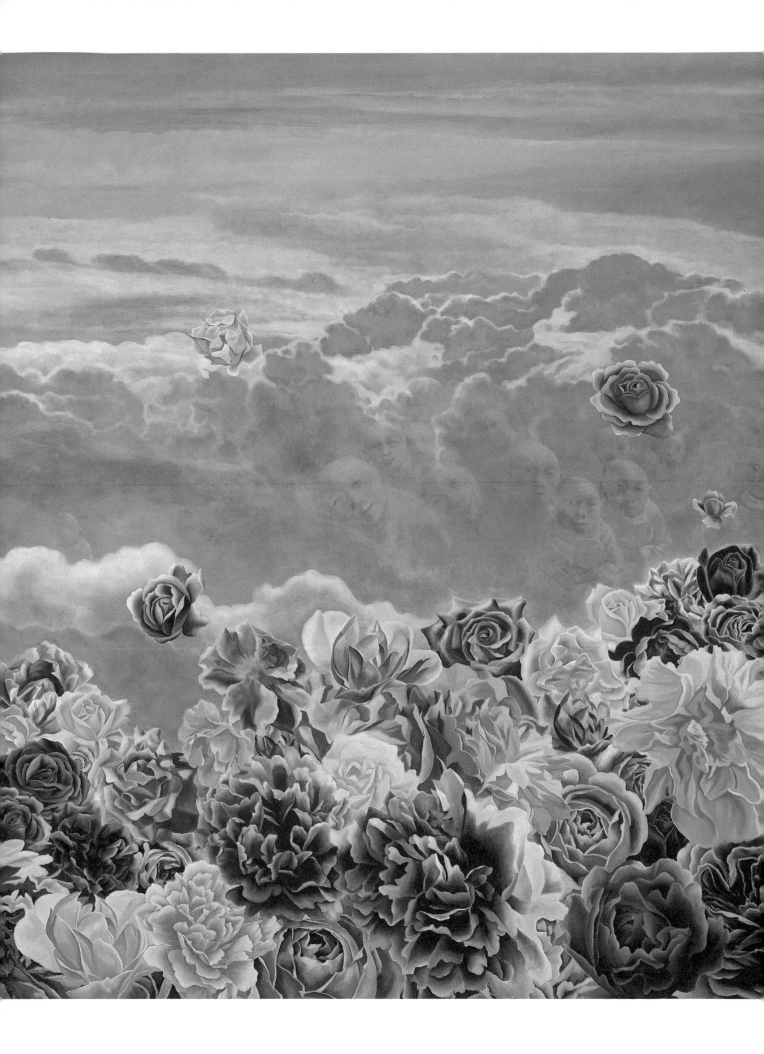

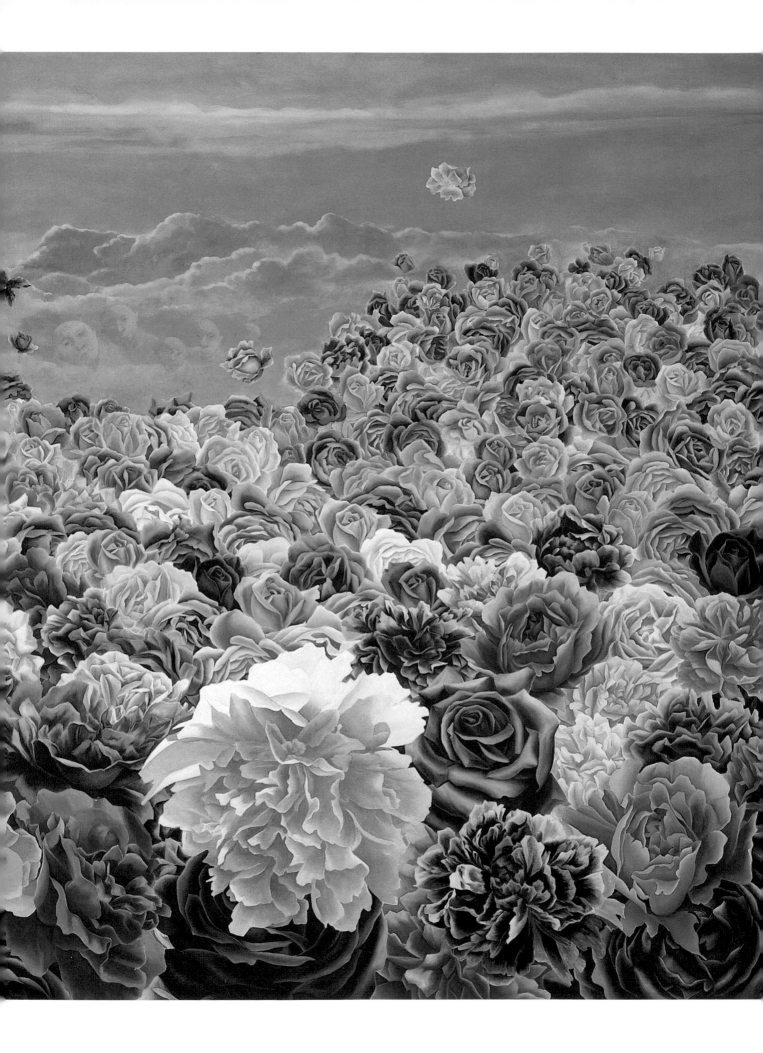

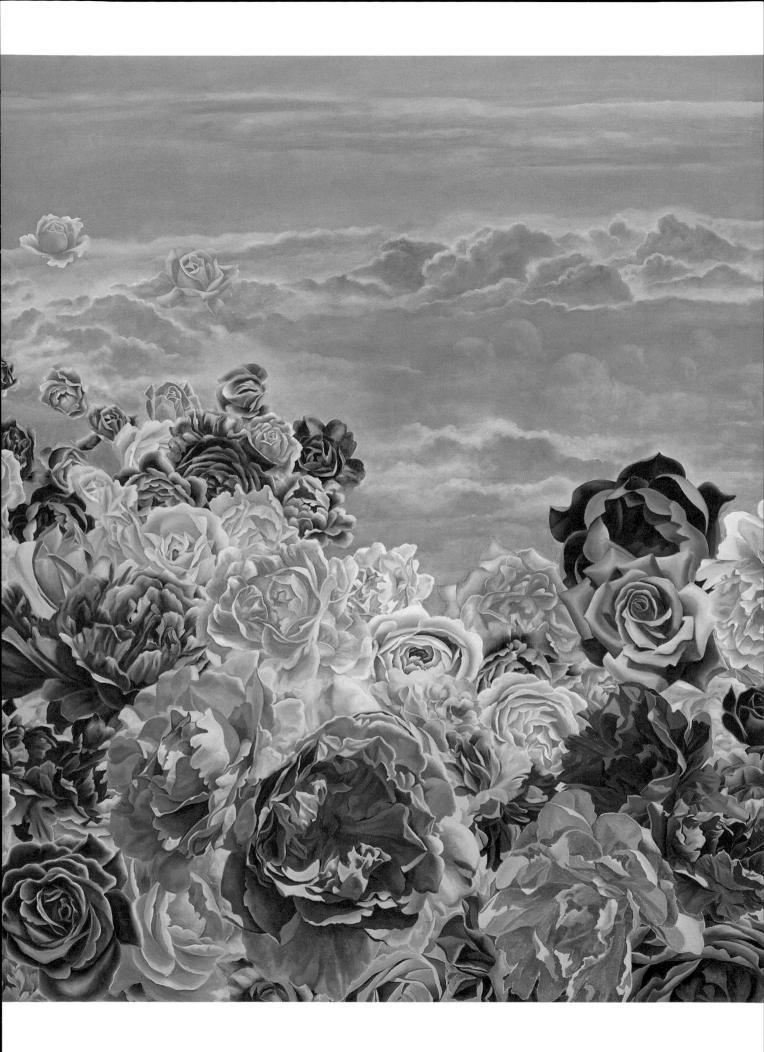

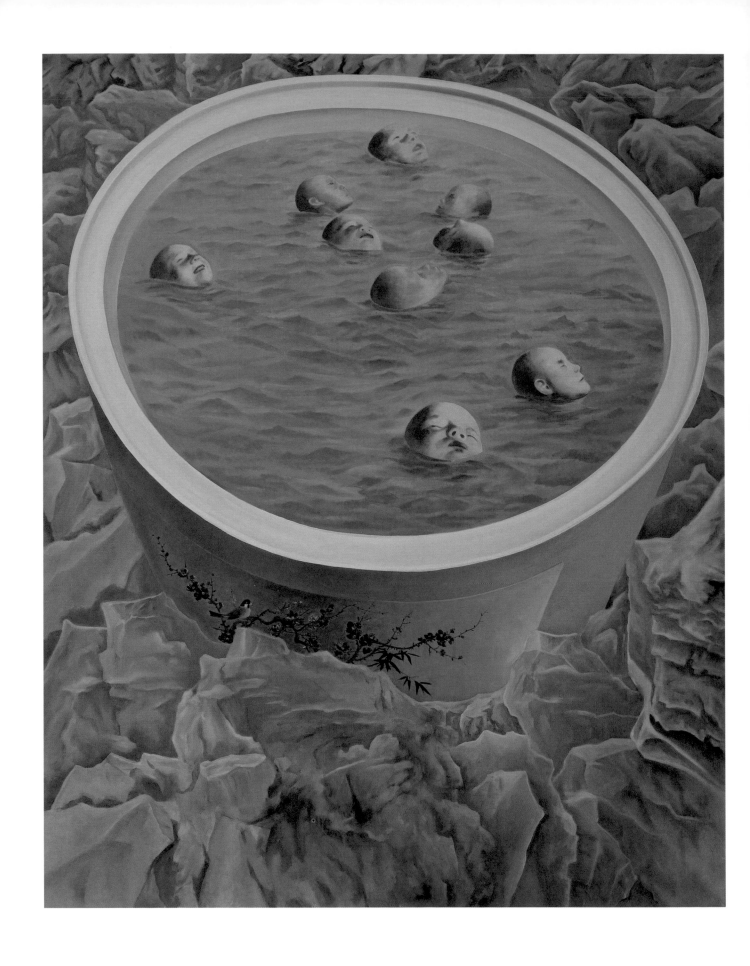

2006.6.1　162×130cm　油彩、畫布　2006　印尼 CP基金會收藏
2006.6.1　162×130cm　Oil on canvas　2006　CP Foundation, Indonesia

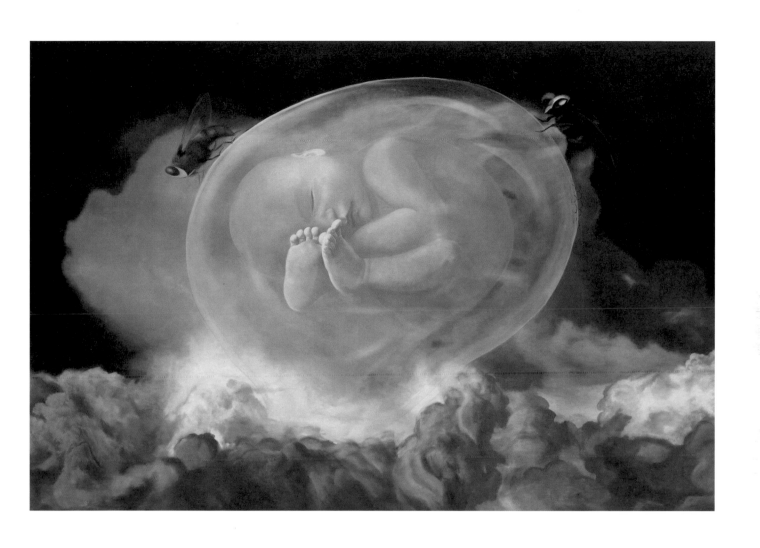

2006.7.1　250×360cm　油彩、畫布　2006　阿拉里奧機構收藏
2006.7.1　250×360cm　Oil on canvas　2006　Arario Beijing

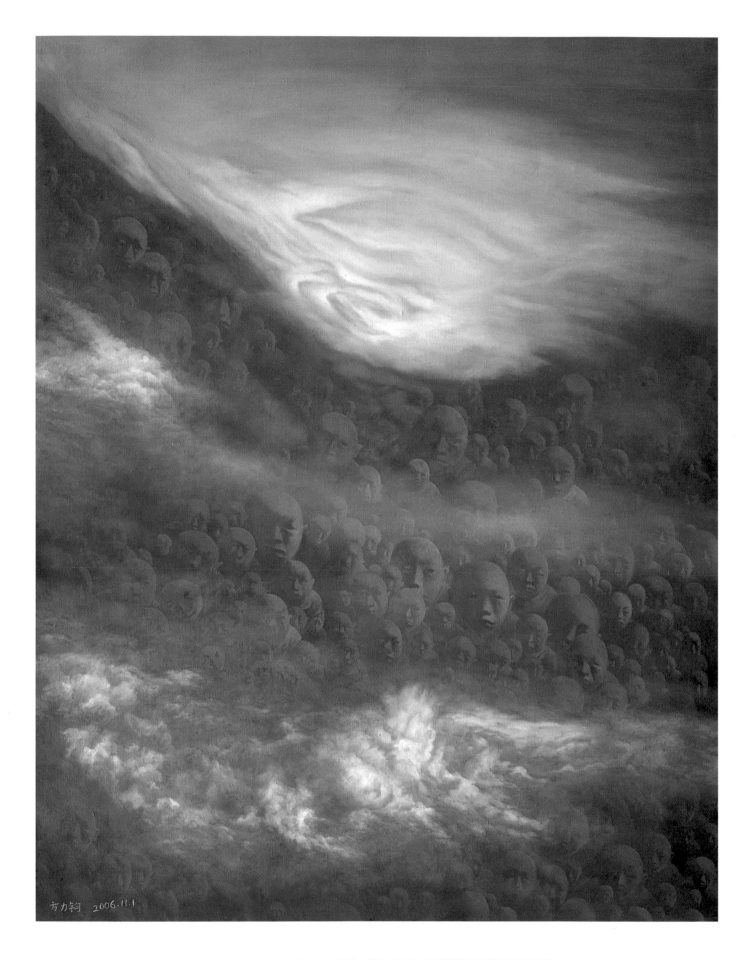

方力钧 2006.11.1

2006.11.1　179.5×138.6cm　油彩、畫布　2006　譚國斌當代藝術博物館收藏
2006.11.1　179.5×138.6cm　Oil on canvas　2006　Tan Guobin Contemporary Art Museum

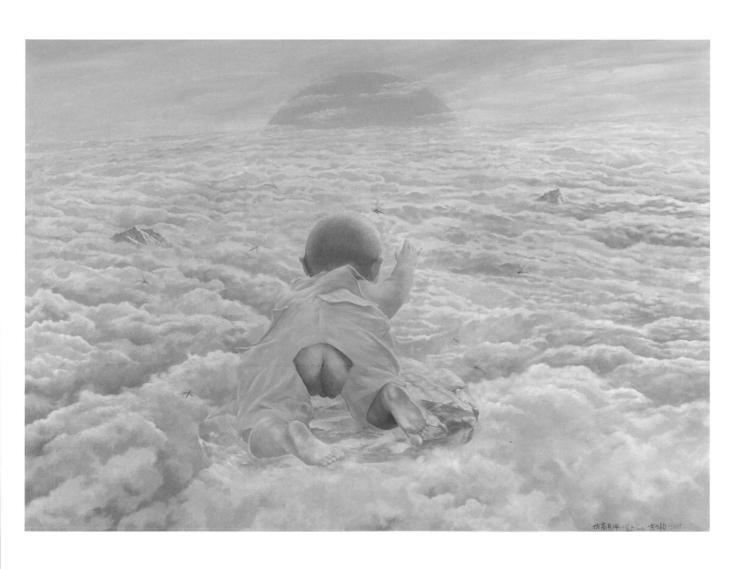

仿高其佩一覽眾山小　180×250cm　油彩、畫布　2007　上海藝博畫廊收藏
A panoramic View from the Top of Mountain　180×250cm　Oil on canvas　2007　Yibo Gallery

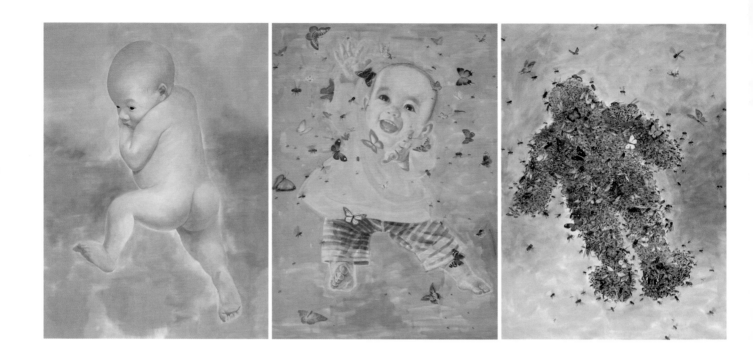

2007 1-3/ 2007 2-3/ 2007 3-3  250×180cm×3張  油彩、畫布  2007  藝術家自藏
2007 1-3/ 2007 2-3/ 2007 3-3  250×180cm×3 pieces  Oil on canvas  2007  Collection of the artist（ p 179 - 181為局部圖 detail）

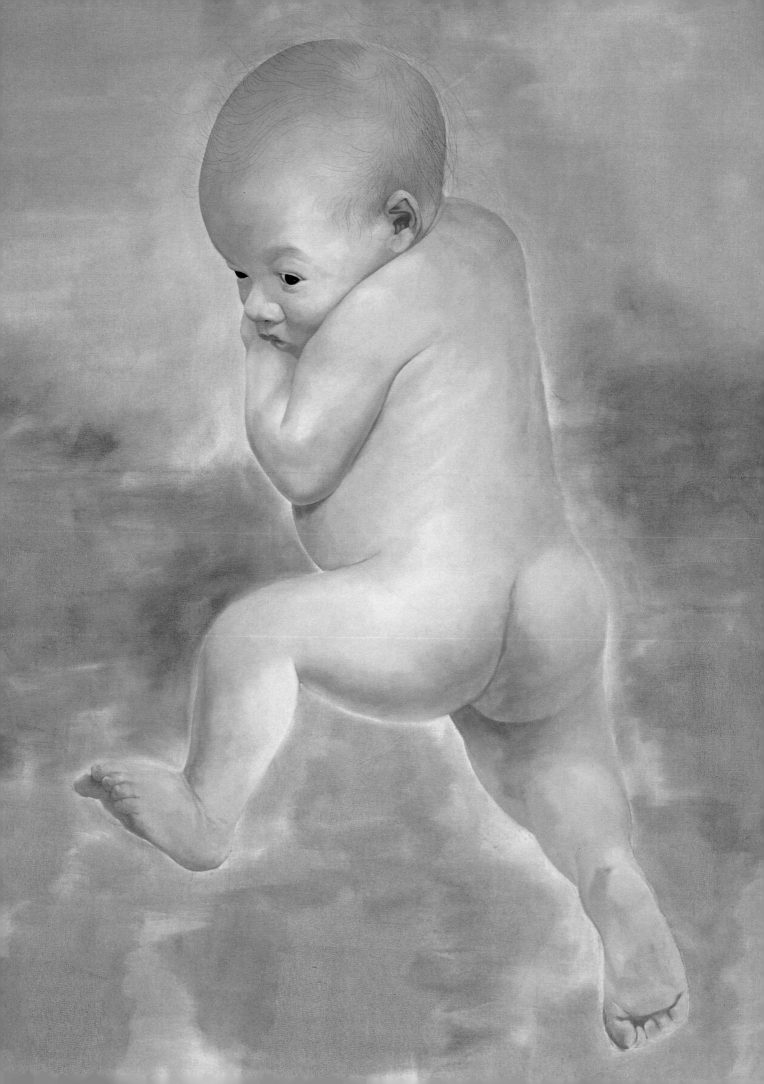

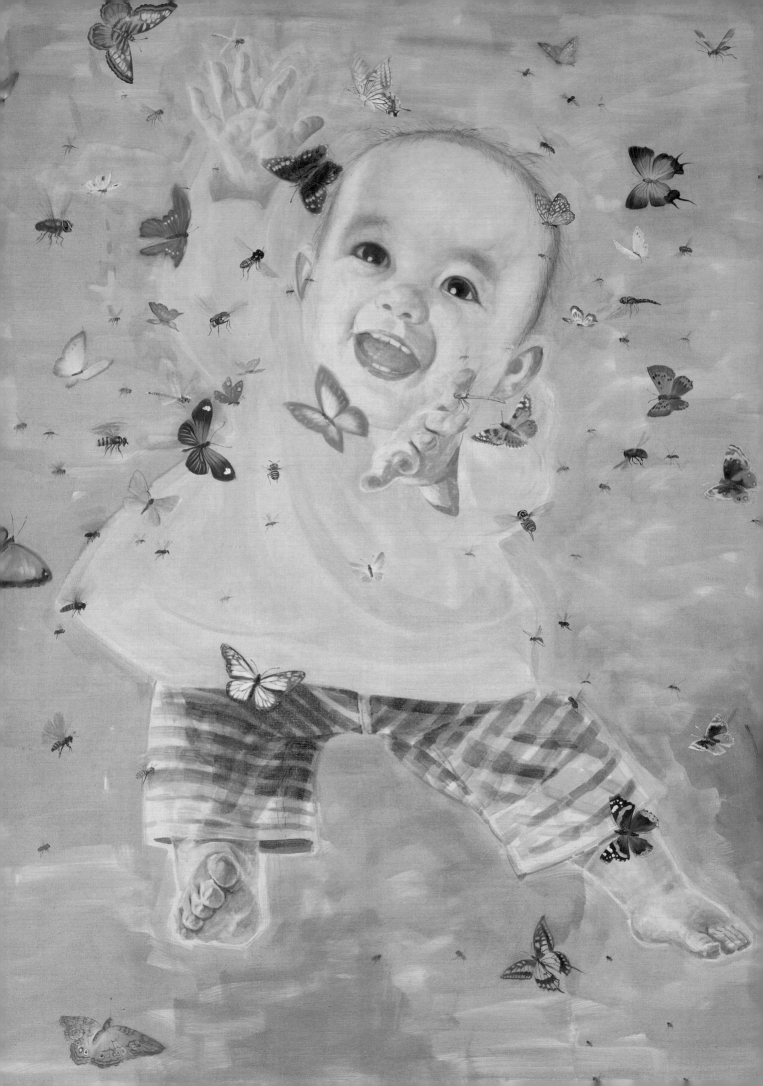

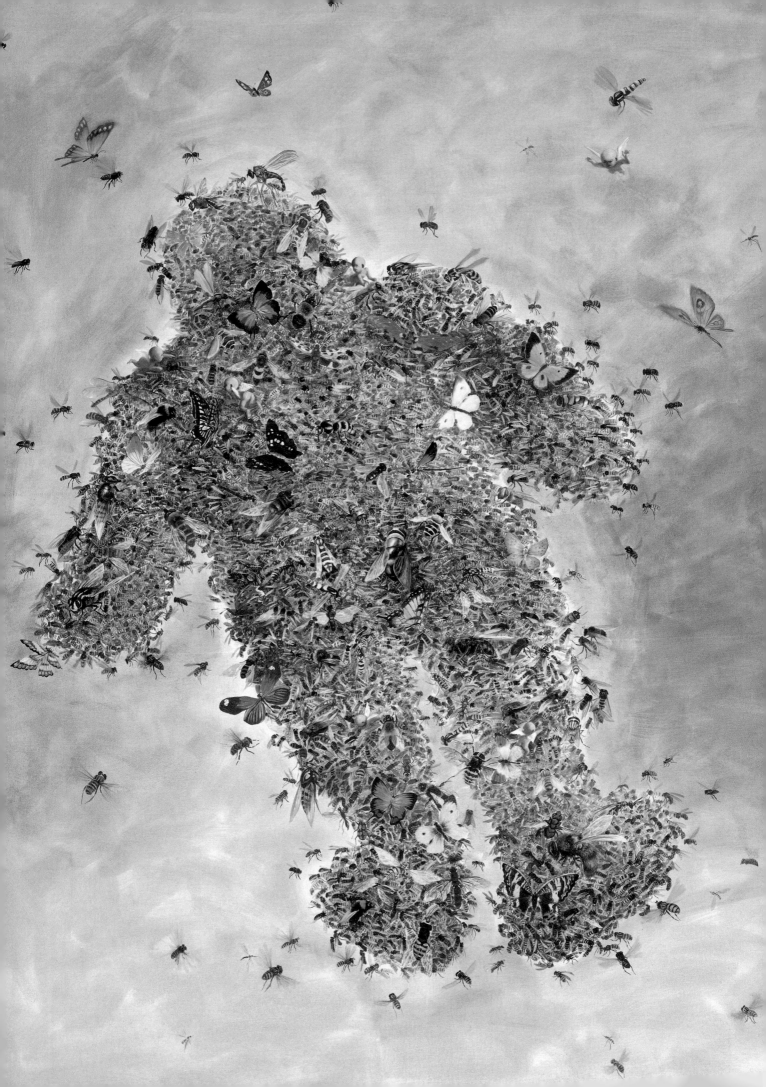

2007.8.1　120×1350cm　油彩、畫布　2007　私人收藏
2007.8.1　120×1350cm　Oil on canvas　2007　Private collection（ p.182下部 - p.189為局部圖 detail）

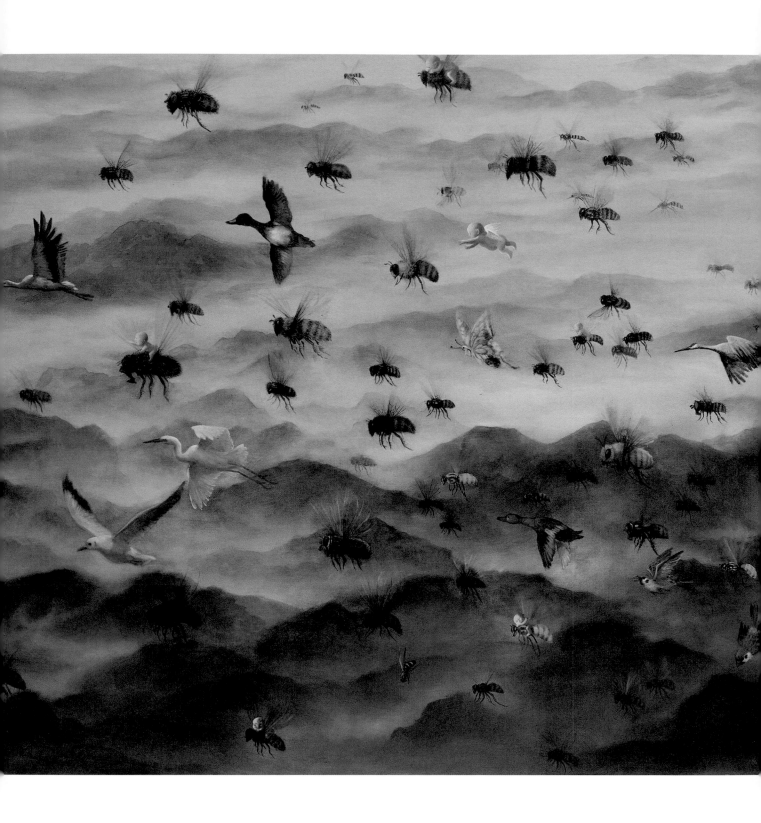

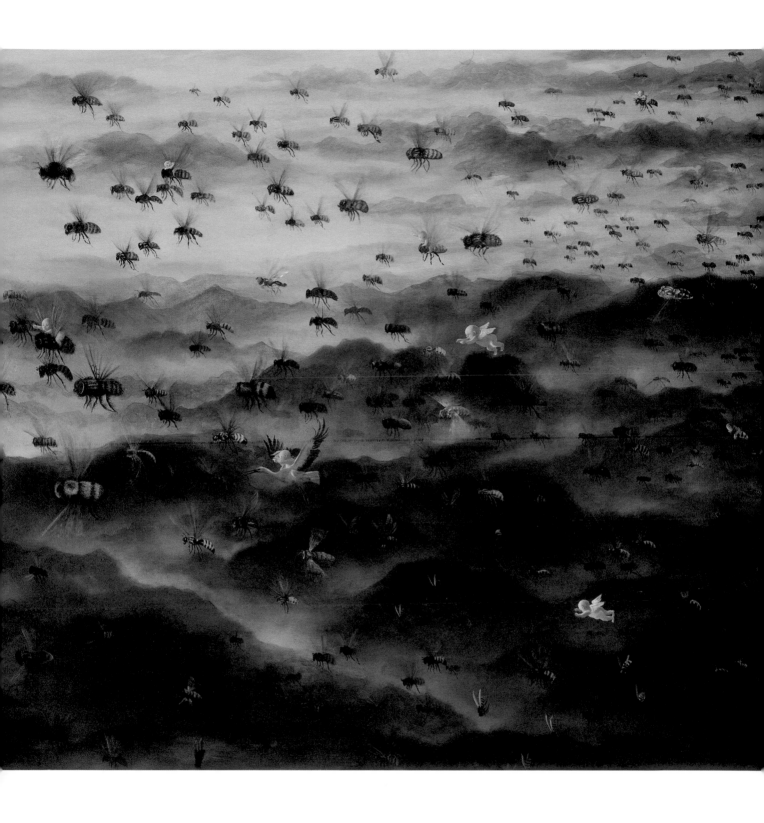

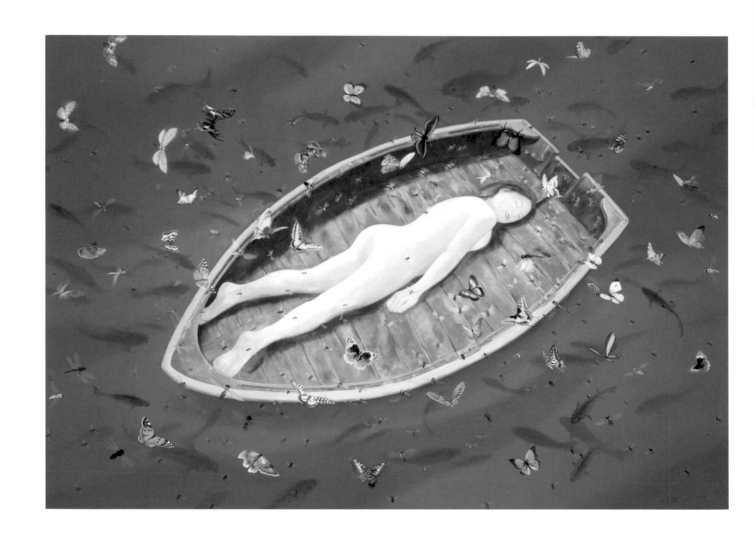

Above：
2007.7.15　250×360cm　油彩、畫布　2007　夏文菁女士收藏
2007.7.15　250×360cm　Oil on canvas　2007　Ms. IVY XIA（上圖）

Right：
無題　130×90cm　油彩、畫布　2005　印尼 CP基金會收藏
Untitled　130×90cm　Oil on canvas　2005　CP Foundation, Indonesia（右頁圖）

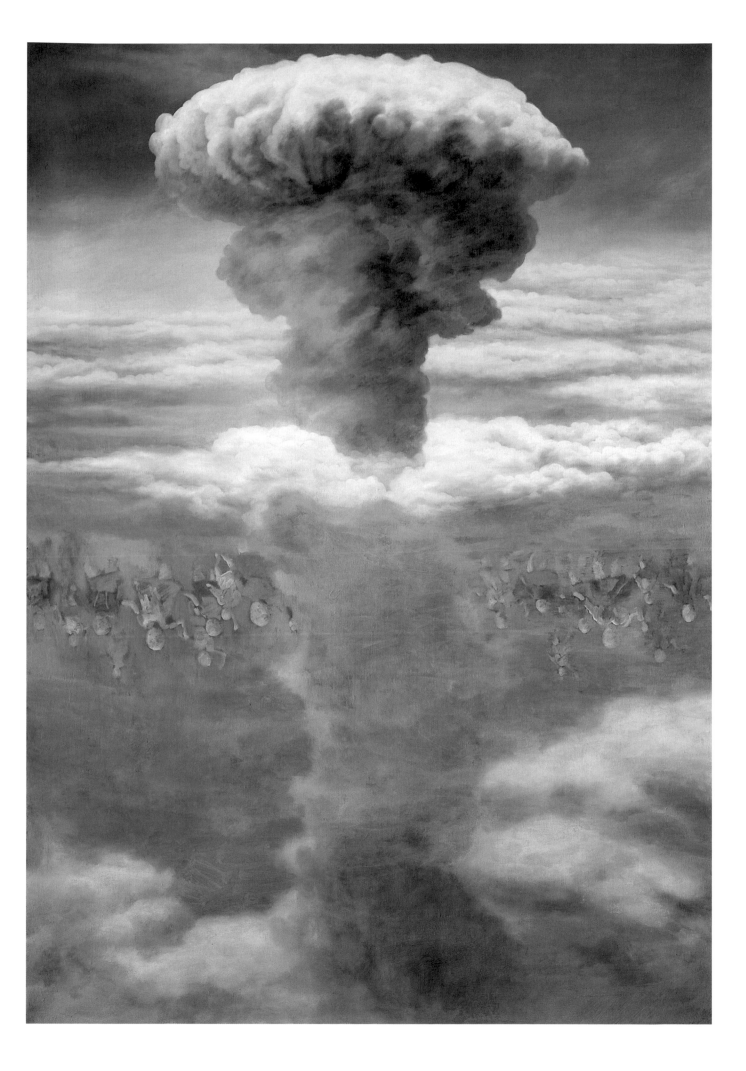

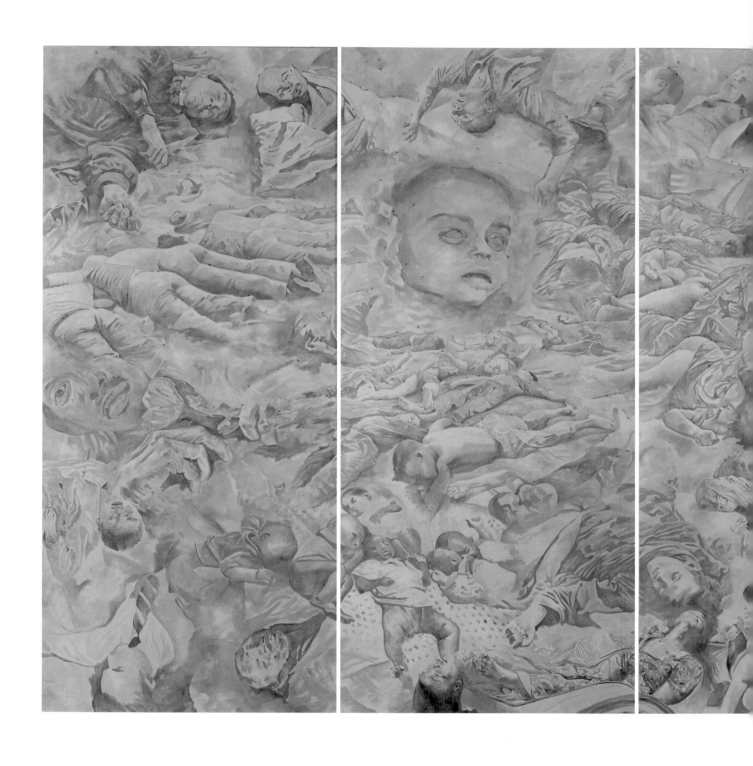

2008春　400×880cm　油彩、畫布　2008　藝術家自藏
2008, the Spring　400×880cm　Oil on canvas　2008　Collection of the artist

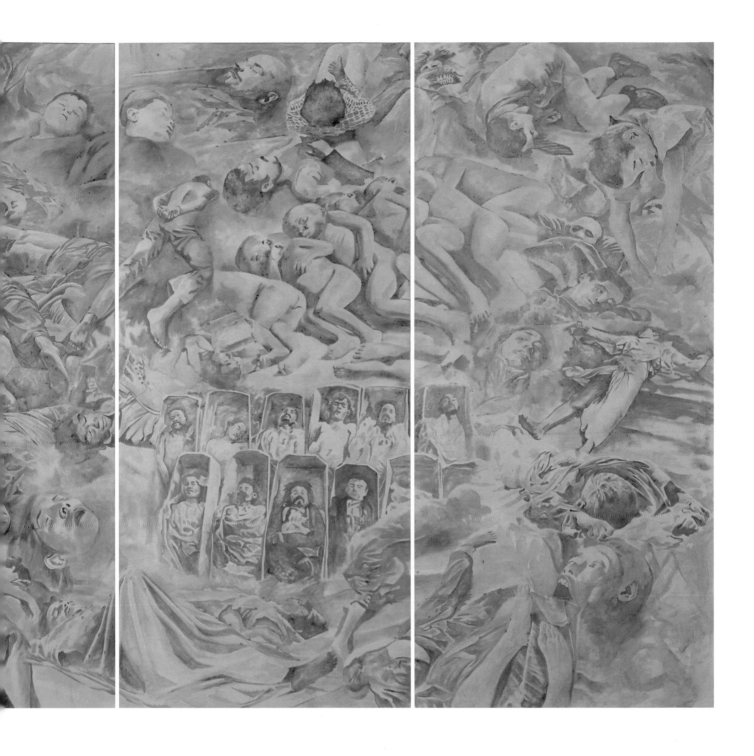

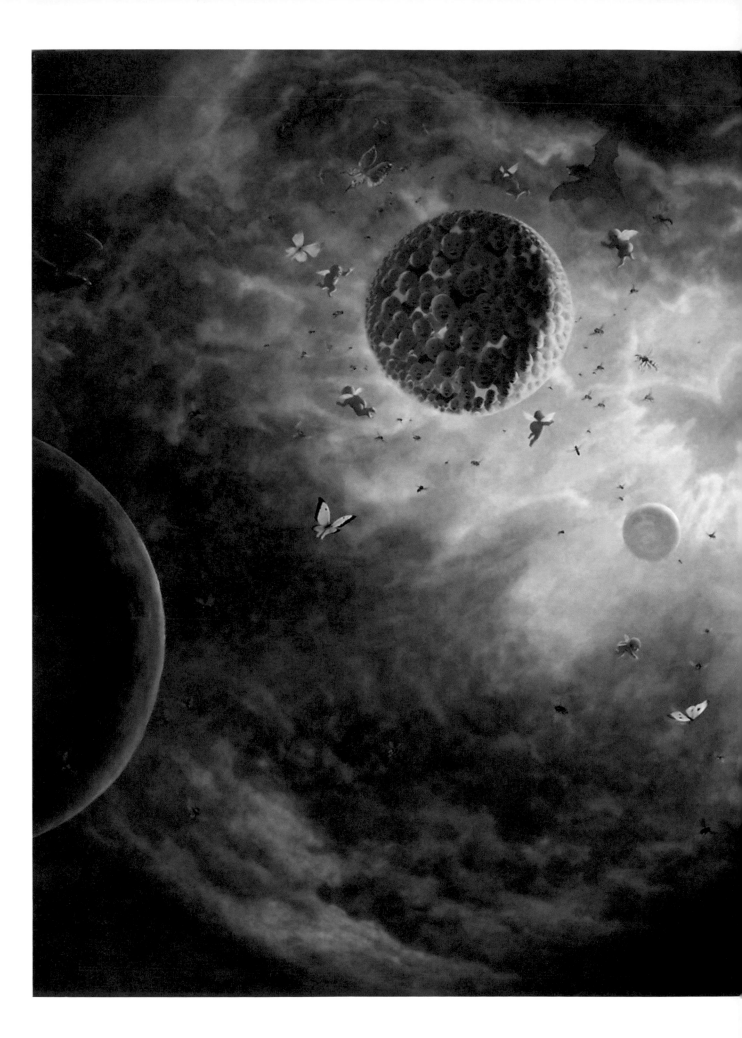

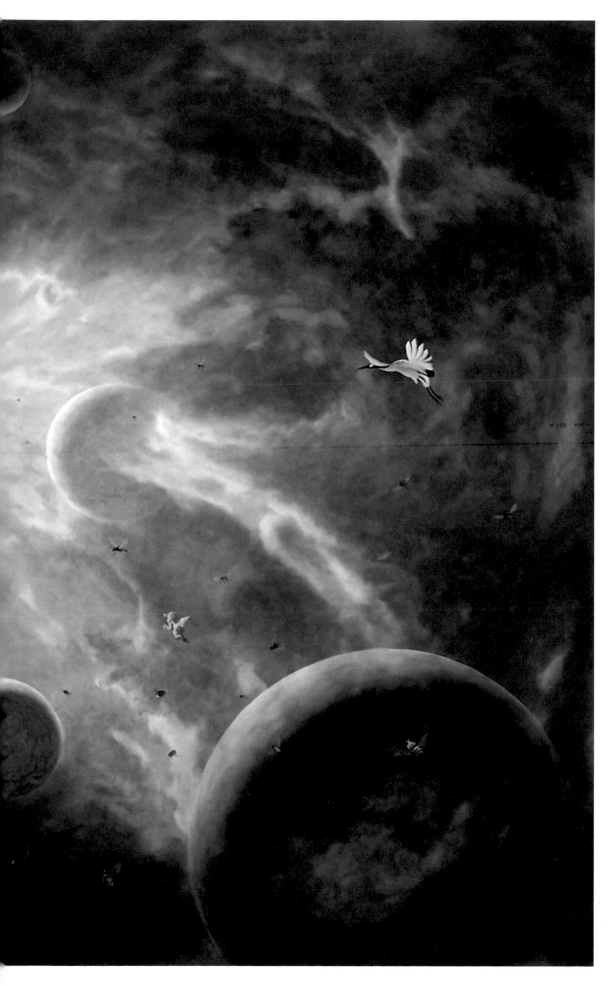

2007-2008.8
250×360cm
油彩、畫布 2007-08
私人收藏

2007-2008.8
250×360cm
Oil on canvas 2007-08
Private collection

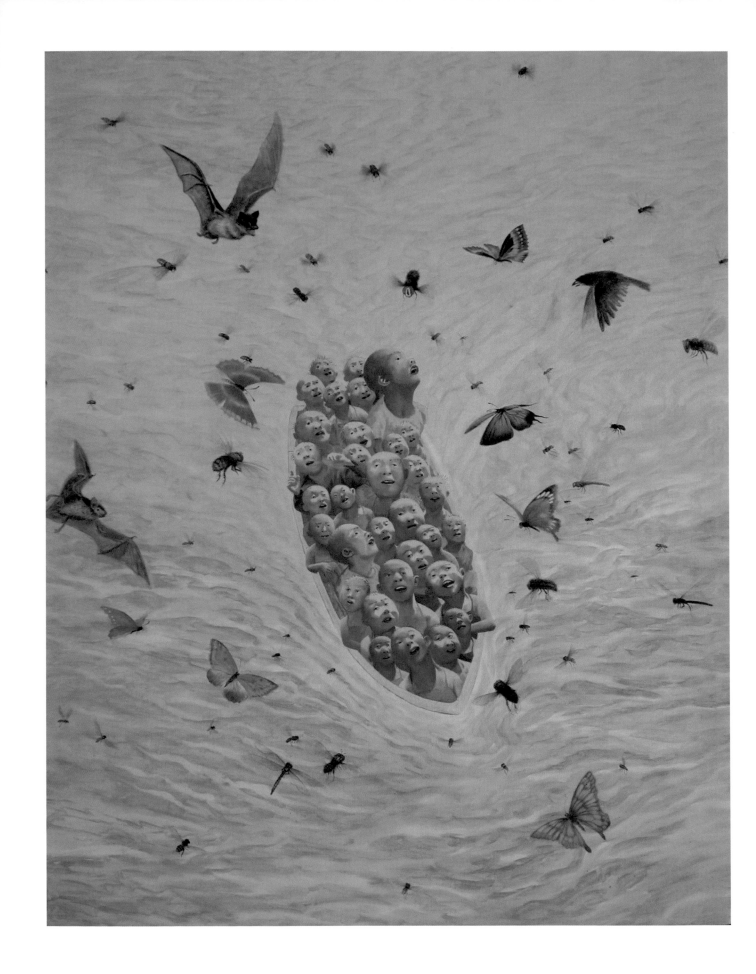

2008.5.21 180×140cm 油彩、畫布 2008 蓋翠宇女士收藏
2008.5.21 180×140cm Oil on canvas 2008 Ms. Gai Cuiyu

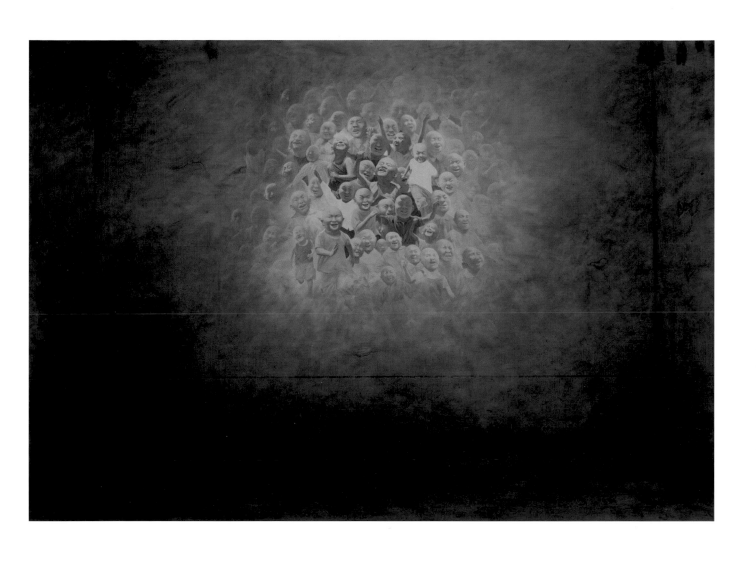

2008 秋　250×360cm　油彩、畫布　2008　私人收藏
2008, the Autumn　250×360cm　Oil on canvas　2008　Private collection

2008.10.15　250×360cm　油彩、畫布　2008　藝術家自藏
2008.10.15　250×360cm　Oil on canvas　2008　Collection of the artist

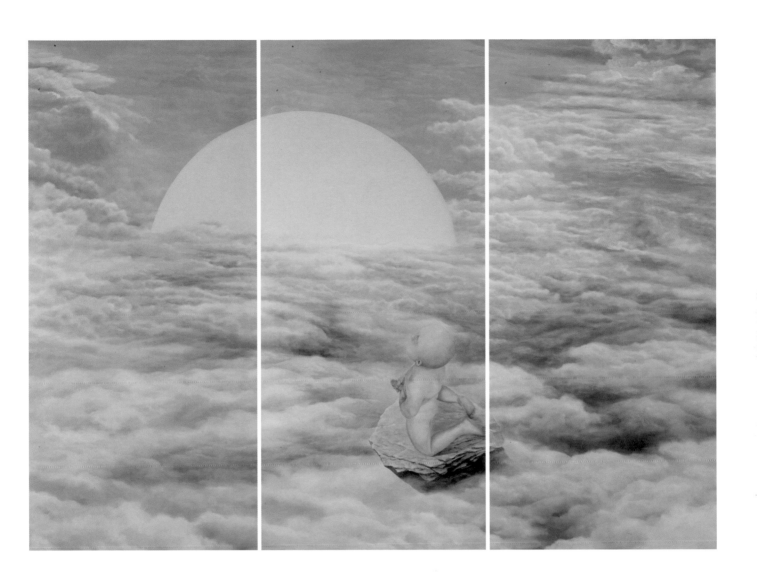

2008 夏　270×360cm　油彩、畫布　2008　私人收藏
2008, the Summer　270×360cm　Oil on canvas　2008　Private collection

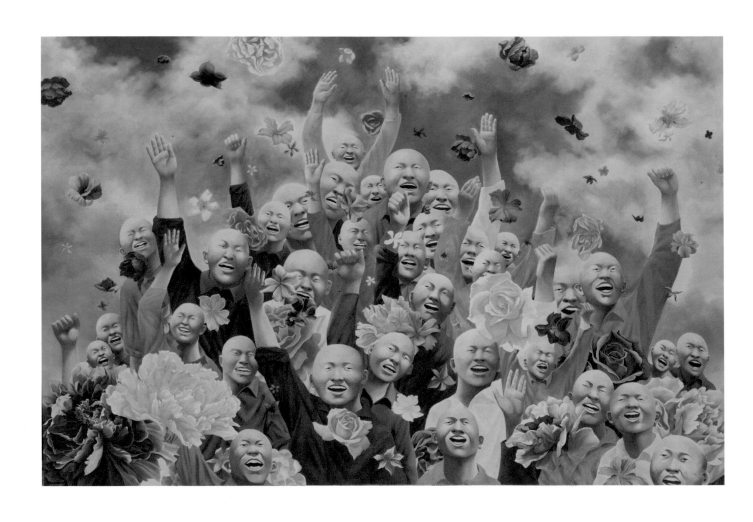

2008.5  160×240cm  油彩、畫布  2008  私人收藏
2008.5  160×240cm  Oil on canvas  2008  Private collection

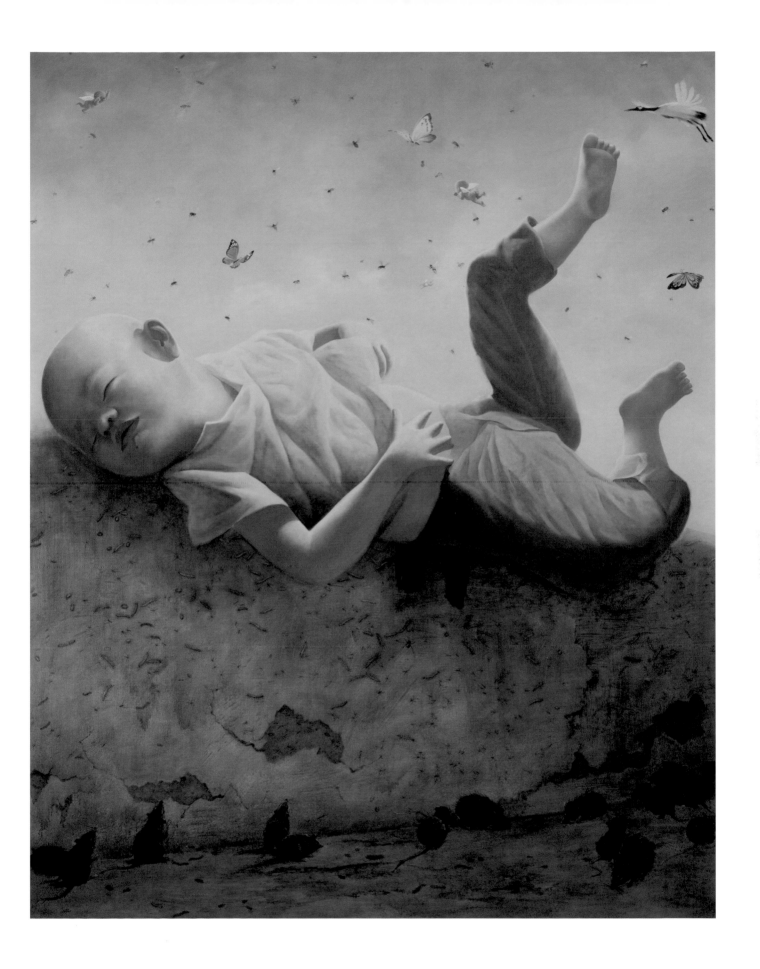

2008.6.1　180×140cm　油彩、畫布　2008　私人收藏
2008.6.1　180×140cm　Oil on canvas　2008　Private collection

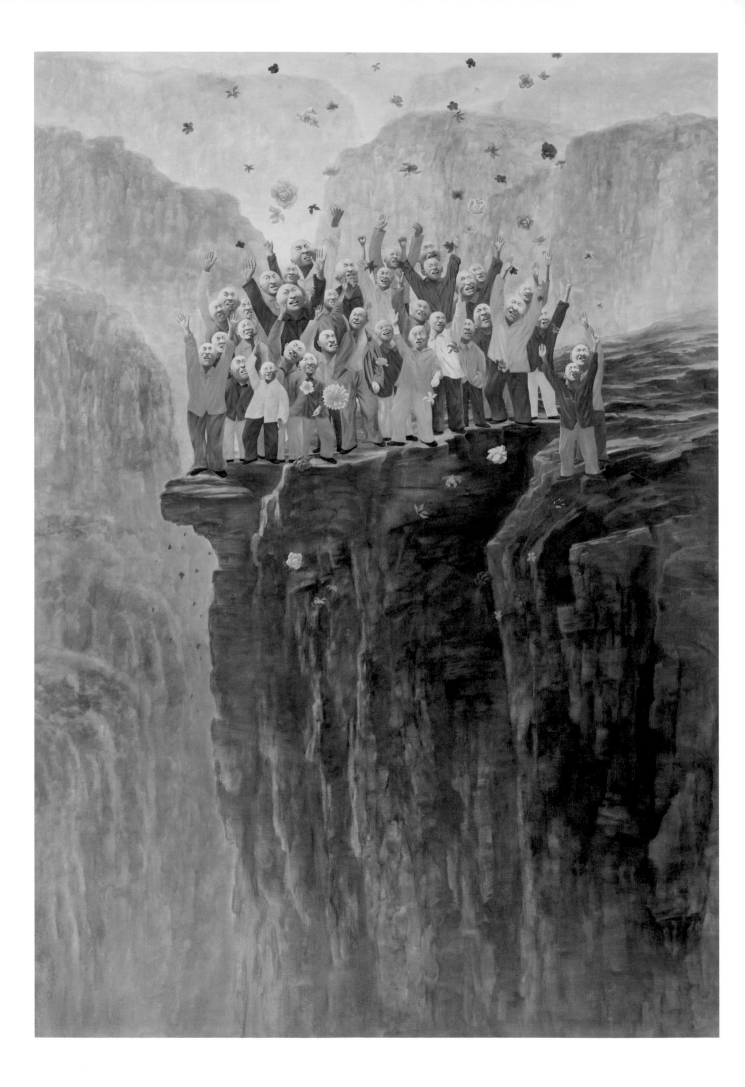

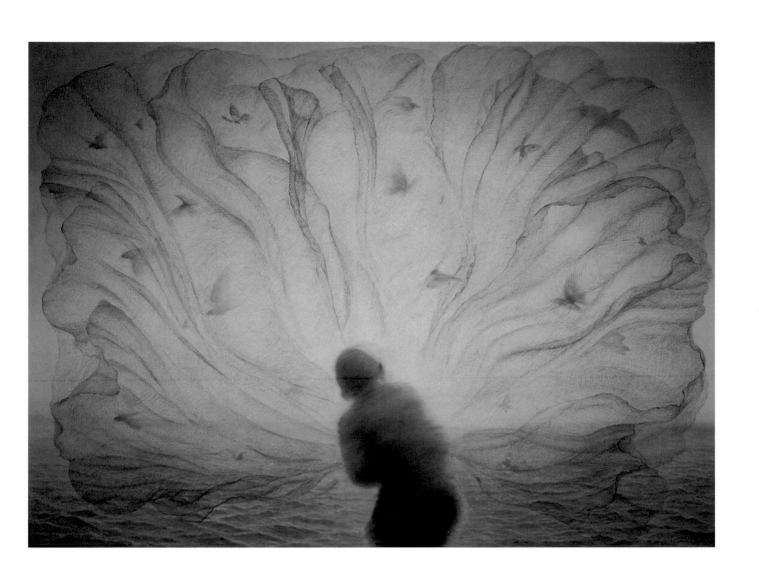

Left：
2007-2008　360×250cm　油彩、畫布　2007-08　私人收藏
2007-2008　360×250cm　Oil on canvas　2007-08　Private collection（左頁圖）

Above：
2009.1.1　180x250cm　油彩、畫布　2009
2009.1.1　180x250cm　Oil on canvas　2009（上圖）

203

2005.2.2（局部） 600×15×15cm 水晶樹脂 2005 藝術家自藏
2005.2.2（detail） 600×15×15cm Crystal resin 2005 Collection of the artist

2006 840×560×32cm 銅、金箔、鋼條、鐵板 2006 藝術家自藏
2006 840×560×32cm Copper, gold foil, steel bars, and iron plates 2006 Collection of the artist

40800mm  4080×6×15cm  壓克力、玻璃鋼等  2007  藝術家自藏
40800mm  4080×6×15cm  Acryl, painted FRP, etc.  2007  Collection of the artist
（ p.206- p.223，p.224- p.231為局部圖 detail）

40800mm 4080×6×15cm 壓克力、玻璃鋼等 2007 藝術家自藏
40800mm 4080×6×15cm Acryl, painted FRP, etc. 2007 Collection of the artist（局部圖 detail）

40800mm　4080×6×15cm　壓克力、玻璃鋼等　2007　藝術家自藏
40800mm　4080×6×15cm　Acryl, painted FRP, etc.　2007　Collection of the artist（局部圖 detail）

40800mm 4080×6×15cm 壓克力、玻璃鋼等 2007 藝術家自藏
40800mm 4080×6×15cm Acryl, painted FRP, etc. 2007 Collection of the artist（局部圖 detail）

40800mm　4080×6×15cm　壓克力、玻璃鋼等　2007　藝術家自藏
40800mm　4080×6×15cm　Acryl, painted FRP, etc.　2007　Collection of the artist（局部圖 detail）

40800mm　4080×6×15cm　壓克力、玻璃鋼等　2007　藝術家自藏
40800mm　4080×6×15cm　Acryl, painted FRP, etc.　2007　Collection of the artist（局部圖 detail）

40800mm　4080×6×15cm　壓克力、玻璃鋼等　2007　藝術家自藏
40800mm　4080×6×15cm　Acryl, painted FRP, etc.　2007　Collection of the artist（局部圖 detail）

40800mm　4080×6×15cm　壓克力、玻璃鋼等　2007　藝術家自藏
40800mm　4080×6×15cm　Acryl, painted FRP, etc.　2007　Collection of the artist（局部圖 detail）

40800mm　4080×6×15cm　壓克力、玻璃鋼等　2007　藝術家自藏
40800mm　4080×6×15cm　Acryl, painted FRP, etc.　2007　Collection of the artist（局部圖 detail）

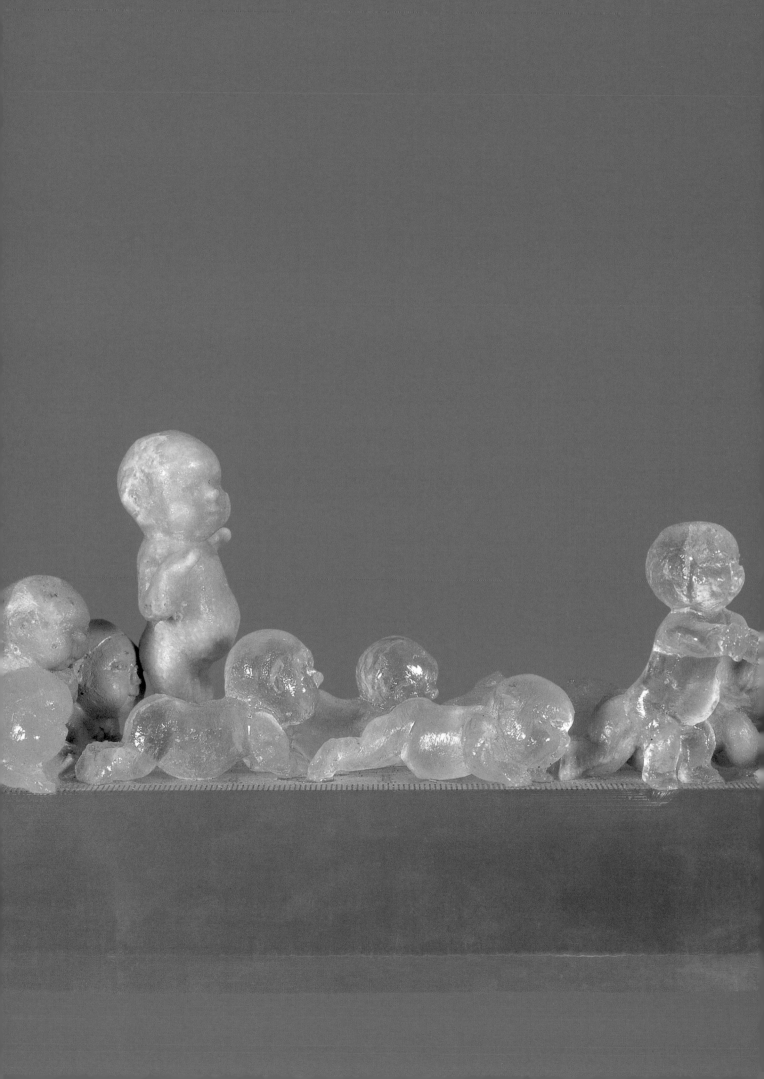

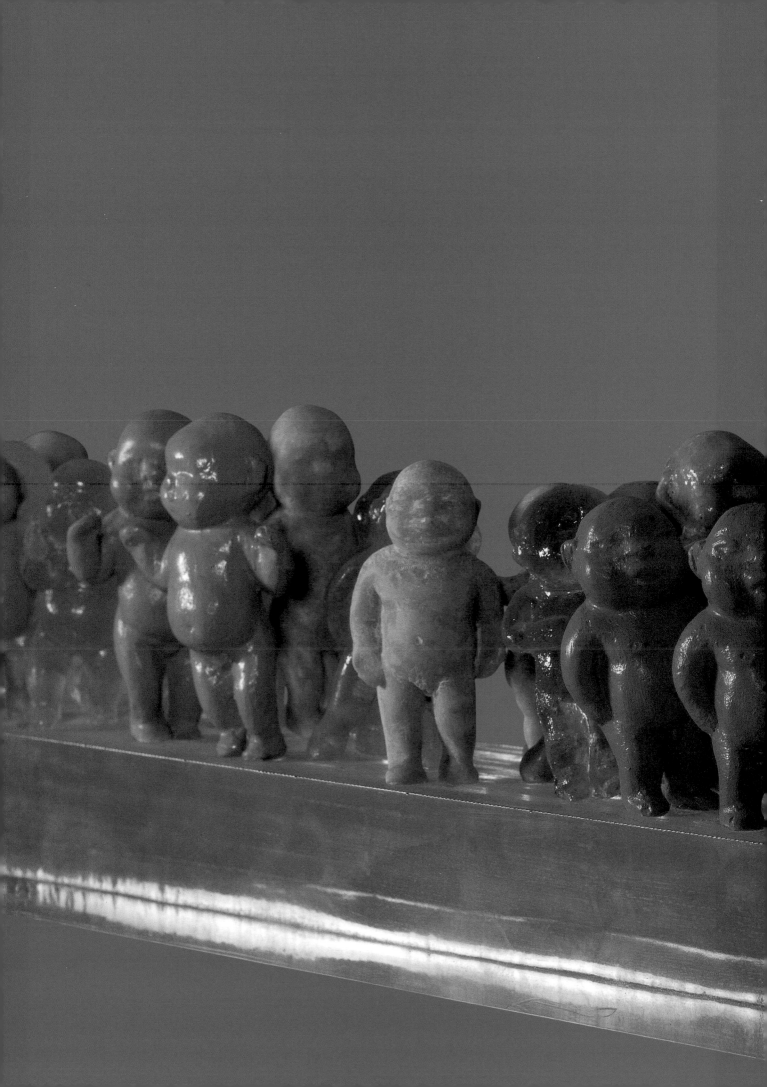

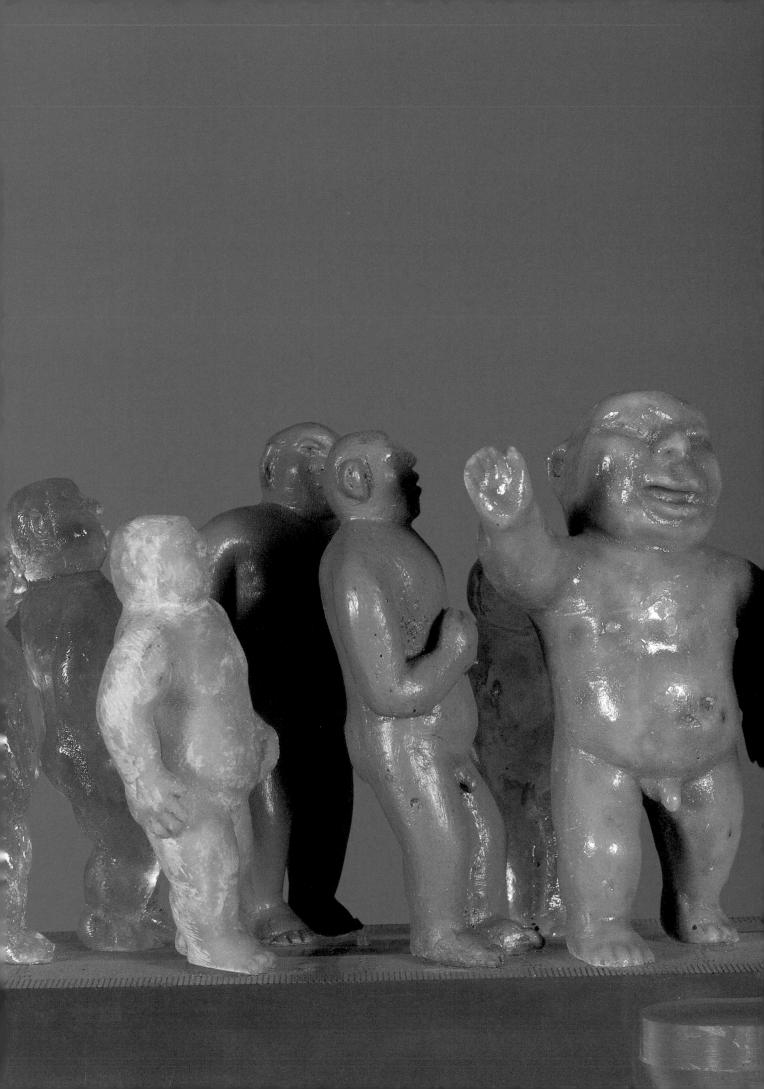

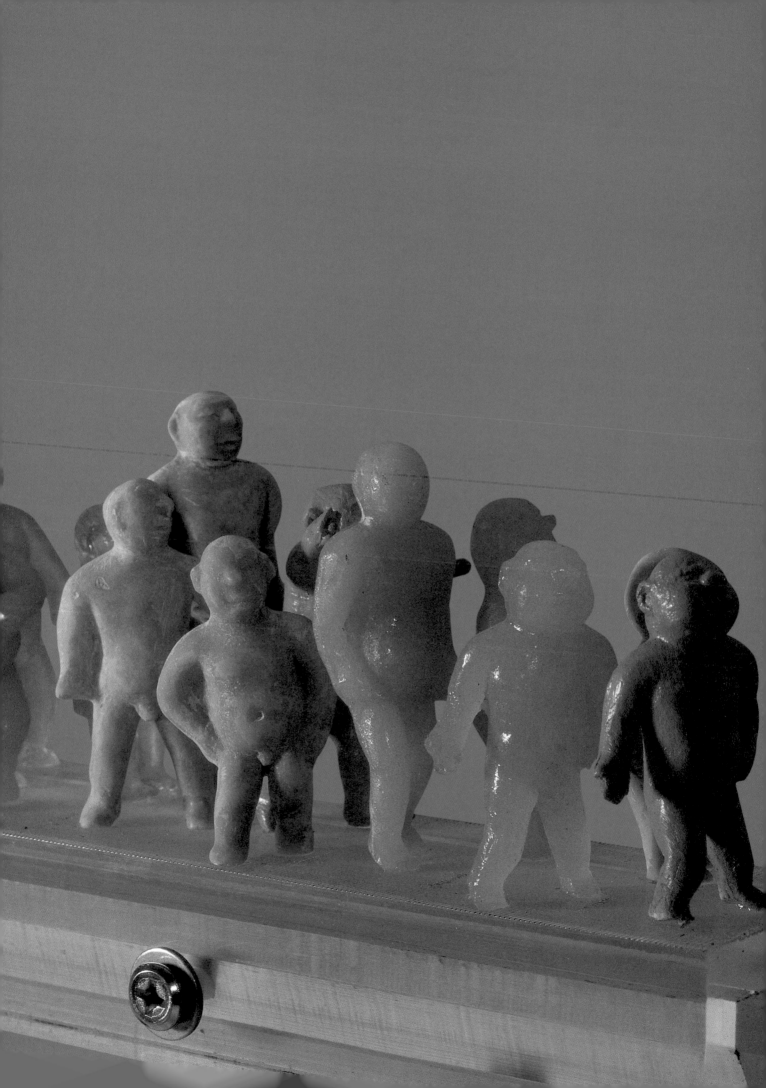

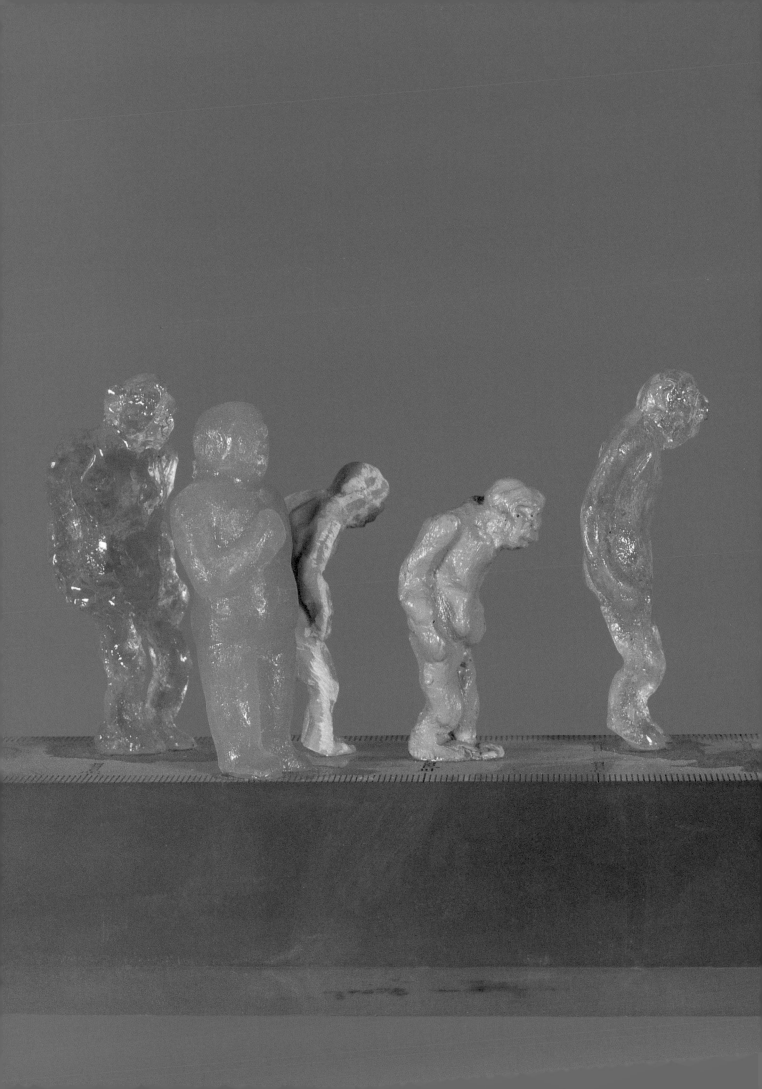

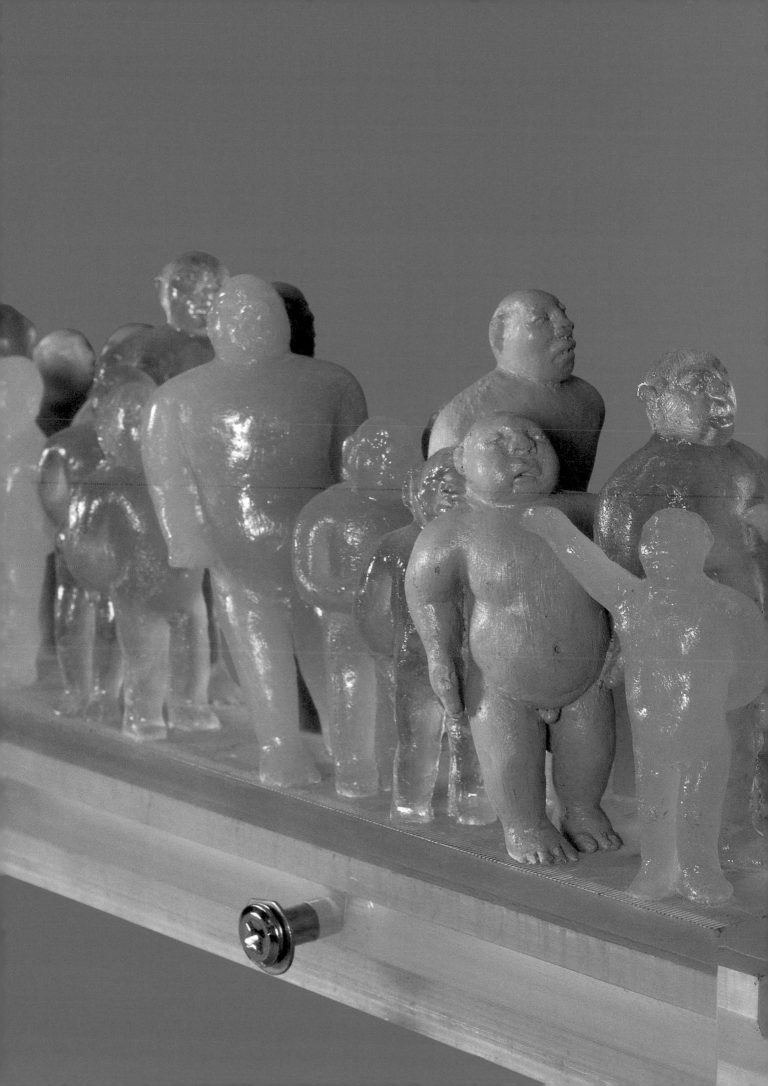

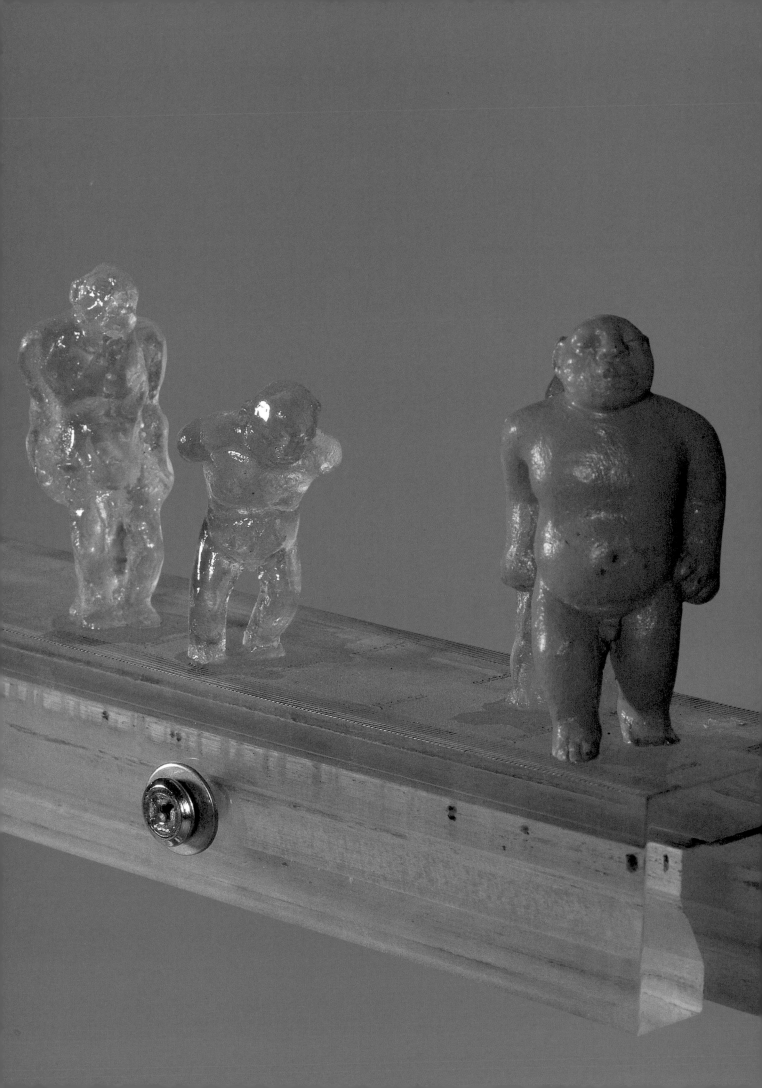

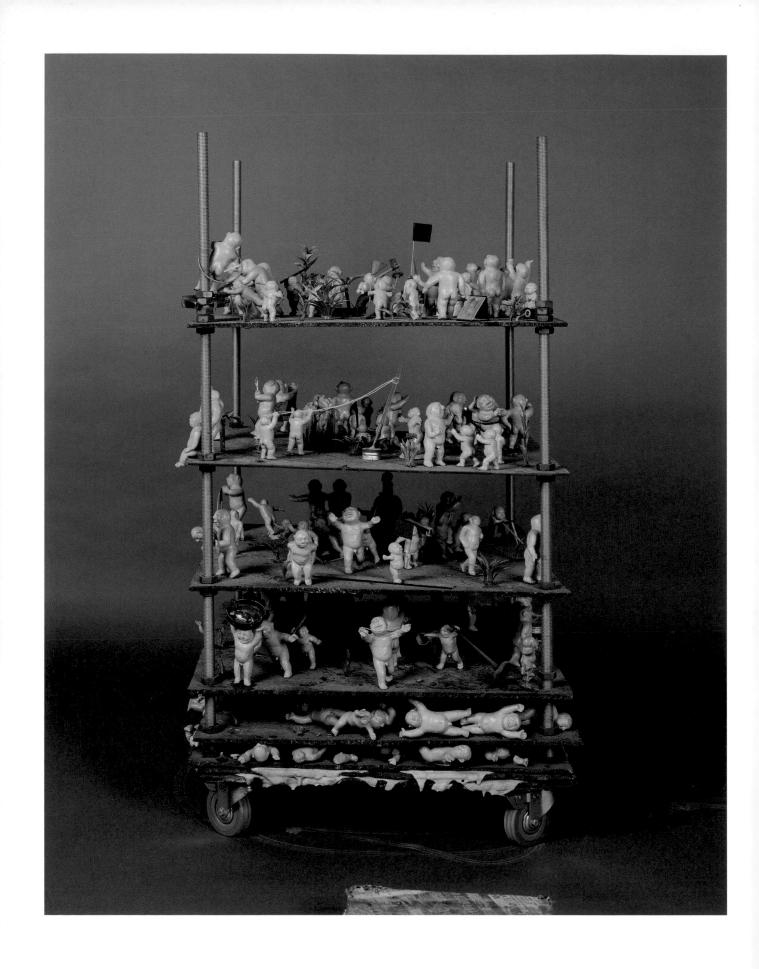

2007.8.5　63×63×101cm　綜合媒材　2007　藝術家自藏
2007.8.5　63×63×101cm　Mixed media　2007　Collection of the artist（右頁為局部圖）

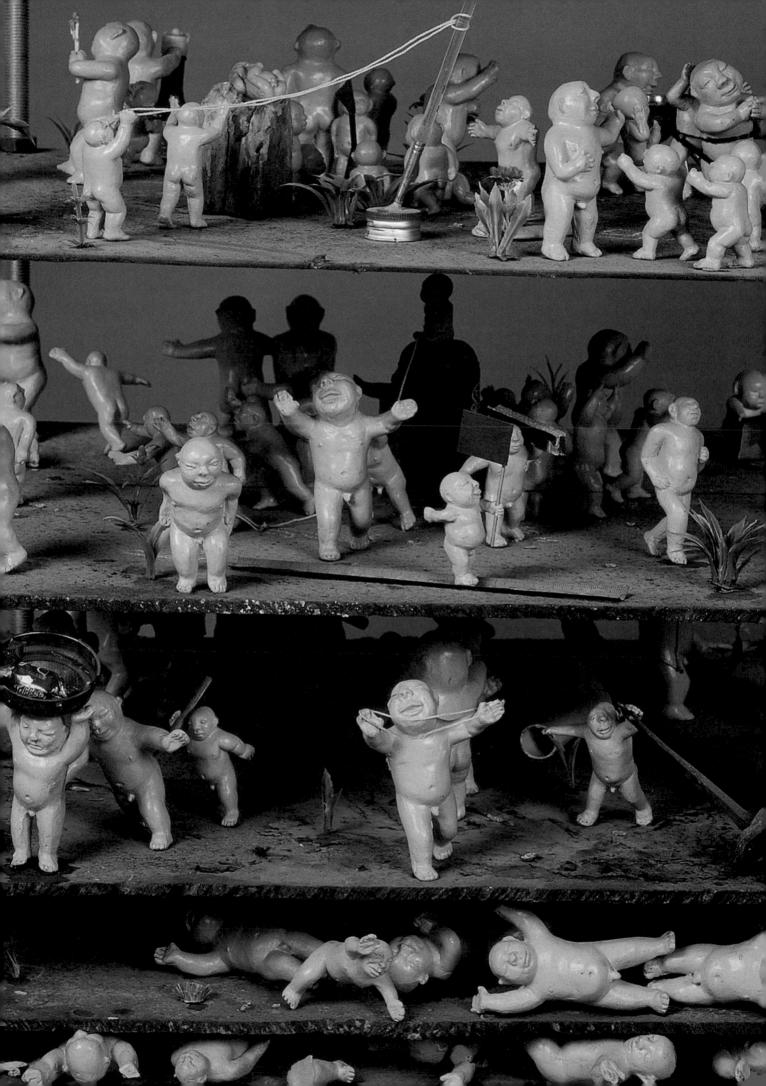

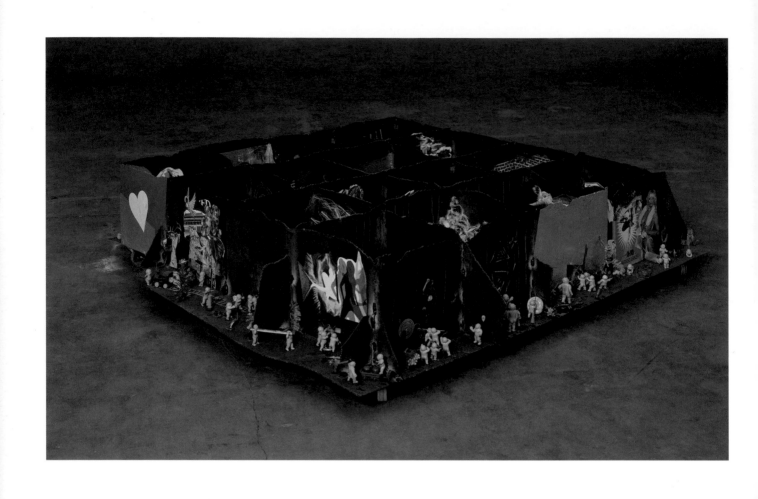

2007.8.10　197×206×46cm　綜合媒材　2007　藝術家自藏
2007.8.10　197×206×46cm　Mixed media　2007　Collection of the artist（左右頁圖）

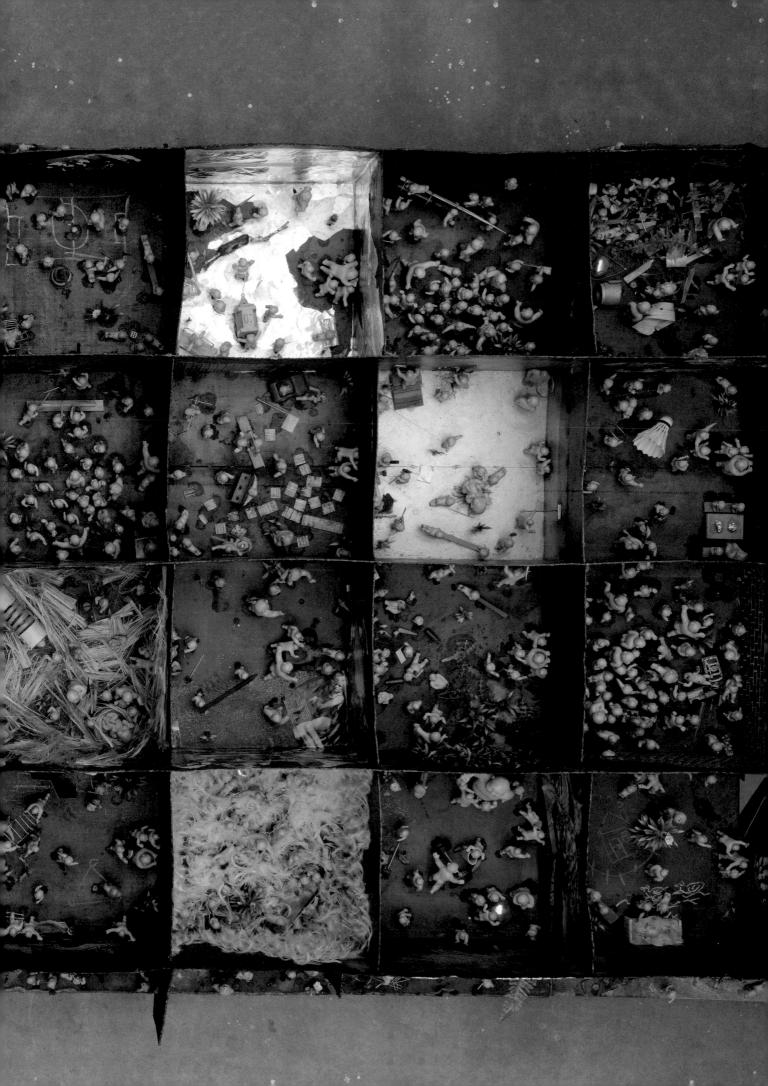

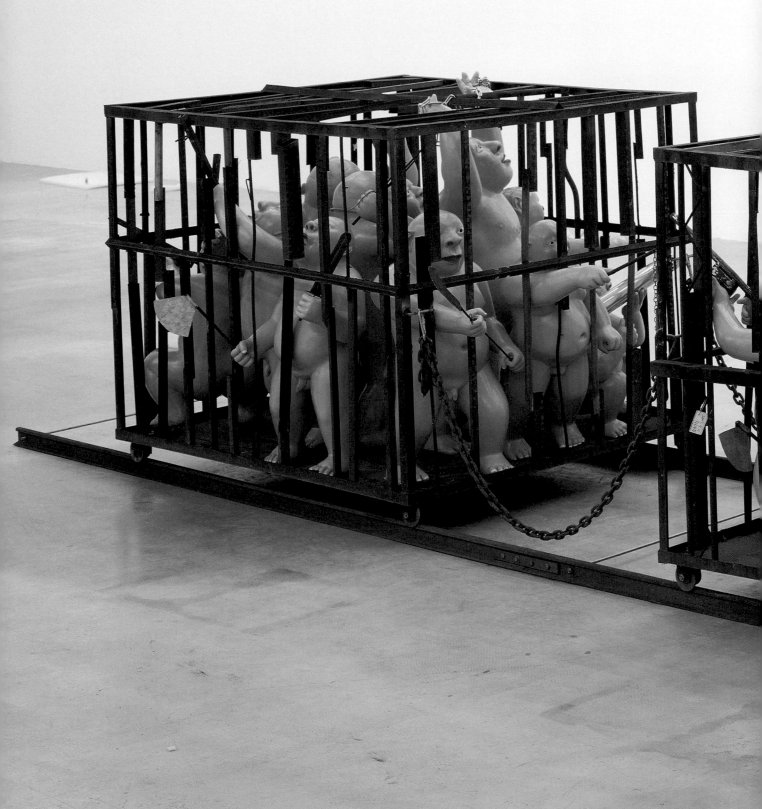

2007.9.11　170×127×120cm／個，共2個　玻璃鋼、鋼、鐵、木、石等　2007　藝術家自藏
2007. 9.11　2 Sculptures　170×127×120cm each, 2 pieces with rails　Thermosetting resin, steel, iron, wood, stone, etc.　2007　Collection of the artist

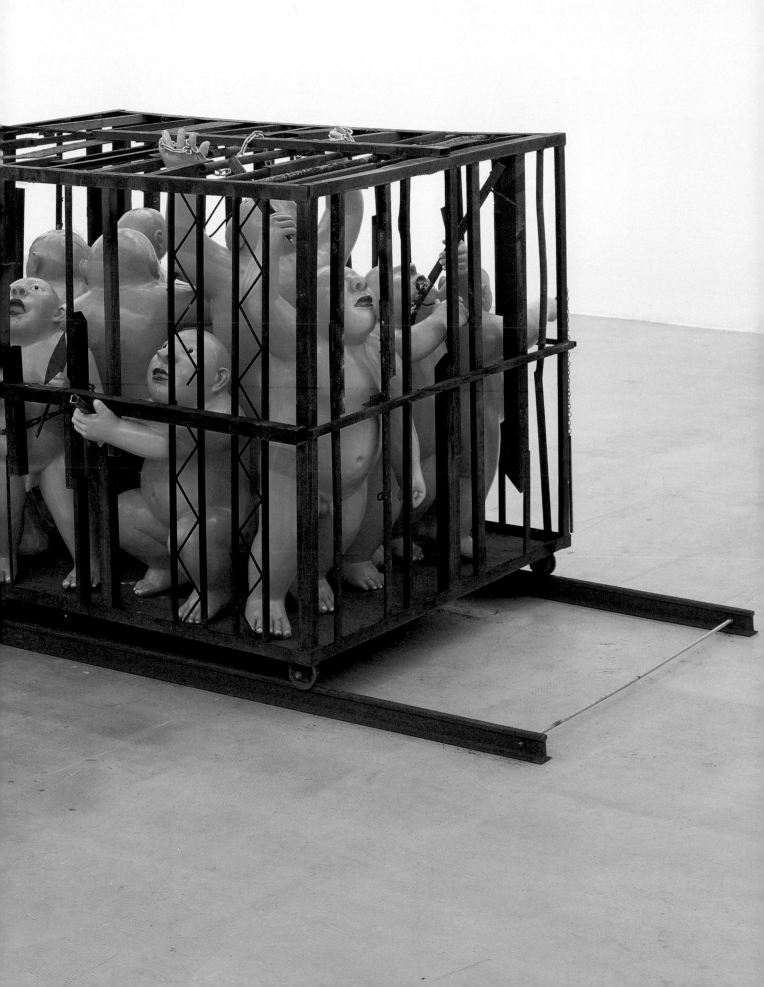

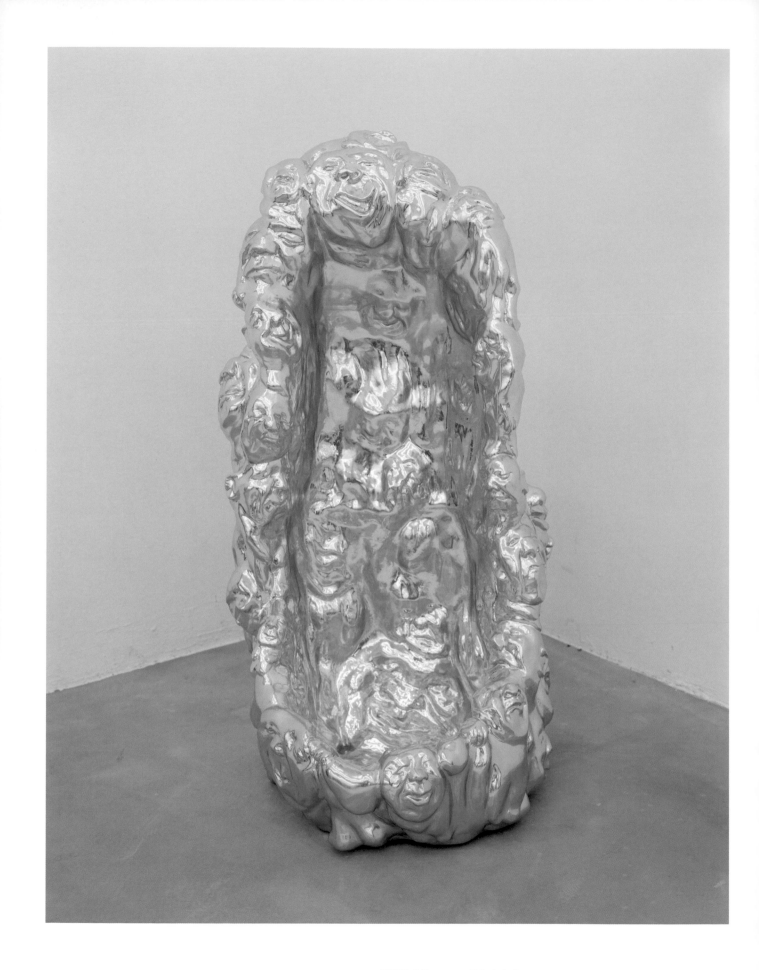

2007.5.1 63×63×101cm 鑄鐵貼金箔 2007 藝術家自藏
2007.5.1 63×63×101cm Goldfoil on iron 2007 Collection of the artist

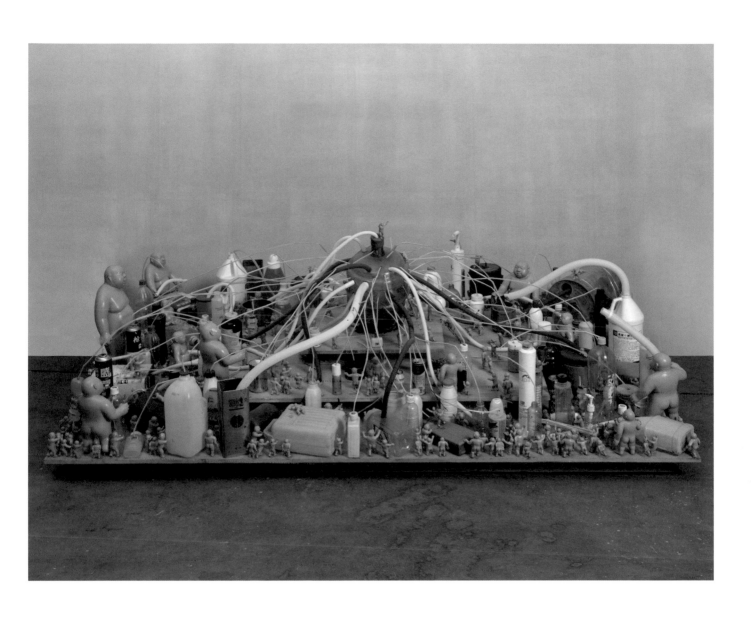

2007.6.6　240×160×90cm　綜合媒材　2007　藝術家自藏
2007.6.6　240×160×90cm　Mixed media　2007　Collection of the artist（p.240- p.241為局部圖 detail）

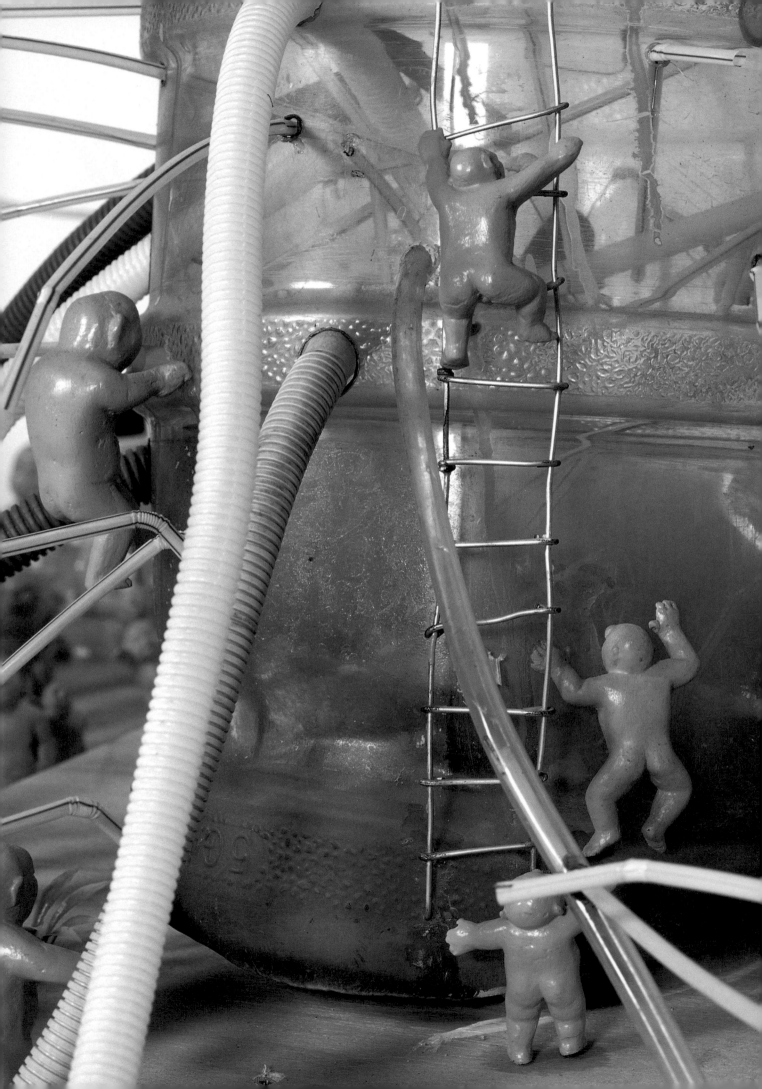

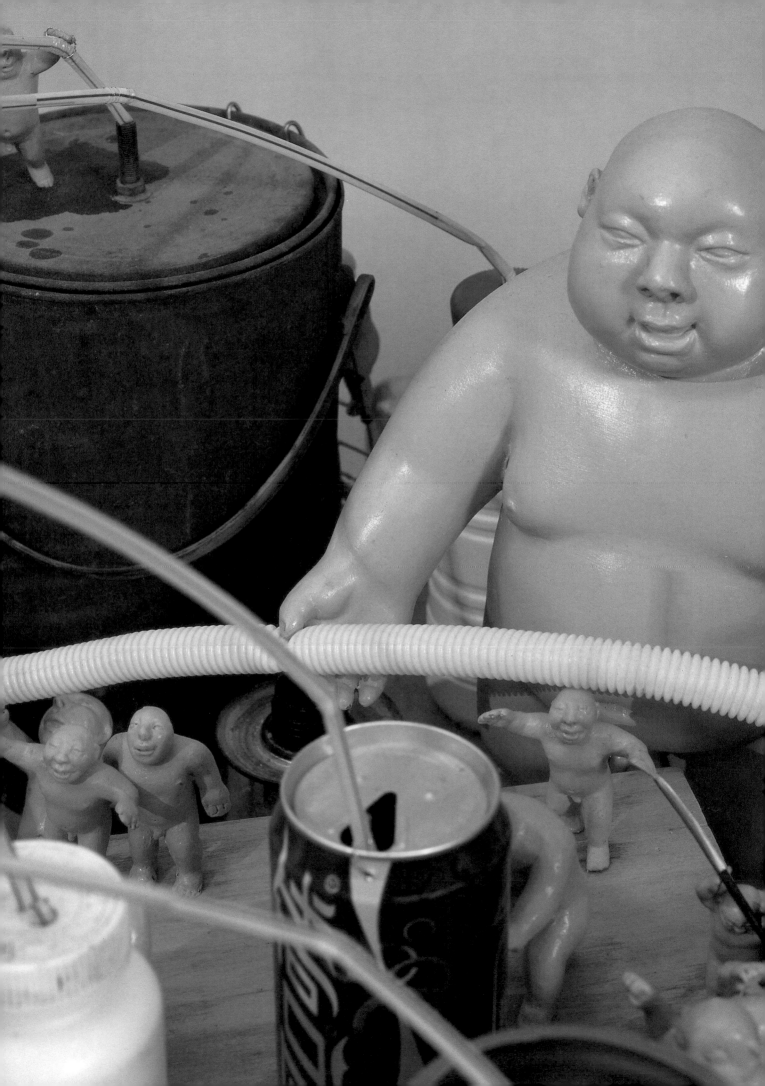

2007.9.1 100×100×200cm 矽膠、壓克力等 2007 藝術家自藏
2007.9.1 100×100×200cm Silica gel, acrylic tubes, etc. 2007 Collection of the artist（右頁為局部圖）

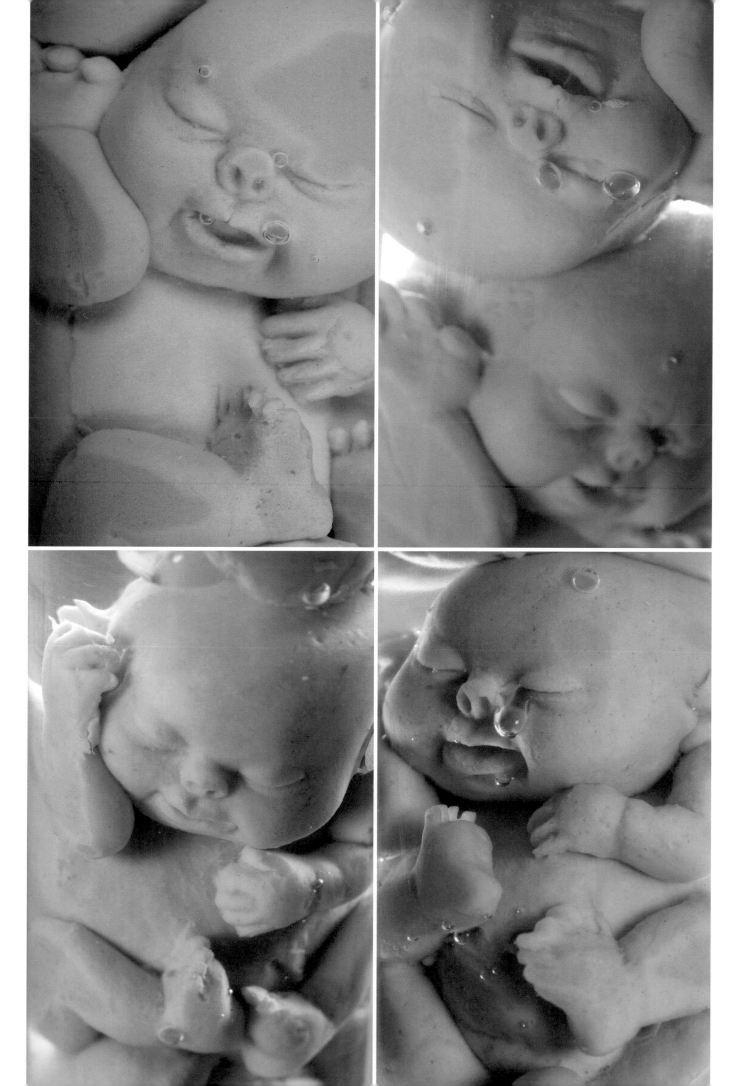

# 方力鈞簡歷

1 9 6 3　12月4日生於河北省邯鄲市
1972-1980　邯鄲鐵路子弟學校
1980-1983　河北輕工業學校陶瓷美術專業
1985-1989　中央美術學院版畫系
2 0 0 4　4月20日被聘為吉林藝術學院美術學院客座教授
2 0 0 5　在河北師範大學美術學院講學，聘為兼職教授。
　　　　　被聘為山西師大美術學院客座教授
2 0 0 6　被聘為四川美術學院客座教授
2 0 0 7　被聘為湖南師範大學美術學院客座教授
2 0 0 8　5月16日被聘為河北理工大學兼職教授

## 個展

1 9 9 5　方力鈞作品展　Belleriord 畫廊，巴黎
　　　　　方力鈞作品展　Serieuse Zaken 畫廊，阿姆斯特丹，荷蘭
1 9 9 6　方力鈞作品展　日本基金會，東京，日本
1 9 9 8　方力鈞作品展　Stedeljik 博物館，阿姆斯特丹，荷蘭
　　　　　方力鈞作品展　Serieuse Zaken 畫廊，阿姆斯特丹，荷蘭
　　　　　方力鈞作品展　Max Protetch 畫廊，紐約，美國
2 0 0 0　方力鈞作品展　斯民藝苑，新加坡
2 0 0 1　方力鈞　亞洲當代藝術，柏林，德國
　　　　　方力鈞　Prüss & Ochs 畫廊，柏林，德國
2 0 0 2　方力鈞　北京和大理之間，Ludwig Forum Für Internationale Kunst Aachen，德國
　　　　　方力鈞　漢雅軒，香港（12.20）
　　　　　方力鈞　香港藝術中心，香港（12.20）
2 0 0 4　方力鈞　Prüss & Ochs 畫廊，柏林，德國（5.15）
　　　　　方力鈞版畫展　法蘭西畫廊，巴黎，法國（6.10）
2 0 0 6　方力鈞，版畫與素描　Kupferstichkabinett 美術館，柏林，德國（1.26-4.17）
　　　　　「從我手中」方力鈞雕塑與版畫　Micheal Berger 畫廊，美國（4.22）
　　　　　生命就是現在──方力鈞個展　印尼國家美術館，雅加達，印尼（5.10-18）
　　　　　生命就是現在──方力鈞個展　CP基金會，雅加達，印尼（5.10）
　　　　　今日方力鈞！　今日美術館，北京，中國（10.7-31）
2 0 0 7　方力鈞頭像　Belmar 藝術和思想實驗室，丹佛，美國（4.18-8.26）
　　　　　方力鈞　Places to Places　Alexander Ochs 柏林/北京畫廊，柏林，德國（6.5）
　　　　　方力鈞　湖南省博物館，長沙，中國（9.15）
　　　　　方力鈞個人作品展　上海美術館，上海，中國（11.19）
　　　　　方力鈞版畫展　丹麥藝術中心，北京，中國（10.20）。首展/北京丹麥藝術中心（10.20-11.11），
　　　　　巡展/丹麥 Kastrupgaard 美術館（2008.1.11-3.24）、法羅群島美術館（2008.4.11-6.1）、丹麥 Vendsyssel 美術館
　　　　　（2008.6.20-9.14）
2 0 0 8　中國繪畫：張曉剛・方力鈞・馮夢波　魯道夫美術館，布拉格，捷克（9.24）
　　　　　方力鈞　阿拉里奧紐約，紐約，美國（11.6）

# 展覽

**1 9 8 4** 第6屆全國美展　廣州

**1 9 8 9** 中國現代藝術展　中國美術館，北京

**1 9 9 1** 方力鈞‧劉煒作品展　北京

**1 9 9 2** 方力鈞‧劉煒作品展　北京藝術博物館

中國新藝術展　巡迴展覽於雪梨新南威爾斯美術館、里斯本昆士蘭美術館、巴拉瑞特市立美術館、坎培拉藝術學校美術館

中國前衛藝術展　巡迴展於柏林世界文化宮、荷蘭鹿特丹藝術廳、牛津現代藝術博物館、丹麥 Odense 藝術廳

**1 9 9 3** 後八九中國新藝術展　香港藝術中心（1.31）

東方之路　威尼斯雙年展，義大利（9.14）

中國新藝術展　瑪勃洛畫廊，倫敦，英國

毛走向大眾　雪梨當代藝術博物館，澳洲

**1 9 9 4** 第4屆亞洲藝術展　福岡美術館，日本（3月）

中國新藝術展　漢雅軒畫廊，台北（3月）

世界道德　巴塞爾藝術廳，瑞士（6月）

聖保羅雙年展　聖保羅，巴西（10.12）

**1 9 9 5** 幸福幻想　日本基金會，東京（2.25）

Couplet 4　Stedelijk 博物館，荷蘭（5月）

我們的世紀　路德維希博物館，德國（7.9）

光州雙年展　韓國（7.9）

中國前衛藝術展　Santa Monica 藝術中心，巴塞隆納，西班牙（7.19）

**1996-1997** 北京，不，不是肥皂劇　Marstall，慕尼黑

與中國對話　路得維希論壇，Aachen 德國

大藝術展，試驗版畫特展　美術之家，慕尼黑，德國

**1 9 9 7** 中國！　Kunstmuseum，波恩，德國（巡迴展，2.29）

鴻溝　加遜尼藝術委員會，荷蘭（10月）

題目，廣島　廣島現代藝術館（11月）

四個交叉點　法蘭西畫廊，巴黎，法國（11月）

光州雙年展　光州，韓國

**1 9 9 8** 是我　勞動人民文化宮，北京，中國（2月）

透視：中國新藝術　亞洲社會博物館，紐約，美國（9.15）

黑與白　當代中國，倫敦，英國（9.23）

5000+10　當代中國，比堡，西班牙

**1 9 9 9** 第5屆亞洲美術展　福岡美術館，福岡，日本（3.6）

開啟通道　東宇美術館，瀋陽，中國（4.24）

開放的邊界　48屆威尼斯雙年展，威尼斯，義大利

新世紀的新現代化主義　Limm畫廊，三藩市，美國

**2 0 0 0** 20世紀藝術中的臉　國立西方藝術博物館，東京，日本

之間　上河會館，昆明，雲南

上海美術館藏品展　上海

20世紀中國油畫展　中國美術館，北京（6月）

上海雙年展　上海美術館，上海（11.6）

當代中國肖像　法蘭索瓦‧密特朗文化中心，法國（12.16）

**2 0 0 1** 2001上海版畫邀請展　上海爾冬強藝術中心，上海

畫壇精英：學院與非學院　上海藝搏畫廊，上海（5月）

宋庄　頂層空間，北京，Staedtische 畫廊，不來梅，德國（4.28）

當代繪畫新形象　中國美術館，北京；上海美術館，上海；成都美術館，成都；廣東省美術館，廣州（5-9）

夢　紅樓軒，倫敦，英國

中國當代繪畫展　新加坡美術館，新加坡（5月）

木刻：杜勒，高更，朋克與其他　波鴻美術館，波鴻，德國

Mercsul 雙年展　Mercsul，巴西（10.15）

成都雙年展　成都現代藝術館，成都（12.15）

…之間…　上河美術館，成都

**2002**　時間的一個點‧在長沙　美侖美術館，長沙（6月）

廣州當代藝術三年展　廣東美術館，廣州（11.18）

方力鈞／約爾格‧伊門道夫　上海現代畫廊，上海（11.20）

圖像就是力量　何香凝美術館，深圳（11.21）

柏林藝術研討會　Prüss & Ochs 畫廊，柏林，德國

**2003**　新繪畫　上海藝博畫廊，上海（1.9）

中國和藝術　國際美術館，雅加達，印尼（3.18）

世界餘日　Neuffer AM Park，德國（4.4）

Alors, la Chine　龐畢度藝術中心，巴黎，法國（6.4）

藝術當代　上海光大會展中心，上海（6.28）

開放的時代　中國美術館（7.23）

CP Open 雙年展　國際美術館，雅加達，印尼（9.3）

三張臉＋三種顏色　藝術畫廊，漢城，韓國（9.24）

中國當代版畫　大英圖書館與木板基金會聯合組辦，英國倫敦大英圖書館，倫敦，英國
　　　（2003.11.7 - 2004.3.19）

超越界限　上海外灘三號滬申畫廊，上海（2003.12.19 - 2004.2.8）

左翼中國當代藝術展　北京左岸公社，北京（12.20）

**2004**　CHINA, THE BODY EVERYWHERE？　馬賽現代藝術博物館，馬賽，法國（3.31）

現代中國　唐人畫廊，曼谷，泰國（1.15）

面對面——中國‧當代‧台灣　第雅藝術有限公司，台灣台南市（5.7 - 6.20）

漢雅軒 20 年慶　漢雅軒，香港藝術中心，香港（4.23）

大風　主題國際設計機構，北京（4.24）

方力鈞，葉永青，岳敏君繪畫與雕塑作品展「妄想的側面」　上海外灘三號滬申畫廊，上海（6.5）

Alexander Ochs 柏林／北京畫廊藝術作品群展　Alexander Ochs 柏林／北京畫廊，柏林，德國（7.9 - 31）

紀念《美術文獻》十周年　《美術文獻》編輯部，武漢，湖北（9.22 - 10.10）

東方風　Franz Gertsch 美術館，瑞士（2004.9.25 - 2005.9.1）

「龍族之夢」——中國當代藝術展　中華人民共和國文化部、愛爾蘭旅遊文化部、愛爾蘭現代美
　　　術館，都柏林，愛爾蘭共和國（10.26）

板起面孔——中國現在藝術第一次版畫聯展　北京現在畫廊，上海多倫現代美術館　北京，上海
　　　（11.3 - 12.20／北京；11.22 - 12.15／上海）

二十四位當代藝術家在中國　空白空間畫廊，北京（2004.12.5 - 2005.1.30）

**2005**　明日，不回眸——中國當代藝術　國立台北藝術大學關渡美術館，台北市（4.29 - 5.29）

自然之語言 Franz Gertsch ＋方力鈞　空白空間畫廊，北京，中國（5.2 - 7.4）

當生活成為觀點——方力鈞、王廣義、岳敏君、張曉剛近作展　上海藝博畫廊，上海（5.13 - 6.15）

中國當代藝術三年展　南京博物院，南京，中國（6.11）

Mahjong　伯爾尼美術館，瑞士（6.12 - 10.16）

Kinderszenen —— Childs Play　柏林，德國（6.26 - 8.28）

New Work／New Acquisitions　MOMA，紐約，美國（6.29 - 9.26）

線索——方力鈞／王音／蕭昱／楊茂源　空白空間畫廊，北京，中國（9.20 - 11.20）

2005 CP 雙年展　CP 基金會，雅加達，印尼（9.5 - 10.5）

緣分的天空——2005 中國當代架上藝術（油畫）邀請展　深圳美術館，深圳，中國（11.30）

「柏拉圖」和它的七種精靈　何香凝美術館、OCT 當代藝術中心，北京，中國（9.23）

Artforum Berlin　亞歷山大畫廊，柏林，德國（9月）

大河上下──新時期中國油畫回顧展　中華人民共和國文化部藝術司、中國美術館、中國油畫學會、
　　中國美術家協會油畫藝術委員會，北京，中國（11.26-12.8）

美麗的諷喻──阿拉里奧北京藝術空間開幕展　阿拉里奧北京藝術空間，北京（2005.12.10-2006.3.12）

溫暖──紅橋畫廊開幕展　紅橋畫廊，上海（12.3）

「翻手為雲，覆手為雨」TS1當代藝術中心第一回展　北京TS1（宋庄壹號）當代藝術中心，北京
　　（2005.11.26-2006.1.15）

**2 0 0 6**　紅──文革後的記憶　第雅藝術，台南市（1.6-2.5）

CHINA COUP　紅樓軒，倫敦，英國（1.24-3.24）

時間的一個點──在武漢　美術文獻雜誌、武漢美術文獻藝術中心（2.26-3.13）

渡·當代水墨方式　匯泰藝術中心，天津（3-4月）

聽取　柏林，德國（6.24-8.13）

中國現代藝術展　阿拉里奧畫廊，天安，韓國（6.28-8.20）

最好亞洲　Artside畫廊，漢城，韓國（9.1-24）

**2 0 0 7**　我們主導未來──第2屆莫斯科雙年展特別計畫　Ethan Cohen Fine Arts，莫斯科，俄羅斯（3.1-4.1）

後解嚴與後八九──兩岸當代美術對照　國立台灣美術館，台中市（3.31-6.17）

中國「當代社會展」　俄羅斯特列恰可夫國家美術館，莫斯科，俄羅斯（3.2-4.15）

地獄與天堂：十周年 Alexander Ochs 柏林/北京畫廊 Alexander Ochs 柏林/北京畫廊，柏林，德國（4）

巴塞爾藝術博覽會　巴塞爾藝術博覽會，巴塞爾，瑞士（6.13-17）

黑白灰──一種主動的文化選擇　今日美術館主館，北京（7.21）

脫域　千高原藝術空間，北京（7.15-8.31）

RED HOT　Fine Arts 博物館，休斯頓，美國（7.22-10.21）

傲慢與浪漫　鄂爾多斯美術館，鄂爾多斯，中國（8.26）

上海當代藝術博覽會　上海展覽中心，上海，中國（9.6）

China-Facing Reality　Kunst Stiftung Ludwig，當代博物館，維也納，奧地利（10.25）

與水墨有關──一次當代藝術家的對話　坦克庫·重慶當代藝術中心，重慶，中國（10.26）

天行健──中國當代藝術前沿展　亞洲藝術中心──北京，北京，中國（2007.12.15-2008.1.13）

**2 0 0 8**　China XXI secolo. Arte fra identità e trasformazione　the Palazzo delle Esposizionz，羅馬，義大利（2.18-5.18）

2007中國當代藝術文獻展──主體展　牆美術館，歌華藝術館，北京，中國（3.8-4.3）

新約──中國當代藝術家早期作品展　凱旋藝術空間，北京，中國（3.15-4.12）

飛地──中國當代新繪畫　南京四方當代美術館，南京，中國（3.15-4.13）

「北京──雅典，來自中國的當代藝術」展　希臘國家當代藝術中心，雅典，希臘（5.12-6.12）

Facing China　Akureyri 美術館，Akureyri，冰島（5.17-6.28）

學院與非學院 II　藝博畫廊，上海，中國（5.15-6.15）

藝術史中的藝術家　北京聖之空間藝術中心，北京，中國（5.25-6.29）

Half-Life of a Dream: Contemporary Chinese Art from the Logan Collection　舊金山當代美術館，舊金山，美國（7.10）

個案：藝術史和藝術批評中的藝術家　北京聖之空間藝術中心，北京，中國（6.15-8.31）

柏林亞洲藝術博物館展覽　柏林亞洲藝術博物館，柏林，德國（7月）

遭遇　Pace北京，北京，中國（8.2-9.21）

生活在宋庄　宋庄美術館，北京，中國（8.6）

「藝術北京2008」當代藝術博覽會　北京農展館，北京，中國（9.6-9.9）

第3屆南京三年展　南京博物院，南京，中國（9.10-11.10）

夢──2008亞洲藝術雙年展　國立台北藝術大學關渡美術館，台北（9.26-11.30）

1st.12" 泰達當代藝術博物館館藏精選展　泰達當代藝術博物館，天津，中國（2008.9.27-2009.1.30）

「前衛·中國──中國當代美術二十年」展　國立國際美術館，大阪，日本（12.9）

# Fang Lijun Curriculum Vitae

**1 9 6 3**   December 4, Born in Handan, Hebei Province

**1972-1980**   Railroad School, Handan, Hebei province

**1980-1983**   Hebei Light Industry College, Ceramic Art Studies

**1985-1989**   Graduate at Print Dept. the Central Institute of Fine Arts, Beijing

**2 0 0 4**   April 20, Visiting Professor of Jilin College of The Arts School of Visual Arts

**2 0 0 5**   Part-Time Professor of Hebei Training University Art College

       Visiting Professor of Shanxi Training University Art College

**2 0 0 6**   Visiting Professor of Sichuan Art College

**2 0 0 7**   Visiting Professor of Hunan Training University Art College

**2 0 0 8**   May 16, Concurrent Professor of Hebei Polytechnic University

## SOLO EXHIBITIONS

**1 9 9 5**   Fang Lijun, Galerie Bellefroid, Paris, France

       Fang Lijun, Galerie Serieuse Zaken, Amsterdam, the Netherlands

**1 9 9 6**   Fang Lijun, Human Images in an Uncertain age. the Japan Foundation. Tokyo, Japan

**1 9 9 8**   Fang Lijun, Stedeljik Museum, Amsterdam, the Netherlands

       Fang Lijun, Galerie Serieuse Saken, Amsterdam, the Netherlands

       Fang Lijun, Max Protetch Gallery, NY, U.S.A.

**2 0 0 0**   Fang Lijun, Soobin Art Gallery, Singapore

**2 0 0 1**   Fang Lijun, New Woodcuts & Paintings, Prüss & Ochs Gallery (former Asian Fine Arts), Berlin

**2 0 0 2**   Fang Lijun, Between Beijing & Dali, Woodcuts & Paintings 1989-2002, Ludwig Forum für Internationale Kunst Aachen

       December 20, Fang Lijun, Hanart T Z Gallery, Hongkong

       December 20, Fang Lijun, Hongkong Art Center, Hongkong

**2 0 0 4**   May 15, Fang Lijun, Prüss & Oshs Gallery, Berlin, Germany

       June 10, Fang Lijun, Galerie de France, Paris, France

**2 0 0 6**   January 26-April 17, Fang Lijun-Holzschnitte und Zeichnungen, S M B Kupferstichkabinett Staatliche Museum zu Berlin, Berlin, Germany

       April 22, From My Hand, Sculptures & Woodcuts by Fang Lijun. Michael Berger Gallery, U.S.A.

       May 10-18, Life is Now. Galerie Nasional Indonesia (Indonesia National Gallery) Jakarta, Indonesia

       May 10, Life is Now. CP Foundation, Jakarta, Indonesia

       October 7-31, Fang Lijun Today. Today Art Museum, Beijing, China

**2 0 0 7**   April18-August26, Fang Lijun Heads. The Laboratory of Art and Ideas at Belmar, Denver, U.S.A.

       June 5, Fang Lijun Places to Places. Alexander Ochs Galleries Berlin / Beijing, Berlin, Germany

       September 15, Fang Lijun. Hunan Provincial Museum, Changsha, China

       November 11, Fang Lijun Solo Exhibition. Shanghai Art Museum, Shanghai, China

       October 20, Fang Lijun Print Exhibition. dARTex (The Danish Art Exchange), Beijing, China. First Exhibition, dARTex (The Danish Art Exchange)(October 20-November 11, 2007) Exhibition Tour: The Kastrupgaard Collection Denmark (January 11-March 24, 2008), The Art Gallery of the Faroe Island (April 11-June 1, 2008), The Art Gallery of Vendsyssel Denmark, (June 20-September 14, 2008)

**2 0 0 8**   September 24, Chinese Painting: Zhang Xiaogang, Fang Lijun and Feng Mengbo. The Galerie Rudolfinum, Prague, Czech

       November 6, Fang Lijun. Arario New York, New York, U.S.A.

## GROUP EXHIBITIONS

**1 9 8 4**    6th National Art Exhibition. Guangzhou

**1 9 8 9**    China Avant-Garde Art Exhibition. China Art Gallery, Beijing

**1 9 9 1**    Fang Lijun and Liu Wei Private Exhibition. Beijing

**1 9 9 2**    Fang Lijun and Liu Wei Oil Painting Exhibition. Beijing Art Museum, Beijing
New Art from China / Post-Mao Product
Toured the Art Gallery of New South Wales, Sydney
Queensland Art Gallery, Brisvane
City of Ballarat Fine Art Gallery, Ballarat
Canberra School of Art Gallery, Canberra, Australia

**1 9 9 3**    Jan 31, China's New Art, Post'89. Hong Kong Arts Center, Hong Kong
Mao Goes Pop. Museum of Contemporary Art, Sydney, Australia
September 14, Passagio ad Oriente. 45th Biennale di Venezia, Italy

**1 9 9 4**    March, The 4th Asian Art Show. Fukuoda Art Museum, Fukuoka, toured Setagaya Art Museum, Tokyo, Japan
March, New Chinese Art. Hanart T Z Gallery, Taipei, Taiwan
June, Welt-Moral. Kunsthalle Basel, Switzerland
October 12, Chinese Contemporary Art at San Paulo
22nd International Biennale of San Paulo. Brazil

**1 9 9 5**    February, Visions of Happiness-Ten Asian Contemporary Artists. The Japan Foundation, Tokyo, Japan
May, Couplet 4. Toured Stedelijk Museum Amsterdam, the Netherland
July 9, Unser Jahrhunder. Museum Ludwig Köln, Gemany
The 1st Kwangju Biennial. Kwangju, Korea
July 19, Avantguardes Artistiques Xinesses. Centre d'Art Santa Monica, Barcelona, Spain

**1 9 9 6**    Begegnungen mit China. Ludwig Forum, Aachen, Germany
Beijing No, No Soap Opera?. MarstallTheater München, curated by Alexander Ochs, Germany
November. New Collection of Commissioned Works on the Theme "Hiroshima" Hiroshima City Museum of Contemporary Art,
    Hiroshima, Japan

**1 9 9 7**    February 29, China!. Kunstmuseum Bonn, Germany
March 8, Die anderen Modernen. Haus der Kulturen der Welt, Berlin
October 13, Chinese Walls. Gasunie's Kunstkomitee, Groningen, the Netherlands

**1 9 9 8**    February, It's Me. Forbidden City, Beijing, China
September 15, Inside Out: New Chinese Art, Asia Society. New York, U.S.A.
China! Haus der Kulturen de Welt, Berlin
September 23, Black & White. Chinses Contemporary, London, U.K.
5000 + 10, Chinese Contemporary. Bibao, Spain

**1 9 9 9**    March 6, The 5th Asian Art Show. Fukuoka Asian Art Museum, Fukuoka, Japan
April 24, Open Channels. Dong Yu Museum of Fine Arts, Shenyang, China APERTO. The 48th Venice Bennial, Venice, Italy
New Modernism for a New Millennium. Limm Gallery, San Francisco, U.S.A.

**2 0 0 0**    Visage: Painting and The Human Face in 20th – Century Art. The National Museum of Western Art, Tokyo, Japan
Between. Upriver Residence, Kunming Yunan
The Collection of Shanghai Art Museum, Shanghai
June, The 20th Century Chinese Oil Painting Exhibition. China Arts Museum, Beijing

November 6, Shanghai Biennial. Shanghai Art Museum, Shanghai

December 16, Portrait of China Contemporaries. Espace culturel François Mitterand de Cateleu, France

**2 0 0 1**    Shanghai International Print Invitation Exhibition. Erdongqiang Print Centre, Shanghai

April 28, Song Zhuang. Top Space. Beijing Städitsche Gallery, Bremen, Germany

May, Painting Genius: Academic and Un-academic. YiBo Gallery, Shanghai

May-September, Towards a New Image: Twenty Years of Contemporary Chinese Painting. Beijing: National Art Museum, Shanghai: Shanghai Art Museum, Chengdu: Sichuan Art Museum, Guangdong: Art Museum Guangzhou

Dream. Red Mansio, London U.K.

October 15, Bienal de Artes. Visuais do Mercosul, Porto Alegre, Brasilien

China Art Now!. Singapore Art Museum, Singapore

In Holz Geschnitten-Dürer, Gauguin, Penck und die Anderen. Museum Bochum, Germany

December 15, Chengdu Biennale. Chengdu Contemporary Art Museum, Chengdu

**2 0 0 2**    June, A point in time. Changsha, Meilun Museum, Changsha

November 18, Guangzhou Triennial 2002. Guangdong Museum of Art, Guangzhou

November 20, Fang Lijun & Jörg Immendorff. Shanghai Contemporary Albrecht, Ochs & Wei, Shanghai

November 21, Image is Power: Wang Guangyi, Zhang Xiaogang, Fang Lijun. He Xiang Ning Art Museum, Shenzhen

Art Forum Berlin, Prüss & Ochs Gallery, Germany

**2 0 0 3**    January 19, New Painting. Shanghai Yibo Gallery, Shanghai

March 18, From China with Art. National Gallery, Jakarta, Indonesia

April 4, DER REST DER WELT. Neuffer Am Park, Pirmasens, Germany

June 4, Alors, la Chine. Pompidou Center, Paris

July 23, An Opening Era. China National Museum, Beijing

September 3, CP Foundation Biennale, National Gallery, Jakarta, Indonesia

September 24, 3 Faces + 3 Colors. Artside Gallery, Seoul, Korea

November 7, 2003-March 19, 2004, Chinese Printmaking Today. British Libtary & Muban Foundation, British Libtary,London, U.K.

December 19, 2003-Feburary 8, 2004, Surpass Infinitude. Shanghai Gallery of Art, Shanghai

December 20, Zuoyi China Modern Art Fair. Beijing Zuo'an Commune, Beijing

**2 0 0 4**    March 31, CHINA, THE BODY EVERYWHERE?. Museum of Contemporary Art, Marseilles, France

January 15, CHINA NOW. Tang Gallery, Bangkok, Thailand

May 7-June 20, Face to Face-China. Now. Taiwan. Robert & Art Gallery, Taiwan Tainan City

April 23, Celebrating 20 Years of Hanart T Z Gallery, Hanart T Z Gallery, Hongkong Arts Centre, Hongkong

April 24, Dafeng. Motif International Design Organization, Beijing

June 5, Painting and Sculpture Exhibition "Face of Illusion" by Fang Lijun, Ye Yongqing and Yun Minjun. Shanghai Gallery of Art, Shanghai

July 9-July 31, The Group Exibition Alexander Ochs Galleries Berlin / Beijing presents artworks of Fang Lijun, Ik-Joong Kang, John Young, Kyungwoo Chun, Ling Jian, Qiu Shihua, Xu Bing, Yin Xiuzhen, Yoo. Jung Hyun, Yue Minjun. Alexander Ochs Galleries Berlin / Beijing, Berlin, Germany

September 22-October 10, Commemorate 《Art Literature》 10 Years Anniversary, 《Art Literature》 Newsroom, Wuhan, Hubei, China

October 25, 2004-January 1, 2005, East Wind. Museum Franz Gertsch, Switzerland

October 26, Dreaming of the Dragon's Nation: Contemporary Art Exhibition from China, Ministry of Culture of People's Republic of China & Department of Arts, Sport and Tourism of the Republic of Ireland, Irish Museum of Modern Art in Dublin, Ireland

November 3-December 20 (Beijing) / November 22-December 15 (Shanghai), Stone Face-China Art Now First Group Printing Exhibition. Beijing Art Now Gallery & Shanghai Duolun Museum of Modern Art, Beijing, Shanghai, China

December 5, 2004- January 30, 2005, Twenty-Four Living Artists in China. Alexander Ochs / White Space Beijing, Beijing, China

    **2 0 0 5**    April 29-May 29 ALWAYS TO THE FRONT- CHINA CONTEMPORARY ART. Kuandu Museum of Fine Arts Taipei

National University of the Arts Taipei, Taiwan

May 2-July 4, The Languages of Nature, Franz Gertsch + Fang Lijun, White Space Gallery, Beijing, China

May 13-June 15, New Works of Fang Lijun, Wang Guangyi, Yue Minjun. Zhang Xiaogang Yibo Gallery, Shanghai, China

June 11, China Contemporary Art. Nanjing Museum, Nanjing, China

June 12-October 16, Mahjong. Bern Museum, Switserland

June 26-August 28, Kinderszenen-Child's play, Wassershlos Grob Luthen / Spreewarld, Berlin, Germany

June 29-Semptember 26, New Work / New Acquisitions. MOMA, New York, U.S.A.

September 20-November 20, Clues — Fang Lijun, Wang Yin, Xiao Yu, Yang Maoyuan. White Space Beijing, Beijing, China

September 5- October 5, CP Biennale II 2005. CP Foundation, Jakarta, Indonesia

September 23, Plato and His Seven Spirits. OCAT, Beijing, China

September, Artforum Berlin. Alexander Ochs Galleries, Berlin, Germany

November 26-December 8, History of River-The Chinese Oil Painting Exhibition In New Era. Culture Ministry Art Bureau of P.R. China, China National Museum, China Oil Painting Institute, China Artist Association Oil Painting Art commission, China National Museum, Beijing, P.R. China

November 30, SKY OF LOT. Shenzhen Museum, Shenzhen, China

December 10, 2005-March 12, 2006, Beautiful Cynicism — ARARIO BEIJING Opening Exhibition. ARARIO BEIJING, Beijing, China

December 3, Land of Warmth — The Opening Exhibition of Red Bridge Gallery, Shanghai, China

**2 0 0 6**   January 6-Feburary 5, Red. Diya Art, Tainan City

January 23-March 24, CHINA COUP. The Red Mansion Foundation, London, U.K,

January 26-March 13, A point in time — in Wuhan. Fine Arts Literature, Wuhan City Fine Arts Literature Art Center, China

March-April, Expressions of Contemporary Chinese Water and Ink Painting. Huitai Art Center, Tianjin, China

June 24-August 18, The Sacred and the Profane. Alexander Ochs Galleries Berlin / Beijing, Berlin, Germany

June 28-August 20, Absolute Images Chinese Contemporary Art. Arario, Cheonan, Korea

September1-24, Best Asia. Gallery Artside, Kwanhoon-Dong, Seoul, Korea

**2 0 0 7**   March 1-April 1,  "We Are Your Future--Contemporary Art from Latin America and China" Special project for the 2nd Moscow Biennale. Ethan Cohen Fine Arts, Moscow, Russia

March 31-June 17, Post-Martial Law vs. Post-'89 — The Contemporary Art in Taiwan and China. National Taiwan Museum of Fine Arts, Taichung City

March 2-April 15, Chinese "Contemporary Sotsart." The State Tretyakov Gallery, Moscow, Russia

April, Inferno in Paradise — 10 Years Alexander Ochs galleries Berlin / Beijing. Berlin, Germany

June 13-17, "Art 38 Basel" Art Basel, Basel, Switzerland

July 21, Black White Gray. Today Art Museum, Beijing, China

July 15, August 31, Disembodying. Qiangaoyuan Gallery, Beijing

July 22-Ocotober 21, RED HOT. The Museum of Fine Arts, Houston, U.S.

August 26, Arrogance & Romance. Ordos Art Museum, Ordos, China

September 6, Shanghai Contemporary. Shanghai Exhibition Center, Shanghai, China

October 25, China-Facing Reality. Museum Modern Kunst Stiftung Ludwig, Vienna, Austria

October 26-November 6, On Ink and Wash — A Dialogue between Contemporary Artists. Tank Loft · Chongqing Contemporary Art Center, Chongqing, China

December 15, 2007-January 13, 2008, The Power of the Universe — Exhibition of Frontier Contemporary Chinese Art. Asia Art Center, Beijing, China

**2 0 0 8**   February 18-May 18, China XXI secolo, Arte fra identità e trasformazione. the Palazzo delle Esposizionz, Roma, Italy

March 15-April 12, New Covenant — Exhibition of Contemporary Chinese Artists. Triumph Art Space, Beijing, China

March 8-April 3, 2007 China Contemporary Art Exhibition, Qiao Art Museum, Gehua Art Museum, Beijing, China

March 15-April 13, Feidi — China Contemporary New Painting. Nanjing Sifang Art Museum, Nanjing, China

May 12-June 12, Beijing-Athens, Contemporary Art from China, Greek Athens National Contemporary Art Center, Athens, Greece

May 17-June 28, Facing China. Akureyri Art Museum, Akureyri, Iceland

May 15-June 15, Academic and Un-academic II. Yibo Gallery, Shanghai, China

May 25-June 29, Artists in Art History Curator. S Z ART CRNTER, Beijing, China

June 15-August 31, Case Studies of Artists in Art History and Art Criticism. SZ ART CENTER, Beijing, China

July 10, Half-Life of a Dream — Contemporary Chinese Art from the Logan Collection. San Francisco Museum of Modern Art (SFMOMA), San Francisco, U.S.A.

July, Museum für Asiatische Kuns Exhibition. Museum für Asiatische Kunst, Berlin, Germany

August 2-September 21, Encounter. Pace Beijing, Beijing, China

August 6, Living in Songzhuang. Songzhuang Art Museum, Beijing, China

September 6-9, Art Beijing 2008. National Agricultural Exhibition Center, Beijing, China

September 10-November 10, Asia 3rd Nanjing Triennial. Nanjing Museum, Nanjing. China

September 26-November 30, 2008 Kunadu Biennale. Kuandu Museum of Fine Arts, Taipei

September 27, 2008-Jan 30, 2009, 1st.12" Taida Contemporary Art Museum Collection Exhibition.Taida Contemporary Art Museum, Tianjin, China

December 9, Avant-Garde China — Twenty Years of Chinese Contemporary Art. The National Museum of Art, Osaka, Japan

**Collection**

The Art Gallery of New South Wales, Sydney, Australia

Modern Art Museum of Melbourne, Melbourne, Australia

Queensland Art Museum, South Brisbane, Australia

National Gallery of Australia, Sidney, Australia

Peter & Irene Ludwig Stiftung, Museum Ludwig, Kšln, Germany

Ludwig Forum fŸr Internationale Kunst, Aachen, Germany

Museum fŸr Ostasiatische Kunst-Staatliche Museen Berlin, Berlin, Germany

Kupferstichkabinett -Staatliche Museen zu Berlin, Berlin, Germany

Collection of the city of Hamburg, Hamburg, Germany

Stedelijk. Museum, Amsterdam, the Netherlands

Henie-Onstad Kunstsenter, Oslo, Norway

Centre de G.Pomidou, Paris, France

Ivry Sur Seine Art Contemporain Museum, Paris, France

Erika Hoffmann Collection, Berlin, Germany

Chinese Print Foundation, London, UK

CP Foundation, Jakarta, Indonesia

Fukuoka Art Museum, Fukuoka, Japan

Modern Art Museum, Tokyo, Japan

Hiroshima City Museum of Contemporary Art., Hiroshima, Japan

Okinawa Modern Art Museum, Okinawa, Japan

Seattle Art Museum, Seattle, USA

Asian Art Museum, New York, USA

San Francisco Museum of Modern Art, San Francisco, USA

Denver Art Museum, Denver, USA

Museum of Modern Art, New York, USA

Philadelphia Museum of Art, Philadelphia, USA

Shanghai Art Museum, Shanghai, China

Singapore National Art Museum, , Singapore

Guangdong Museum of Art, Guangzhou, China

Shenzhen Museum of Art, Shenzhen, China

Today Art Museum, Beijing, China

Wuhan City Fine Arts Literature Art Center, Wuhan, China

Taida Art Museum, Tianjin, China

He Xiangning Art Museum, Shenzhen, China

OCT Contemporary Art Terminal, Shenzhen, China

Liang Jiehua Foundation, Hongkong, China

Tan Guobin Contemporary Museum, Changsha, China

Arario Collection, Cheonan, Korea

Max Proterch Gallery, NY, USA

Chinese Contemporary Gallery, London, UK

Galerie de France, Paris, France

ARTSIED Gallery, Seoul, Korea

Soobin Art Gallery, Singapore, Singapore

Deddy Irianto(Langgeng Gallery), Deddy Kusuma, Jakarta, Indonesia

Soka Gallery, Beijing, China

Beijing Art Now Gallery, Beijing, China

AEY Gallery, Beijing, China

Shanghai Gallery of Art, Shanghai, China

Diya Art Center, Tainan, Taiwan

Shanghai Yibo Gallery, Shanghai, China

SCHOENI Gallery, , Hongkong

Hanart TZ Gallery, Hongkong

China Club, Hongkong

Cultural Relic Shop of Hunan, Changsha, China

Mr. and Mrs. ANDREAS & NANCY VEITH MAX ANDREAS

REITH SCARSDALE, NY, USA

Mr. and Mrs.Kent & VICKI LOGAN VAIL, USA

Karen Smith&Liu Xiangcheng, USA

NEUBERGER & BERMAN, LLC, NY, USA

Oliver Stone, USA

Rupert Murdoch, USA

SCARSDALE, USA

MIKE DANOFF, USA

Erika Hoffmann, Berlin, Germany

ULI SIGG, Switzerland

Karlheinz Essl Private Museum, Austria

GUY ULLENS, Belgium

MATTHIAS POPP, Germany

AARTA STEPHAN AMLING, Germany

PETER FISCHER GRUEHWALD, Germany

RALF SCHM ENBERG, Germany

MICK FLICK, Germany

Susanna, the Netherlands

WOLFGANG JOOP, Germany

Fu Ruide, the Netherlands

FEZI KAHLESI, the Netherlands

PROMARVO, the Netherlands

Valentino, Italy

LOIC GOUZER, Switzerland

Montblanc, Switzerland

Porsche, Switzerland

DEI HONG DJIEN, Indonesia

Eddy Hartanto, Jakarta, Indonesia

FS JAKARTA, Indonesia

MAGELAN, Indonesia

STEFANI SUGIALAM, Jakarta, Indonesia

TJHIN TJONG YEN, Indonesia

Ai Weiwei, Beijing, China

Chen Ke, Beijing, China

Chen Nian, Beijing, China

Chen Jiagang, Chengdu, China

Chen Tong, Beijing, China

Cai Jiang, Neimenggu, China

Cai Haiyan, Dalian, China

Cui Dabai, Beijing, China

Cui Jian, Beijing, China

Cheng Xindong, Beijing, China

Dan Bo, Xi'an, China

Dou Honggang, Shanghai, China

Guan Yi, Beijing, China

Gu Changwei, Beijing, China

Guo Xin, Beijing, China

Huang Jun, Shanghai, China

Huang Rui, Beijing, China

Hu Heli, Beijing, China

Jia Zhangke, Beijing, China

Li Jin, Tianjin, China

Lin Song, Beijing, China

Li Bing, Shenyang, China

Li Rongqi, Beijing, China

Li Luming, Changsha, China

Li Ning, Beijing, China

Li Tong, Beijing, China

Liu Yuan, Beijing, China

Liu Ming, Wuhan, China

Li Xianting&Liao Wen, Beijing, China

Lv Huanbin, Changsha, China

Li Jie, Shanghai, China

Lu Hao, Beijing, China

茅野裕诚子, Japan

Ma Liuming, Beijing, China

Ma Huidong, Tianjin, China

Mo Gen, Beijing, China

Mang Ke, Beijing, China

Mi Qiu, Shanghai, China

Meng Changming, Beijing, China

Nie Rongqing, Kunming, China

Ning Lihong, Hongkong

Nie Mei, Changsha, China

Ouyang Song, Beijing, China

Qian Laizhong, Chengdu, China

Shu Kewen, Beijing, China

Sun Jinzhong, Shenyang, China

Tan Ping, Beijing, China

Wang Guangyi, Beijing, China

Wang Dainsen, Beijing, China

Wang Shuo, Beijing, China

Wang Yin, Beijing, China

Wang Yonggang, Beijing, China

Wang Yigang, Shenyang, China

Wu Wenguang, Beijing, China

Wei Xiaoping, Beijing, China

森田, Japan

Xia Xing, Beijing, China

Xiao Yu, Beijing, China

Xing Jizhu, Beijing, China

Yu Changsheng, Hongkong

Yang Shaobin, Beijing, China

Yang Maoyuan, Beijing, China

Yang Jianguo, Beijing, China

Yue Mingjun, Beijing, China

Yue Jianhua, Beijing, China

Yin Ling, Beijing, China

Ye Yongqing, Kunming, China

Yu Tianhong, Beijing, China

Zhang Yuan, Beijing, China

Zhang Hongbo, Beijing, China

Zhang Haoming, Beijing, China

Zhang Qing, Shanghai, China

Zhang Mi, Ha'erbin, China

Zhu Huiping, Beijing, China

Zeng Fanzhi, Beijing, China

Zhao Xu, Beijing, China

Zhao Jianping, Beijing, China

Zhou Chunya, Chengdu, China

# 感 謝 誌
## Acknowledgements

我們要對右列個人與機構表達最誠摯的感謝，因為他們的鼎力支持與協助，才使得這個展覽得以順利完成。

We would like to express our heartfelt thanks to the following individuals and organizations whose generous support and cooperation made this exhibition possible.

Special thanks to:　才　江　先生　Mr. Cai Jiang
尹在甲　先生　Mr. Yun Cheagab
尤傳莉　女士　Ms. Jasmine Yu
田　原　女士　Ms. Tian Yuan
托瑪斯‧克萊因　先生　Mr. Thomas Kellein
呂　澎　先生　Mr. Lu Peng
吳悅宇　女士　Ms. Shelly Wu
吳青峯　先生　Mr. Wu Ching Fong
李蘭芳　女士　Ms. Li Lanfang
金秀花　女士　Ms. Joshua Kim
林家如　女士　Ms. Evelyn Lin
佩茲‧里特曼　先生　Mr. Paz Littman
亞歷山大‧奧克斯　先生　Mr. Alexander Ochs
建畠哲　先生　Mr. Akira Tatehata
俞建安　先生　Mr. Tjianan Djie
洪致美　女士　Ms. Joyce Hung
烏利‧希克　先生　Mr. Uli Sigg
張榮華　先生　Mr. Alex Chang
張　蘭　女士　Ms. Zhang Lan
張皓明　先生　Mr. Zhang Haomung
張子康　先生　Mr. Zhang Zikang
張丁元　先生　Mr. Eric Chang
張頌仁　先生　Mr. Johnson Tsongzung Chang
麥克斯‧伏爾斯特　先生　Mr. Max Vorst
莎隆‧郝魯茲　夫人　Mrs. Sharon Haluts
陳筱君　女士　Ms. Chen Hsiao Chun
陳　艷　女士　Ms. Chen Yan
黃燎原　先生　Mr. Huang Liaoyuan
福瑞得　先生　Mr. Fu Ruide
福瑞茲‧凱瑟　先生　Mr. Fritz Kaiscr
楊　濱　先生　Mr. Yang Bin
廖建欽　先生　Mr. Liao Chien Chin
趙　旭　先生　Mr. Mr. Zhao Xu
趙建平　先生　Mr. Zhao Jianping
蓋翠宇　女士　Ms. Gai Cuiyu
蔡斯民　先生　Mr. Chua SooBin
蔡宜靜　女士　Ms. I-Ching Tsai
樊　紅　女士　Ms. Hong Fan
盧迎華　女士　Ms. Yinghua Lu
賽門‧史多克　先生　Mr. Simon Stock
夏文菁　女士　Ms. IVY XIA
譚國斌　先生　Mr. Tan Guobin
蘇姍娜‧伏爾斯特　女士　Ms. Susanna Vorst

Special thanks to:　88 MOCCA 中國當代藝術博物館　88 MOCCA Museum of Chinese Contemporary Art
上海藝博畫廊　Yibo Gallery
日本國立國際美術館　The National Museum of Art, Osaka
北京凱旋藝術中心　Triumph Art Space
北京現在畫廊　Beijing Art Now Gallery
印尼CP基金會　CP foundation
佳士得香港有限公司　Christie's Hong Kong
空白空間　White Space Beijing
典藏藝術家庭　Art & Collection Group
亞歷山大畫廊　Alexander Ochs Galleries
香港漢雅軒　Hanart T Z Gallery
阿拉里奧畫廊　Arario Beijing
第雅藝術　Robert & Li Art Gallery
鄂爾多斯美術館　Ordos Art Museum
斯民國際藝苑　SooBin Art International Pte Ltd
譚國斌當代藝術博物館　Tan Guobin Contemporary Art Museum
蘇富比有限公司（香港、紐約、倫敦）　Sotheby's（Hong Kong, New York and London）

特別感謝　Special thanks to:　比利菲爾德美術館　Kunsthalle Bielefeld Museum
北京今日美術館　Beijing Today Art Museum
羲之堂　Xi Zhi Tang Gallery

255

國家圖書館出版品預行編目資料

生命之渺：方力鈞創作25年展＝Endlessness of life:
25 Years Retrospect of Fang Lijun／胡永芬撰文
初版. -- 臺北市：藝術家，2009〔民98〕
256面；21×29公分.--

ISBN  978-986-6565-30-4（平裝）

1. 版畫  2. 繪畫  3. 雕塑  4. 畫冊
902.33                              98003787

# 生命之渺：
# 方力鈞創作25年展

## 展　覽

| | |
|---|---|
| 主辦單位 | 臺北市立美術館 |
| 合作單位 | 德國比利菲爾德美術館 |
| 協辦單位 | 藝術家雜誌社 |
| 策 展 人 | 胡永芬・盧迎華 |

| | |
|---|---|
| 展覽組組長 | 吳昭瑩 |
| 展覽執行 | 雷逸婷・邱麗卿 |
| 展場設計 | 馮健華・支涵郁 |
| 公　關 | 盧立偉 |
| 總　務 | 甘恩光・張銘育 |
| 會　計 | 李秀枝・黃明潔 |
| 展覽地點 | 臺北市立美術館三樓展覽室 |
| 展覽日期 | 中華民國98年4月18日至7月5日 |

## 專　輯

| | |
|---|---|
| 發 行 人 | 何政廣 |
| 主　編 | 王庭玫 |
| 編　輯 | 謝汝萱 |
| 翻　譯 | 崔延蕙・簡鈺聲 |
| 美　編 | 曾小芬・張紓嘉 |
| 出 版 者 | 藝術家出版社 |
| | 台北市重慶南路一段147號6樓 |
| | TEL：（02）2371-9692～3 |
| | FAX：（02）2331-7096 |
| | 網站：www.artist-magazine.com |
| | 郵政劃撥：01044798 藝術家雜誌社帳戶 |

| | |
|---|---|
| 總 經 銷 | 時報文化出版企業股份有限公司 |
| | 台北縣中和市連城路134巷16號 |
| | TEL：（02）2306-6842 |
| 南區代理 | 台南市西門路一段223巷10弄26號 |
| | TEL：（06）261-7268 |
| | FAX：（06）263-7698 |

| | |
|---|---|
| 製版印刷 | 欣佑彩色製版印刷股份有限公司 |
| 出版日期 | 2009年4月 |
| 定　價 | 新台幣1200元 |
| I S B N | 978-986-6565-30-4（平裝） |

## Endlessness of life:
## 25 Years Retrospect of Fang Lijun

## Exhibition

Organizer / Taipei Fine Arts Museum
Cooperator / Kunsthalle Bielefeld Museum
Co-organizer / Artist Magazine
Curators / Hu Yung-fen, Yinghua Lu

Chief Curator TFAM / Chao-ying Wu
Assistant Curators in charge of the exhibition / Yi-ting Lei, Li-ching Chiu
Exhibition Display / Chien-hua Feng, Han-yu Chi
Public Relations / Li-wei Lu
General Affairs / En-kuang Kan, Ming-yu Chang
Accountants / Hsiu-chi Li, Ming-chieh Huang
Exhibition Place / Galleries 3A, 3B, 3C, Taipei Fine Arts Museum
Exhibition Dates / April 18 – July 5, 2009

## Catalogue

Publisher / Ho Cheng-Kuang
Editor-in-Chief / Ting-mei Wang
Editor / Ju-hsian Hsieh
Translators / Tsuei Yen-huei, Yu-sheng Chien
Graphic Designer / Hsiao-fen Tseng, Shu-chia Chang
Publisher / Artist Publishing Co.
    Address / 6F., No. 147, Chongqing S. Rd., Sec. 1, Taipei 100, Taiwan, R.O.C.
    Tel / +886 2 2371 9692~3
    Fax / +886 2 2331 7096
    Website / www.artist-magazine.com
    Account No. / 01044798 Artist Magazine

Distributor / China Times Publishing Co.
Printing Company / Sinew Color Printing & Reproduction Co. Ltd
Publishing Date / April 2009  First Print
Price / TWD 1200.